The Erotic Cloth

Reiko Sudo/NUNO, *Sealskin, 1995*. 100% Polyester. Photographer: Sue McNab.

The Erotic Cloth

Seduction and Fetishism in Textiles

Edited by
LESLEY MILLAR AND ALICE KETTLE

Bloomsbury Academic
An imprint of Bloomsbury Publishing Plc

BLOOMSBURY
LONDON · OXFORD · NEW YORK · NEW DELHI · SYDNEY

Bloomsbury Academic

An imprint of Bloomsbury Publishing Plc

50 Bedford Square 1385 Broadway
London New York
WC1B 3DP NY 10018
UK USA

www.bloomsbury.com

BLOOMSBURY and the Diana logo are trademarks of Bloomsbury Publishing Plc

First published 2018

British Library Cataloguing-in-Publication Data

A catalogue record for this book is available from the British Library.

ISBN: PB: 978-1-4742-8680-0
ePDF: 978-1-4742-8175-1
ePub: 978-1-4742-8173-7

Library of Congress Cataloging-in-Publication Data

A catalog record for this book is available from the Library of Congress.

Cover design: Adriana Brioso
Cover Image © Kevin Twomey/Alamy Stock Photo

Typeset by RefineCatch Limited, Bungay, Suffolk
Printed and bound in India

Figure 1 Minako Nishiyama, *Nice Little Girl's Wonderful Dressing-up*, 1992. Installation at Gallery Shimada, Tokyo, Japan. 320 × 320 cm. Photographer: Shin Kurosawa.

CONTENTS

ILLUSTRATIONS

NOTES ON CONTRIBUTORS

Savithri Bartlett is Senior Research Fellow (Knowledge Exchange) at the University of Winchester, teaching the Cultural History of Dress and Sociological Perspectives of Fashion. Her research and design practice concerns the "body" as the site where, through fashion, competing ideologies of class, gender, and ethnicity are fought out. She undertook her M.Phil. in Textile Print at the Royal College of Art, London, and worked in the *haute couture* industry prior to completing her Ph.D. in laser dye-fiber treatment at the University of Loughborough.

Catherine Dormor is Head of Research Programmes at the Royal College of Art, London. A practicing artist and researcher, her interests bring together materiality, imagery, and language of cloth as a way for thinking, making, and writing. Catherine's practice incorporates stitch, photography, video, and sculpture, always referencing cloth, its structures and behaviors. Her publication project is *A Philosophy of Textile: Between Practice and Theory* (Bloomsbury). She regularly writes for *Textile: the Journal of Cloth & Culture* and her artworks feature in a number of collections, including the Roberta Ahmandson College (Irvine, California). Catherine is an active member of the 62 Group of Textile Artists UK.

Malcolm Garrett, Creative Director at design consultancy Images&Co, is regarded as a key influence on the development of contemporary British graphic design. As a first-generation punk, and while still at art school in Manchester in 1977, he founded the graphic design group Assorted iMaGes, and went on to create landmark designs for Buzzcocks, Magazine, The Members, Duran Duran, Boy George, and Simple Minds. In 1983 he established, with other like-minded artists and designers, the first design studio in Shoreditch, London. He introduced computers to the design studio in the mid–1980s, and became one of the first designers using interactive design and design for digital platforms. Malcolm is an RSA Royal Designer (RDI), an Ambassador of Manchester School of Art, and is a founder and joint artistic director of Design Manchester festival.

Catherine Harper is Professor of Textiles and Deputy Vice-Chancellor of the University of Chichester. Editor-in-Chief of the Routledge journal *TEXTILE: Cloth & Culture*, she is editor of and contributor to *Textiles: Critical and Primary Sources* (Bloomsbury 2012) and author of *Intersex* (Berg 2007). She has published in O'Brien and Moran's *Love Objects* and Taylor & Francis' *Social Identities: Journal for the Study of Race, Nation and Culture*. As a visual artist, Catherine's sculpture, performance, and public arts practice has been exhibited internationally. Variously Artist-in-Residence at the Irish Museum of Modern Art, the Canadian Banff Centre for the Arts, Finland's Nordiskt Konstcentrum, and the National Museum of Prague, her work is in numerous collections: the Irish government, the UK's National Health Service Trust, and the Tyrone Guthrie Centre. She is researching stained and bloodied cloths of Ireland, supported by the Marc Fitch Fund and the Society of Antiquities, London.

Ruth Hingston is an independent visual artist, focusing on human responses to landscape. Her artistic work is held in the state galleries of Queensland and Western Australia, Bathurst Regional Art Gallery, and numerous private collections. She was artist-in-residence at Hill End, New

South Wales (2000); Le Savel, France (2006); Fakultet Likovonih Umjetnosti, Montenegro (2007); The National Archives of Australia, ACT (2015); and Namadgi National Park, ACT (2015–16). Ruth's work has been exhibited internationally. She has held a number of teaching positions, including Senior Lecturer in Textiles, Kalgoorlie College, Western Australia, and Coordinator, Bachelor of Design (Fashion), Canberra Institute of Technology.

Nigel Hurlstone has lectured in textiles and embroidery at institutions such as the Glasgow School of Art; Liverpool John Moores University; University of the West of England, Bristol; and as Program Leader for Embroidery at Manchester Metropolitan University. He is now Senior Lecturer at MMU, Visiting Lecturer at the Royal College of Art, London, and a freelance artist. He exhibits internationally and was the Welsh nomination for the Lodz Tapestry Triennial (2016), receiving a highly commended award. He has authored chapters for *Machine Stitch Perspectives* (A&C Black 2010) and *Hand Stitch Perspectives* (Bloomsbury 2012). His recent research focuses on exploring alternative forms of writing to critically appraise textiles.

Yuko Ikeda, M.A. Senior Curator, The National Museum of Western Art, Tokyo. She studied German and art history in Osaka and Bern, Switzerland with her Master's degree thesis on Paul Klee. 1994–2017, Curator in the National Museum of Modern Art, Kyoto where her main research field is classic modern art and design in German-speaking countries. Curator of the following exhibitions and editor/author of their catalogues: *Vom Sofakissen zum Städtebau: Hermann Muthesius und der Deutsche Werkbund – Modern Design in Deutschland 1900–1927* (Kyoto/Tokyo, 2002–3); *Ernst Barlach Retrospective* (Kyoto/Tokyo/Yamanashi, 2006); *Moderne Deutsche Plakate 1890–1933* (Kyoto/Toyota/Utsunomiya, 2008); *Paul Klee – Art in the Making 1883–1940* (Kyoto/Tokyo, 2011); *KATAGAMI Style* (Tokyo/Kyoto/Tsu, 2012) and others.

Claire Jones is Lecturer in History of Art, University of Birmingham. She is an art historian and curator specializing in nineteenth-century French and British sculpture and the decorative arts. Her publications include *Sculptors and Design Reform in France, 1848–1895: Sculpture and the Decorative Arts* (2014), and a new monograph on Victorian sculpture. Her interests include the intersections between the arts, particularly between sculpture and other disciplines; discourses of making; the fragment and the composite work; reproduction and its histories; and artistic engagements with histories of art. Claire was formerly the Postdoctoral Research Fellow on the Displaying Victorian Sculpture project (University of York, 2010–13) and Curator of Furniture at The Bowes Museum (2001–7).

Alice Kettle is Professor of Textile Arts at Manchester School of Art, Manchester Metropolitan University, and Honorary Professor at the University of Winchester. Her artistic work is held in many international collections, including the Crafts Council in London, the Whitworth, Manchester, and Manchester City Art Gallery; MIAAO, Turin; Museum of Decorative Art and Design, Riga; Ararat Art Gallery, Victoria; and the Belger Arts Centre, Kansas City. In 2015 she was the invited artist at the VAS:T Scottish Royal Society of Arts and held the inaugural exhibition for the contemporary art program at the Queen's House, National Maritime Museum, London (2013). Commissions include the National Library of Australia; Scottish High Court, Edinburgh; Gloucester and Winchester Cathedrals; Manchester University; Winchester Discovery Centre (Public Art and RIBA Award); and Lloyd's Register. She has co-authored *Machine Stitch Perspectives* (2010), *Hand Stitch Perspectives* (2012), *Collaboration through Craft* (2013), and *Making Stories* I-book (2014).

Angela Maddock is Research Fellow in Textiles at Swansea College of Art. She is Visiting Tutor at the Royal College of Art, London, where she is also a researcher. Angela's work is concerned with issues of distance and proximity, making and unmaking, relatedness and care. She is interested in developing a mode of textile writing that expresses our material and sensual engagement with cloth and its production and handling. She received a Crafts Council of Great Britain Parallel Practices Award (2016) to explore themes of material empathy with students of the Florence Nightingale School of Nursing and Midwifery at King's College London.

Masako Matsushita is a freelance dance artist. She graduated in 2012 from Trinity Laban Conservatoire of Music & Dance in London, receiving the Simone Michelle Award for choreography. Her works have explored the fusion between object and body, creating lands and atmospheres enquiring into the presence of the body in time and space. By connecting cultures and aesthetics with her way of constructing structures, her works become moving paintings. She has been artist-in-residence internationally and

presented at various international festivals, including Neu/Now Festival, Its Festival; Dredesera Festival; Festival Ammutinamenti; CivitanovaDanza 2.0; Sånafest; Kilowatt Festival; Bolzano Danza; 16a Quadriennale d'Arte. As dancer and performer, she has also worked with Josiah McElheny, Susan Sentler, Rachel Lopez De La Nieta, Jeremy Nelson, Sivan Rubinstein, Cornelia Voglmayr, Ingvild Isaksen, Curandi Katz, and Matteo Fantoni.

Lesley Millar is Professor of Textile Culture, and Director of the International Textile Research Centre at the University for the Creative Arts. She is a curator specializing in textiles, with major international touring exhibitions including: *Textural Space* (2001); *Through the Surface* (2003–5); *21:21 – the Textile Vision of Reiko Sudo and NUNO* (2005–7); *Cloth & Culture NOW* (2008); *Lost in Lace* (2011–12.); *Cloth & Memory {2}* (2013); *Kawaii: Crafting the Japanese Culture of Cute* (2015); *Here & Now: Contemporary Tapestry* (2016–17). She was Principal Investigator for the EU project "Transparent Boundaries" (2012–14) with partners in Denmark, Greece, Italy, and Poland. She writes regularly about textile practice in Britain and Japan. In 2008 she received the Japan Society Award for significant contribution to Anglo-Japanese relationships and in 2011 was appointed MBE for her contribution to higher education.

Liz Rideal is Reader at the Slade School of Fine Art, University College London. She has exhibited extensively and received various public commissions, including the BBC; Compton Verney; Birmingham Hippodrome (RIBA award); and Oxford Radcliffe Trust. Her artwork is held in public collections including the Tate Museum; Victoria & Albert Museum; British Museum; National Portrait Gallery, London; Vancouver Art Gallery; Museet for Fotokunst, Odense; Portland Art Museum, Oregon; George Eastman Museum & Yale Centre for British Art. Liz received a Leverhulme Fellowship in 2016–17, a British Academy grant to work in India in 2011, and the Rome Wingate Scholarship at the British School at Rome, 2008–9. She is author of *Mirror/Mirror: Self-portraits by Women Artists* (2001); *Insights: Self-portraits* (2005); and *How to Read Painting* (2014 and 2015). She is co-author of *Madam and Eve: Images of Women by Women 1968–2018* (2018).

Debra Roberts is Subject Leader for Printed Textiles and Surface Pattern Design at Leeds Arts University. Inspired by collections and textile history, her practice explores the impact of embodied learning on contemporary practice, through reconstruction and simulation of past techniques. She has exhibited in *Behind the Glass Mosaic* and *The Process Continues*, Leeds College of Art; Lotherton Hall, Leeds, in Highlights Contemporary Craft Tour, 2014. Papers include "Textile Fragments: Incomplete Textiles and Dress in Museums and Historic Houses" (2014) and "Collecting and the Collector" (2015); "Craftsmanship and the Hand Made: Crafting Contexts, Transition: Rethinking Textiles & Surfaces" (2014); "Legacies of Female-Connoted Craft Practice in Design Education," in Feminisms, Power & Pedagogy conference (2015).

Mary Schoeser is Honorary Senior Research Fellow at the Victoria and Albert Museum, where her research is focused on the rebranding of Spitalfields in London over the course of the nineteenth century. As an independent scholar, she has published numerous books, chapters, and articles, most recently the principal essay in *Diane Harrison: Working in Cloth* (2016). Her volume *Textiles: The Art of Mankind* was published by Thames & Hudson in 2012 and has since been translated into French, German, and Chinese. She is Honorary President of the Textile Society and Patron, the School of Textiles (Coggeshall).

Georgina Williams is an artist, writer, and independent researcher. She authored *Propaganda and Hogarth's Line of Beauty in the First World War* (2016) and "Advertising Conflict: Propagandist Aesthetics in 1914," a contributory chapter to the publication *1914: guerre et avant-gardes* (2016). She is writing "Politics and Aesthetics of the Female Form, 1908–1918" for @PalgraveHistory. Her artwork was exhibited in the following exhibitions at Harbour Lights Picturehouse in Southampton: *Brave New World* (architectural photography) in 2010; *Exposed* (paintings of the female form) in 2011; *Industrialia: The Patina of Urban Degradation* (photography) in 2013. She has worked in arts education in the UK, China, and Singapore.

Caroline Wintersgill is Visiting Lecturer in English, Creative Writing, and American Studies at the University of Winchester. Her research is on modernist and postmodernist fiction and film with a particular interest in post-apocalyptic narratives. In 2015 she was the recipient of a 175th anniversary Ph.D. studentship to research endings in the contemporary novel, combining theoretically informed close readings with empirical work among reading groups and members of the literary industry.

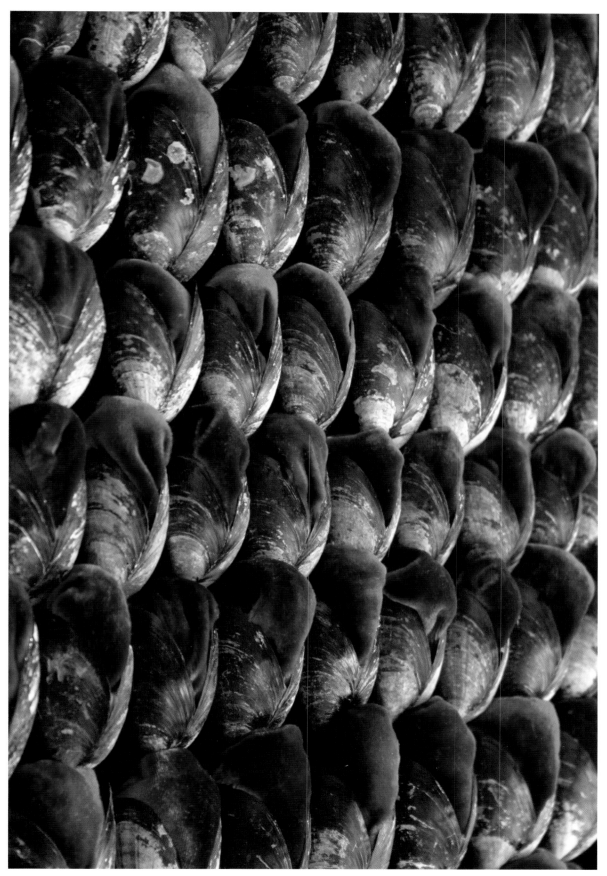

Figure 2 Susie MacMurray, *Shell* (detail 2), 2006. 22,000 mussel shells, red silk velvet. Installation at Pallant House Gallery, Chichester, West Sussex, UK. Photographer: Susie MacMurray.

ACKNOWLEDGMENTS

We wish to thank University of the Creative Arts, UK, and Manchester Metropolitan University, UK.

We also thank all our colleagues and friends who have shown such interest and support for this publication, to Tamsin Koumis and Bob White, and particularly our research assistant Christine Day.

With special thanks to Dr Artur Skweres for his original ideas for the inclusion of *Blade Runner*.

FOREWORD

In his complex novel of 1836 (first serialized in 1833–4), Thomas Carlyle creates a fictional German philosopher who is part parody and part vehicle for Carlyle's own musings on his "new Philosophy of Clothes." *Sartor Resartus*[1]—meaning "the tailor re-tailored"—has since then continued to be an influence in literature and philosophy, as well as a starting point for reevaluations of the history of dress.[2] A central point within is that the meanings invested in matter change as cultures change. Given that erotic cloth has as many meanings as there are cultures and subcultures, Carlyle's novel seems a good place to start our discussion.

"Society is founded upon Cloth," says Carlyle's protagonist, and "Society sails through the Infinitude on Cloth, as on a Faust's Mantle, or rather like the Sheet of clean and unclean beasts in the Apostle's Dream; and without such Sheet or Mantle, would sink to endless depths, or mount to inane limboes, and in either case be no more." With this in mind, consider Sir Peter Lely's portrait of Diana Kirke, later Countess of Oxford, painted in about 1665. Its composition is copied from a Parmigiano drawing of 1535 (then in Lely's possession and now in the British Museum) that employs drapery in a manner often seen in sixteenth-century depictions of the Madonna but, created over a century later and lacking the presence of a child, it has become—in today's eyes—an artfully disarranged signal of sensuality. But when did this meaning arise? In the eighteenth century Horace Walpole described Diana's garb as a "fantastic night-gown, fastened with a single pin," and thus perhaps a harmless-enough painterly device. Yet late in

2001, when Lely's portrait of Diana was selected as the cover for the book accompanying the National Portrait Gallery's exhibition *Painted Ladies*, as a poster this image was banned from display in the London Underground.[3] Might Carlyle also have found Diana's falling-away silken mantle suggestive of tempting "endless depths"? And did, in fact, his novel gradually introduce a more conscious societal awareness of the meaning of clothes and cloth? Perhaps.

Another possibility is provided by Robin Dunbar, a developmental geneticist and author of *Grooming, Gossip and the Development of Language* (1996). He argues that language emerged in humans to replace the grooming activity among great apes that establishes essential group bonds. Cloth, as we know, speaks volumes, or "gossips." It also functions as a literal tool in grooming, as well as an allegorical narrative that enhances haptic "touching." As First World societies have become detached from fixed locations—something that began during the Renaissance with trade and proto-industrialization and has accelerated ever since—it appears that one can trace a historical trajectory towards cloths constructed with increased erotic potential: from knitted shape-hugging silk stockings, scintillating satins, and sheer gauzes to elasticated denims, plasticized cottons, and rubberized polyesters. Such cloths can provide an erotic message that betters spoken communication: it can be "heard" at a distance, no matter how loud the music, and only by people who "speak" the same language. Importantly, our reading of cloth is so fluent that it can articulate meanings at one stage removed, metaphorically touching us via art and design, film, and photography.

We no longer need to share the same space to create those life-affirming (and occasionally life-saving) bonds.

This volume foregrounds aspects of what the editors rightly describe as formerly a largely unspoken discourse, although cloth, it is clear, has been "talking" about it for centuries. It is both timely and challenging, breaking new ground at a moment in history when sexual individualism seeks understanding. Carlyle in his own day described his analysis of clothing as "an untried, almost inconceivable region, or chaos," and in these pages his further words offer the most fitting preface for a study of erotic cloth: "in venturing upon [this], how difficult, yet how unspeakably important it is to know what course, of survey and conquest, is the true one . . .".

Mary Schoeser FRSA,
School of Textiles Patron
Honorary Senior Research Fellow, V&A
Honorary President, The Textile Society

Notes

1 The Project Gutenberg ebook of *Sartor Resartus* by Thomas Carlyle, http://www.gutenberg.org/files/1051/1051-h/1051-h.htm (accessed February 19, 2017).

2 My own copy of *Sartor Resartus* is a 7th edition (1921) of a 1908 first impression by J. M. Dent & Sons, London; the citations given here are from p. 38. For recent dress history see, for example, 'Dress & History since 1965', the text of a paper presented by Dr. Rebecca Arnold at the Women Make Fashion/Fashion Makes Women Conference held at the Courtauld Institute of Art, London on May 16, 2015, http://blog.courtauld.ac.uk/documentingfashion/files/2015/05/Dress-History-since–1965.pdf (accessed February 19, 2017).

3 See 'The Delightfully Racy World of the Merry Monarch', *Telegraph*, October 17, 2001, http://www.telegraph.co.uk/culture/4726093/The-delightfully-racy-world-of-the-Merry-Monarch.html (accessed February 19, 2017).

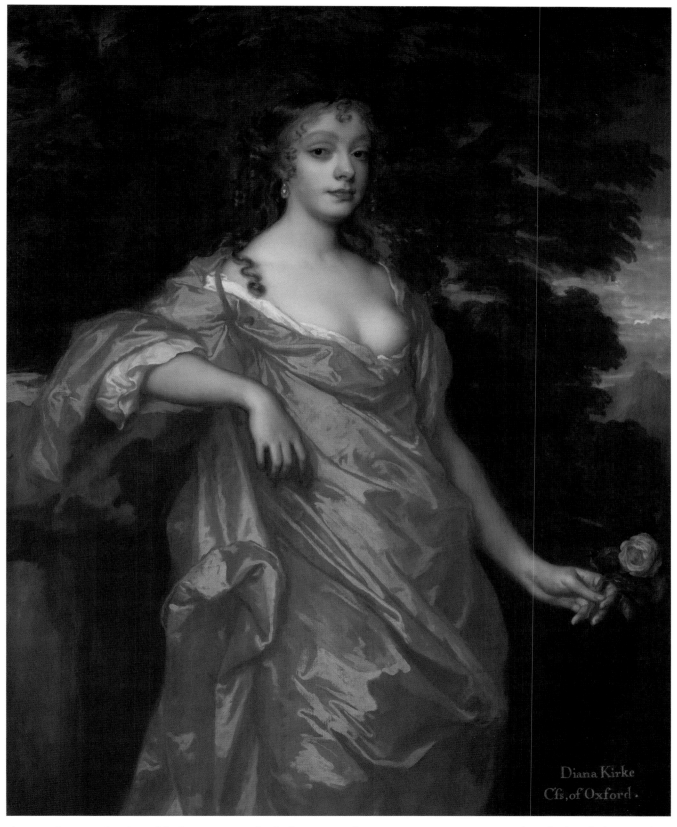

Figure 3 Sir Peter Lely, *Diana Kirke, later Countess of Oxford*, 1665–70. Oil on canvas. 154.9 × 127 × 9.5 cm. In the collection of Yale Center for British Art, Paul Mellon Collection.

Introduction

To dearest Maggie

Lesley Millar Alice Kettle

LESLEY MILLAR AND ALICE KETTLE

The fundamental relationship between cloth and the body has been discussed in depth since the late twentieth century, mainly with a focus on the sociopolitical and narrative particularities of textiles. With the emergence of Haptic studies, the connection between the surface of the skin and the surface of cloth has been considered in the discussion of the sense of touch. However, the erotic nature of that relationship has tended to be the subtext of previous discourse, acknowledged but to a large degree unspoken. *The Erotic Cloth* specifically seeks to discover the ways in which the qualities of cloth that seduce, conceal, and reveal have been explored and exploited in art, design, cinema, politics, and dance.

This volume posits a variety of interpretations in which erotic is a multifaceted state, historically and culturally connected. We have opened this book with an Introduction that discusses the theme from a Western historical and contemporary context, and which draws upon our specialism in textiles as artistic practice. We close with an Afterword that builds upon the Japanese focus in our final chapter, looking at the notion from an entirely non-Western perspective. By doing this, we hope it will act as a signpost for further research into ways in which other cultures negotiate the relationship between cloth and the erotic.

The chapters focus on the aesthetics of cloth which excite and disturb through its materiality, alongside the metaphorical qualities of cloth which are seductive, erotic, intimate, and, at times, shocking. Our definition of erotic is not fixed or presumed, much as the erotic sensation itself is changeable, ephemeral, and individual. The contributions are written in a variety of tones, including those of practitioners and academics whose interest in the erotic is located within the context of cloth. It is a context that embraces the potency of the combination caught by the author Leonardo Padura in his book *Havana Red*: "The heat descends like a tight, stretchy cloak of red silk, wrapping itself round bodies, trees and things, to inject there . . . a slower, certain death" (1997: 1).

This is a book that has emerged from a passionate engagement with textiles. We, the editors—Alice Kettle and Lesley Millar—have spent a lifetime working in and with textiles; for us cloth is more than the fabric laid out to be cut, pieced and pleated, folded or fitted around the body in motion or in repose. We have dyed the fibers, woven the fabric, and penetrated its surface with the needle. We have

fought with it, trying to form it to our desire before, finally and inevitably, moving with it towards that moment when the construction and surface become one and the same. We know that the cloth we hold in our hands is the sum of each of its component parts, elements that have been placed in relationship to each other and to ourselves. Oicherman describes the "outrageous closeness of cloth" (2015: 114) while for Jane Graves it is a "tempestuous love affair with materials."[1] We have been seduced—by the processes of making.

The Weaver: Lesley Millar

My grandmother worked in the cotton mills of Lancashire and, in her later years, often described the frankness of behavior of the women she had worked with. They were aided in this by the processes of weaving—a rich source of metaphor and innuendo—as the traditional song "The Weaver" celebrates:

> She says, "Young man, what trade do you bear?"
> Says I, "I'm a weaver, I do declare.
> I am a weaver, brisk and free."
> "Would you weave upon my loom, kind sir?" said she.
> There was Nancy Right and Nancy Rill:
> For them I wove the Diamond Twill;
> Nancy Blue and Nancy Brown:
> For them I wove the Rose and the Crown.[2]

Beyond these sly and teasing allusions, the bodily engagement required of the weaver to produce the cloth indeed parallels the intimacy of the embrace. We begin by imagining the connection between the threads and fibers. We understand, as we feel the threads with our fingers, what will happen when one thread is placed in tension with another, how they will respond one to another, how they will move and come together. We think about "the strength of a warp and the pliability of a weft, the saturation of colors, the individual components of a pattern" (Kahlenberg 1998: 52). Our fingers tell us how the final cloth will drape and fold, falling and stretching like skin; and how the narrative of our bodies will be embedded within the cloth through our touch, our push and pull. And then we let go— we hand over the cloth to hold the narratives of other lives: to be the agent of their alternative presentations of the self,

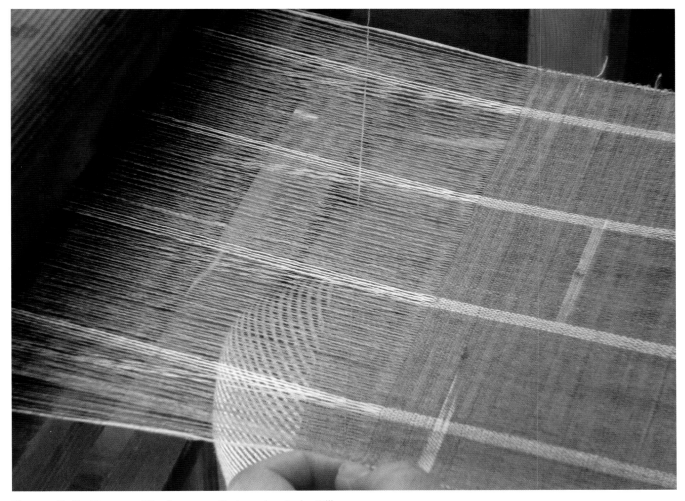

Figure 4 *Yoriko Murayama Weaving*, **2013.** Photographer: Lesley Millar.

to absorb their bodily traces, which silently co-mingle with ours, the creators of the cloth.

This book sets out to discover what is the role of cloth in the expression of the erotic when the cloth is in the hands of others: the dressmaker, the wearer, the artist, the writer. What fantasies are projected, what memories are evoked, what traces and sediments remain?

The Embroiderer: Alice Kettle

The subtext to my own work is the magic power of the needle, the forgiving character of cloth and thread to explore the fertile transformative nature of self-revelation and reproduction. This process is simultaneously physical and fantastic. It is easier to talk about the erotic private self through the language of cloth. My own works often show nakedness, not overtly sexual, but more concerned with vulnerability, exposure, and desire. Certain works are more explicit in owning sexual power to create a validating self-image. The idea of the erotic, with cloth as a site and myself as a maker in its production, creates a loop between sensation and imagination that is constant and co-generative. The artistic process arouses a true physical engagement, a space between imagination and reality where experiences can be encountered, taken apart, and remade. The pulse and rhythm of the sewing machine, the depth of concentration and immersion in making, the tensile thread, and the sympathetic surface are where the sensual feelings are aroused and I discover a way of being whole. Luce Irigaray describes the "female imaginary" as a site for understanding the nature of maternal desire,

Figure 5 Alice Kettle, *Ruko* **(detail), 2012.** Thread on linen. 190 × 120 cm. Photographer: Joe Low.

implicit in the body's creative potential. This link of spirit and flesh is perhaps the source of creative impulse and sensation of her body. In the stitching of cloth I discover a creative sensual self.

The Erotic Cloth

The background to an artistic understanding of textile as materially sexual is evident in the elaborate drapery and clothing of portraiture, often used as an allegorical device for emphasis and emotional impact. In the *Arnolfini Portrait* (1434) by Jan van Eyck, which shows the husband and wife as central, it is the heavy folds of green thick cloth of the wife's dress which draw the eye and that imply a fertile reproductive state. Sculpture has historically relied upon cloth to make soft what is hard and bring movement into solid material. As in Claire Jones' chapter, cloth becomes the representation of what could be seen as sensual, possible to caress but held in stone. The sketch *Drapery for a Seated Figure* (fourteenth/fifteenth century) by Leonardo da Vinci, perhaps a preparatory sketch for sculpture, studies cloth as actual, physical, sensual, and abundantly falling onto the floor.

Anne Hollander's writing on this subject expresses the sensuality in the painted representation of cloth. The sixteenth century saw Venetian artists painting "semi-erotic quasi-portraits . . . which required putting seductive drapery on the sitter and leaving the setting bare of folds" (Hollander 2002: 57). Drapery was exaggerated and excessive as in Titian's *Bacchus and Ariadne*[3] (1520–2), where the eroticism is emphasized by the improbably festooned cloth barely draping the protagonists. Bacchus' leap from the chariot is displacing his robe, suggesting his intention towards Ariadne. She clutches her slipping drapery with her left hand holding a red sash around the lower half of her body. In a later Titian, *Venus with a Mirror*[4] (1554), the cloth encircles and reflects the intimacy of the body. The fur-lined fabric becomes a second skin, drawing the eye of the viewer to the breast and hip in a highly erotic contrast to the gesture of modesty exhibited by her one hand in the lap and the other on the breast.

Also, for the later painters of the baroque, "the fabric contrasted against bare flesh with sensuality . . . heightened by causing specific modern garments to assume the folds of unspecific, classical-looking draperies which could then behave in unaccountable ways" (Hollander 2002: 60). For example, the subject of Boucher's painting *Rinaldo and Armida* (1734)[5] is not only the slightly coy ripeness of Armida, but also the extravagant drapes that seem to flow from her and encircle her lover. The Goncourt Brothers write of Boucher as painting "female nudities who have undressed; but who knows better how to undress them" (Goncourt 1948: 65).

The material itself as erotic was adopted in the seminal works of the fiber movement of the 1960s and 1970s by artists such as Magdalene Abakanowicz and Claire Zeislerbrought. Glenn Adamson calls this sensuous, fibrous textile as holding onto "gravity," becoming an "edifice of artistic potency being challenged by their flaccid forms" (2016: 144). The presentation of art as sexual cloth is powerfully present in the feminist works of Judy Chicago (1974–9) and the materiality of gendered self in the works of Eva Hesse, and in Dorothea Tanning's textile sculptures (1960s and 1970s), the latter which embody the sensual in ambiguous figural forms as they sprawl in copulation, conception, and rebirth arriving replete in post-coital *tristesse* (Kettle 2015: 30). Tanning says, "in league with my sewing machine, I pulled and stitched and stuffed the banal materials of human clothing in a transformative process where the most astonished witness was myself. Almost before I knew it, I had an 'oeuvre,' a family of sculptures that were the avatars" (2001: 281).

More recently a new narrative between cloth and the erotic has been developed as seen in the work of Erin M. Riley. She has used intimate selfies that she has taken to "send to lovers" (Millar 2016: 37) and translated them into woven tapestries. Here the gaze, the subject, the intention, the image, and the maker have become one through the very structure of the cloth.

Alongside these, and other artists' responses to cloth and sexuality, there is another connection between cloth and the erotic, one which is present in all our lives. Cloth is permeated with so many memories in its bodily associations and its haptic sensations: the stain, the cut, the feel, the drape, the smell, the sound, all of which may activate the erotic through the remembrance of the forgotten. For each of us, the erotic character of cloth is formed within the unconscious tendencies of our imagination. We touch or remember the smooth/rough nap of velvet, the softness of cashmere, the coolness of silk, and we experience a

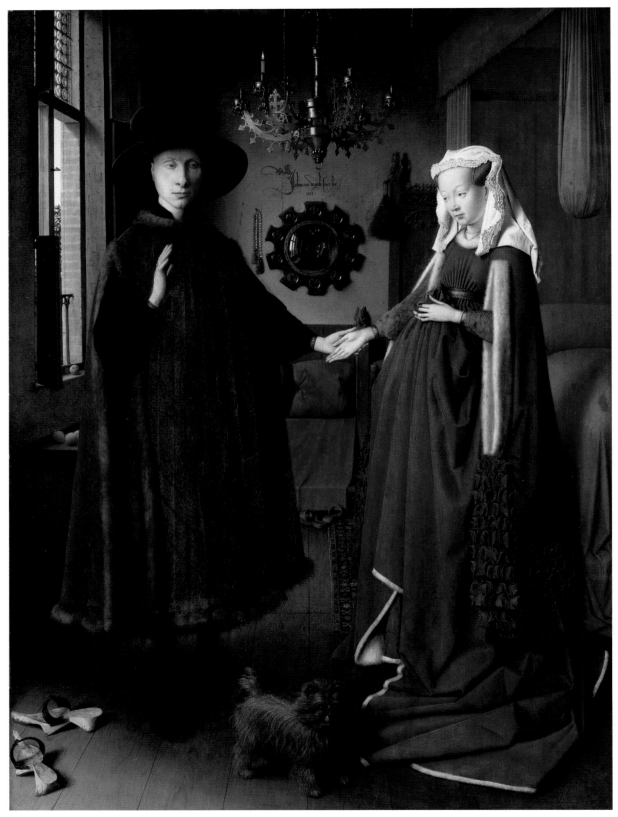

Figure 6 Jan van Eyck, *Portrait of Giovanni Arnolfini and His Wife*, 1434. Oil on oak. 82.2 × 60 cm. *Getty images Fine Art/* Contributor Editorial #:544226862. Collection: Corbis Historical.

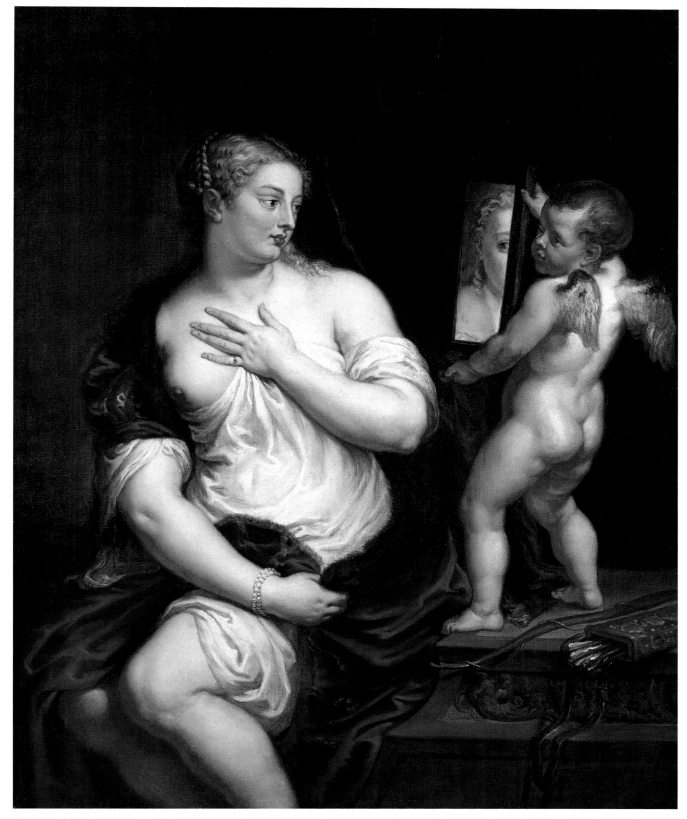

Figure 7 Titian, *Venus and the Mirror*, c. 1555. Oil on canvas. 157.48 × 139.07 cm. Andrew Mellon Collection National Gallery of Art Washington # 1937.1.34.

Figure 8 Magdalena Abakanowicz, *Abakan Rouge III*, 1970–71. Sissal. 300 × 300 × 45 cm. Collection: Fondation Toms Pauli, Lausanne. Photographer: Arnaud Conne.

somatic shift to other times and places, sometimes back to our earliest, non-verbal, relationship.

For Freud, the erotic imagination is founded on the concept of concealment and revelation, which he describes as springing from the moment of "trauma" when the infant child glimpses the maternal body and sees it as flesh, with the breast exposed as cloth is moved away. Anne Hamlyn calls this the space "of potential revelation" (2012: 18) and where the proximity of cloth to both mother and child absorbs the revelatory moment of this trauma and of

sexuality. The cloth memorizes, absorbs, and becomes the symbol of this encounter and takes on, according to Freud, the status of fetish object. The moment when cloth is removed and the body exposed is fundamental to the desire to look and to be looked at, of voyeurism and of exhibitionism.[6] Freud's focus is on gendered heterosexuality and the revelation and awakening to the sensuous, and cloth is part of this experience. In the following chapters, the erotic cloth can often be seen through this background of Freud's concepts and those of Donald Winnicott who

Figure 9 Erin M. Riley, *Self Portrait 1*, 2012. Wool and cotton. 182.88 × 121.92 cm. Photographer: Erin M. Riley.

develops Freud's theory further. He suggests that where cloth, in the infant experience, is a comfort blanket which can act as a material remembering of the original "traumatic" encounter, it takes on deeper sensory meaning in adulthood. Cloth can be described in Winnicott's terms as a "transitional object" which mediates and transports us through our encounters of and with the world, and those with whom we engage. Cloth is the "imaginative bridge," the common fabric at hand, which carries with it the intimacies of past tactile experiences (Jefferies 2015: 97) and is a fabric of sensation for other physical and fantastic meetings. Cloth as intermediary or as fetish object, is a fabric/skin, for "to touch is also to be touched" (Winnicott 1971).

As cloth becomes our second skin, it mediates between our embodied selves and how we are physically in the world. Cloth becomes the membrane onto which we project our sensory perceptions, and clothing, as Steele recounts, extends this encounter: "Because clothing is intimately associated with physical body, [and] at the deepest level clothing is erotic" (1985: 9). This erotic and potent relationship between clothing, skin, body is so close that Mario Perniola encourages us to think of our bodies as sentient clothing for the "insatiable speculative excitement that never tires of traversing it, penetrating it, wearing it, and that enters, insinuates, sticks into us, opening us toward a complete exteriority in which everything is surface, skin and fabric" (2004: 11).

By way of contrast, the erotic cloth is described by Anne Hamlyn as a contest of the body and the mind, where sense and sensation are in opposition.

it is often assumed . . . that one cannot be both seduced by the tactile play of surfaces of the kind that fabric sets up and critically incisive at the same time . . . you either occupy the world of knowledge and insight, commanding language and representation [the Lacanian Symbolic], or you are

fated to remain embedded in the seductive world of the sensual . . . experience that Lacan associates with the Imaginary.

<div align="right">**HAMLYN 2012: 15**</div>

Like the reverse and surface of fabric, sense and sensation are different, but not resistant to each other—synthesized and woven together much like the fabric itself, warp and weft crossing paths and inter-weaving to become one cloth. This double-sidedness of fabric, which is of course mutual and co-constituted, also symbolizes and embodies the connectedness within ourselves, sensible, senseless, and sensuous. In describing the character of cloth as a "membrane of simultaneous connection and division," Claire Pajaczowska is similarly describing the sensory body, the imaginary self, and the rational mind (2015: 81).[7]

Joanne Entwistle speaks of the private and visceral relationship of clothes and body to the world, suggesting that the dressed body "is uniquely individual, private and sensual . . . our relationship to cloth [is] socially and historically constituted" (2007: 94). The hidden and intimate relationship between the body and clothing, which is closely linked to the erotic, has been formalized in Japan in the traditional *haori* kimono jackets worn by men. As described by Yuko Ikeda in the Afterword to this book, these are plain and unostentatious on the outside, but inside are lined with fine silk onto which are printed beautiful designs which are often erotic (Shunga) images—hidden from view, next to the skin and known only to the wearer.

While it is true that the situating of the erotic is intensely private and intimate, through the chapters of this book, threads of connection have materialized where we, the editors, would have expected there to be expressions of difference. Each excursion into the erotic/cloth takes a highly personal tone and focus (some imply the intrinsic nature of love as an aspect of the erotic); however, they are

Figure 10 *Haori Kimono* **(detail), c. 1930.** Silk. 90 × 140 cm. Collection of Koji Takaki. Photographer: Koji Takaki.

linked together through a fascination with a sense of between-ness and becoming, the essential ambiguity of non-arrival. The erotic indicates how, in wearing and making cloth, we move between, transcend, or synthesize multiple sensations. As sensual beings, we discover the erotic located in the space between what has been and what might be, often predicated on a memory, an association, which may only exist at the edges of our consciousness—forgotten to be remembered through the agency of cloth. It is the ebb and flow of feeling, through its fluidity of movement, that cloth facilitates, acting as the mediating surface for the visceral body and the longed-for absent body.

The association between cloth and the body is embedded in our haptic memory and with a swish we are taken back to those buried memories. Back to unspoken longings that hover at the periphery of our vision, catching us and creating a somatic reaction. An interviewee for Lutz Becker's 2005 film *What Is Cloth to Me?* observed: "There is very often an erotic connection to the sound textiles make. The sound they make when people are walking and I think expensive textiles especially make a more beautiful sound . . . I remember the rustle of my mother's dresses when she was going out for the evening." He does not describe what she was wearing, but he refers to the sound of the movement of cloth against cloth, or cloth moving against skin, as Janis Jefferies describes the range of

surfaces, "rough, smooth, shiny and sticky" which touch the flesh, and encourage the autoerotic experience. (Jefferies 2015:97). It is the experience rather than the object and, as such, when recalled, remains erotic.

A phenomenological viewpoint suggests that this erotic imaginary is both the lived/physical and metaphysical dimensions of being in the world (Schalow 2009). Fabric as fetish becomes the concrete experience from which the imagination can enact an "ecstatic" dimension to embodiment (Schalow quoting Heidegger 1991: 198). In remembering of the sound therefore, but not the dress itself, the associations remain erotic and fugitive, as pointed out by Adam Phillips: "The erotic in dress may be the very thing that makes the erotic forgettable—the clothes become the object of desire" (2013). In his film *In the Mood for Love*, the director Wong Kar-wai plays with this transference using his female character's cheongsam, the traditional Chinese fitted dress, as worn by the main female character. Through its changing pattern and color, the cheongsam is first the mediator and then the narrator of the erotic exchange between the man and the woman. Finally, the cheongsam itself becomes the object of desire as we wait for its next appearance.

The cheongsam is a modest garment; it has a high neckline and the length is to the knee, but as it is a fitted dress, in order to facilitate movement, the seam is not joined along

Figure 11 *In the Mood for Love,* **2000.** Screengrab. Director: Wong Kar-wai. Producer: Wong Kar-wai.

Figure 12 Bob White, *Between Cloth and Skin*, 2004. Acrylic on calico. 163 × 66 cm. Photographer: Bob White.

part of the upper leg. When Roland Barthes asks, "Is not the most erotic portion of the body where the garment gapes?" (1975: 9), he is directing our gaze towards the glimpsed, nuanced space where our imagination finds its place between the cloth and the body. The glimpsed body is most present when the clothing is made from lace, or contains lace elements. The lace allows for an undefined, a hoped for suggestion, caught for a moment, but not wholly revealed. An intimate space between two surfaces: the known and the unknown; the forgotten and the remembered. If we take the use of lace in lingerie, it denotes a boundary, which could become a borderline: a space for encounter, the edge of the garment and the beginning of the (untouchable) space beyond. Lace performs as the erotic edge between the open and the secret, the pure and the impure, innocence and transgression, providing the perfect mise-en-scène, leading yet fugitive, high definition and low definition, occupying the foreground and then receding to become a backdrop (Millar 2011). Always it is in that ambiguous space of between and becoming that the erotic floats.

As we gaze upon the other, we map the body, using the cloth as our tool of cartography to apprehend what lies beneath. While the sculptor traces the lines of the body with cloth, for a dancer, the body and the cloth form a relationship of revealing and veiling. Cloth in movement is ambiguous, embracing, tracing. The caress of the cloth and its interrelationship, direct and indirect, with the body, pulls us back to the corporeal, activated by our imagination and our memory of the body absent. We have recognized the sensuous sign that "does us violence; it mobilizes the memory, it sets the soul in motion" (Deleuze 2000: 101). It is a fierce trigger, a cognizance of separation, characterized by Georges Bataille as "the crack [that] belongs intimately to human sensuality and is the mainspring of pleasure" (Bataille 2012: 105). Such moments catch us by surprise in the here and now, and then become the slowly revealed recognition of the feeling. This thread between the past and the future brings the absent body to mind, which is not the body in its totality but fugitive, like a shifting cloth across the body.

The Representation of Cloth

In Part I of this book, the erotic is presented in art through its representation in cloth. The erotic cloth draws upon the

use of textile within the canon of artistic history. It looks at the erotic as a revelatory sensation, staging cloth within artistic representation, which—like desire—is viewed as a subjective state. Immanuel Kant expresses desire possessing an expectation of pleasure. In his *Third Critique*, Kant distinguishes between pleasures, one as sensuous, empirical and the other as contemplative and connected to aesthetic judgment (Kant 1996: 20–22). The chapters in Part I express the erotic as both sensed and observed through the portrayal of cloth and advanced through artistic response. The erotic emerges from the historical, from the Italian sixteenth-century painting of Moroni in Angela Maddock's chapter, Claire Jones' mid nineteenth century marble sculpture, and Nigel Hurlstone's description of cinema and Glover's early twentieth century photographic images. The erotic is staged and re-presented in cloth as a responsive site. All are observers of the erotic, with Maddock and Hurlstone's own work springing from these sources as a cause and effect of desire. Moroni's brushstrokes of the tailor, the marble bodies and the filmic and photographic images of dressed-up men are representations that "express and embody erotic desires" using cloth as a pretext and prop to assist in beguiling, frustrating, and implying what Jones calls the "space between flesh and cloth." They describe the tension of the erotic, with desire as both longed for and indecent. Kant's desire characterizes the aesthetic enjoyment of beauty as "disinterested" and the sensuous experience as pleasure. These distinctions are the practical and poetic distances between cloth and implied flesh.

These chapters examine the public exhibition and private pleasure of the erotic within the shifts of social attitudes. Erotic turbulences of the inner self negotiate putative morality and the allegorically acceptable representations of the sensual. For Jones, a radical reconfiguring of ideal sculpture occurred through cloth placed over the bodies of would-be real young women, teasing out the erotic as strokeable even though made of hard white stone; "These girls may be silent or silenced, with bowed heads and pliant limbs, but they are also independent, conscious, absorbed, in ways in which allegorical child sculpture is not." These everyday subjects are likewise the substance of the erotic in Maddock's and Hurlstone's chapters. The tailor, the boys, and bravely they themselves as artists are "of the real world." They can be touched by human hands, desired and aroused with all the accompanying censorial, sensorial, and ethical implications. Real implies down to

earth, and Jones suggests that this comes with a distinction in class where working Risorgimento women are "conscious, active beings," where pleasure is in Maddock's labouring tailor and where Hurlstone's working and uniformed men are eroticized and virile.

The representation and re-presentation of the erotic through the artistic hand problematizes the "erotic being" in these chapters. They demonstrate the difficulties of making public the erotic, and becoming a form of exhibitionism when exposed within the public sphere. The private erotic translated into a more public setting is described by Hurlstone as "illusive and slippery." He indicates that what we are talking about are "fundamental questions of sexual values, behaviors and moralities in an age where sex, celebrity, youth, exploitation and recrimination congregate en masse to make this an age of erotic uncertainty for all." Surely the erotic is and has always been troublesome, even more so when made public and trespassing into questions of taste and compromise. The erotic is an unsettling presence in Jones' chapter. The pure whiteness of marble pubescent girls, with exposed breasts, are made more real through their three-dimensional human scale and clothed in nightdresses. The violence of cutting, cutting up, and cutting out erotic deviancy is powerfully alive in the giant shears of Maddock's *Il Tagliapanni*. Hurlstone registers the painfulness of the erotic as seepage of homosexuality: "I deliberately begin to wear clothes that cover my flesh almost entirely," which, by his own admission, encourages a new erotic and fetish sensation. He reminds us of the AIDS crisis, which is an acute and real consequence of, for example, Rock Hudson's homosexuality. Hurlstone expresses the prejudice toward homosexuality, the assumption at this time that it is deviant, infectious and "septic" and his consequent feelings of shame.

The difficulties of portraying the erotic as authentic and non-voyeuristic are part of its illusory nature. It is a sensation that is implied, encountered, and contested. These chapters show us the private erotic image emerging publically with cloth assisting in, as Hurlstone says, "re-constructing and de-constructing both its aesthetic, content and context with the implications of exhibitionism." We have spoken already about the concealment and revelation by cloth of the erotic as part of its contradictory state. The chapters also tell us of the joy and anxiety, and what Jones refers to as the conflation of public and private spheres, the domestic and the political, as contested sites

of respectability and acceptability within the erotic encounter. The erotic is never resolved or properly found since, as these chapters imply, it carries the morality of the past which even when represented "is connected to an interrupted narrative in which what has gone before, and what comes after are always left to speculation and imagination." Re-fixing the erotic within the cloth as an artistic gesture mediates the erotic self into the world. Cloth appears to express and absorb desire and pleasure without presuming to resolve the difficulties it implies.

Making and Remaking the Cloth

Part II explores the erotic nature of cloth in design and making. It also addresses unmaking and fashion with cloth as an embodied and fetish substrate. The erotic cloth arouses and provokes as a weapon both of defense against the erotic and as a defiant projection of it. Stitching and cloth are used as the means to escape and address issues of repression and bondage, interpreted also as ways of being bound into sexual expectations and of social binding. The powerful physical action of stitching, with its ability to change form and reshape, is appropriated as gestures and metaphors for social change. Ruth Hingston sews to physically withdraw herself from others and to create a barrier countering the erotic, while Debra Roberts systematically reconstructs cloth, exposing a residue of the erotic ever present in historic cloth. Their restraint is a counterpoint to the defiantly erotic of punk clothing, the aggressively sexual counter-culture of the 1970s. This, and its legacy of liberalism to clothing and permissiveness, is treated by Malcolm Garrett.

All express the compelling contradictory nature of the erotic. Roberts' historical approach to cloth analyses its structure which restricts and exaggerates the wealthy female form in a tightened bodice and abundant flowing trail. The feminine body is displayed in the bindings of socially gendered hierarchies and status, as sexualized and reproductive. She describes how the dress was designed to seduce. The suggestion is that women are expected to seduce as erotic beings whether they choose to or not. Roberts nevertheless is affected by the lingering sensuality of the cloth. As a historian, her resistance to its effect is shaped by her own somatic response to its texture. She probes into its inside and other side, recalling what

she calls Ribeiro's "vitiated imagination." In other words, the thrill and intimacy of, for example, when Rosalie Calvert "opened the bodice under the arm to insert a new piece of cloth."

Sexual objectification is disarmed by Hingston in the isolated intensity of an arid gold-mining town in Australia. Rejecting the dominating masculinity which objectifies women, and with which often the women collude, she describes how desire with its "raw and brutal tension" exploits and destroys relationships and the physical being of one and the other, man and woman. Hingston turns to stitching cloth as a shield against the erotic, to effectively survive the prejudices of the place, only to unearth her female self in a state of *jouissance*. In this withdrawal and in her own interiorization, the erotic is both excluded and discovered in other ways within herself as the experience of finding the physical and emotional being.

Mario Perniola's description of sexuality is an experiencing of and becoming of the self. He uses the phrase "neutral sexuality," where sexuality is not concerned with desire for seeking or controlling pleasure or orgasm, but is focused on the opening up of one's own sensual subjectivity (Perniola 2014: 44). "So it's not about loving objects. It's about *becoming* them" (Marino 2010: 179).[8] Roberts and Hingston in their chapters both touch upon this idea of becoming, despite their own reticence, stimulated through or by means of cloth or making. The erotic is not experienced as a predictable sensation but recognized within the taxonomy of what can be aroused and surprisingly felt.

The difficulties of sexual morality and of owning sexual autonomy is the undercurrent within the Hingston and Roberts chapters. Punk differently confronts these issues, subverts and satirizes them. Garrett talks of moral entrapment, impotence (in the words of the Sex Pistols) through "having no future."[9] This frustration is symbolized through a mini-revolution where clothing embraced a graphic language of resistance. Bondage clothing worn as fashion was about reclaiming independence as a liberating act of self-expression and the subversion of social respectability. Garrett and friends painted and customized clothes when Vivienne Westwood's clothes were beyond their economic reach. Their homemade clothes, like the making of Hingston and Roberts, become the material means to express individuality. Garrett however explains that individualism was both about standing apart from established norms and becoming the same despite differences in

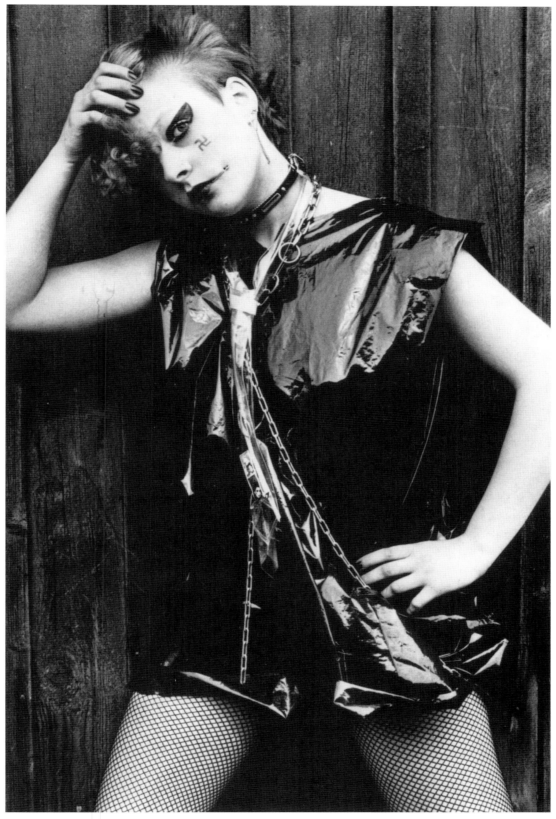

Figure 13 *Punk*, **1977.** Keystone Features/Stringer. 3271169. Collection: Hulton Archive. Photograph by Keystone Features/Getty Images.

gender and multiple sexual proclivities and identities. He says that "the inter-changeability of the sexes," rather than the exploitation or domination of gender, encouraged a "liberalisation of sexuality as experimental and challenging of norms." Interestingly, Patricia Marino, speaking about Perniola, says that we ourselves are becoming sexual beings in new and radical ways (2010: 182). Garrett's punk clothing is transformative, he becomes superhuman, leading an "assault on the dominant ideology of gender, sexuality and romance." Surprisingly these clothes were not about having sex or being sexual, as "the clothes simultaneously ignored and exploited eroticism." Instead the erotic cloth reclaimed power and empowerment both individually and collectively. This paradigm shift is the legacy to our contemporary view of fashion with the erotic fetish as a barometer of taste, exploitation, and outrage. Using Perniola's analogy, all three chapters describe the cloth as the transformative material which owns the erotic as a discreet or powerful aspect of identity.

The Alternative Cloth

The dancer and choreographer Guilio D'Anna has written "let me be on your skin and under it, down to the bones of each other" and Part III of the book explores cloth and cloth/skin as the site of exchange—of emotions, of caresses and of fluids—cloth as the witness to the body in all its states and stages. All three of the writers develop ideas around clothing as skin/ skin as clothing, and the eroticism of the intermingling as "the clothes that make up the body of the partner are mixed with one's own" (Perniola 2004: 10). In Martin Cruz Smith's novel *Havana Bay*, his Russian hero Arkady Renko, despite the sweltering Cuban heat, refuses to take off his winter cashmere overcoat, given to him by his dead wife, because "the coat bore the faint lingering perfume of Irina, a secret, tactile sense of her, and when the thought of her became unbearable this scent was a final ally against her loss" (Cruz Smith 1999: 33).

Although erotic feelings are often a response to something outside ourselves, Georges Bataille writes of eroticism answering "the *innerness* of the desire" (2012: 29), it disorders our thinking and shakes our sense of reality. However, if there is no action without reaction then cloth may give permission to be, and to expose, our transgressive Other, recording our indiscretions as a part of the

erotic condition. Going back to *Havana Bay*, Renko's new lover secretly wears the coat in an attempt to achieve intimacy with him. Holding the seepage of emotions and the leakages from our bodies from the cradle to the grave, cloth signposts alternative versions of life, modes of living and of dying.

Catherine Harper, in her chapter "Present or Absent Shirts: Creation of a Lexicon of Erotic Intimacy and Masculine Mourning," takes us to the heart of the matter— to matter itself: the body beneath the cloth. Her cloth is an agent that records, caresses, binds, and ruptures life experience and allows us to experience the fierce eroticism of death. The body is absent. The abject cloth, with its stains, marks, and rips, is the body in absentia. The abjection described is that which, as Julia Kristeva has written, "does not respect borders, positions, rules. The in-between, the ambiguous, the composite. Abjection is . . . a passion that uses the body for barter . . ." (Kristeva 1982: 4). We touch the cloth and we are penetrated, we feel the longed-for body. We take that particular cloth, with its traces of the fluids of life, and it becomes the focus for our yearning, representing that porous border between life and death. As long as the cloth exists the body is never fully eradicated from the experiential world.

The interconnectedness of cloth/skin/body is central to the film *Blade Runner* (dir. Scott. 1982), where the Replicants (androids) are referred to as "skinjobs." For the Replicants, their cloth/skin allows them to contravene the societal norms of being human, passing amongst us but they are not us. While their mechanized interior is "clothed" by skin, a covering up, it also betrays them: "the body conceals itself precisely in the act of revealing what is Other" (Leder 1990: 22). Their clothing of skin is an illusion; the Replicants are removed from "the perennial chasing after . . . love and hate" (Perniola 2004: 11). In their chapter "Empowering the Replicant: Visual and Haptic Narratives in *Blade Runner*," Caroline Wintersgill and Savithri Bartlett examine the haptic narrative embedded in the clothes/skin of the Replicants. Violence and eroticism are present equally, signaled by their various costumes, as starkly illustrated by the character Pris as she removes her ripped and laddered clothes prior to her murderous attack. Or Rachael, who is first seen as a fetishized version of buttoned-up, tight-waisted, shoulder-padded, inaccessible 1940s film noir woman, and then undergoes several transformations of style and role.

Figure 14 Sarah Sudhoff, *At the Hour of Our Death: Suicide with Shotgun, Male, 60 Years Old (I)*, 2011. Archival Pigment Print. Edition 1/9. 101 × 76 cm. Photographer: Sarah Sudhoff.

Nothing is as it seems. A further layer of uncertainty is added within the mise-en-scène by the constant rain, adding a veil of glimpsed erotic ambiguity.

The touch of the cloth on skin, of skin on cloth, cloth as skin, skin as cloth— these themes are present for Catherine Dormor in her chapter "Caressing Cloth: The Warp and Weft as Site of Exchange." It is a caress of both co-dependency and separateness that allows us to explore our sense of self and that of the Other. It is a touch that "binds and unbinds two others in a flesh that is still and always untouched by mastery" (Irigaray 1984: 155). Such an act of mutuality, of equality and completed-ness, Dormor suggests, is also present in the weaving together of the warp and weft of a piece of cloth. The threads interlace in an act of completion, the toucher and the touched "may momentarily lose . . . independence and identity, and fuse with the body of another" (Pallasmaa 2009: 29)—cloth as skin, skin as cloth. The absent body is mine. The cloth becomes my absent body and/or the absent body of the Other—a co-mingling of both. The spaces between the threads, between the cloth and skin, between the dermis and epidermis, offer the writer and the artist a site of erotic transition.

The Performing Cloth

Part IV of the book is concerned with the momentum of folding and caressing, as the cloth both evokes and withholds what it conceals. Cloth in movement is mysterious, embracing, tracing, and always evocative of the body. The cloth and the body "become rolls of material that fold and unfold on one another . . ." (Perniola 2004: 1), as in the opening sequence of Pedro Almodóvar's 2016 film *Julieta*, which is an extended close-up of red silk falling in labial folds. Slowly, the viewer becomes aware of gentle, breathing movements, drawing the gaze into the deep interior of the fabric folds. The trembling cloth, with its beating center, describes the sensation of the body, and foreshadows the narrative of the film. The camera draws back and reveals the silk to be a kimono-style gown worn by the character Julieta of the title as she sits at her desk. Cloth becomes the medium, the mysterious erotic "condition of 'betweenness' and a quality of 'becoming'" (Bruno 2014: 5). Equally, cloth when swiftly or slowly drawn away exposes what we think had been described through drape and fold. We see a form that may be empty space—the

space occupied by the complicit relationship between our imagination and the cloth.

In her chapter, Georgina Williams takes Hogarth's *Serpentine Curve* (his *Line of Beauty*) and follows the curve to reach the *Serpentine Dance* of Loïe Fuller.[10] The very phrase "The Serpentine Curve" catches the imagination, always moving, bending, arcing, and bowing, away from the central axis, taking us back to Eve, Adam, and the serpent: temptation for, and an awareness of, something without being able to name it. Our eye follows the line, taking pleasure from its meanderings, not actually needing to reach a point of finality. On the way we discover Loïe Fuller, cloth and body moving as one, the cloth extending the body, creating flowing arcs through the air as she spirals around, pre-figuring the Futurists' ideas of continuity in space. The dancer is before us in an image created by light and shadow through the film made in 1897, body and cloth forever forming the serpentine curve. The cloth folds and unfolds around her body, using the reflective qualities of her cloth as illuminated by the newly discovered electric light. Tracing her lines in space, she moves across another cloth, the membrane of the cinema screen, a screen that the Dutch called the "Window of Linen."[11]

The filming of the movement of cloth through space, forming ever-changing shapes, and then projected onto the Window of Linen is yet another understanding of cloth as active, potent, and erotically charged. Liz Rideal maintains that "film can work better than other media in expressing erotic subtleties because the moving image can easily show and imply touch and the physical rhythm of sex." In "The echoes of erotic cloth in film" she invites us to consider our (unforbidden) pleasure in looking at the (forbidden) intimate narratives played out on film through cloth and clothing. Cloth and clothing provide a language that we recognize and are able to use in order to access hidden longings and erotic connections. Their mutability is appropriated as agent of sublimation and metaphor for erotic encounter, forming an innuendo of an embrace. And always there is the "safety" of the mediating surface of film, separating us—this is not us, we may read what is being implied but we are not the initiators. In that dark, intimate space that surrounds us, we become fellow travelers, traveling within the cloth on the film and of the film, taken by double proxy to a place beyond our inhibitions.

Dancers place their body at the intersection between what is real in the physical sense and what is imagined.

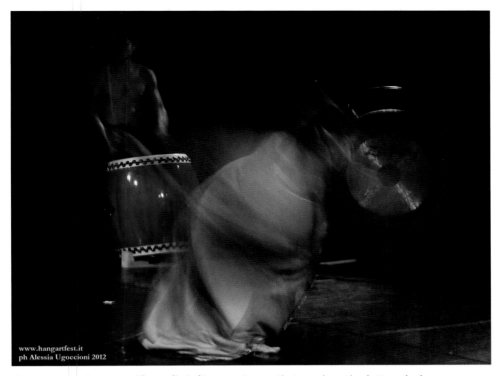

Figure 15 Masako Matsushita, *TaikokaiT*, 2012. Dance. Photographer: Alessia Ugoccioni.

The dancer's existence is transient, always foreshadowing the body's disappearance as they dance. Traditionally the dancer exists as "a demonstration of that which is desired but is not real. Her body flames with the charged wantings of so many eyes . . ." (Foster 2005). The dancers give their body to our imagination; we are reading their movements, anticipating the narrative, but always a step behind. In the chapter "*UN/DRESS*" Japanese/Italian dancer and choreographer Masako Matsushita describes this state: "I give myself up ecstatically to the immersion and fusion of the my-body with the object-body." Her costume is as close to her body as possible, a true second skin, one that moves with her every flex of muscle, holding her, becoming her. It is the means to "house the motion of emotion" (Bruno 2014: 18) and it is a skin that she peels off once the performance is complete; the sloughed off cloth/skin lies on the ground becoming the absent/present body.

Conclusion

The Erotic Cloth draws from the fields of art, design, film, and performance in its aim to reflect a range of presentations of sensual material that contribute to the debates around the human encounters with cloth. These are ideas and discussions that are at the heart of contemporary textile practice, popular culture, and research. We have witnessed Beyoncé announcing her pregnancy through the media in images that show cloth as powerfully, colorfully, and seductively instrumental in expressing the erotic maternal, accentuating the sexuality of her fulsome condition. Warsan Shire's poetry accompanying the photographs reads "mother is a cocoon where cells spark, limbs form, mother swells and stretches to protect her child, mother has one foot in this world and one foot in the next, mother, black venus" (Shire 2017).

The following chapters explore different states of cloth as erotic through the themes outlined above, which include the historical, gendered, social, static, and dynamic forms of cloth. The various descriptions and methodologies range from the overtly explicit to the subtly implied, all of which are held within the fabric of cloth. In responding to the materiality and gesture of cloth we may appreciate our erotic desires and impulses, which in turn may reflect back on our cultural histories. The erotic lies in ambiguous, unnamed anticipation; it is varied and variable, much like the multiple characteristics of cloth. Cloth is also double sided: one side may be smooth and the reverse frictive, and

at times the erotic is also fierce, and sometimes poleaxing in its revelatory qualities. However, once the feeling is identified and named, it changes, it moves from the erotic and becomes desire, which is accompanied by the need to control and sometimes to consume.

In the presentations and sensual embrace of cloth we discover the erotic potential and tension of multiple sexual proclivities. We can make no assumptions about the erotic, or the nature of pleasure or desire as taut and flowing sensations. Feminist, post-feminist, and queer theory discourses have been referred to but not engaged with explicitly. These writings (Foucault 1976; Butler 1990, 1993) refer to the de-categorization of sexuality, acknowledging the fluid channels of sexual individualism. The collection in this book, although referencing some Japanese sensibilities, is largely from a Western perspective with its specific cultural hegemony, and offers a starting point from which to explore the erotic further through different cultural and ethnic viewpoints. Other interpretations of the erotic can be suggested which are expressed through alternative sexualities and relationships. Cloth configures and reconfigures itself as a significant actor in these territories. Descriptive in its materiality, sensual in its surface, performative in its motion, cloth is an active participant with the erotic. Cloth with its properties as a membrane allows us to present our erotic self; it can also signpost those things we cannot, or do not wish to, name—veiling the specifics of our erotic longings, while we engage with our forbidden.

Notes

1 For Graves, it is glitter that is "mysterious. It retains the primal narcissistic magic of our first mirror, in which we see ourselves in our mother's loving gaze" (2009: 80).

2 Traditional Music Library On Line Tunebook (Shareware Version). Copies of this score may be freely distributed—further information from www.traditionalmusic.co.uk (accessed December 10, 2016).

3 In the National Gallery, London.

4 In the National Gallery of Art, Washington.

5 In the Louvre, Paris.

6 Freud himself suggests that what he identifies as distinctive "drives" of voyeurism and exhibitionism (to look at and to be looked at) are, in fact, part of each gender in early years and only distinctly gendered later (Entwhistle 2000: 185).

7 Claire Pajaczowska relates this to psychoanalytical writings of Freud on attachment and body ego (Freud 1923/1964).

8 Review of Mario Perniola (2010), pp. 179–82.

9 "No future" were words in the song "God Save the Queen" (1977) by punk-rock band the Sex Pistols. It was included on their album *Never Mind the Bollocks, Here's the Sex Pistols.*

10 Some dispute the dancer's identity, suggesting that it is Papinta, The Flame Dancer.

11 As discussed in conversation with film maker Lutz Becker on 30.11.17.

References

Adamson, G. (2016), "Soft Power," in Jenelle Porter (ed.), *Fiber: Sculpture 1960–Present*, 142–52, New York: Prestel.

Barthes, R. (1975), *The Pleasure of Text*, trans. R. Miller, New York: HarperCollins.

Bataille, G. (2012), *Eroticism*, London: Penguin Classics.

Blade Runner (1982) [Film] Dir. Ridley Scott, California: Warner Bros.

Bruno, G. (2014), *Surface. Matters of Aesthetics, Materiality, and Media*, Chicago: University of Chicago Press.

Butler, J. (1990), *Gender Trouble: Feminism and the Subversion of Identity*, London: Routledge.

Butler, J. (1993), *Bodies that Matter: On the Discursive Limits of "Sex,"* London: Routledge.

Cruz Smith, M. (1999), *Havana Bay*, Oxford: Macmillan Pan Books.

Dant, T. (1996), "Fetishism and the Social Value of Objects," *Sociological Review*, 44 (3): 495–516.

Deleuze, G. (1964), *Proust and Signs*, trans. R. Howard, New York: Braziller.

Dunbar, R. (1996), *Grooming, Gossip and the Development of Language*, London: Faber and Faber.

Entwhistle, J. (2000), *The Fashioned Body Fashion, Dress and Modern Social Theory*, Cambridge, Oxford: Polity Press.

Foster, S. (2005), *Corporealities: Dancing Knowledge, Culture and Power*, Taylor & Francis e-Library.

Foucault, M. (1976), *The History of Sexuality Volume One: The Will to Knowledge*, London: Penguin.

Freud, S. (1923/1964), *The Ego and the Id*, London: Hogarth Press.

Freud, S. (1991b [1927]), "Fetishism" in A. Richards (ed.), *On Sexuality: Three Essays on the Theory of Sexuality and Other Works*, 88–120, Harmondsworth: Penguin Books.

Goncourt, E. and J. (1948 edition), *French XVIII Century Painters*, London: Phaidon.

Graves, J. (2009), *The Secret Lives of Objects*, Bloomington, IN: Trafford Publishing.

Hamlyn, A. (2012), "Freud Fetish and Fabric," in J. Hemmings (ed.), *The Textile Reader*, 14–27, London: Berg.

Hollander, A. (2002), *Fabric of Vision, Dress and Drapery in Painting*, London: Bloomsbury.

In the Mood for Love (2000) [Film] Dir. Wong Kar-Wai, prod. Wong Kar-wai, Block 2 Pictures, Jet Tone Production, Paris: Paradis Films.

Irigaray, L. (1991), *The Irigaray Reader*, ed. M. Whitford, trans. D. Macey, Oxford: Blackwell.

Jefferies, J. (2015), "Editorial Introduction: Part Two: Textile, Narrative, Identity, Archives," in J. Jefferies, D. Wood Conroy, and H. Clark (eds.) *The Handbook of Textile Culture*, 97–105, London: Bloomsbury Academic.

Jefferies, J., Wood Conroy, D., and Clark, H. (eds.) (2015), *The Handbook of Textile Culture*, London: Bloomsbury Academic.

Julieta (2016) [Film] Dir. Pedro Amodóvar, Los Angeles: Echo Lake Entertainment.

Kahlenberg, M. H. (1998), *The Extraordinary in the Ordinary*, New York: Harry N. Abrams Inc.

Kant, I. (1996), "Critique of Practical Reason," in *Practical Philosophy*, trans. M. Gregor, 20–22, Cambridge: Cambridge University Press.

Kettle, A. (2015), *Creating a Space of Enchantment: Thread as a Narrator of the Feminine*, PhD Manchester Metropolitan University.

Kristeva, J. (1982), *Powers of Horror: An Essay on Abjection*, trans. L. Roudiez, New York: Columbia University Press.

Leder, D. (1990), *The Absent Body*, Chicago: University of Chicago Press.

Marino, P. (2010), "Review of Mario Perniola, "The Sex Appeal of the Inorganic" (Massimo Verdicchio, Translator)," *Journal of the History of Sexuality*, 19: 179–82, January 2010. Available at SSRN: https://ssrn.com/abstract=1969499 (accessed January 15, 2017)

Millar, L. (2011), *Lost in Lace*, Birmingham: Birmingham Museum and Art Gallery.

Millar, L. (2016), *Here & Now: Contemporary Tapestry*, Sleaford: National Centre for Craft and Design.

Oicherman, K. (2015), "Binding Autobiographies: A Jewishing Cloth" in J. Jefferies, D. Wood Conroy, and H. Clark (eds.) *The Handbook of Textile Culture*, 104–21, London: Bloomsbury Academic.

Padura, L. (1997/2005), *Havana Red*, trans. P. Bush, London: Bitter Lemon Press.

Pajaczowska, C. (2015), "Making Known: The Textiles Toolbox—Psychoanalysis of Seven Types of Textile Thinking," in J. Jefferies, D. Wood Conroy, and H. Clark (eds.) *The Handbook of Textile Culture*, 79–97, London: Bloomsbury Academic.

Pallasmaa, J. (2009), *The Thinking Hand*, Chichester: John Wiley.

Perniola, M. (2004), *The Sex Appeal of the Inorganic: Philosophies of Desire in the Modern World*, London: Continuum.

Phillips, A. (2013). *Clothing Eros: the Erotic Potentials of Dress*. Conversation with Judith Clark and Frances Corner. Available online: https://podcasts.ox.ac.uk/clothing-eros-erotic-potentials-dress (accessed January 13, 2016).

Schalow, F. (2009), "Fantasies and Fetishes: The Erotic Imagination and the Problem of Embodiment," *Journal of the British Society for Phenomenology*, 40 (1): 66–82, DOI:10.1080/00071773.2009.11006666.

Shire, W. (2017), Available online: https://qz.com/901348/who-shot-beyonces-maternity-photos-awol-erizku-an-ethiopian-born-new-york-and-los-angeles-based-artist/ (accessed February 10, 2017).

Steele, V. (1985), *Fashion and Eroticism: Ideals of Feminine Beauty from the Victorian Age to the Jazz Age*, Oxford: Oxford University Press.

Tanning, D. (2001), *Between Lives*. Available online: http://www.tate.org.uk/art/artworks/tanning-nue-couchee-t07989/text-catalogue-entry (accessed May 21, 2015).

What is Cloth to Me? (2005) [Video] Dir. L. Becker, London: University for the Creative Arts.

Winnicott, D. (1971[1989]), *Playing and Reality*, London: Routledge.

Further Reading

Calefato P. (2004), *The Clothed Body*, Oxford: Berg.

Entwhistle, J. (2001), "The Dressed Body" in Joanne Entwistle and Elizabeth Wilson (eds.), *Body Dressing (Dress, Body, Culture)*, 33–58, London: Berg.

Skelly, J. (2017), *Radical Decadence: Excess in Contemporary Feminist Textiles and Craft*. New York. Bloomsbury Academic

Figure 16 Reiko Sudo/NUNO, *Amate*, 2000. Rayon Polyester paper. Photographer: Sue McNab.

PART I

The Representation of Cloth

The erotic use of cloth has historically operated as a subtext in figurative art with its material presence used to accentuate or imply sensuality. Cloth engages with the erotic in art as a covering of nudity, implying the seductive body, and the sensory. Either it offers a veil of respectability or conversely elicits the erotic as a fugitive or explicit presence. Cloth functions as a distraction, a disguise, a servant to propriety, and offers insights into cultural and social connections. It also serves as a sympathetic fabric that entices the erotic response from painting and sculpture. The historic conventions associated with the representation of cloth in the arts imply eroticism through symbolic and metaphorical force.

These chapters explore the mannerisms and translations in the portrayal of cloth through the artist's hand by delving into the personal and subjective erotic, material aesthetics, and perceptions of beauty. They present the fetishistic nature of self-display, of exhibitionism and of longing and desire. The presentation and representation of cloth as erotic is acknowledged through paint, stone, and film. Two chapters describe the elusive sensation of the erotic from these historic portrayals which are reworked back into cloth, which itself becomes the erotic subject and provocative agent. These chapters see the erotic in art and artistic practice residing within the folds and substance of cloth and represented as the residual fabric of the erotic in art.

Thoughts on the erotic:

There is the best pleasure in thinking, in imagining what might be. For the erotic is bound up in anticipation, the twin sister of desire. It is worn at my skin but mostly within me, is sensuous and reminds me that I am with the "other" not just unto myself. Beyond manufacture—each to their own and each in their own way—and sometimes the fantasy is all we have.

ANGELA MADDOCK

Folds, Scissors, and Cleavage in Giovanni Battista Moroni's *Il Tagliapanni*

ANGELA MADDOCK

Dream State: I look for you. Climbing stairs and hurrying down corridors. I look for you and there you are, head tilted, your eyes returning my gaze—those very lovely, deep brown eyes—the thumb and index finger of your left hand tenderly holding the edge of a chalked-up stretch of black cloth. A cloth laid across a table and marked for the flesh of a body that will never be dressed. And yet you are so beautifully dressed: ruffles at your throat and wrists, folds of cloth at your hips. I like to imagine the cloth you hold might be for me, for my body. And there are your scissors, tailor's shears, tips parted in anticipation.

MADDOCK 2015

Like Roland Barthes, "I have an Other-ache" (Barthes 2002: 57). For years I have made the same pilgrimage: climbed stairs, walked corridors ... sought him out. Occasionally he is absent, transported elsewhere for conservation or exhibition in another place. But mostly he is dependable; reminding me that it is not only women who wait. I stand before him, as so many times before. A pilgrimage that is long lasting, fanciful, and irrational: like desire itself. A longing that is reflected in my own language of desire: "It is as if I had words instead of fingers, or fingers at the tip of my words" (ibid.: 73).

This is Giovanni Battista Moroni's *Il Tagliapanni* or *The Tailor*, and for me it is the jewel of the Northern Italian Portraiture room of London's National Gallery. *Il Tagliapanni* was painted in oils by Moroni c. 1570 and purchased by Sir Charles Eastlake for the gallery from the collection of Federico Frizzoni de Salis in Bellagio almost 300 years later. At £320 (Penny 2004: 238), it came at a price, yet even then its eye-catching potential was well understood, with the art critic and writer Lady Elizabeth Eastlake predicting: "This will be a popular picture" (ibid.: 238).

It, no *he*, holds a particular fascination for me. I have become attached to him and, like Odysseus, have become the wanderer who returns. I might explain this attitude as a reflection of who I am and what I feel. Growing up as the daughter of a dressmaker meant a childhood surrounded by cloth and the tools of making: pattern papers, scissors, tape measures, pins piercing chair arms, more pins on floors. Always something in the making, something I might have to model, and the very real risk that a motherly hug came with the prick of needles and pins worn at her chest, her emblem. Of always knowing how something felt well before it was touched, and wanting to touch, to stroke, to caress; for like bell hooks, "I have always been a girl for fibers, for textiles, and for the feel of comforting cloth against my skin" (hooks in Robinson 2001: 635).

And so we have something in common, this tailor and me—a shared understanding. I know the weight of those scissors in his hand, their density and their noise at the table, the feel of the warp and weft between his fingers and thumb, and the anticipation of the first cut into that very perfect edge—of making our mark. Cloth is our habit, our tacit knowledge. But there is more than maker's empathy at play here; something that extends beyond his occupation and our shared association.

My habitual pilgrimage brings me to stand before him, gazing upon him and imagining his gaze upon me. When I cannot see him in the flesh—for we are often separated by meaningful distance—I search for him on the studio wall or the pin board above my desk. I look for reminders of him—not souvenirs, for there is no need for souvenirs of repeatable events (Stewart 1993: 135); he is not lost and I can always return: a sentinel or lighthouse or anchor—my north star.

Susan Sontag wrote that "Real art has the capacity to make us nervous" (2009: 8) and I am nervous. Nervous that he might not be there when I begin my journeying, nervous that my gaze is more akin to longing; nervous that lingering here for too long, too often (am I recognized?) is far too revealing. I imagine that somewhere, within these walls, there is a rogues' gallery of all-too-frequent visitors and that my face is on that wall. I am nervous because this painting acts upon me like no other painting; it holds me on tenterhooks.[1] My relationship with it, my desire for it, might appear beyond logic. I will always be at the edge of it, forever held at a distance and caught in a state of permanent longing.

I have heard myself say "I love that painting," and it is hard to speak confidently of loving things, for loving the inanimate has the potential for revealing shallowness, of lacking depth, and of being preoccupied with the surface of things. Which is, of course, the truth; I am preoccupied with surface, a painted surface. Yet so many things we might associate with love appear to me when this painting comes to mind, lodges in my mind. I cherish it. *The Tailor* gives me pleasure; it works upon me like no other. I linger over it, pay close attention to its details—and when I finally turn to leave, usually with a last glance over my shoulder, I am always better, my heart always lifted and a smile upon my lips. My response is not just at my skin, which is perhaps the most imagined site of the erotic, but also within me, perhaps more soulful. I am quite certain I would mourn if he were permanently lost to me; and is mourning not a sign of losing something we have loved?

I am also nervous that in looking too deeply I risk undoing something—unpicking my tailor almost—that I might finish in a place where interpretation, so reviled by Sontag, might undo his magic and reveal something of me that is itself best left hidden. Yet this is my task. Like his scissors, like the erotic itself, I am poised at the edge of something.

So let me begin to unravel this mystery, or maybe unpick, since we are both occupied with cloth. Who are you? There were more than 830 tailors working in

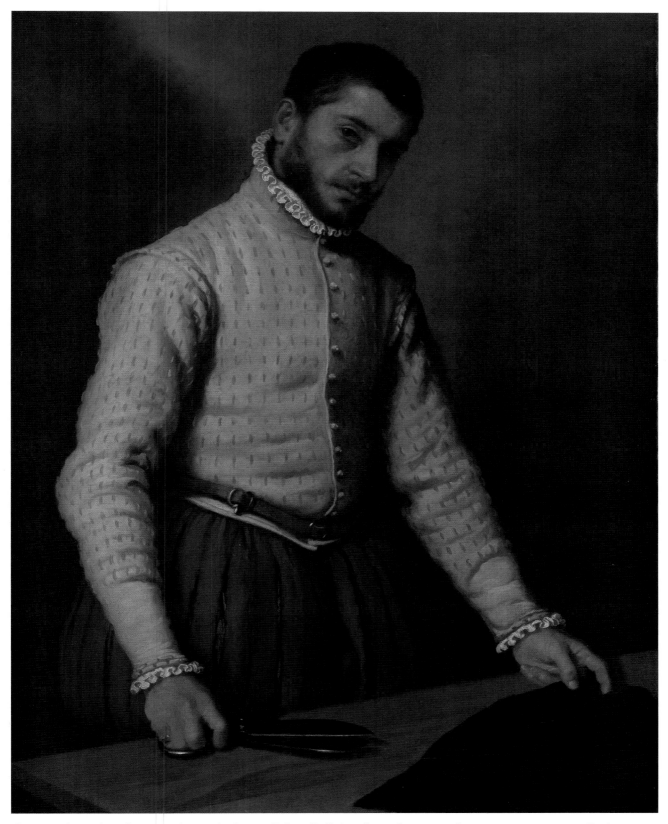

Figure 17 Giovanni Battista Moroni, *Portrait of a Man ("The Tailor") Il Tagliapanni*, c. 1570. Oil on canvas. 99.5 × 77 cm. Collection: NG697 © The National Gallery, London.

Lombardy in the sixteenth century. Some are known by name and yet my tailor is not one of them (Ede in Campbell et al. 2008: 127). Of Giovanni Battista Moroni (1521–1580) we know a little more. The son of an architect and a pupil of Alessandro Bonvicino (Moretto), he lived his entire life in Lombardy, sharing his time between Bergamo, Brescia, Trento, and the smaller town of Albino, where he was born and died. He was not much of a traveler.

Moroni began as a painter of religious themes but is most celebrated for his later work as a painter of northern Italian nobility and, more rarely, the artisan. A nameless tailor might seem an unusual subject among this otherwise grand cast. Only one other Moroni painting, that of the sculptor *Alessandro Vittoria*, shares similarities with *Il Tagliapanni* and both hold characteristic emblems of their trade. Alessandro, sleeve rolled to reveal the musculature of his left arm, raises a *modello* to meet our gaze as tenderly and assuredly as a mother might hold a small child. This unusual subject choice certainly disarmed Charles Eastlake, for he simply could not believe Moroni would paint someone working with his hands, preferring to maintain this bearded young man as dressed in the guise of a tailor (Penny 2004: 236).

That no one can pin him down means he will always have a fugitive air, which is all the better for dreaming. This not knowing heightens speculation about how the painting came into being. Commissioning a portrait is expensive and suggests our tailor to have been particularly successful or—and this contributes to the speculation surrounding the relationship between Moroni and his subject—the tailor and artist were friends, even lovers. Another possibility is that Moroni painted the portrait in exchange for garments, a reflection of the equivalent status of artists and artisans at this time. It would seem there is no truth; some things are simply lost to us.

Fugitive flesh . . . we all know what Roland Barthes meant when he wrote, "Is not the most erotic portion of a body *where the garment gapes*?" (1980: 9), for we have seen it with our own eyes: the momentary glimpse of toned flesh as he raises his arms above his head and curls of dark hair pass briefly before our eyes, a cleavage glimpsed through gaping buttons. Barthes reinforces what we already know: "it is intermittence which is erotic [. . .] the staging of an appearance-as-disappearance" (ibid.). It is in these very brief moments that we properly understand the relationship between clothing and our sensual selves.

Lingering before the painting, I begin to understand that edges are all I have. My fingers tracing edges between cloth and skin, tracing that point where your hand meets the cuff of your shirt (and I first wrote "meats," an unconscious spill of real fleshiness). Border territory where body meets cloth; and borders, as we know, are always sites of heightened anxiety. The small triangle of skin outlined by the edge of your beard, the lobe of your right ear and the collar of your shirt. That place, how it might feel against the soft pad of my index finger, as if brushing across the nap of velvet—so much of so little. I can barely feel the flesh of you; instead, what passes is enjoying folds, the folds of your clothes. Tracing the creases of your jacket, the ruffles at your wrist and neck, caressing the edges that mark the folds of your breeches, those particular folds, for—as Gilles Deleuze explains—folds are all that matters (1993: 137).

Edges also preoccupied Jacques Lacan. In the body he found them to be erotogenic, describing "'the lips, the enclosure of the teeth,' the rim of the anus, the penile groove, the vagina, and the slit formed by the eyelids [. . .] as cuts at the margins or borders of the body, points at which the subject as margin, on the cusp of being neither inside nor outside, its edge" (Lacan 2007: 692–3). I realize that my imaginary tracing of these edges, my fingertips probing beneath pleats and folds, has the quality of moving beneath the surface, of enjoying your clothes as flesh, where edges and folds function as prosthetic grooves, rims, and bodily apertures. This pleasure appears limitless; it leads me "nowhere," at least in our ordinary understanding of where bodily pleasure ends, and I am cast into thinking of you as matter itself. Your clothes *become* you as I transform you into some strange version of Mario Perniola's "sentient body," as I enjoy your "fleshy clothes" (Perniola 2004: 11) in a place where "everything is surface, skin, fabric" (ibid.: 12). In this scenario I become drenched in cloth, even merged with it. In this I risk becoming undone, of becoming lost to any sense of my rational self. This undoing bears some equivalence with virtue, with the undoing of the surface of me, as if all my outer layers—my clothed body—are stripped away and I am left truly exposed, indecent.

Amidst this apparently fetish-driven reverie, I wonder how a simple painting came to count for so much, how it came to be so compelling. He stares out from my laptop screen as I fly home from Helsinki and a particularly

ridiculous fantasy circulates within me. Moroni's work has been described as "art without time" (McTighe 2015: 85), and in this instant, in this mid-air nowhere, I see for the first time the emptiness of his surroundings: behind him the grey of so many contemporary spaces. My tailor is literally without time and place—in this brief moment, we are both travelers.

Gabriel Josipovici suggests that a pilgrim's efforts are rewarded by arrival at a shrine, either culturally sanctioned or self-declared, and some physical contact that confirms "Its presence to you, but also your presence to it" (Josipovici 1996: 59). In Josipovici's journeying, the telos is dipping his hands into the waters of the Pacific Ocean (ibid.: 58). Until 2008, pilgrims of the Camino de Santiago marked the end of their journey in knocking their heads against another head, that of the life-sized figure of the sculptor *Maestro Mateo*, a practice now forbidden because of conservation concerns (Bailey 2009: 28). Like them, I am also denied that physical "doubleness" or reciprocated return that Josipovici describes as essential. Instead, I must look from a prescribed distance, certain in the knowledge that touching—still prohibited, anyway—will probably perform as an inversion of the *Doubting Thomas* principle.[2]

In a *Lover's Discourse*, Roland Barthes tells us that desire is dependent on "a little prohibition" (2002: 137), and I realize the truth that you are twice unavailable to me: I cannot touch you because you are not there and they will not let me. My pleasure relies on a continued disavowal of truth; the paradox is that distance enables the fantasy that you are "real" (whatever that means for me). I fool myself and am stuck in a permanent state of expectation. If touch affirms truth (that mark of authenticity), then I am in a constant state of untruth, not knowing . . . even lying to myself. If I am not touching anyone else, anything else, am I then touching myself? Another pleasure prohibited.

It is difficult to think about pilgrimage, if this is what this is, without also considering the phenomenon of the aura, that metaphysical glow which circulates the body of the object and testifies to its authenticity, the intangible thing that marks it as unique. In his writing, Walter Benjamin associates aura with distance—that which separates him from me—but also with fixity, the original object's "presence in time and space" (1982: 218); where you are now, on that wall. Both, Benjamin maintains, are prerequisites to any understanding of authenticity (ibid.: 220). The

significance of authenticity, in relation to my tailor, is acknowledged in Nicholas Penny's catalogue discussion of the painting, where he notes late nineteenth-century approval that the tailor sat as himself and not as a fine gentleman (Penny 2004: 238). In this interpretation, he is without artifice, has nothing to hide.

The idea of reciprocity is also central to Benjamin's thinking. Here we might see the return as that which is given, or the pleasure taken in the collapsing of distance and marveling in the aura, a different "touching." As Yi-Fu Tuan confirms: "Most tactile expressions reach us indirectly, through the eyes" (Yi-Fu Tuan in Classen 2005: 76). Giuliana Bruno supports this embodied sense of touch in her exploration of the haptic and tactile when she writes: "Emotions are produced within the fabric of what we touch and from that which touches us: we 'handle' them, even when we cannot handle them [. . .] Touch is never unidirectional" (2014: 19).

And so my pilgrimage is an endless to-ing and fro-ing, which bears traces of Freud's fort/da game—but here I am the spool of thread held in someone else's clutches. I imagine myself bound to this spot—traveling away, returning, looping, and traveling. While I will never literally touch him, at least not without impunity, it is very clear that I am touched by him. A touching that happens not at my flesh, but within me.

My own work is concerned with intimacy, distance, and proximity, and mostly finds its place in the making and knitting up of yarn. Its locus is the in-between world of the transitional. Here I have built myself a soft place, mostly inhabited by mothers and daughters and the occasional intervention from D. W. Winnicott, the benevolent father.[3] In this in-between world I have been making scissors that do not work, deliberately disappointing the things that cut. Small scissors bound with yarn, their blades fused together; and huge flaccid beasts fabricated from worn linen bedsheets, cloth witnesses to many other desiring bodies.

My "in-between space" is unformed, disordered, and always in a state of becoming: no finish in sight, no boundary, and no selvedge. This is the place Barthes describes when he writes of "the return to the mother [a place where] everything is suspended: time, law, prohibition: nothing is exhausted, nothing is wanted: all desires are abolished, for they seem definitively fulfilled" (2002: 104).

I remember feeding my daughter as a baby. Her father came into the room and spoke. She turned her head, taking

Figure 18 Angela Maddock, *Bound*, 2016. Silver scissors and red yarn. 15 × 5 cm. Photographer: Matthew Otten.

my breast with her, not quite wishing to give me up but also wanting him, wanting the best of both worlds. For the transitional space is also the place of gradual disenchantment, of discovering our own selves and our relationship with the wider world. And now I am there too, I have turned my head. In research, we must try to work out what things mean for us, for our work. I look back at you and realize that I have brought these sharp things into the soft and unformed, the maternal space where children are discouraged from "playing with scissors."

The archaeologist and anthropologist Mary Beaudry distinguishes between scissors and shears and offers an engaging taxonomy of bows, shanks, and blades. Those used by tailors and dressmakers are usually large bladed with different-sized bows and offset shanks, which enable closer contact with cloth. Such scissors might have blades as long as forty centimeters (Beaudry 2007: 126). This means our tailor holds a pair of shears. As a dressmaker's

daughter I can confirm this and they should only ever be used on cloth: *the law of the scissors*. Our tailor's shears are long, the total length close to that of his forearm. He holds them just as my mum holds hers and I hold mine. They are our "tools of the trade." And so I look back at you. I notice a sight line of sorts, scissor tips pointing towards chalk marks, a dynamic about to be set in motion. For tailor and dressmaker both deal in the fantasy of what our clothing might allow us to become, the dress that will be just me; or rather, the me I would like to be, the suit that fits the job, even if we might not. In her work, my mum cuts out wedding dress dreams, dresses that embody the hopes or fantasies of the perfect day and the wished-for future.

To function effectively, to do their job of cutting through cloth, scissors need to pivot around a central pin, to come together, slice through matter and part. They also need to be sharp. This brings me to cleave, one of Freud's antithetical words, words that simultaneously denote "at once a thing and its opposite" (Freud 1910: 156). Freud contrasts *cleave* with *kleben*. In English, cleave means to split, and we are familiar with the cleavage of breasts and the cleaver wielded by a butcher. The equivalent word in German is *kleben*, to stick or glue. Scissors too must join and split. Their blades should also twist inwards slightly, this keeps the blade edges on cut when working through cloth and "when closed and not in use, scissor blades should touch only at their tips" (Beaudry 2007: 122). Even scissor blades never fully meet; there is always something or nothing between them. Bodies must also cleave, for we are unable to stand permanent fusion.

Cleaving as a process is not a permanent, fusing thing, but a brief moment: a joining and separating that produces an outcome, a permanent cut to which, even if repaired, cloth—and anything else that comes between the blades—always bears witness. Scissors cut; they slice through wholeness.

Like de Clérambault's *Parissienes*, maybe even the man himself, I cannot resist silk.[4] In her book *Drapery: Classicism and Barbarism in Visual Culture*, Gen Doy reminds us that much of silk's ability to give pleasure is activated through its animation (2002: 111). When it moves, it returns light and rewards our gaze. A bolt of silk tossed across a table. A promise of many things and the possible satisfaction of none, but still there's the promise . . . Nothing has failed and nothing, in Mario Perniola's thinking, is finished. Endless possibilities.

Figure 19 Angela Maddock, _Of Steel, Wool and Flesh_, 2006. Installation. Steel, silk and wool.
Photographer: Edith Maybin.

Child's play: a silk curtain, it was supposed to be like the blue of Ingre's _Odalisque_ or was it the perfect blue of Velazquez's _Toilet of Venus_? Another painting that speaks to me and bears witness to a moment where desire overwhelmed prohibition—that particular cut, no slashed, body. For the truth is, whenever I see her, see Venus, I am always searching for some trace of Mary Richardson's meat cleaver, a meeting of beauty and violence.[5] This is a very certain blue, for like the academic and writer Carol Mavor, "I am trying to be a connoisseur of blue" (2013: 11). My blue is boundless, unformed and generous in its spill, the perfect aquamarine blue sea. I liked it most when straight off the roll—a cloth body, flowing across cutting table, unfettered. I once used it in a performance. Fueled by chocolate and French fancies, I was meant to knit through day and night, swathes of blue silk beneath me and wool in my hands, but it all became too much and I vomited into a sink, a perfect reminder that pleasure without limit always ends badly. This blue, my blue, "performs to excess" (Barthes 2002: 27). I am smothered and there you are . . . you with your scissors: a rescuer of sorts, for cutting brings form to the unformed and gives shape to that which has none.

On cutting: Caroline Case considers the emotional affect of working with scissors in her observations of children cutting up, cutting out, and sticking down in therapeutic settings (Case 2005). Case observes that cutting up is usually impulsive and potentially destructive—like the cuts at Venus' flesh—whereas cutting out is more reflective, demonstrating preparation and care. Children cut around lines and color within them. The line acts as a boundary, a container of sorts. Lines give form to the formless; they give us form.

A tailor works to translate the second dimension into the third. Cloth is smoothed across the cutting table, measured and marked with chalk—a process known as "striking out." In the domestic arena this usually means paper pattern and pins. Shears, fingers through their bows, are introduced at the selvedge; blades will part fibers, slice through warp and weft, separate threads, cut thorough matter. Tailors cut cloth with the body in mind.

Fashion designer and nomadic cutter Julian Roberts has shared his open cutting technique in twenty-five countries and wears a self-styled chatelaine around his neck as he works. Roberts cuts into long tubes of cloth; he cuts holes through which the body will move, snake-like, holes that join with other holes, forming folds, pleats, gathers and tunnels. These are perfect Baroque garments: blousy, folding, draping things. He tells me stories of oil and saliva, of tailors lubricating their shears on the back of

their heads and spitting on the blades. I watch him as he cuts right into the body of cloth, huge holes, no hesitating at the edge.

Hand knitting, my method and process, does not require scissors and yet it relies on cleaving: the momentary meeting and parting of needles and the wrapping of yarn around them. Scissors are rarely used in knitting. Mostly fingers are used to pull fibers apart and break yarn.[6] Indeed, the designer Amy Twigger Holroyd declares cutting into knitting a savage act (2013: 202).

This concern with the cutting of yarn and cloth is explored by Eicher et al. who describe the wearing of uncut cloth garments in Hindu religious rituals (2008: 252). More specifically, Daniel Miller explains that these garments are known as *dhoti*, that they are also unsewn and are worn by Hindu men for *puja* worship. Miller speculates that the preoccupation with the uncut and unsewn "reflects an underlying concept of necessity of completeness, or unpenetratedness, of totality which is congruent with Hindu ideas of cosmogony" (2001: 413). This concern with the whole as analogous to the pure is reflected in other rituals; Mary Douglas describes the Havik Brahmin preoccupation with wholeness in the preparation and consumption of food (2002: 41). In these contexts, it is as if the act of cutting undoes structure, even violates. I am reminded of Gen Doy's discomfort in watching the erotically charged film *Le Cri de la Soie*, and the all-too-closely drawn association between the tearing of silk and female flesh (2002: 114). Cloth is, after all, often described as our second skin.

In a curious turn I find myself unable to cut into cloth. I had planned to make more soft scissors and had set aside two linen bedsheets bought many years ago. I launder them, lay them across the floor, smooth them out, pin down pattern pieces, bring shears to selvedge and falter. I am unable to cut into them. I have to buy others, without history, because somehow they have become more than they are, more than two simple linen sheets. They have become infused with a particular moment in time, a family holiday in France when my children were very small. To cut into them seems reckless, as if I might be cutting into our shared past, editing my own history. I reflect on the tailor, with his chalked-out cloth and poised shears; he too stands at the edge of wholeness, at the point of cutting into something. His are not savage tools and yet still they split and divide and work to undo a whole.

The cut, or act of cutting, is also central to psychoanalytic thinking. It marks our movement from the imaginary, pre-oedipal state toward individuation, ourselves as subjects. Joan Copjec confirms this when she writes, "the One is not that which is split, but rather that which is formed from the splitting" (2012: 46). This reminds us of Roland Barthes' "Other ache": to desire the other (someone other than me, or her) requires this separation. To achieve this independence, we need first to separate from the mother; as Claire Pajaczkowska affirms, "this primary bond needs to be severed" (2007: 146). My dictionary tells me that severing is "to divide by cutting or slicing, especially suddenly or forcibly" (*Oxford English Dictionary* 2010). This, then, is not a gentle cutting out. Such drama leaves a residue, a scar. Broadly speaking, this residue formulates the object of desire—the thing, idea or fantasy that we imagine might make us whole again. In Lacanian thinking, the residue—what is left behind—is the *objet petit a*, that which is lost in the splitting, what is lost in our separation from the maternal. Psychoanalytically, this cut is essential—quite simply, without it there is no desire.

Boredom has always appeared to me as the antithesis of desire, not too far distant from a lack of curiosity or the turning of one's head inwards and away from the world. Yet being bored is part of becoming an individual subject, an in-between state, more simply "after something and before something else" (Phillips 1993: 72). In this sense boredom is an agent of desire, a threshold state that brings us to looking. And yet desire, as Bruce Fink tells us, "has no object'—nothing is either capable of satisfying or "extinguishing it" (1997: 90). Quite simply, once we are "cut loose," we are permanently desiring subjects—not desiring "objects," as such, but desiring desire itself. As Roland Barthes confirms: "it is my desire I desire, and the loved being is no more than its tool" (2002: 31).

My heart trembles. I pay to see him "in the flesh" for the first time—butterflies, a quicker tread on the steps, I am close to flying up those marble stairs—the barely contained anticipation of seeking him out in a different place, the Royal Academy. I dismiss the exhibition plan, preferring instead the childish game of hide and seek; I will find him for myself. Weaving through crowds, like a kid in a sweet shop, my eyes are spotlight-searching the walls. The first room, not him but others—so many Moroni portraits together—and in one quick instant I am overwhelmed with the most dreadful disappointment. For what I had

fantasized as *my* tailor's look—*his* gaze, *his* uniqueness, *him* for me—is nothing more than a painterly device. I recognize it "with my own eyes" and can then identify—in painting after painting on the Royal Academy's walls—Moroni's highly successful stratagem in portraiture: "the head and shoulders are placed at a diagonal with the head slightly turned to one side and lowered; the eyes gaze across the canvas to meet those of the spectator" (Royal Academy of Arts 2015). In my disenchantment, a senseless reeling of sorts, I pause before his portrait of *Lucrezia Vertova Agliardi* and am momentarily persuaded she holds not a Bible, but a mobile phone.

It seems only right that I should have found him on a wall of his own. On his left, the very tender *Portrait of a Gentleman and his Two Daughters (The Widower)*—and me standing there, getting the measure of him. Now he is elsewhere, I see him differently—in a newer and perhaps less forgiving light. The beveled edge of his ruby ring, the height and detail of the bolt that binds the blades of his shears, the absent sword he chooses not to wear, and the water stain described by Penny (2004: 236)—they all seem particularly keen. And then, a moment of tenderness unfolds—your left hand holding the edge of the black cloth as lightly as the *Gentleman* father rests his on his children's shoulders; a shared gesture, both of you poised in the act of making.

Buttons on clothing always mark a return to that favored childhood nursery rhyme.[7] I count in the hope that Moroni anticipated this pleasure: two buttons too many, a sailor, and an altogether different man. And, for the first time, I see a sickly green tinge to his flesh. He is not well perhaps. This sign of a weakened state makes him much less the embodiment of my ideal fantasy and has the effect of making him too much alive. The possibility that he might well have been real makes him more definitively *gone*. Energy seems to have escaped me. I am heavier, turning to leave as if something, or someone, might have died.

Archives are places where we might find answers, extend or question our knowledge. They are also sites of desire: temporary homes for the curious, where there is searching to be done, boxes and files to be opened, papers to sift; another form of undressing. Archives mark the "institutional passage from private to public" (Derrida 1995: 10) and come with the promise of discovering something as yet unknown, another fantasy. In the archive of the National

Gallery—high ceilings, reassuringly heavy doors, wide desks and a satisfying hush—my tailor is dossier 697, safely counted into the fold and contained within grey files, card boxes, and photocopies. All these things serve as evidence of your presence, of you being here. Within these folds I discover that I am not alone in my searching; there are others who have tried and failed to find out who you are. There is evidence of reproductions in circulation—facsimile tailors—and the discovery that you were once woven into a cloth no bigger than my hand. Sifting: searchlight to spotlight, aware that it is the past that narrows my field, looking backwards for the point of origin: "the most archaic place of absolute commencement" (ibid.: 91). My smile when I realize you came to London 100 years before my birth, a gift of sorts. Then, on the thinnest of pale-blue papers, the handwriting of Sir Charles Eastlake dated September 21, 1862. A heartbeat skipped, and I read: "There is only a portrait by Moroni—which as a single picture I fear the proprietor will hardly part with." I know I have found you; archive fever has done its work, returned me to the point of authenticity.

I have lingered in a soft place, the soft space that marks the maternal. My pleasure in this softness mimics a "motionless cradling," a return to the mother, that place that Barthes describes as a "companionable incest, [where] nothing is wanted: all desires are abolished" (2002:104), a place that finds some equivalence in Perniola's thinking where bodies "become rolls of material that fold and unfold on one another" (2004: 10), where the sensual pleasure of cloth is neither tied to the erotic nor framed by the fetish—as nothing is yet lost.

As pleasurable as this place might be, I have not stayed, could not stay. With his scissors, I have cut myself free of the first place, immersed myself in another, discovered that desire requires distance, and that cutting leaves a scar yet also gives shape, gives form. In exploring my desire for him I have understood that *desire is the object of desire*, and that cloth, in all its guises, has the potential both to excite and satisfy—and occasionally, even to disappoint. And yet, in all this drive for knowledge and the rational, some things remain unfathomable, more felt at the flesh, within the body, than known. I finish with a return to Susan Sontag and her appeal to privilege this state of being: "What is important now is to recover our senses. We must learn to *see* more, to *hear* more, to *feel* more" (2009: 14).

Notes

1 Being "on tenterhooks" refers to the practice of stretching woven cloth on a tenter frame. This holds it under tension and prevents shrinkage.

2 Thomas the Apostle, or "Doubting Thomas," only accepted the resurrection of Christ after feeling the wounds inflicted upon his body. In this, Thomas claims touch as the mark of authenticity or truth. Here, my concern is that touching might act in the same way and undo my fantasy.

3 D. W. Winnicott was a British pediatrician and child psychoanalyst whose major study *Transitional Objects and Transitional Phenomena* is central to my work.

4 The French psychiatrist Gaëtan de Clérambault took a particular interest in the treatment of women who stole cloth from Parisian department stores (Doy 2002).

5 On March 10, 1914, in an act of "deeds not words," the suffragist Mary Richardson took a meat cleaver to the body of Venus in Velazquez's painting.

6 One exception is the cutting of a steek, where a garment is knitted in the round and opened up, usually at the center, through cutting.

7 "Tinker, tailor, soldier, sailor" is a traditional "small children's fortune-telling rhyme used when counting cherry stones, waistcoat buttons, daisy petals or the seeds of Timothy grass" (Opie and Opie 1988: 404).

References

Bailey, M. (2009), "Santiago de Compostela Prepares to Stop the Rot," *The Art Newspaper*, September, 18 (205): 28.

Barthes, R. (1980), *The Pleasure of the Text*, trans. Richard Miller, New York: Hill & Wang.

Barthes, R. (2002), *A Lover's Discourse*, London: Vintage Classics.

Beaudry, M. (2007), *Findings: The Material Culture of Needlework and Sewing*, New York: Yale University Press.

Benjamin, W. (1982), "The Work of Art in the Age of Mechanical Reproduction," in F. Frascina (ed.), *Modern Art and Modernism: A Critical Anthology*, 217–20, London: Sage.

Bruno, G. (2014), *Surface: Matters of Aesthetics, Materiality, and Media*, Chicago: University of Chicago Press.

Campbell, L. et al. (2008), *Renaissance Faces: Van Eyck to Titian*, London: National Gallery.

Case, C. (2005), "Observations of Children Cutting up, Cutting out and Sticking Down," *International Journal of Art Therapy*, 10 (2): 53–62.

Classen, C. (2005), *The Book of Touch*, Oxford: Berg.

Copjec, J. (2012), "The Sexual Compact," *Angelaki, Journal of the Theoretical Humanities*, 17 (2): 31–48.

Deleuze, G. (1993), *The Fold: Leibniz and the Baroque*, trans. Tom Conley, Minneapolis, MN: University of Minnesota Press.

Derrida, J. (1995), "Archive Fever: A Freudian Impression," *Diacritics*, Summer, 25 (2): 9–63.

Douglas, M. (2002), *Purity and Danger*, London: Routledge.

Doy, G. (2002), *Drapery: Classicism and Barbarism in Visual Culture*, London: I.B. Tauris.

Eicher, J. B. et al. (2008), *The Visible Self: Global Perspectives on Dress, Culture, and Society*, 3rd ed., New York: Fairchild Publications.

Fink, B. (1997), *The Lacanian Subject: Between Language and Jouissance*, Princeton, NJ: Princeton University Press.

Freud, S. (1910), "On the antithetical meanings of primal words in Five Lectures on Psycho-Analysis, Leonardo da Vinci and Other Works," in *The Standard Edition of the Works of Sigmund Freud*, Vol. X1 (1957), 155–63, London: Hogarth Press and The Institute of Psychoanalysis.

Josipovici, G. (1996), *Touch*, New, CT: Yale University Press.

Lacan, J. (2007), *Ecrits*, trans. Bruce Fink, New York: W. W. Norton & Co.

Mavor, C. (2013), *Blue Mythologies: Reflections on a Colour*, London: Reaktion.

McTighe (2015), "Fresh Faces: Moroni at the Royal Academy," *Apollo Magazine*, January, 181 (627): 83–5.

Miller, D. (2001), *Consumption: Critical Concepts in the Social Sciences*, London: Routledge.

Opie, I. and Opie, P. (1988), *The Oxford Dictionary of Nursery Rhymes*, Oxford: Oxford University Press.

Oxford English Dictionary (2010), 3rd ed., Oxford: Oxford University Press.

Pajaczkowska, C. (2007), "Thread of Attachment," *Textile: Cloth and Culture*, 5 (2): 140–153.

Penny, N. (2004), "The National Gallery Catalogues: The Sixteenth Century Italian Paintings," in *Paintings from Bergamo, Brescia and Cremona*, Vol. 1, London: National Gallery.

Perniola, M. (2004), *The Sex Appeal of the Inorganic: Philosophies of Desire in the Modern World*, London: Continuum.

Phillips, A. (1993), *On Kissing, Tickling and Being Bored*, London: Faber and Faber.

Robinson, H. (2001), *Feminist Art Theory: An Anthology, 1968–2000*, Malden, MA: Blackwell.

Royal Academy of Arts, List of Works: Giovanni Battista Moroni https://royal-academy-production-asset.s3.amazonaws.com/uploads/655520b7–66d1–4571–8c85-ae860a4f3e5f/Moroni+Large+Print+Labels.pdf (accessed October 15, 2016).

Sontag, S. (2009), *Against Interpretation and Other Essays*, London: Penguin Classics.

Stewart, S. (1993), *On Longing: Narratives of the Gigantic, the Souvenir, the Collection*, Durham, NC: Duke University Press.

Twigger Holroyd, A. (2013), "Folk Fashion: Amateur Reknitting as a Strategy for Sustainability," PhD thesis, Birmingham: Birmingham Institute of Art and Design, Birmingham City University.

Further Reading

Barthes, R. (2007), *Where the Garment Gapes*, reproduced in M. Barnard (ed.), *Fashion Theory: A Reader*, London: Routledge.

hooks, b. (2001), *Women Artists: The Creative Process* in H. Robinson (ed.), *Feminism Art Theory: An Anthology 1968–2000*, 635–40, Oxford: Blackwell.

Winnicott, D. W. (1953), "Transitional Objects and Transitional Phenomena—a Study of the First Not Me Possession," *International Journal of Psychoanalysis*, 34: 89–97.

Yi-Fu Tuan (2005), *The Pleasures of Touch*, in C. Classen (ed.) *The Book of Touch*, 74–9, Oxford: Berg.

Thoughts on the erotic:

The idea of erotic cloth has helped me develop ways of understanding a particular change in sculpture that has troubled me for a number of years, because of its unsettling combination of the ideal, the innocent and the sensual.

CLAIRE JONES

2

"A Perverted Taste": Italian Depictions of Cloth and Puberty in Mid-Nineteenth-Century Marble

CLAIRE JONES

This essay addresses the role of cloth in mid-nineteenth-century sculptural depictions of childhood. I focus on north Italian sculpture, whose spectacular realism generated particular qualities of texture, concealment, and flesh that invited close and sustained viewing, even touching. These works came to the attention of British sculptors, art critics, and the general public at the international exhibitions that dominated the circulation of artworks during the nineteenth century, the first of which was held at the Crystal Palace in London in 1851. Notable examples include Pietro Magni's *Reading Girl* (1861), first exhibited in Britain at the International Exhibition held in London in 1862. The detailed rendering of different materials in these works, from rush-seated chairs to lace-trimmed chemises, typify the new sculptural realism emerging from northern Italy in the 1850s and 1860s.

British art critics applauded the technical virtuosity of these works, yet decried what they perceived to be a superficial engagement with detail and surface. Subsequent historians have followed this lead, acknowledging the complexity of surface textures (Bryant 2002; Penny 2008; Murphy 2010), and similarly regarding this as a technical achievement rather than as carrying intellectual, moral, political, or sensual meaning. This is in contrast to the extensive scholarship on another form of sculptural realism, the New Sculpture, which emerged in Britain in the 1870s, and whose emphasis on surface, skin, and clothing is understood as an avant-garde precursor to twentieth-century modernism (Beattie 1983; Getsy 2004).

In this essay, I argue that these earlier Italian experiments in realism, far from embodying a superficial engagement with surface detail, offered radical—and sometimes unsettling—new ways of engaging with the modern world. Central to this was their rendering of cloth in marble. In part, this essay is therefore a provocation to art historians to look more closely at the ways in which these sculptors engage so thoughtfully and meticulously with cloth. We need to question a history of sculpture in which classical drapery trumps realism and the hierarchies of ideal beauty, surface, and decoration that that implies. It is also intended as a stimulus to textile and costume historians to engage more closely with representations of cloth and clothing in sculpture.

Far from being superficial, carving cut and stitched clothing, complete with buttons, lace, and ribbons, injected a contemporary dimension into what was still essentially a classical medium, creating a complex nexus of sensory, sensual, material, religious, domestic, commercial, and political resonances. This disrupted the 'ideal' abstracted lines of classical drapery, transgressing its apparently timeless and eternal qualities to situate these sculptures firmly within the 1850s and 1860s, creating a three-dimensional space in which contemporary desires could be articulated and contested.[1]

Take Giovanni Spertini's *Girl Intent on Writing* (1866). In this work, a young girl sits writing at an elaborately carved occasional table, perched on an upholstered stool with delicate braiding. Her naked feet rest on a carpet woven with roses. The pierced detail of the table's design finds echo in her lace-trimmed handkerchief, and in the lace that adorns the cuffs and neckline of her long chemise or nightdress. This curls away from her body, creating deep cavities between the flesh and lace. The lace itself sits above a triple row of stitches, which also gathers the dress's fabric together in thin and even folds. Further stitching is visible in the side panels and hem. A thin ribbon precariously prevents the garment from falling even further from her exposed shoulders and further revealing her growing breasts.

Carving adolescent girls in modern lace-trimmed chemises not only introduced a new realism to sculpture, but it also presented a potent combination of the contemporary and the everyday that enabled its audience to see *itself* rather than Greek gods in its exhibition halls and art galleries. This, in turn, generated a differently erotic relationship with sculpture. Its emphasis on materiality accentuates the sensual pleasures of cloth, to the eye, memory, mind, and hand. It focuses the viewer's attention on the tactility and sensuality of made cloth and clothing; of hands, chalk, and scissors on cloth; of the prick of a needle; the rustling of cloth; the feel of cotton, silk, or lace against skin; and the airy spaces between body and cloth. This invites close viewing, and an imagined or actual touching of hands on (marble) cloth, creating an erotic tension between the represented and the real, between the fleshly body, woven cloth and cold, hard marble. The fact that these works also introduce the bodies of partially clothed adolescent girls opens up particularly troubling ideas regarding the location of cloth and the erotic in sculpture.

My study primarily draws on contemporary British responses to these sculptures, and, to a lesser extent, to

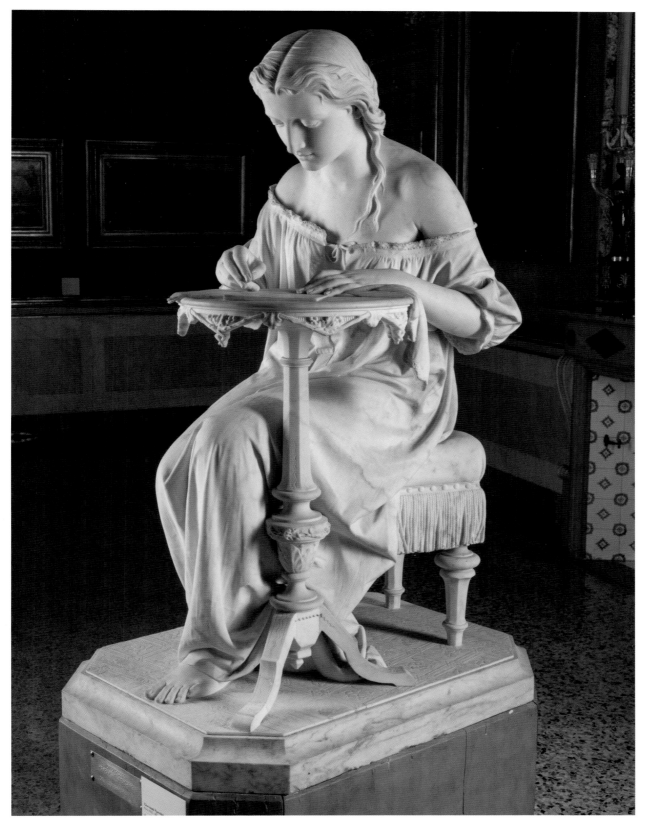

Figure 20 Giovanni Spertini, *Girl Intent on Writing*, 1866. Galleria d'Arte Moderna, Milano.

their contemporary Italian context. The evident British unease at these works highlights particular tensions, from concerns over realism in sculpture to the sexualization of children. Their Italian origins raise the additional context of the politics of cloth during the unification of Italy, including domestic sewing activities. The display of these sculptures at the international exhibitions introduces questions of manufacture, modern consumerism, touch, and desire, which further complicate the interrelation of cloth and the erotic in these works.

British Responses to Italian Realist Sculpture

As my essay centers on the British reception of Italian sculpture, I therefore begin with a brief overview of the dominant approach underpinning sculpture in mid-nineteenth-century Britain, in order to identify what was regarded as particularly novel and troubling about these Italian works. At the time in which these sculptures were produced and exhibited, antique classical sculpture was considered the supreme standard for all modern works. This followed the teachings of the Royal Academy of Arts, which, from its inception in 1768, had promoted classical sculpture as the ideal model for contemporary sculpture. Sculptors were trained through the study of ancient Greek and Roman statues, which prioritized the nude or semi-nude adult figure, and ideas of harmony and restraint. Drapery served a variety of functions, from structural support to suggesting movement and narrative. The surface of the cloth itself was polished smooth and undecorated, avoiding any references to contemporary fashion, and maintaining the illusion of ideal sculpture as transcending time and the everyday.

The emphasis placed on materiality in Italian realist sculpture presented a particular threat to ideal sculpture's apparent purity. It modified the abstracted bodies of classical sculpture with eyelashes, eyebrows, and dimples, even tears. The 'timeless' classical curls were updated with intricately combed and plaited hairstyles, while the undecorated folds of drapery were brought sharply into the present through tailored clothing, replete not only with lace trimmings and buttons, but showing actual evidence of stitched seams and hems, and gathered necklines. The classical trope of a figure leaning against a tree stump to

support the weight of a marble figure was now supplanted by the startlingly modern addition of a rush-bottomed chair or an elaborately carved writing table.

British critics were quick to recognize the ways in which Italian sculptors were able to imitate different types of textiles in marble. The extensive display of Italian works at the Dublin International Exhibition of 1865 led one critic to comment, "there are instances where the art of the artist, the genius of the sculptor, triumphs over everything, and can make his stone drapery lie in folds as soft, as light, and as natural as cloth or silk" ('Sculpture: the Dublin Exhibition of 1865' 1865: 56). The facility for sculptors to create the illusion of different weights of cloth in marble has a long history, and was a key component of sculpture practice well into the late nineteenth century. What distinguished the modern Italian sculpture is that, on close viewing, the cloth had become increasingly particularized as clothing. Take Antonio Tantardini's *Lady Reading a Letter*, also exhibited in Dublin in 1865. A contemporary critic specifically noted the innovation in Tantardini's rendering of cloth:

> The imitation of the *surface* of satin is nothing distinct, for such a surface is common to many smooth fabrics. But by a study of the peculiar breaks and stiff bending in the folds, and of the 'puckering' in the seams and 'hems', the spectator is taught to feel that he is in the presence of satin, with all its false style and boudoir air.
>
> **ATKINSON 1867: 168**

It was therefore not so much the sculptor's technical ability in imitating the surface of satin that was remarked upon, but his understanding of the ways in which the satin hung as a made garment, including the pull of the stitching against the fabric. The smooth contours of classical drapery were giving way to a more precisely cut and stitched item of clothing, with a gathered neckline, stitched side panels, hemmed edges, and stitched opening to the neck or waist. This is not simply cloth, but cloth made into a garment.

Contemporary British critics were both impressed by the technical virtuosity needed to produce such levels of realism and detail, and alarmed at this new departure in sculpture. Observing the Italian displays at the London International Exhibition of 1862, one art critic lashed out against what they perceived to be its excessive and unbridled realism:

Only a very perverted taste can see aught to admire in such a triumph of mechanical cleverness. True sculpture scorns to waste itself on needless fripperies and imitative lacework. Its right and noble office is to express the poetry of form in the noblest and purest manner; not to enchant us with mere feats of millinery in stone.

'The Art-Show at the Great Exhibition' 1862: 141

This passage regards the degree of realism and ornamentation in these sculptures not only as excessive, but as morally deviant. This 'perversion' is expressed in its prioritization of decoration over form, technical dexterity over true sculpture, and the caprices of fashion over purity. The critique is also gendered, and centers on women's clothing: 'needless fripperies' and 'millinery in stone'. The abhorrence of excess, decoration and surface detail reflected deep-seated worldviews regarding civilized and barbarous nations, and the threat of ornamentation to modern Western society—particularly on women's apparently more susceptible emotions and psyches.

A further problem was that these works were proving extremely popular with the British public. Magni's *Reading Girl* was one of the most reproduced works at the London International Exhibition of 1862, the novel form of the stereograph enabling it to be later viewed in almost three dimension (Salvesen 1997). Visitors were drawn to the marble sculpture, its realism generating a physical response that would have been unacceptable in relation to a classical nude. As one critic explained: "The tendency of modern *popular* sculpture is to be material and realistic . . . Tens of thousands [of the hundreds of thousands who saw the *Reading Girl*] enjoyed the luxury of putting their hands on the wicker-work of the chair, and were thrown into rhapsodies" ('Sculpture: the Dublin Exhibition of 1865' 1865: 56).

The novel depiction of such everyday objects as a rush-bottomed chair encouraged close and sustained viewing by the public, even touching. Whether this extended to the touching of the girl's half-dressed body or clothing is not recorded. The contrast between the drapery and the smooth flesh, with its narrow bony back, seems to similarly invite physical, sensory engagement.

This tactile and potentially sensuous engagement with an artwork was particularly problematic in the context of the Roman Catholic revival in Britain. The Roman Catholic Church was gaining power in the 1840s and 1850s and Protestant critics were extremely wary of its seductive

sensory stimulation. Although no direct allusions to religion are made in published responses to Italian sculpture, it cannot be coincidental that it adopts a similar language as that applied to Roman Catholicism in this period.[2] Both were regularly described as trivial, superficial, degenerate, and corrupt. For example, an 1879 article 'Modern Italian Picturesque Sculpture: The Rising School of Realism' attempted to stem what it perceived to be this 'evil' tide of contemporary Italian realism from seducing British sculptors, patrons, art critics, and the general public. The author asserts that only a deprived mind could make and support this type of immoral sculpture, advocating that "Modern taste should at once stamp it out by welcoming only that which is sound in principle and pure in feeling, as well as true and beautiful in execution" (Jarves 1879: 251).

I am not suggesting that Italian sculpture was necessarily thought to represent Roman Catholic doctrine, but that it could be viewed as a symptom of the inherent threat of Roman Catholicism. Works such as the *Reading Girl* displayed unacceptable baroque (i.e. Roman Catholic) qualities resurfacing in Italian sculpture which generated a dangerously sensuous and haptic response from British audiences, who were evidently receptive to their seductive charms. Works such as Vincenzo Vela's *Morning Prayer* (1846), which represented adolescent girls engaged in ardent prayer, were particularly troubling because of their conflation of religious ardor with this new sculptural realism. This had the potential to corrupt through its sensuous materiality.

From Cloth to Clothing: The Sensuality of the Everyday

These statues therefore represent a complex shift in sculpture, from ideal classicism to a new realism. I suggest that one of the most transgressive aspects of this change is the representation of the contemporary everyday. Elements of ideal classicism remain present, including allegory and the alleged purity of white marble, but these are subverted and disrupted with hems and buttons and stitching. Through a minute depiction of cloth and costume, this verismo sculpture introduced aspects of modern life into what was still essentially a classically based medium. The combination of enhanced realism and contemporary

clothing heightens the affinity of these sculptures to a modern reality and makes them seem more present. This, in turn, complicates their bodyliness. As one critic noted in relation to Magni's *Reading Girl*, it disrupted the accepted norms of ideal(ized) beauty:

> everything is true and faithful in the spirit of every-day life to a degree almost approaching ugliness, its charm lying in the reality and simplicity which characterize it, rather than the intrinsic loveliness of form, feature, and drapery which are ordinarily supposed to constitute the primary excellences of sculpture.

'The Dublin International Exhibition' 1865: 296

Another suggested that Magni had brought a 'domestic freshness' to sculpture. There is something powerful in depicting a young girl in marble in a simple or elaborate chemise, absorbed in everyday, domestic activities, as opposed to the more standard portraits of monarchs or politicians, or memorials to military heroes.

These sculptural depictions of young, working- and middle-class girls are significant as subjects which are rarely if ever seen fit to be carved in marble. Through a novel rendering of cloth, these are transformed from mythical or generic figures, to more familiar girls of the 1850s and 1860s. Classical subjects are substituted for the ordinary and the everyday, and the ordinary and the everyday are elevated to the extraordinary by their representation in marble. These girls may be silent or silenced, with bowed heads and pliant limbs, but they are also independent, conscious, absorbed, in ways in which allegorical child sculpture is not. In the case of the reading and writing girls, this might also represent a new, contemporary form of allegory—universal education. By being engaged in activities such as reading, writing, or prayer, their minds and hearts are undergoing intellectual and moral growth. Their erotic thoughts and feelings can also be imagined as their growing bodies reshape the contours of their clothing, and their sensory engagement with the textures that surround them take on new, pleasurable resonances.

The erotic dimension of cloth, particularly in relation to women, was of contemporary concern as an increasing variety of textiles became available at the international exhibitions and in the newly emerging department stores. These were economically significant to both Italian trade and to British imperialism, but their economic benefits were in part tempered by their perceived and gendered threat to women's morality and virtue, as they were seduced by an unwholesome attraction to fashion and conspicuous consumption. Emile Zola's *Au Bonheur des Dames*, published in 1883 yet set in 1864–69, captures the heightened sensory and sensual experience of department stores, its vivid description of a sale of white goods indicating both the increasing specialization of cloth, and the complex knowledge required to navigate this white sea of silk, cotton, muslin, wool, and increasingly differentiated forms of textiles.

So while the white marble cloth of these statues might seem to generically represent ideas of purity associated with ideal sculpture, audiences in the 1860s were also skilled at identifying nuanced differences in white cloth. As one critic noted at the International Exhibition in Dublin in 1865, a culture of close observation was necessary as manufacturers and consumers surveyed and analyzed the goods on offer:

> the merchant-connoisseur may bring over his friend, and say [in relation to realist painting], "Look at the leaf of that cap, sir"; or at "the medicine-bottle with the label half-torn off"; or "the bit of flannel round his head: you might touch it, sir,'—so there seems to be growing up a demand for "back-kitchen" sculpture also.

'Sculpture: the Dublin Exhibition of 1865' 1865: 55

This delight in imitation raises questions regarding the making of sculpture and the making of cloth. The polished uniformity of classical sculpture, with its abstract, timeless folds, seems to erase the agency of the human hand. In contrast, realist sculpture foregrounds traces of making. The fact that visitors were touching these works suggests that they half-believed that they were what they purported to be, and that the act of touching might help them understand the ways in which the sculptor created the illusion of cloth, stitching, hems, borders, seams, and buttons through careful carving, chiseling and polishing. This foregrounds the human labor involved in making not only the sculpture, but also the garments they depict. The general public in the 1860s would have been closer to the making and mending of garments than those in the West are today. Indeed, their knowledge of 'fripperies' and 'lacework' would have also been greater than their knowledge of classical sculpture, and these modern works, with their close observation

of contemporary fashion, could be regarded as both populist and democratic in their content.

The production of cloth, lace, garment, and sculpture all involve a high degree of technical, manual, and artistic skill. The marble figures of girls reading and writing also found their echo in contemporary illustrated advertisements for sewing machines. For example, Wheeler & Wilson's 1865 advertisement for its prize-winning lock-stitch machines includes an engraving of a 'Miss Annie Bell hemming her handkerchief on a Wheeler and Wilson' (*Official Catalogue Advertiser* 1865: 7). Her seated figure bends forward in concentration over her work, reminiscent of her marble counterparts. She is surrounded by key words: hems, fells, tucks, gathers, quilts, binds, braids, and cords—exactly the types of techniques illustrated in the marble sculptures. The accompanying text notes the machine's ability to sew the 'Finest Book of Swiss Muslin, Silk, Linen, Calico, Flannel, or the Thickest Cloth'. This suggests both its technical capabilities in terms of stitching cloth and the company's expectations regarding the public's knowledge of different textiles and sewing techniques. The mechanization of sewing in this advertisement also suggests an alternative reading of the 'imitative lacework' in marble noted previously. While this was sculpturally skilled work, its reference to mimesis might refer to deskilling, as advancements in machine-made lace threatened the handmade British lace industry.

The Politics of Cloth

Domestic sewing, however, held particular political associations in the context of mid-century Italy, notably in Milan, which was an important center of both the Italian Risorgimento and of realism in sculpture. Olson identifies Odoardo Borrani's painting *26 April 1859* (1861) as an example of the type of patriotic artworks favored by regional governments after the formation of the Kingdom of Italy in 1861 (Olson 2013: 219). This painting depicts a young woman, at home, sewing the Italian flag. Similar works include Borrani's *Sewing Red Shirts for the Volunteers* (1863), in which four young women sit sewing in a bourgeois living room. A seemingly innocuous scene, the engraving of Garibaldi on the adjacent wall alerts the viewer to the fact that their sewing is an active political gesture as they are making red shirts for those fighting for Italian independence. Within this context of the Risorgimento, women at work—either sewing, reading or writing—express political agency, personal risk, and patriotic idealism. And if the erotic is partly associated with transgression, then quietly political scenes such as these, which conflate public and private spheres, the domestic and the political, and class distinctions, can also be read, in part, as erotic. The soft white hands are touching, cutting, and stitching the red shirts that will be soon clothe the torsos of (all social classes of) militarized men, and this cannot have escaped the imaginations of the depicted young women, or viewers of the painting.

The politics of cloth expressed in the act of sewing and in paintings such as these are also evident in the carefully carved stitched cloth and clothing of sculptures such as the *Reading Girl*. The version exhibited in London in 1862 depicted her wearing a portrait medallion of the Italian nationalist Guiseppe Garibaldi around her neck and reading a patriotic poem by Giovanni Battista Niccolini (whose printed pages were once pasted to the marble book). This has been interpreted as a 'somewhat opportunistic' response to the Risorgimento in which 'the girl herself was understood to stand for the earnest young adolescent nation' (Penny 2008: 164). This young girl, dressed in a white chemise, can therefore be interpreted as a political allegory. She is reading intently, oblivious to the fact that one of her breasts has become exposed as the chemise slips from her right shoulder.

Given the political context generated by the Garibaldi medallion, this partial nudity might be accounted for as a symbol of national innocence and growth. Garibaldi was an ardent anti-Catholic and this version of the *Reading Girl* may have been selected expressly for exhibition in London to appeal to similar anti-Catholic sentiments in Britain and Protestant engagements with the Bible (the act of reading). In other versions, the girl wears a crucifix, rather than a medallion of Garibaldi, suggesting that the sculpture was modified to appeal to more or less Catholic audiences. Yet in both versions, the body and its chemise remain the same, startling in their realism; as is the exposed breast of this adolescent girl. Having examined the eroticism generated by the realism of the clothing in works such as these, how then might we make sense of this nexus of cloth and pubescent body? In the final part of this essay, I will focus on the specific relationship between cloth and the bodies of adolescent girls through the study of two specific statues.

Sculptures of Pubescent Girls

Displayed in the Saloon at Brodsworth Hall near Doncaster are two works by the Italian sculptor Giuseppe Lazzerini, *Vanity* (c. 1862) and *Nymph Going to Bathe* (c. 1862). At a distance, they seem to follow the conventions of classical sculpture. Both are made of white marble, and feature semi-nude female figures, seemingly wearing classical drapery. Their titles reinforce the classical allusions through their emphasis on mythological themes. *Vanity* gazes into a now lost mirror, while *Nymph Going to Bathe* stands at the river's edge, about to disrobe and enter the water. Yet on closer viewing, there is something troubling happening in these works. These half-naked bodies depict pubescent girls, rather than the adult nudes more commonly found in antique and neoclassical sculpture. These are girls on the point of crossing the threshold into adulthood, younger versions of their classical selves. And this carries with it a transgressive erotic charge. These young, evidently growing bodies, with their small breasts and slender limbs, disrupt the polite veneer of ideal sculpture as timeless and pure.

As with adult women in ideal sculpture, the subjects' eyes are averted and the viewer can gaze at will on the marble form. But the signs of growth and transformation in these young bodies are somehow more bodily, more immediate, than in their fully formed adult selves. The classical women might now be their mothers, aunts, or sisters, transporting these once isolated forms into an extended family of sculpture, with more human qualities than those associated with classical forms. The girls generate a number of tensions between adulthood and childhood, sexual knowledge and sexual innocence, the subjects' averted eyes and the viewers' gaze, between classicism and realism, and between cloth and skin. In combination, these factors generate a troubling eroticism which is perhaps particularly challenging in relation to sculpture, which can be fully three-dimensional and to human scale. Elements of ideal sculpture remain present, including allegory and the alleged purity of white marble, but these are subverted and disrupted through their age, bodies, and cloth.

At first glance, the figures appear to be clad in quite conventional classical drapery. Yet on closer inspection, they are clearly dressed in modern nineteenth-century clothing. They wear meticulously cut and stitched chemises, with a gathered neckline and a deep, gaping placket. This hangs low at their waists, exposing their naked torsos and growing breasts. The folds of cloth echo classical drapery, but the stitched neckline and the tailored sleeves disrupt the classical allusion, bringing these girls directly into the 1860s. The chemises are in danger of falling entirely off

Figure 21 Giuseppe Lazzerini, *Nymph Going to Bathe*, 1862. Brodsworth Hall. © Historic England Archive.

their bodies, only held in place in *Nymph Going to Bathe* by the pressure of a clutched hand, grasping the gathered folds of cloth in a tight grip and, in the case of *Vanity*, by the erect handle of the now lost mirror. Cloth and skin are intensely connected in these works and find their most sexually explicit realization in the deep v-shaped slit of the neck's opening as it exposes her abdomen and draws the eye further downwards. The neckline's single button, rather than keeping the chemise in place, hovers precariously below her waist, having seemingly formed an imprint on her body in the echoing indentation of her belly button. As viewers, we are witnessing the undressing and exposing of a young girl's changing body.

One way of understanding these works might be to try and recover what they meant for their Victorian contemporaries. In the nineteenth century, children in stages of undress were often regarded as allegories of innocence and therefore as devoid of erotic or sexual content.[3] Prince Albert, for example, commissioned sculptural portraits of the royal children from the sculptor to the crown, Mary Thornycroft, as a gift to his wife Queen Victoria in 1846. The royal children are depicted as classical allegories of the four seasons. Within this context of an apparently model family, their off-the-shoulder drapery would seemingly symbolize childhood innocence. The implication being that we, the viewer, are at fault if we see anything but innocence in the figure of a child. Yet even some Victorians felt that something was wrong. In 1847, an anonymous article raised concerns regarding a now lost sculpture by the north Italian sculptor Raffaele Monti. Monti was particularly renowned for his virtuoso feats of sculptural carving, notably his veiled faces of women (Williams 2014). The work was described as follows:

> [T]here is a group of two children looking at a snake and entitled "Innocence". . . . The female child has its hair dressed like a woman, and the countenance is certainly nearer to maturity than to infancy. We see the wish, which would hardly enter into the thought of the most corrupt of English birth, and grind our teeth at the hardihood of the libertine who has dared acknowledge it. The little things we love to play and fondle with are to be regarded with lustful eyes, and the passionless loveliness of the child is to be contemplated with beastly anticipation. Those who are able to interpret works

of art must see in these sculptures, thoughts that are disgraceful and unfitted for exhibition, at all events in this country.

'Some Sculptures by Geatano and Raffaelle Monti di Ravenna' 1847: 5

The accusation of 'lustful' child sculpture here is clearly xenophobic; allegations of deviancy are drawn along national lines. As Annemarie McAllister suggests, in her study of English representations of Italians in the Risorgimento period, British critics were predisposed to read Italian bodies as more inherently sexual than their own: "Italians were depicted as wearing clothing which was bright, light, and loose, rather than dark and buttoned up, as seen on the English, and this in itself implied more sexual accessibility" (McAllister 2004 vol. 1: 59). The above passage on Monti is significant in that it is a rare, if not unique, suggestion that sculptural representations of children could be erotic and sexual. It proposes that there is something bodily and expressive in these works that disrupts the accepted tenets of ideal sculpture as pure, and it exposes sculpture's potential to incite a bodily and lustful response in its (male) viewers. This in part reflects a growing contemporary critique of the sculptural nude as morally questionable. It is the ambivalence between childhood and adulthood, between permitted and unlawful desire, which is so transgressive, unsettling, and, for the aforementioned critic, potentially erotic, in Monti's *Innocence*.

At the time the sculptures were made, English common law set the age of consent to between the ages of ten and twelve. This was raised to thirteen in 1875 and to sixteen in 1885. Within this British context, Italian sculptures of pubescent girls such as *Nymph Going to Bathe* and *Vanity* represented a state of physical and sexual metamorphosis, in which the (male) sculptor and viewer actively participated in the construction of meaning. Contemporary sculptors were attempting to depict not only children, but to explore the challenging states between childhood and adulthood. Monti is described as having combined elements of the female child and adult, bringing them together in such a way that the child could no longer be regarded as fully innocent. Conflating childhood and adulthood, innocence and eroticism in this way presented a particularly fraught area of sculptural negotiation that embodied a complex set of responses to childhood, sexuality, eroticism, and puberty. One critic responded to the

above article by stating that 'we shall not soil our columns . . . by the dirtiness of attack upon the artist' and the matter disappeared from published discourse ('Sculpture by Geatano and Raphael Monti' 1847: 503–4). The language of dirt and soil however does little to restore the purity of white marble to these sculptures.

Conclusion

In this essay, I have argued that the treatment of cloth in mid-nineteenth-century Italian verismo sculpture represents a radical reconfiguration of ideal sculpture and prompts a different erotic relationship with sculpture. The detailed stitching, lacework, hemmed edges, and dropped sleeves disrupt the smooth and polished surfaces of classical drapery, creating a heightened sense of materiality that makes the sculptures more corporeal (and touchable) than their classical counterparts. This, in turn, enables these marble bodies to express and embody erotic desires and to have those desires projected on to them. Furthermore, by clothing them in identifiably modern dress, the subjects of these modern Italian sculptures are brought emphatically into the present, the wrinkles, creases, stitches, and buttons introducing traces of wearing, making, and touching that carry a complex range of contemporary concerns, from consumerism to practices of making. The detailed rendering of cloth is the central element in this transformation.

The changing bodies of these pubescent girls add a further disruption to the inviolable, eternal body of ideal sculpture. This creates a rare, and much-needed, space for examining the particular experiences encountered and negotiated during adolescence. While troubling in their potential sexualization of young girls, they also recognize that these girls are themselves experiencing bodily, intellectual, and sensory changes, perhaps most immediately in their responses to the textiles and clothes that touch their own bodies. As viewers, we also bring our own individual perspectives to these works, the complex renderings of cloth opening up a range of possible associations. This motivated visitors to the London International Exhibition of 1862 to touch the sculptures, perhaps awakening their own sensory memories of cloth against skin, and, in a corseted age, the particular sensations of wearing a loosely fitting chemise.

Notes

1 I am not suggesting that drapery does not hold a multiplicity of meanings. Gen Doy's *Drapery: Classicism and Barbarism in Visual Culture* (2002), for example, foregrounds ideas around drapery, commodification, and fetishism. What distinguishes the works of the Italian realists explored in this essay, however, are the ways in which they particularize and modernize cloth, transforming it from drapery into made cloth and clothing. I argue that this materiality holds related, but different, ideas around cloth, making, touch, and the body.

2 On anti-Catholic rhetoric see Janes (2009) and Cantor (2011).

3 There is now an extensive bibliography on sex and childhood in Victorian Britain, including James Kincaid's *Child-Loving: The Erotic Child and Victorian Culture* (1992) and Louise A. Jackson's *Child Sexual Abuse in Victorian England* (2000). On visual representations of childhood see Brown (2002).

References

'The Art-Show at the Great Exhibition,' *Dublin University Magazine*, August 1862: 141.

Atkinson, J. Beavington (1867), 'Art in the Paris Exhibition,' *The Contemporary Review*, October: 152–71.

Beattie, S. (1983), *The New Sculpture*, New Haven, CT: Yale University Press.

Brown, M. R. (ed.) (2002), *Picturing Children: Constructions of Childhood between Rousseau and Freud*, Aldershot: Ashgate.

Bryant, J. (2002), 'Bergonzoli's *Amori degli Angeli:* The Victorian's taste for contemporary Latin sculpture,' *Apollo*, September: 16–21.

Cantor, Geoffrey (2011), *Religion and the Great Exhibition 1851*, Oxford: Oxford University Press.

Doy, G. (2002), *Drapery: Classicism and Barbarism in Visual Culture*, London: I.B. Tauris.

'The Dublin International Exhibition,' *The London Reader*, July 8, 1865: 296.

Getsy, D. J. (2004), *Body Doubles, Sculpture in Britain 1877–1905*, New Haven, CT: Yale University Press.

Jackson, Louise A. (2000), *Child Sexual Abuse in Victorian England*, London: Routledge.

Janes, Dominic (2009), *Victorian Reformation: The Fight over Idolatry in the Church of England, 1840–1860*, Oxford: Oxford University Press.

Jarves, J. J. (1879), 'Modern Italian Picturesque Sculpture. The Rising School of Realism: Gori, Albano, Carnielo, and Gallori of Florence; their Works and Spirit,' *Art Journal*, November: 249–51.

Kincaid, J. (1992), *Child-Loving: The Erotic Child and Victorian Culture*, London: Routledge.

McAllister, A. (2004), 'English Representations of Italians in the Risorgimento Period: Their Use in the Construction of

Nationality and Masculinity,' PhD dissertation, 2 vols., Salford: University of Salford.

Murphy, P. (2010), *Nineteenth-Century Irish Sculpture: Native Genius Reaffirmed*, New Haven: Yale University Press.

'Official Catalogue Advertiser' (1865), *Dublin International Exhibition of Arts and Manufactures, 1865 Official Catalogue*, fourth ed., Dublin: John Falconer.

Olson, R. J. M. (2013), 'Art for a New Audience in the Risorgimento: A Meditation,' *Journal of Modern Italian Studies*, 18 (2): 211–24.

Penny, N. (2008), 'Pietro Magni and his Reading Girl,' in C. Chevillot and L. de Margerie (eds.), *La Sculpture au XIXe siècle: Mélanges pour Anne Pingeot*, 158–64, Paris: Nicolas Chaudin.

Salvesen, B. (1997), 'The Most Magnificent, Useful, and Interesting Souvenir': Representations of the International Exhibition of 1862, *Visual Resources*, 13 (1): 1–32.

'Sculpture: the Dublin Exhibition of 1865' (1865), *Temple Bar*, August 15: 55–6.

'Sculpture by Geatano and Raphael Monti' (1847), *The Fine Arts Journal*, June 12: 503–4.

'Some Sculptures by Geatano and Raffaelle Monti di Ravenna' (1847), *The Morning Post*, June 5: 5.

Williams, G. (2014), 'Italian Tricks for London Shows: Raffaele Monti at the Royal Panopticon,' *Sculpture Journal*, 23 (2): 131–43.

Further Reading

Ascoli, A. B. and K. von Henneberg (2001) (eds), *Making and Remaking Italy: the Cultivation of National Identity around the Risorgimento*, Oxford: Berg.

Hatt, M. (2001), 'Thoughts and Things: Sculpture and the Victorian Nude,' in A. Smith (ed.), *Exposed: The Victorian Nude*, 37–49, London: Tate Publishing.

Thoughts on the erotic:

I have 562 postcards of Victorian and Edwardian men wearing business suits, bathing costumes, sportswear, military uniforms, cloth caps and bowler hats hanging on my bedroom wall. This is my collection of erotica. I kiss many of them before I go to bed. It scares me sometimes—looking at the marks of my mouth on the lips of dead men and the grease from my finger where I have caressed their threads.

NIGEL HURLSTONE

3

Stitching Up: Embroidering the Sex Life of a Fetishist Image-Maker

NIGEL HURLSTONE

I learn how to kiss men sitting in Norma's hairdressing salon while my mother has a perm. And nobody knows anything about it. My eyes are firmly fixed on the TV screen in the corner. The BBC is showing a double-bill Saturday matinee of Elizabeth Taylor and Montgomery Clift starring in *A Place in the Sun*, followed by *Suddenly Last Summer*. As Montgomery Clift's shapely rear comes into frame, clad only in the briefest of trunks, I desperately want to take the place of the surprised-looking Miss Taylor for what must have been the perfect view. Unexpectedly, Norma turns on my mother's dryer and all reception is lost. A fuzz of lines obliterates the screen for what seems like forever. My first erotic moment frustrated by gusts of warm air.

By the time reception resumes, the couple are about to become better acquainted. Mr. Cliff circles Miss Taylor's face with his eyes and then dips his head slightly to be at a parallel level with her lips. He opens his mouth ever so slightly before clasping her towards him, to facilitate what appears to be a perfect kiss. There is no collision of teeth, unsightly tongues, or unwelcome saliva to ruin romance and turn everything into something ugly.

I accompany my mother to the salon for months afterwards. The Saturday matinees are never again charged with this same thrill, but I begin to love the Hollywood stars like Rock Hudson and Paul Heinreid. Even if the TV was switched off, I could sit and admire an array of celebrities on walls crammed full of movie stills and coffee tables groaning with weeklies. Clients would occasionally prod a picture and ask for a style "just like that," while I spent hours inspecting portraits of famous faces sagging like drunks in cardboard mounts on windowsills awash with condensation.

Heaving coat hooks carrying the paraphernalia of clients provided even more opportunities for conjecture. Tough terylene macks shared space with languid hand-me-down furs crowned by brightly printed headscarves that fluttered to the command of hot dryers. Images caught my eye, but these textiles activated my desire to do more than look. I surreptitiously run my fingers through this cornucopia of cloth, pushing my hands deep within their folds, and wonder if the cured hide of a sheepskin feels like the buttocks of the man on screen; if his close-shaven face has all the ease of silk and if his trunks grow as heavy as Norma's wet towels.

I soon realize that these fantasies may not just be mine. Everyone seems complicit in the knowledge that it is OK to escape here, to imagine a place in the sun and wishing to be just a bit like Elizabeth Taylor or Montgomery Clift, however briefly, is fine. The radio is on but full of nothing else but suggestions on how to cope with refuse mountains, burying the dead and the necessity of keeping out of hospitals in this "Winter of Discontent."[1] "Could I wear that with my color?" inquires a hopeful client from beneath her dryer while perusing Miss Taylor's latest purple pantsuit in *Cosmopolitan*. "Of course, Enid," purrs Norma, "we all love a bit of dressing up don't we, ladies?" Excited by the possibility, Enid presses a bony finger against the page and declares that Richard Burton favors wearing nothing in bed.

Amongst the silver shards of foils and bottles oozing emollients, suspending a bleak reality by invoking fantasy seemed relatively easy, but then on one Saturday afternoon, the movies showed me that finding out who we are might actually be more exciting than pretending to be somebody else. For the first time, I watch MGM's classic film adaptation of Frank L. Baum's *The Wizard of Oz*. As the film unfolds, I begin to realize that I feel as safe with these women as the Tin Man, the Scarecrow, and the Cowardly Lion do with the gingham-clad Dorothy and take great solace in this weird ménage on screen. "This way is a very nice way," exclaims the scarecrow to Dorothy. "It's pleasant down that way too. Of course, some people go both ways." I known that I desire men, but importantly, when at the salon, I also have the belief that one day I will have the daring to act upon it, because there is so much courage here. The Wicked Witch of the West for all her faults seems to echo Margaret Thatcher and women on both sides of the political spectrum who have become energized, radicalized, capable (and culpable) on their own terms during the miners' strike.[2] But these women also have their hair done. They are sitting with me at Norma's. They are not good or wicked; just prepared and preparing to fight.

I soon become a coward when I leave this world behind. My father's words ring in my ears later that day. Raising his eyebrows as I clamber into the car with my mother, he asks what the attraction of the salon *is* for a teenage boy. "It's not right him being around those women all afternoon," he mumbles with a frown. "It'll make him strange. In fact, it's not right for anybody." It is the first time this concern has been spoken and I am immediately put ill at ease. There is a whiff in the air that this sustained proximity to women could throw a boy's libido in the wrong direction, and that anyway, women left unchecked are more prone to cause

havoc.[3] My mother remains silent, but snaps closed the fasteners on her coat until they reach the very top of her neck. My father turns his head and I see his eyes prick with tears.

Decades later, I am making work out of those films I watched at the salon, but perhaps not about the films at all. Reflection on childhood fantasy articulated through the lens of adulthood can mislead; it implies a rather linear and well-mapped journey that is as much defined as the Yellow Brick Road itself. But this work is not that. It is an attempt to re-enter a space and time in which "coming out," to oneself, seemed just as redemptive as teenage boys who roamed the streets in old saloons playing songs about love being king and death as adventure. I want to conjure that briefest of moments up again, like a magician.

Our expectation in magic, of course, is that it will hopefully delight with some alteration of the known and expected order and, ultimately, the work that has emerged makes an attempt at some type of conjuring act. I extract stills from the MGM film adaptation of *The Wizard of Oz*, print them onto cloth, and then machine embroider the fabric. Stitching these celluloid frames allows them to exist outside of the flickering and fragile cinematic world from whence they came. They become a static part of the present and can be viewed with no screen interface. There is never a point in which these fabric screens give up their mystery, color, or image to reveal themselves as just a big piece of hardened white plastic or glassy TV. We are held perpetually in a single frame selected to collide a fragment of the filmic narrative with a flash of personal revelation, be this a bygone wish, lesson learnt, or an observation on how to (maybe) capture a man.

The cloth is purposely made to beguile the viewer into sharing these instances of intense and magical wonder and hold them in a moment of (hopefully) shared delight. The surface of the cloth is intensely worked in order to produce a "screen" that has the potential to glow and glimmer. Mixtures of metallic and luminescent threads are stitched

Figure 22 Nigel Hurlstone, 2012. "The End" series. Digital print on viscose with chiffon overlay and machine embroidery. 120 × 80 cm. With thanks to SIT. Photography: Ben Blackall.

into the cloth to make it twinkle like the eyes of the Scarecrow and the cheeks of a well-oiled Tin Man. It deliberately provokes the desire to touch in its rhythms, textures, and colors, and certainly, the cloth demands an intimacy and sensitivity to touch as it is made. There is much teasing of the surface as it is rubbed, shrunk, and stretched between fingers to make the thread lie in an exacting fashion. It expands and moves in unexpected ways as the needle punctures and pulls at the surface. Too much pressure tears and bruises; too little achieves nothing. It is persistently caressed into being; but this caressing is no longer the furtive or frantic fumbles of a teenager fondling fur coats and dreaming of stroking the hairy chest of George Best. It is controlled, slower, and more adept. And when stitching is complete and the work finished, I step back. No touching allowed. Just looking. The cloth hangs on a gallery wall. The frustration of a desire to touch and feel may be the most erotic recipe I can conjure.

But the work also tries to defy the melancholy at the close of film by holding back the moment when we realize that we are in the same seat, in the same reality and that our journey into storyland has come to "The End." Here, the stories and characters of our encounter do literally disappear and there is a very real sense, however briefly, of being horribly deserted and somehow left bereft. "The End" is emphatic and conclusive. It cuts off our imaginings and almost instructs us to get back from whence we came. It is the point at which most of us will cry, but often the kind of tears that are held back from view or quickly wiped away by a stealthy finger.

There has also been a literal "holding back" of actors and players within these scenes. They have been taken off the set, buried beneath layers of stitch and blurring chiffons, so that eventually nothing more than the scenic landscapes of Oz are figured. Perhaps this is the ultimate magic trick: that of the vanishing act. Where did Dorothy and her traveling companions go? They should be here walking briskly down that Yellow Brick Road, falling asleep in the poppy field or being blown across the empty Kansas plains by that terrible tornado. But like tears, they have been wiped away too. The euphoria of realizing that the world could be a place in which my desires were able to flourish was relatively short lived. Many of the characters (both real and imagined) that I once cradled in my mind as either role models or objects of desire were unexpectedly swept away by another kind of terrible storm: AIDS.

A woman dressed all in black strides into the salon, fails to wait at the reception desk, and settles herself into the vinyl couch intended for clients with appointments. Norma flicks at a page in her diary with the sharp tail of a comb and asks for a name. After much deliberation a space is found, though six heads nursing curlers under tight elastic bonnets sit wide-eyed under the lulling breeze of nodding dryers. The woman unzips her boots and stacks them on top of the radiator before snatching a newspaper from her bag. Her face quickly turns to a grimace as she prods a picture on the front page, and then, as if preparing to swat a fly, holds it aloft for all to see. "Who the hell would be touching that," she proclaims, "let alone kiss it." The emaciated portrait of Rock Hudson, juxtaposed with a smaller fanzine image from the 1950s, was accompanied by a headline proclaiming his death from AIDS.[4] Reports of the "agony" of *Dynasty*'s Linda Evans, who had had a screen kiss with the star only two weeks before and now feared being infected herself, added further column inches to the story.[5] "Well I've never been one for too much kissing," sniffs Norma.

Heads nod in agreement, which gives the woman on the couch encouragement to proceed further. "The trouble is with these people," she proclaims with authority, "is that *they* don't know where their husbands are. I mean, how can they when they're not home and here, there and everywhere all the time? And say what you like, but some of them shouldn't be married anyway. No wonder they get ill with what they're getting up to." And if there was any doubt of what that might be, she had plenty of other stories that left every client squeezing their face in disapproval. The luminaries on the salon wall and windowsills suddenly became mourners rather than romancers, more septic than sparkling, and ladies resisted glancing upwards to ask for a style "just like that," choosing instead to touch the tip of an ear or spot on the neck to show where curls should end.

"You're very quiet today young man," Norma observes while scrubbing with curiously added zeal at china teacups used by the morning's first clients. I don't reply but am instructed by my mother to uncross my legs, sit properly, and stop doing "that thing," with my feet. "Practicing for ballet?" cackles the woman without an appointment, "or is he just the *musical* type?" I immediately correct myself and sense my mother shift awkwardly in her chair. I sink backwards into the seat by the TV that I seem to have

occupied for years. For the first time, I feel desperately uncomfortable in my own skin. It is a skin that recently has become the site for constant inspection and anxiety. I imagine a lesion appearing here or there, a cancer spreading; because I have kissed a man.[6] A ten-penny piece was soon dropped into the box by the phone. My father is told that we are ready to be collected. Both of us felt in a rush to return home.

Early reporting of AIDS was, to some extent, designed to send everybody home; adulterous spouses back to monogamous marriages, gay men out of their sauna fun houses to a life of abstinence or, at best, celibacy with their partner(s). Many sick and dying were forced back to (often) estranged families, when their friends and lovers had either died, were too ill to care for others, or had fled to escape infection themselves.[7] But what was significant about the media images that accompanied the announcement of Rock Hudson's death was how the diseased body was shown in parallel to the publicity stills that had graced the likes of *Time* magazine and "Norma's" salon for years. And these images were much more overtly erotic than they were sexual, in as much as while they depicted Hudson's stupendous, masculine proportions, his body always, "seemed somewhat immobile, available as an object or erotic delectation but without the threat of male action . . . [he] offered not only the visual pleasure of his form . . . but the promise to control that big body, the promise not to pounce" (Meyer in Fudd 1991: 262–3).

Hudson was closeted for all his life so images of his AIDS-ravaged moribund figure became more than just a depiction of the disease. They registered his outing as a gay man and, by implication, the subsequent contamination of this once "pure boy" (Harris 1958: 48). As Meyer notes, "what is now meant to be visible—to be visibly leaking out—is his homosexuality . . . Rock Hudson's secret finally registers, Dorian Gray-like on the surface of his body" (Meyer in Fudd 1991: 262).

I deliberately begin to wear clothes that cover my flesh almost entirely. Shirts are buttoned up to the neck and fixed in place with a firm tie. I buy a prickly secondhand trench coat that skims the floor and grips my waist with a beaten buckle. Curled and colored hair is buried under an old knitted hat. This invented uniform hid what I believed had become the obvious body of a homosexual. Its initial intent was to both eliminate and guard against any potential speculation that queerness was near, since nobody wanted to be in proximity to a body that could be tainted by the "disease of the already diseased."[8] Nothing would be allowed to "leak out."[9]

But in all this dressing up, I inadvertently mobilize desires that I am so desperate to suppress. I feel strangely liberated in this oversized gabardine outfit and somehow unencumbered by the specters of sickness, fear, and mourning that have filled my head. However briefly, I become capable and brave enough to express erotic desire and importantly, accept that my body can be, and is, desired. I readily climb into cars with men hiding wedding bands seeking their own "brief encounter." I smell of mothballs and old tobacco. The shredded lining of the coat soaks up saliva, sweat, and semen. "You're a lovely bit of young rough," they say. I think this cloth makes me immune to contagion, convincing myself that it is only pretty boys and movie stars who get ill anyway. I am neither of those in this garb. The men I meet seem to desire me more in my costume of choice; it puts them at ease in their feats of daring do. "You're not a gay are you?" one inquires hastily. "You don't *look* like one." I shake my head vigorously to give reassurance. When he departs, I grin like Trevor Howard as he waves to Celia Johnson on that long steamy platform at Milford.[10] I have finally passed as a straight boy who just so happens to suck cock. Dressing up can bring such pleasure.

I have kept the gabardine. It is my own "erotic cloth." When I retrieve it from the back of my wardrobe, it still seems charged with the frisson of those hastily expressed desires and now seems more erotic than watching the intricacies of sex that I can so easily consume on the Internet. For the erotic never figures the fully realized workings of passion. It is irretrievably connected to an interrupted narrative in which what has gone before and what comes after are always left to speculation and imagination. I am more seduced by this now than the pornographic movie. It is perhaps for this reason that I reach for a favorite picture book, full of men, and look again at (and for) erotic pleasure.

The book is a published selection of photographs and letters from a vast archive accumulated by Montague Glover (1898–1983).[11] Glover was an architect, an army officer awarded the Military Cross for bravery during World War I, an amateur photographer, and a man who had the fortune to have an enduring fifty-year relationship with his lover, Ralph Hall.

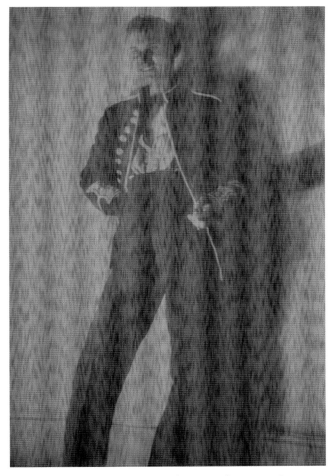

Figure 23 Nigel Hurlstone, *What Pleasure* **1 of 12, 2013.** Cotton organdie, cotton and burmilana thread, digital print, couching. 128 × 94 cm. Photographer: Nigel Hurlstone.

The images are remarkable on many levels, but primarily what makes them so unusual is that Glover recorded his life—and, primarily, his erotic sensibilities—as a homosexual through photographs. In an age where pornography for gay men was unavailable, Glover made his own erotic imagery by photographing his partner, but much more extensively, working-class men to whom he was attracted. However, his subjects are never naked nor presented as some kind of post-trick trophy. At no point do the images depict sexual contact or even nudity. The cut of their cloth seems as much a focus for the lens as the men themselves. He meticulously catalogues the garb of builders, road-sweepers, milkmen, delivery boys, dockers, and farm laborers, thereby turning working-class clothing into a series of types or fetishes. The images are a unique chronicle of one man's personal queer erotic.

Clothing in the form of military uniforms is represented in this oeuvre too. These photographs are undoubtedly an extension of Glover's work picturing working-class men and boys. They are the same men, but the fact that they are wearing a different cloth has transformed them into heroes and given them a different aesthetic virility that is bound up in the fetish for raunchy, hyper-masculinity. Beaming at the camera with cheery smiles or adopting the pose of nonchalant models, they are deliciously provocative in their scarlet wool, tight white trousers, and knee-high shiny boots that look as hard and lickable as treacle toffee.

Yet by far the most personally compelling images in this collection are a number of very different prints of an almost identical format. They consist of singular portraits of men, often posed in mismatching uniforms or undergarments that were given to them out of a dressing-up prop box that Glover kept at home. What this group of images seem to represent is the "portrait" of one man's sex life and, in particular, the fetishist at play. And that play does not appear to be one that is somehow forced on the subject against their will. There is an obvious interaction between photographer and model, army captain and private. Sexual excitement is evidenced by seemingly vast silhouettes in straining shorts while flat-fronted breeches struggle to contain what appear to be exceptional exemplars of manhood. Judging by their grins and smiles, a great deal of fun is being had too.

Initially, I have no intention to make work from, or about, these images. I sit and enjoy them, letting my imagination run wild once I have exorcized the more polite interpretations of them from my head. And then something happens. The media is full of planned events to mark the centenary of World War I. They are primarily governmentally initiated, funded, and scrutinized, and the pervading narrative to emerge is (expectedly) one of heroes and the brave, sacrifice and slaughter, man and wife, boy meets girl. Alan Turing[12] is eventually pardoned by the Queen as a nod toward equality, but the process and narrative around it has the unmistakable stench of opportunist heterosexist forgiveness for a deviant who is absolved because he just so happened to be clever at cracking codes.[13] I decide to make work from Glover's pictures; it is an attempt to place parallel lives and experiences within all the abundant, though selective, historical, and cultural narratives in circulation.

Or at least I convince myself that this is the reason and very noble that is too. However, it would be disingenuous to posit outraged politics as a singular motivation. Glover's

images have become a constant companion. I am addicted to them for my own erotic fulfillment and crave to see more. But there is, and never will be, any further photographs of these men, shot in this shabby bedroom amidst what I imagine to be much bluster and bravado. I wonder if these images can yield up more, not only for the purposes of personal pleasure, but as significant artefacts that can help unravel deceits and reveal the remarkable in what was one man's erotic odyssey.

Initially, I reprint the images at human scale rather than the thumbnail gauge of the original. Immediately there is something richly transformative about their presence. Not only is the sexual display of the model revealed more acutely, along with the detail inherent to the "costumes" worn, but shifting their pose from the printed page to the vertical arena of my bedroom wall, where they loom large and strange, feels akin to some unearthly resurrection. As I snap off the light, I wonder if the morning will bring the same unease as that felt by Victor Frankenstein when catching sight of his own diabolical creation.

But when the sun comes up, there is no horror to confront me. My waking is greeted by a line-up of vigorous, sexy yet mysterious men that, for the first time, seem animated and full of high jinks. The cloth on which they are printed shifts slightly as I pull back blinds and let the light in. Their once sepulchral limbs and faces, embedded and fixed to paper, seem to change. They playfully sway on this fabric and seem to acknowledge the presence of each other through stolen glances and quivering limbs that hint at a collective choreography. I imagine them on a stage; their individual performances no longer seen through the lens of a singular picture taker, but in an auditorium full of fellow pleasure seekers who might handclap and finger click to the sight and sound of all this rough trade strutting and pouting before them. I cannot build them a theater, but I do give them a proscenium on the gallery wall instead. The erotic cut of their cloths, the silly assemblage of uniforms and the suggestive poses of their bodies finally exposed for view in a public rather than private realm.

In any good theater, the performers on stage can be easily seen; grand twists and turns of bodies able to be read alongside the slightest nuance of touch or glance. But this band of players are not so easily observed. Stitch is used to deliberately veil their image and break the structure of the cloth. Their cheeky jibes and smiles become embedded beneath a busy blur of dominant embroidered lines.

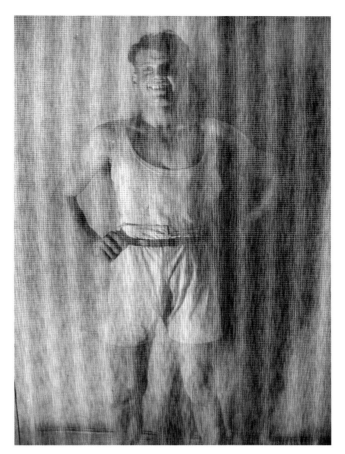

Figure 24 Nigel Hurlstone, *What Pleasure* 1 of 12, 2013. Cotton organdie, cotton and burmilana thread, digital print, couching. 128 × 94 cm. Photographer: Nigel Hurlstone.

Perhaps this is an attempt to bring Glover himself to the stage. The insistent patterning recalls time-exposure strips dangling in darkrooms above chemically laden trays. The fetishist at work in the manufacture of his own photographic pleasures is here, but somewhere offstage performing alchemy with silvered paper and bromide. But perhaps this veiling comes from somewhere else too. It certainly recalls the fuzzy lines of TV interference that break my fantasy at Norma's when trying to look at Montgomery Clift. Or it could be my own perverse attempt to break into the looking of the audience, for these printed and stitched cloths are undeniably seductive and they deliberately court intense scrutiny. They tempt the viewer close in an attempt to see through or beyond the insistent patternation to the bodies figured beneath, but this can be a rather fraught activity. There is the embarrassing possibility of being caught looking a little too much at these men; or even worse, lingering too long and being accused of staring.

The ability of the eye to rest easily on any part of this work is certainly compromised. The stitch not only holds back the image but deliberately creates turbulences across the entire surface of it. The passive consumption of intimate private fantasy becomes a public decoding of a monumentally staged theater troop of erotic queer performance. Take a seat and enjoy, though as at any show, try not to be too distracted by the rest of the audience whom you will watch for glimpses of puritanical horror or potential lecherous vice. And be aware that you are being watched too.

For what this public showing of private erotica brings into sharp focus are fundamental questions of sexual values, behaviors, and moralities in an age where sex, celebrity, youth, exploitation, and recrimination congregate en masse to make this an age of erotic uncertainty for all. Take too much pleasure in these models or, indeed, appear too nonchalant, and suspicion of perversion or dysfunction may abound. I become nervous of these images when they are revealed in the public gallery. While some are clearly mature men, others are not. I imagine that these models are youths and not boys. I also convince myself that the smiles of all these models would not be so bright if coerced into being; but I cannot be sure of anything. But surety it is not where this work originates from nor what it seeks to reveal; the erotic is illusive and slippery.

It is certainly safer and easier to speak of how these images contain universal significance about human sexualities and how with the hindsight of history they reveal the comradely ideal that Whitman, Carpenter, and Symonds proposed.[14] However, to imbue the work with such readings would be dishonest. For this is nothing more than postproduction rhetoric that begins to feel like apologetics or, at the very least, attempts to locate more honorable justifications for appropriating, making, and exhibiting the erotic. A more honest motivation may be found in the fact that making this work enables polite and permissible artistic activity to coalesce with my desire to look at these men for sustained and uninterrupted periods while surrounding myself with the threads and fabrics I so dearly love to caress and cajole. I am as much a fetishist at play as Glover.

But it is also more than looking. I touch and feel the images of these men in just the same way as I did at the salon. Their bulging loins arouse me and invite pathetic comparison to my thin stripped reflection in the mirror. The contours of their faces and bodies stretch out beneath my hands on a work table. Their eyes twinkle, toothy grins

tease, and thrusting hips excite, though surly glances also warn of possible temper. Hands push down hard on hips, fingers caress the tops of shorts, or grip firm onto batons meant for beating rhythm or twirling high into open skies. I feel their shadow and imagine they hold my arm, my hand, the back of my neck; lightly touching. "You are beautiful," I whisper. I think I can hear them laughing; all this ridiculous dressing up. I return to work the cloth and, when stitching is complete, I kiss them. All of them, by now, dead men.

At the time of making, I persuade myself that all this looking, all this touching, is absolutely necessary to gain knowledge of the bodies that I sew in order to "make art." But if I strip away these pompous justifications, perhaps the writings of Andrea Dworkin about the erotic being just "high-class porn. Better produced, better conceived, better executed, better packed, designed for a better class of consumer," could make for a more credible and honest interpretation of this work (1981: 10). Perhaps I have simply made queer porn for the gallery wall, but framing it under the guise of an academic discourse on erotic cloth serves to somewhat neutralize and validate its production beyond its function as a masturbatory aid. More fearless practitioners of erotic art, such as the late Tom of Finland,[15] had no such reservations about how his own stylized handdrawn illustrations of archetypes such as lumberjacks, policemen, sailors, and bikers were intended to effect the viewer: "I always want to make them cum."

While I make no such claims for this work trying to prompt a similar climax from viewers, the sort of contribution that it may make (I hope) goes beyond either the sexual titillation of the audience or the usual appeal for tolerance of gay relations realized by attempts at normalization. After all, erotica generated through and realized in dressing up and role play is a sexual proclivity that crosses both genders and sexual preferences; it is not unusual. However, what this "erotic cloth" does show, in its retrieval and (re)presentation of cross-class, cross-economic and inter-generational gay relations, is a way of being in the world that is at odds with mainstream cultural thinking. It seeks out, actively celebrates and shows "otherness" in a society that currently seems fixated on mainstream integration. I have concerns about joining that mainstream and wish to resist, since inevitably it will suck on then spit out the subcultures, practices, and representations it cannot swallow.

It is perhaps to the erotic image that we should turn to remind ourselves of the beauty to be found in diversity and

plurality, for distilled in the erotic is the human condition made potent and irresistible in all its guises. It is where we can learn about the frailty of self, but also gain strength. It is where we can construct desires and take pleasure when we can. It is where we are most honest, but also the most vulnerable. It is unpredictable, stealthy, and momentous. It is also the sweet stinging on my lips left by a man who has just been kissed.

Notes

1 "Winter of Discontent" refers to the winter of 1978/79 during which there were widespread strikes by public sector trade unions.

2 The UK miners' strike 1984–85 was a major industrial action to shut down the British coal industry in an attempt to prevent colliery closures.

3 For a thorough analysis of the changing nature of gender divisions and familial power structures in 1980s Britain, see Dicks et al. (1998).

4 Rock Hudson (1925–85) was an American actor known for his parts as a leading man in Hollywood films of the 1950s and 1960s. He began a second career in TV starring in the soap opera *Dynasty*, in which he appeared with Linda Evans, who played the character of Crystal Carrington. In 1985, he became the first major celebrity to die from an AIDS-related illness. His body was cremated only hours after death.

5 At the time, it was thought that the AIDS virus was present in low quantities in saliva and tears, but there had (and never has been) any reported cases of transmission by kissing. While a myth, it was also suspected that AIDS could be transmitted through saliva left on eating and drinking vessels, or even urine on lavatory seats.

6 Kaposi's Sarcoma, a relatively rare form of skin cancer, became a complication aligned to people living with AIDS who, due to weakened immune systems, could develop severe cases of the disease. The cancer could be cited around the mouth (amongst other places), which added to anxieties regarding the possibility of infection through kissing.

7 This had been the case for David Kirby, who died in Ohio from AIDS in 2000. His final moments, captured on camera, were used by Benetton in their "Pieta" advertising campaign some months later.

8 The saying "Disease of the already diseased" is attributed to Jeffrey Weeks (2007a: 16).

9 UK opinion surveys showed a growing unpopularity of lesbians and gays throughout the 1980s. In 1983, 62 percent censured homosexual relationships; in 1985, 69 percent did so and in 1987, it was 74 percent. Figures quoted in Weeks (2007b: 17).

10 *Brief Encounter* was a British romantic drama released in 1945. Directed by David Lean and adapted from the one-act play by Noël Coward entitled *Still Life*, it featured Celia Johnson and Trevor Howard in the leading roles. "Milford" refers to the (fictional) railway station where much of the film is set.

11 See Gardiner (1992).

12 Alan Mathison Turing (1912–54) played a pivotal role in deciphering Nazi codes that proved invaluable to the Allies war effort. In 1952, he was prosecuted for homosexual acts and was found dead in 1954 from cyanide poisoning. His death has often been attributed to suicide. He was granted a posthumous royal pardon in 2013 following an official apology in 2009, for "the appalling way he was treated" from the then Labour government prime minister, Gordon Brown.

13 For a more detailed explanation of the process of Alan Turing's royal pardon, see Wright (2013).

14 See Sinfield (1994: 149).

15 For a full biography, see Slade (2001: 545–6). For an anthology of the graphic works, see Ramakers et al. (2002).

References

Baum, Frank, L. (2001), *The Wonderful Wizard of Oz*, New York: Centennial Edition, ibooks, inc.

Beckett, Andy (2015), *Promised You a Miracle UK 1980–82*, London: Penguin Random House.

Dicks, B., Waddington, D., and Critcher, C. (1998) "Redundant Men and Overburdened Women: Local Service Providers and the Construction of Gender in Ex-Mining Communities," in J. Popay, J. Hearn, and J. Edwards (eds.), *Men, Gender Divisions and Welfare*, 287–94, London: Routledge.

Dworkin, Andrea (1981), *Pornography: Men Possessing Women*, London: Women's Press.

Fudd, Diana (ed.) (1991), *Inside/out: Lesbian Theories, Gay Theories*, New York: Routledge.

Gardiner, J. (1992), *A Class Apart: The Private Pictures of Montague Glover*, Bristol: Serpents Tail, Longdunn Press.

Harris, Eleanor (1958), "Rock Hudson, Why He's Number 1," *Look*, March 18: 48.

Mohr, Richard, D. (1992), *Gay Ideas: Outing and Other Controversies*, Boston: Beacon Press.

Ramakers, Micha and Riemschneider, Burkhard (eds.) (2002), *Tom of Finland: The Art of Pleasure*, Cologne: Taschen.

Saslow, James, M. (1999), *Pictures and Passions: A History of Homosexuality in the Visual Arts*, New York: Viking.

Simpson, Mark (1996), *It's a Queer World*, London: Vintage.

Sinfield, Alan (1994), *The Wilde Century: Effeminacy, Oscar Wilde and the Queer Movement*, London: Cassell.

Slade, Joseph, W. (2001), *Porn and Sexual Representation: A Reference Guide*, Vol. 2, Westport, CT: Greenwood Publishing Group.

Weeks, Jeffrey (2007a), *Invented Moralities: Sexual Values in an Age of Uncertainty*, Cambridge: Polity Press.

Weeks, Jeffrey (2007b), *The World We Have Won: The Remaking of Erotic and Intimate Life*, London: Routledge.

The Wizard of Oz (1939) [Film] Dir. Victor Fleming, Los Angeles: Metro-Goldwyn-Mayer

Wright, O. (2013), "Alan Turing Gets His Royal Pardon for "Gross Indecency"—61 Years After He Poisoned Himself," *Independent*, 23 December.

PART II

Making and Remaking the Cloth

In this section the erotic is encountered and encouraged through designing, making, remaking, and handling of cloth. The writers present the erotic through clothing or counter the erotic using cloth as a boundary and protective covering of the body. The erotic is seen in the material substance of cloth, in clothing, and through the physical actions of stitching and cutting cloth. These actions show how cloth is a transformative medium, used for dressing up, to alter in style, to drape, and be customized in order to become an erotic being. Cloth is styled to emphasize the sensuous contour of the female body in the sack-back dress and as defiantly erotic in punk clothing. The type of fabric and manner in which cloth is used captures the range of erotic types: soft, sensual, shiny, rubberized, and transparent. The different approach to construction increases the erotic presence of cloth: fulsome and flowing in luxurious lengths, in transparent light membranes and layers, cropped, wrapped with taut bodices, belts, straps, and apertures. In these chapters we see the gestures of working with cloth as a portal to the erotic. Through the rhythm of stitching, the changing of shape, the opening up and layering of fabric, these writers present the sensual character of making and the physical aspect of cloth.

Thoughts on the erotic:

The word erotic evokes a sense of the intangible, yet highly personal, emotionally charged all-consuming passion that pervades the mind and body. It conjures up images of soft billowing translucent cloth that gently, fleetingly touches the skin, sensuous and captivating. It is warmth, real, human, measured, timeless.

DEBRA ROBERTS

4

The Rustle of Taffeta: The Value of Hapticity in Research and Reconstruction of an Eighteenth-Century Sack-Back Dress

DEBRA ROBERTS

The Vitiated Imagination

As a collector of historical fabrics, which I use to inspire my own textile designs, I am seduced both by the material, the look, the touch, and the hidden narrative and histories of these fabrics. The physical experience of making and re-making conjures these indelible histories from the fabric confines. Fragments of old cloth connect us to the past, while the haptic, corporeal exploration enables us to discover not only how things were made, but to appreciate their lived embodied histories. This chapter is material-focused research that communicates the "secrets" of cloth, which reveal its stories by using the sensations of touch and emotion.

Writing in the eighteenth century, Samuel Fawconer's words, cited in Ribeiro (1986), resonate and encapsulate the thrill of sourcing, and wearing fabric:

> How is the whole scope of our fancy continually on the stretch, in designing and contriving this drapery of the species. How do we travel from east to west, and ransack the several elements for materials to decorate these our corruptible bodies. To please a vitiated imagination of our own, or attract the eyes of the beholders, and provoke their envy, how content are we to forgo our own ease. Samuel Fawconer, *An Essay on Modern Luxury*, 1765.
>
> **RIBEIRO 1986: 95**

What qualities of material can seduce? In this case, the attraction was a bundle of silk pieces discovered in a box at an antique textile fair. I was drawn to feel the fabric, the touch of the crisp cool lustrous silk, the colors still of fine gentle rose pink and greens in a contrasting stripe, despite slight fading. Handling the silk raised the question of its provenance and place of manufacture. The dealer described the fabric as eighteenth-century French. This conjured up an image of a rich tableaux of fine court clothing, colorful silk damask and taffeta materials, and a society that relished the lustrous surfaces and decoration of fabric and objects as an indication of rank, good taste, and morality. This reflected the extravagant influence of the French courts and the elaborate court dress that was encouraged.

In the bundle there were various pieces of silk,

including two smaller fragments that might have been pieces from a bodice. I was told the fragments had been bought in the south-west region of France from a house-clearance sale. This prompted questions of ownership, origin, and the significance of preserving the separate pieces. Conversations with the dealer, curators, and textile historians confirmed the material as silk taffeta, probably woven in Lyons in the late eighteenth century. Evidence of stitch marks and folds suggested the fabric might originally have been part of a sack-back dress, or *robe a la Française*. There was evidence of pleated cloth that was folded with color less worn and a neckline that suggested the pleats were placed at the back, all features familiar to the sack-back dress. The discovery of discarded fragments suggested a once-complete dress and previous life of its owner. I felt compelled to explore this past, approaching it in part as historian through analysis of the facts, text, and archive-based research, and primarily as a maker, by moving beyond objective analysis to a subjective, experiential, and material response. The handling of fabric accessed the trapped sense of the "other" woman whose life was entangled within the threads of the fabric; that is the fabric had an aliveness of the past. As a historian, I was prompted by the tension between the rational and emotive analysis of these fabric pieces. The artistic self with the vitiated imagination took the lead supported by a more considered factual investigation.

The research involved a physical analysis of cloth, which examined the imprint and traces of the wearer. This analysis focused on the making and wearing of the dress as practical processes. I further looked for cloth-held "secrets," implications that suggested the link to the people involved, the maker and wearer. I was unable to substantiate the real history of the dress, but as an "archaeologist of memory" (Lowenthal 1985: 251) I found that the material provided clues to an authentic and remembered past.

The style and dimensions of a sack-back dress can be authenticated through eighteenth-century paintings, historical texts, and archives at Platt Hall Gallery of Costume in Manchester; Lotherton Hall, Leeds; and the Victoria and Albert Museum, London, all of which have extensive dress collections. The eighteenth-century painter Antoine Watteau depicted the wearing of the sack-back dress, placing the women in romantic/erotic settings that an allegoric idyll of rural domestic French of domestic

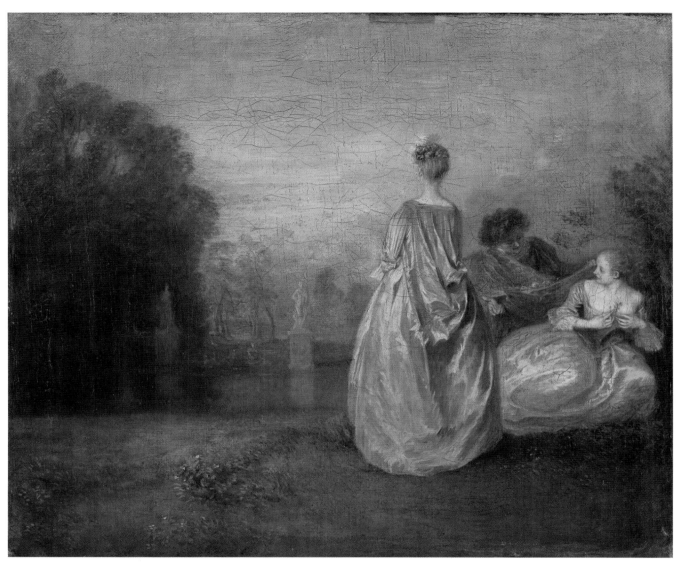

Figure 25 Jean-Antoine Watteau, *Les Deux Cousines (Two Cousins)*, 1716. Oil on canvas. 30 × 36 cm. Collection: the Louvre, Paris. Heritage Images/Contributor. Getty images: 520724703 Hulton Fine Art Collection.

French lifestyle. In the painting, the back of the dress is evident with a clear focus on the box pleats that create the fullness and shape of the "sack," a term that contradicts the opulence of fabric but defines the abundance of the cloth that, like a train, swept down the back and over the skirt of the dress. The back-facing flowing trail of cloth was arrestingly sensual, with the neckline and bodice taming the womanly body. This was a dress that was designed to entice, expressive in its folds of fabric and tight fastening. In its contradictions of design and reversal from back to front, it implied the teasing nature of desire. While texts by Arnold (1977), Baumgarten et al. (1999), Bradfield (1997),

Hart and North (1998), and Waugh (1968) were invaluable to understanding the style and detail of the dressmaking, illustrating the construction of the box pleating, the shape of the bodice, and types of trimming, the archive visits gave an immediate understanding of the actual scale, proportion, color, and decorative features of a sack-back dress.

The more personal examination of the private inside of a dress seemed voyeuristic and intrusive. This intimacy with the person, the wearer, and of the makers of the dress was not recorded other than within the cloth itself. The lines of stitch, alterations, repairs, and stains provided

useful clues of manufacture and use. Handling the fabric, I was affected by, as Allmer (2009) defines, the *punctum*, which acted as a moment of recognition within the life of the fabric trace. I thus sensed the actuality of wearing the dress with the rich cloth folded and stitched to encase the body, made taut and drawn to accentuate the waist, with voluptuous lengths of fabric flowing down the back to the floor. The vitiated imagination was powerfully present in reimagining this past attire.

The investigation next focused on reforming the remnants to replicate the original sack-back dress with an understanding of the fabric as a historical message carrier. In analyzing the found pieces and copying the fabric shapes onto calico, it became clear from noting specific marks and matching the lines of stitch that, apart from the bodice piece, the fabric had originally all been one larger piece and was, in fact, the complete left back of a dress. Where, therefore, was the rest of the dress and why had this particular fabric been retained for over 200 years? It was possible it had survived through benign neglect, or more purposefully stored as valuable fabric for future dressmaking and restyling. Silk taffeta represented a valuable commodity, and the sack-back dress was a conspicuous display of wealth, taste, identity, class, and fashionable consumption in the quantity and type of cloth. Worn by noble and bourgeois women, the dress signified an implicit understanding of etiquette, convention, and flirtation. The fabric "sack" both revealed and concealed the female body, implying the erotic presence beneath its plentiful folds.

> Fabric acts to conceal and cover objects and persons while at the same time, disclosing them—hinting at their presence. Fabric is malleable. It lends itself to wrapping, draping, and swathing. It restricts direct access to the naked object, but it also has the ability to suggest, enhance, and draw attention to what it covers over and adorns.
>
> **HAMLYN 2012: 16**

The style of the dress was designed to seduce, to entice in the formality of courtly liaison.

The habitual way of wearing a sack-back dress included a cotton shift worn as an undergarment to protect both the skin of the wearer and the silk fabric. Stays were worn over the undergarment to shape and confine the body, followed by the petticoat, and finally the robe itself. Sack-back dresses were designed both to emphasize and contain the feminine shape. The corset flattened the front, pushed the breasts upwards, and forced the shoulders back. The dress with the "sack" was formed by folding lengths of fabric in box pleats on the back neckline, with the material falling loosely to form a train. The skirt fabric was closely fitted to the curve of the waist and worn over a hoop to emphasize the hips. There would have been a matching petticoat, and a *fichu* of lighter muslin or gauze worn over the shoulders and chest to cover the skin, while at the same time drawing the eyes towards the soft contrasting fabric and what lay beneath. Dressing and undressing became ritualized and performative, and was carried out both privately and publicly. The selection of the dress was particular since not only did it define status, identity, femininity, but also as Jones implies "the woman she longed to be" (Jones 2004: xv). The sack-back dress was a transformative dress of becoming other.

The selection of fabrics and accessories, the sequence of layering of cloth on cloth, of covering and constraining the body, drew attention to and exaggerated the nature of the seductive body beneath. A "world of sensuality and a language of coquetry" (Ribeiro 1986: 105) was conveyed through bodily movements and flirtatious gestures exaggerated by the sweep and movement of cloth. The luxurious fabric, its decorative embellishments and how the dress was worn all contrived to engage and delight the onlooker, and gratify the social sensibilities of eighteenth-century etiquette (Koda and Bolton 2006: 17). The sack-back dress, even at its most formal, portrayed a provocative contrast of constricted body and soft gentle roundness of fabric.

The material in the silk taffeta pieces that I had discovered was tightly woven in *ombre* stripes of pinks and greens, which were typical of Lyons silk from this period. The owner of the dress may have purchased the silk directly from a silk mercer choosing from an array of colorful silks. She may have visited the *marchand des modes*, which were shops filled with colorful trimmings, ribbons, and lace in order to personalize the made dress as her own. The *marchand des modes* provided an important variety and customization of haberdashery.

Eighteenth-century dress relied on surface decoration and appearance to allure and excite. Often embellishments were added to enhance and draw attention to the wearer as crucial elements of seduction.

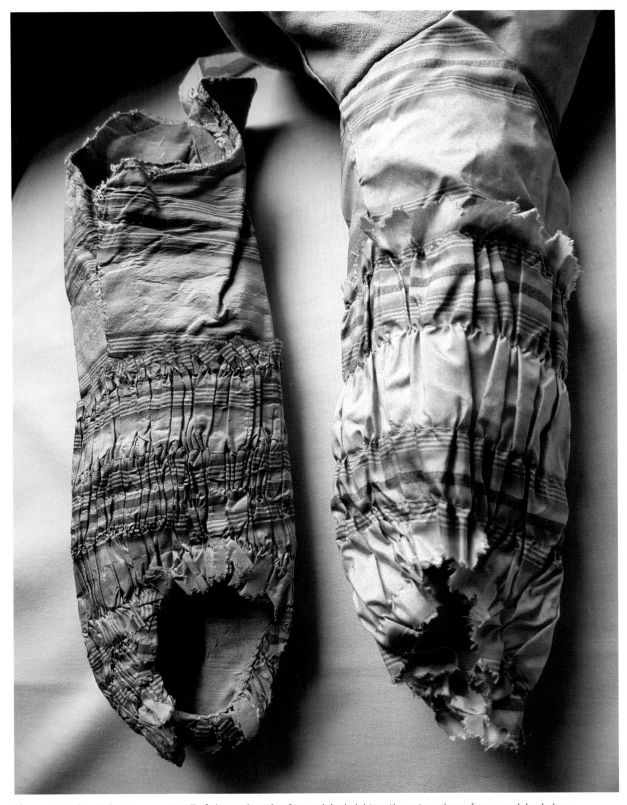

Figure 26 Debra Roberts, 2017. Detail of sleeve alteration from original eighteenth-century sleeve from a sack-back dress. Eighteenth-century silk taffeta. Photographer: Debra Roberts.

Contriving the Drapery

Text and archive-based research indicated that this type of silk remnant was more likely to have been part of an every-day dress, worn for informal daywear, during the latter part of the eighteenth century. Activities were an important factor in the life of a fashionable woman, such as paying and receiving calls, dining out, attending the theatre, balls, the opera, or simply promenading, being seen as part of an established hierarchy, and someone who understands fully the conventions of wearing such dresses.

The sack-back dress would have been made with exper-tise, styled and constructed by a dressmaker or mantua maker specifically to fit the wearer. While silk taffeta was a cheaper silk, it still represented a considerable investment and required skill in cutting the fabric to ensure as little waste as possible. François Gersault (Arnold 1977: 6) docu-mented the availability of a basic pattern at this time for a sack-back dress, which the dressmaker could customize to measure and fit directly onto the body. Other methods were employed where dresses were taken apart to be copied.

This customization offers a clue to my silk fragment pieces; however, these pieces went on to be further cut and dissembled. Through the identification of the silk pieces as the complete left back of a dress, there was a clear resem-blance in the shape to the pattern recorded by Gersault. This information helped me to understand how the mate-rial was engineered into the sack-back form, and allowed the copy to be developed by resolving the missing pieces.

The reconstruction of the complete dress created the imaginary body in real scale and shape. The material acted as a palimpsest by recording through cloth the provenance of maker, the original location of the dress manufacture and the taking apart of the dress. In my own remaking I evoked the past presence of this apparently silent cloth, reanimated and restored through imagining its past meet-ing the present.

I examined the fabric itself, carefully touching and looking by using a lightbox to visualize the hidden evidence and identify traces where material had been stitched and unpicked. Allmer (2009) suggests that the *punctum* is the moment when optic transforms into haptic vision, where *punctum* is translated as something that "pricks," "pierces," "marks," and "touches." She is referring to Barthes' description of *punctum* as a sense of selection, defining what we are drawn to. Stitching can be unpicked but once the holes are made they cannot be erased; they remain as evidence as punctures and pierces to the surface. Touching the fabric gave rise to an understanding of its layered history, like the *punctum* that acts as a moment of recognition, of making sense; the handling of the fabric provided a truth of attribution. Each piece of cloth was formally documented, the detail of stitch and alteration was obsessively traced, identifying the transformations that the fabric had undergone, as it was fitted and adapted to each body that it touched.

Through a process of mapping, the surface as palimpsest revealed the traces of minor, everyday events in a common day life. Advice was taken from expert costume and textile curators at Lotherton Hall in Leeds, Chertsey Museum, and the Victoria and Albert Museum in London. The discussions confirmed that the focus for eighteenth-century dressmakers was to show off the beauty of the fabric. The pieces of silk were compared to dresses in similar fabrics and the styles indicated that there would probably have been a closed bodice and substantially more trimmings. Gauging exactly what the missing pieces would have looked like was compli-cated by the alterations that had taken place; however, on the basis that all the dresses were different, I was encour-aged to interpret the material evidence presented. The significant amount of material (typically a sack-back dress could require approximately thirteen and a half meters of fabric) used in its construction represented a valuable asset that exceeded the cost of labor. This indicated a common approach to economy where clothes were altered, updated, and recycled. Tozer and Levitt give a realistic account illus-trating how precious fabric had been stored for future use: "Mrs Mary Gilpin's 'laylock sattin gown unmade' would consist of lengths of lilac silk, carefully unpicked and smoothed, the trimmings removed and folded, and laid by in her clothes chest awaiting refashioning" (1983: 45).

The longer lengths of fabric were hand-stitched loosely and trimmed according to fashion and individual taste. In addition to the ruched and pinked bands of material still evident, colored ribbons and lace might have been added. When fashions changed, or the body shape altered, the fabric would be unpicked and refitted, disguising the origi-nal style, but also the original body. "The expense of hand-woven textiles dictated that useful cloth was salvaged when possible by mending and patching, retrimming the garment to make it look different, taking in or letting out seams, cutting it down so it could be worn by a child, or

taking it apart entirely to start over" (Baumgarten et al. 1999: 7).

My analysis showed the bodice had traces of stitch where it had originally been trimmed with fabric or ribbon in a serpentine design, its removal indicating a preference for a more fashionable simpler neoclassical style. The edge of the bodice had been trimmed with the same dress fabric, lengths of which had been sewn together and then ruched and pinked. There were two different sets of hooks, one at the top of the bodice, with an additional set added at a later date. There are anomalies; the seams on the longer lengths of material have been unpicked, subsequently re-stitched using a backstitch, where we would expect to see a loose running stitch. It is rare to see such a wasteful use of valuable thread on a skirt seam, and questions the motive for the alteration. It could have been a test of the makers' skill or a child learning to sew.

At the back, on the hemline, a piece of fabric has been inserted to repair a tear; the stitch is finely executed, the stripes are matched, the mend is perfectly applied and invisible, prolonging the life of the dress. It raises a question as to whose foot was caught to rip the fabric, since there are splatters of mud above the back hemline or evidence of what could be blood. These "momentous and miniscule events and significations of life" (Harper 2012: 36) are those that Harper reminds us are in the cloth as silent witnesses of everyday life.

At the top of the fabric, which was originally the neckline, there are traces of stitch where a ruched trim might have been attached, and further down evidence of where the pleats have been stitched down, using longer cross-stitches in linen thread. The alterations are important historical traces of the dress and its story. It is a story that is more deeply accessed through this close proximity to the cloth. It "open[s] us to a story we have not yet heard . . . a narrative without a beginning and an end" (Manning 2007: 13) and identifies an in-between space that can be filled with the imagined reality.

The sack-back dress is constructed from lengths of fabric stitched together to create a large rectangular piece that can then be carefully cut. Hand-stitching the printed lengths of fabric together, it became apparent how much space was needed to work with such a large amount of cloth; the scale and weight of material is vast. Engulfed in fabric I was aware that, as Lurie comments, "The most sensual aspect of a garment is the material of which it is made" (2000: 232).

In reconstructing the dress and the alterations, I approached it with authentic methods. There are inherent difficulties in trying to replicate material and to reproduce an antique dress. This requires learning the skills of eighteenth-century dressmaking. It was crucial to use a similar weight silk to achieve an authentic drape and movement to the cloth. Silk taffeta has a particular texture; it is crisp, smooth, the tight weave enables it to retain the shape of garments, and there is a subtle rustle as the fabric moves, drawing attention to the wearer. It was difficult to source a sufficient quantity of old silk; for example, in 1767 Barbara Johnson ordered twenty-two yards of lilac silk for a sack-back dress (Ribiero 2002: 57). While this required a level of authenticity, digitally printing the striped design onto a suitable weight taffeta offered a practical and economic solution with a good color match.

Half the dress used the digitally printed fabric in order to replicate the remaining pieces. The missing sections of the dress were made in a plain silk taffeta that would show the traces of stitch as ghostly references to past reconstruction. The dress relied on a "hand-madeness" to appreciate the authentic making process.

Typically, dresses could be completed in four days, longer if more decoration or detail was added. The fabric worn closely to skin would require tighter stitching as this area would take most of the stress of the body movement. The skirt lengths were pieced together loosely, to facilitate taking the dress apart at a later date, for cleaning or alteration.

I tentatively made the first cut into precious fabric, concerned at the riskiness involved. "Cutting was the most delicate and demanding aspect of the garment trades; stitches were easily removed and replaced, but a mistake in cutting would destroy valuable cloth" (Crowston 2001: 150). The piecing together of the original fabric had established an outline of the left back of the dress, and this could be compared to dress patterns in Waugh (1968), Baumgarten et al. (1999), and Arnold (1977). The closest match was a robe a la Française in Janet Arnold's publication on eighteenth-century dress patterns (1977: 35). Dated between 1770 and 1775, this dress came with a compere, a bodice made with a closed center front, and Janet Arnold's pattern enabled me to reconstruct the missing pieces. The sack-back dress is commonly constructed directly onto the body to create the folds of material following the body contours.

The costume reference books mentioned above, and first-hand observation of similar day dresses, clarified the

construction of the dress. The fabrics were woven silks, in both striped and checked designs, and the dress styles showed a simple bodice front, and offered a number of sleeve options. The trimmings were of the same fabric, pinked, and ruched, and so gave a strong indication of how the embellishments might be applied. The investigation of the interior of the dresses became an analytical process, providing information concerning the construction and choice of design.

The missing pieces of dress, specifically the sleeves, required a combination of investigation and intuition. I decided on a ruched and capped sleeve, typically worn in everyday dress. This was a serendipitous choice, as in contacting the dealer to establish any further information about the missing pieces she advised that she had kept two pieces. These comprised a sleeve and a large piece of fabric that resembled a petticoat. The sleeve showed little evidence of alteration and was still lined with oddments of blue linen. In reviewing the collection at Colonial Williamsburg, Baumgarten discusses how Rosalie Calvert altered her daughter's dress in 1817: she "opened the bodice under the arm and inserted a small piece there as well as on the sleeve" (2002: 187). My newly found sleeve revealed similar evidence, where the seam had been let out, and at the top an additional piece of silk had been inserted in exactly the same way. There is an appreciation of a real woman for whom the dress was being altered. Significantly, the style of the actual sleeve was exactly as predicted. While I am not a dressmaker nor a historical dressmaker, as a maker/textile designer my understanding of the capacity of cloth was deepened through reconstructing the dress. I saw how the material should be folded not cut, where to place holding stitches, and what their function was. Recreating the sleeve, its structure, and its close intimacy to the body produced an irresistible urge to slip my arm inside in order to appreciate how it might have felt then and how, with a linen lining, the roughness of the fabric might feel like now.

The larger piece was a combination of skirt lengths, bodice pieces, and trimmings, comprising five full widths of fabric and an additional half width, where the original dress had been taken apart and recycled. The hem was lined with an ivory silk ribbon; this ribbon was not evident on the original material. There is evidence through a double row of stitch marks that there had been a ruffle attached, now unpicked. Each width of fabric had pieces added to it and in some instances there were larger pieces

of fabric, while in others the inserts were made up of tiny pieces that resembled the remnants of trimmings. Tucked neatly into the petticoat was a piece that very much resembled the other half of the bodice. The discoveries within the fabric were endless. The stitching was exquisitely executed with each tiny fragment carefully matched to ensure continuity in the striped design. Somebody had laboriously unpicked the trimmings and meticulously stitched each tiny piece together to create a square insert of fabric, skillfully pieced with immaculate tiny stitches rendering the insertions virtually invisible. There is a beautiful intervention where fabric has been darned as reinforcement. At some point the petticoat had been extended with the addition of a couple of vibrant green silk inserts to add fullness; this may have been to allow for a pregnancy, or a change in fashion. That the inserted green silk was such a vibrant contrast to the original fabric would not have been a problem, since the inserts would have been largely invisible underneath the folds of the sackback dress. The slits for pockets were evident and these matched the robe; pockets were worn under the petticoat and dress as they would not be seen among the gathered material. The value of the cloth was such that every tiny fragment seemed to have been saved, reused; each small hole or tear had been repaired to ensure that the fabric lasted as long as possible, a beautiful interpretation of recycling, "even if it meant arduously splicing a piece together from smaller scraps" (Baumgarten 2002: 7).

Sewing quietly, steadily, created a space for the imaginative speculation with the hand connecting with the material in a steady and hypnotic rhythm. These were not decorative stitches to embellish; rather holding stitches that pieced the dress together. They required a meticulous attention to detail, to ensure that the reproduction of the original pieces was accurate. In eighteenth-century France, there had been a gendered system of production. However, the seamstresses' guild offered women a powerful public identity and a strong sense of self as autonomous urban workers (Jones 2004: 80). By the late eighteenth century, 10,000 women were working in Paris alone, cutting and sewing clothing. There were, however, disparities in status between seamstresses and marchands des modes, the sellers of accessories and trimmings. Seamstresses faced restrictions as they were only allowed to decorate clothing with the same fabric from which the garments were made. This suggests that the original dress had been made by a

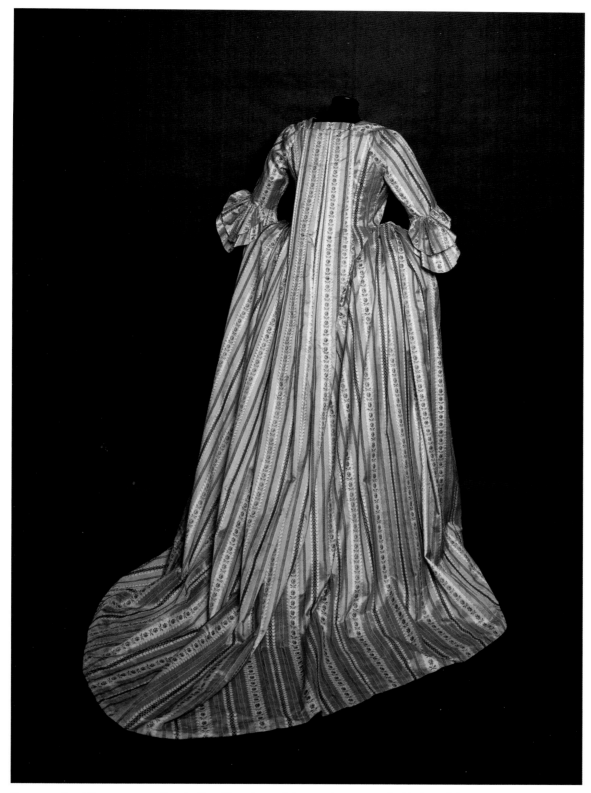

Figure 27 *Court Dress*, c. 1770. French silk pekin, salmon-pink ground ornamented with three ribbon types, and consisting of a blouse with wide back drapery and a full skirt. Italian manufacture, Rome or Marche Region. Dea Picture Library. Getty Creative: 119706947.

seamstress or certainly altered by one. The female fashion merchants "claimed to produce something more elusive and more significant than mere garments painstakingly stitched from cloth by seamstresses working within domestic workshops. They claimed to produce not merely clothing, but *la Mode* itself" (Baumgarten 2002: 81)

The cloth became a bond between myself and the eighteenth-century dressmaker; there was an awareness of a lingering presence, in the visual rendering of the dress the absent body is ever present. Evans refers to Raphael Samuel's *Theatres of Memory*, defining objects as "emotion holders, traces of the past and carriers of discourse from other times into the present" (Evans 2003: 12). Recreating the dress and enacting the movements and bodily motions of dressmakers deepened a visceral understanding of the size and height of the absent woman's body and her connection with the folds of the cloth. The dress is tiny so if there was more than one wearer they must have been petite. I am tempted to drape the dress around myself as part of the reimagining and remaking of the sack-back experience. As the fabric falls over my shoulders, I sense the vital, powerful presence of the woman in her sensual self emphasized by the cloth wrapping the body and following in a sweeping billowing trail.

The reconstruction is designed to be incomplete, to partially reveal what the dress might have looked like and to evidence the existence of the dressmakers. Mapping the detail onto the plain silk taffeta made the process and maker visible, accentuated the stitching and alterations that explicitly embody the traces of an imaginary life and conceptualize narratives of the past. Touch is implicit in the reconstruction, this was not simply a faithful historical reconstruction but a maker's textile truth that brought the past alive through a constructed memory, and giving an aura of enchantment in "approximating the knowledge of the maker" (Adamson 2013: 101).

An incomplete dress further signified the condition of cloth that had been stored away while awaiting reconstruction. In this presentation a partially made dress would allow the viewer to imagine its changeable nature as opposed to viewing it simply as an item of costume that overlooked its biographical account. What is left as speculative is more suggestive where it raises awareness of absence and excites the imagination of concealment. The work in its incompleteness suggests an ongoing life beyond the various wearers themselves. The dress is presented suspended on a hanger as if floating so that the viewer is able to see the effects of the pleats with the silk catching the light in the shadows. The dress is released from the confining undergarments and seen as a fabric opening the vitiated imagination to the seductive absent body through its sweeping cloth.

Walter Benjamin asserts that the aura of an object or material presence is associated with touch and is lost in reproduction. However, in reproducing the dress the reconstruction manifests a new aura of the possibilities and conjecture on the sensual capacity of cloth. The original dress in its complete form is distant but in touching the material there is an alignment with the past and an appreciation of its context and relational presence that comes through the intimacy of the fabric and making. My reconstruction reproduces the past not as an original but as an incomplete realization of invented history that encourages a sensory character to emerge. There is a somatic presence in the dress where the smell of fabric stored away and her (their) presence is evident in the repairs, tears, and stains. The essence of the antique material is enriched through the historical research and the power of the imagination with the closeness of maker and wearer absorbed and imbued into the cloth. A serendipitous encounter in finding the fragments has effected a new personal relationship with cloth as, for example, Proust's description where, "The past is hidden somewhere outside the realm, beyond the reach of intellect in some material object (in the sensation which that material object will give us) of which we have no inkling. And it depends on chance whether or not we come upon this object" (Kwimt et al. 1999: 2). The cloth captivated, and through touching it more of its affect was revealed. My interpretation of cloth is of a living intimate presence that provokes and arouses memory and experience; in a similar way that Susan Stewart describes, my cloth has become a "living memory, storing information beyond individual experience. Entering us through the senses, they become history" (Stewart in ibid.).

The historian analyses and interprets evidence about the dress but the maker has formed a new history and constructed a fresh identity for this sack-back dress. As Jones suggests, that discerning meaning is beyond a purely historical analysis, since "personal identity staged in the wearing of a particular hat or dress lies beyond the scope of the historian—traditional historical documents fall silent here" (2004: xvii).

The sack-back dress is not a practical garment. The billowing lengths of fabric restricted movement, but this dress disregards comfort in favor of the power to seduce. In setting the scene for the exhibition *Dangerous Liasions*, held in the Metropolitan Museum of Art, New York, Koda and Bolton describe the sack-back dress drawing attention to the female form:

> Melite was probably attired in a *robe a la Française* . . . Her natural silhouette would have been exaggerated by her corset and panniers, the one constraining her body as the other amplifies its effect. The finely embellished, elaborately brocaded silk comprising her dress would have been arranged to display the finer points of her exposed nape and bust.
>
> **2006: 13**

Through my own actions of touching and manipulating cloth in order to recreate the sack-back dress, the "real" knowledge of cloth and its powerful haptic presence was revealed. The cloth, in particular silk, held the residue of past seductions. The sack-back dress with its trail of fabric was erotic by design.

References

Adamson, G. (2013), *The Invention of Craft*, London: Bloomsbury.

Allmer, P. (2009), *On Being Touched*, Manchester: Manchester University Press.

Arnold, J. (1977), *Patterns of Fashion 1*, Basingstoke: Macmillan.

Baumgarten, Linda (2002), *What Clothes Reveal: The Language of Clothing in Colonial and Federal America*, New Haven, CT: The Colonial Williamsburg Foundation in association with Yale University Press.

Baumgarten, L. and Watson, J. with Carr, F. (1999), *Costume Close Up*, New Haven, CT: Yale University Press.

Bradfield, N. (1997), *Costume in Detail 1730–1930*, Hollywood, CA: Costume & Fashion Press.

Crowston, C. H. (2001), *Fabricating Women: The Seamstresses of Old Regime France, 1675–1791*, Durham, NC: Duke University Press.

Evans, C. (2003), *Fashion at the Edge*, London: Yale University Press.

Gauntlett, D. (2011), *Making is Connecting*, Cambridge: Polity Press.

Hamlyn, A. (2012), "Freud, Fabric, Fetish," in J. Hemmings (ed.), *The Textile Reader*, 14–26, London: Berg.

Hart, A. and North, S. (1998), *Historical Fashion in Detail: The 17th and 18th Centuries*, London: V&A Publications.

Jones, M. (2004), *Sexing la mode: Gender, Fashion and Commercial Culture in Old Regime France*, Oxford: Berg.

Koda, H. and Bolton, A. (2006), *Dangerous Liaisons: Fashion and Furniture in the Eighteenth Century*, New York: The Metropolitan Museum of Art and New Haven, CT: Yale University Press.

Kwimt, M., Breward, C., and Aynsley, J. (1999), *Material Memories: Design and Evocation*, Oxford: Berg.

Lowenthal, D. (1985), *The Past Is a Foreign Country*, Cambridge: Cambridge University Press.

Lurie, A. (2000), *The Language of Clothes*, New York: Henry Holt & Co.

Manning, E. (2007), *Politics of Touch*, Minneapolis, MN: University of Minnesota Press

Ribeiro, A. (1986), *Dress and Morality*, London: B. T. Batsford Ltd.

Ribeiro, A. (2002), *Dress in Eighteenth Century Europe 1715–1789*, rev. ed., New Haven, CT: Yale University Press.

Taylor, L. (2002), *The Study of Dress History*, Manchester: Manchester University Press.

Tozer, J. and Levitt, S. (1983), *Fabric of Society: A Century of People and their Clothes 1770–1870*, Powys: Laura Ashley Limited.

Waugh, Nora (1968), *The Cut of Women's Clothes 1600–1930*, London: Faber & Faber.

Further Reading

Bristow, M. (2012), "Continuity of Touch—Textile as Silent Witness" in J. Hemmings (ed.), *The Textile Reader*, 44–51, London: Berg.

Stallybrass, P. (2012), "Worn Worlds: Clothes, Mourning and the Life of Things," in J. Hemmings (ed.), *The Textile Reader*, 68–78, London: Berg.

Thoughts on the erotic:

The erotic cloth is an object of desire and signification for me. It is a site of intimacy where I experience a profound gratification, both sensory and intellectual. This intimate relationship arising from stitching cloth empowered me to reject a brutal, raw machismo and experience a heightened pleasure, a jouissance.

RUTH HINGSTON

5

The Embroiderer's *Jouissance*: Stitching a Feminine Identity in an Environment of Mining Machismo

RUTH HINGSTON

In this chapter I shall explore the contradictory role that embroidery has played in the context of a Western Australian mining region: at once a tool for suppressing and narrowly defining women within the stereotype of "home maker," while simultaneously providing an outlet for their creative freedom. I shall explore my personal experience of discovering an embroiderer's *jouissance*, and I show that this discovery came about as a direct reaction to the harsh, masculine, threatening context in which I found myself temporarily displaced.

Using embroidery as a reaction to the specific circumstances, I came to understand myself and other embroiderers outside conventional gendered roles and their restrictive codes of behavior.

Kalgoorlie is a gold-mining center in a semi-arid landscape. In the 1990s the dominant presence was still masculine and raw, offering women only a harsh environment to live in. A woman does not easily find the feminine in this repressive male culture because the feminine voice is largely mute. As a result, stitching became my way to seek out the intimate feminine and the contemplative. The erotic can be seen both as the dominating aspect of this culture at this time and also differently within the private quietness of making. This reading of the erotic is oblique and as a recognition of the powerful resistance that is *jouissance*, arrived at through embroidery.

Drawing on Lacan's theory of the Mirror Phase (1949 [1977]: 1–7), I shall reflect on my experiences of living in a patriarchal society characterized by hard graft in an unforgiving landscape. Just as men sought wealth by mining for gold, some women sought their fulfillment by stitching on cloth. In Lacanian terms, embroidery is the tool through which they are able to search for their Real and Symbolic selves in an eternal search to satisfy an internal *lack*.

"Who needs an education when ya can earn sixty grand drivin' one of them trucks in the Super Pit," retorted the attendant at the petrol station. February 10, 1994 was a hot, dry summer day with a brilliant blue sky stretching over the orange-red earth of Western Australia. I drove the

Figure 28 *Windowsill trim, the Little Pink Camp*, **Gwalia, Australia, 1995.** Photographer: Tim Brook.

six hours inland from Perth to Kalgoorlie with the temperature at 42 degrees Celsius. I was about to start two years as the Textile Lecturer at Kalgoorlie College. As I pulled over to fill up the car, a gust of hot wind sprayed red dust through the open car window. The attendant had asked why I was going to Kalgoorlie. "Ya look a bit too clean and respectable," he commented. "One of them trucks is the height of a two-story building. The tires are the height of me house. But women make better drivers on them trucks," he continued. "They got more patience than blokes on that slow drive, up and down. Ya do it a fair few times in a twelve-hour shift. But it's great money. Ya could get a better job doin' that. And plenty of blokes to choose from too."

The landscapes in Western Australia have long been a powerful source of inspiration, like a muse, for Australian artists. The intense colors and textures, the heat, and the remoteness offer a last-frontier experience. Other artists had sought the wide open spaces and big clear skies as an opportunity to think and create. I imagined great potential here for students of textile arts.

A headframe[1] from the underground mine overlooks the northern end of the main street of Kalgoorlie, and an enormous open-cut mine, the Super Pit,[2] dominates that side of the town. Kalgoorlie has always been described as a "man's town." It has a culture that lives on its myths, reveling in its notoriety and its isolation. Most people go there for the gold. In a few years they can make plenty of money from the mines. It is a good way to set oneself up for life—or so the story goes. The real stories about domestic violence, drunkenness, drug dependence, racial violence, and suicide are not as alluring. These stories are trivialized in the conventional stereotype of Australian masculinity. When I lived there in the 1990s, a man was expected to be dominant, strong, self-sufficient, fearless, and unrestrained. In Kalgoorlie this masculine ideal encouraged self-indulgent spending. Powerful machines and destructive behavior were part of their entertainment, and bikie[3] gangs were a menacing presence. "Show us ya tits" was routinely yelled from carloads of men to any woman alone on the streets; Kalgoorlie's famous brothels have always been tolerated, even when strictly illegal; "tossing the barmaid"[4] is still an accepted ritual in some pubs.

As I observed the dynamics between the mining culture and the natural beauty of the landscape, I realized the relationship between culture and nature was a tense and complex one. There was a raw and brutal tension in the relationship between the masculine and the feminine; neither could resist the desire to claim or destroy the other. The men who desired the earth's riches feared the very land they plundered. They often referred to the land as female: on a good day as "Mother Earth'; on a bad day as "a tough bitch to break." The earth did reveal her riches, but only when men risked their lives. Mining was dangerous and death was a daily risk. A miner could be temporarily blinded by the hyper-saline water[5] in an underground mine or die from lack of water in the bush. In this culture a woman was narrowly categorized as wife, mother, prostitute, or skimpy.[6] Any woman who worked in an open-cut mine was expected to accept the excesses of the masculine culture. As a female artist, I rapidly identified as Other in this restrictive culture. In my first week some male colleagues invited me to go the pub after work: "Let's have a beer and toss a skimpy!" I did not want to participate in a ritual that objectified women. This was a defining moment for me. In rejecting this ritual I had rejected their culture and set myself apart. I now view these experiences in the context of a feminist discourse that was not available to me at the time.

Traditionally, women had been forbidden to work in the mines[7] and employment opportunities were still very limited. Most women I met in the Goldfields wanted to return to the coast, the city or their home countries. It was just a matter of time and money. Images of fish, palm trees, and beach umbrellas were regular motifs on their clothing and home decorations. These motifs were often reproduced by students in their textiles projects. Only the artists among them were drawn to the rich colors, textures, and spaciousness of the surrounding landscape. I soon came to appreciate the rich patterning on the land made both by natural processes and by mining operations.

One hot evening, I picked up a scrap of fabric and began to stitch. I was surprised by the relief I felt in my body from such a small gesture. It was a quiet, comforting and reassuring calm that settled within me. My interest was piqued. I decided to respond intuitively to the stitching, not plan a direction. Eventually, I began to embellish the surface, dyeing, stitching, stuffing, and beading. I wanted to create a crust that I could mine, as an echo of the gold mining in the nearby workings.[8] I developed a growing obsession with hand stitching, immersing myself in the meditative rhythm: the needle piercing the cloth, emerging to tug the thread through, then lunging back to form the stitch. Suddenly, I paused to look at my embroidery. What was it that captured my attention? I saw the color and luster of the threads, the

Figure 29 Ruth Hingston, *Salt Lakes and Mines*, 1995. Cotton velveteen, stained with natural eucalypt dyes; polyester wadding; silk, wool, cotton thread; copper wire; glass beads. 25 × 110 × 1 cm. Photographer: Tim Brook.

pattern revealed by the stitches, the textures of the stitches on the smooth woven surface. The more I embroidered the cloth, the more pleasure I felt. It was a deep-grounded sensation, which grew, proliferated, and became externalized. Embroidery had become my enabling voice.

In this process I discovered the erotic as an intimate and alternative expression. The stitches became a language for constructing an identity that could be female, but more importantly it was embodied, sensual, and non-stereotypical. This was an embroiderer's *jouissance*.[9] The essence of my transgression lay in celebrating the land, instead of denying, changing, or exploiting it. The *jouissance* arose from following the conventions of needlework, as acceptably female, and using them as a medium to speak out against the wider expectations of the surrounding culture. Experiencing this *jouissance* was powerfully liberating. My embroidery flourished in a challenging domain where there were no obvious signifiers to reflect my sense of self.

My job as a Textile Lecturer was at Kalgoorlie College, a regional community college aligned with the Western Australian School of Mines.[10] The teaching staff in the college delivered training courses, classes for work accreditation, and leisure classes. Students enrolled locally or undertook distance learning. Art-department staff often traveled out to the regional towns for final assessments. The majority of arts students were women with a small number of men. They came from a variety of social backgrounds, with varying levels of commitment. Students included high-school truants, unemployed youth, social welfare recipients, bikies' molls, mine workers' partners, and pastoralists' wives. There were none of the promised degree-level students. Working in the mines offered excellent money for people with a poor education. Making money was their focus. Little value was placed on formal education and even less on informal creative pursuits, which some regarded with suspicion and resentment.

My evenings and weekends were often spent in the workshop planning and preparing classes. The intensity of class preparation provided a useful opportunity to avoid suggestive comments and sexual proposals. Teaching in a regional post-secondary college, I quickly became aware that many students had not had positive experiences in either their general education or their creative efforts, so I encouraged students to develop their curiosity by experimenting with textiles. Projects with practical outcomes motivated their interest, and dyeing became a favorite activity in the warmer months. Tie-dyed T-shirts could be prepared and dyed in the morning, hung up to dry during lunchtime, then unpicked and worn home in the afternoon. The mature-age students especially enjoyed the process of carefully stitching their shibori patterns. As students became more engaged they began to leave the workshop positive and energized.

Cloth was the preserve of the feminine in this culture. For some female students quilt-making was a competitive activity. They had ample money to indulge in buying the most expensive fabrics and stitching in a self-conscious display. For others it was simply a solace or an attempt to deny their surroundings. In every case there remained an obsessiveness in their stitching and an underlying striving to reclaim their previous lives in other places.

In my own embroidery work, my desire is first sparked by the anticipation in preparing to stitch. It is cultivated in the joy of choosing the right cloth, the right yarn, the right needle, and then deciding which single color from a rainbow of threads to use for the first stitch. It is the look, the feel, and the smell of the cloth that arouse my desire to stitch. The pleasure, the tenderness in caring for each of these details, is where the *jouissance* resides; they are all counter to the aggressive machismo I had encountered. As Darian Leader observes, "Desire itself will emerge in the little details and hence Lacan's insistence on hunting it down, on searching for desire in-between the lines, where it is least obvious" (Leader and Groves 1995: 84). So, if stitches are language, the action of stitching takes on a significant meaning. By stitching an image with which I could identity, the embroidery becomes the External Image from Lacan's Mirror Phase. The process of repetitively stitching is then a process that attempts to capture the External Image. However, according to Lacan, the External Image never adequately reflects what you search for, so I am driven repeatedly to captivate myself in creating new images. Lacan's "amorous captivation of the subject in the image" (Laplanche and Pontalis 1973: 256) aptly describes these actions. In the world of Lacan's Symbolic, a single stitch and an embroidered image are both viewed as signifiers, as both are attempts to satisfy the desire of the Imaginary. Each new embroidery becomes a new signifier for the External Image.

In Kalgoorlie my search for a feminine reflection led me to explore the surrounding landscape, to create a non-literal depiction of the delicate details on the ground and the impacts of mining on this land. I began by collecting found objects from this environment. These objects, like the stitches, became signifiers. I visited abandoned mines and old workings, and found items discarded by early prospectors, such as buttons, bottles, cutlery, tins, and shards of crockery with delicate nineteenth-century European patterns. I was attracted to a miner's cottage, a tiny pink corrugated iron hut, in an abandoned township. One windowsill was decorated with a white scalloped trim cut from flattened corrugated iron. It became a dominant and lasting image in my work.

Away from the old workings, I found other traces of a softer, feminine presence. There were small, isolated cemeteries scattered through the Goldfields, some still bearing their earth-reddened gravestones and funerary ornaments. I was drawn to the elegant lace ironwork with its decorative flourishes. Once, I found a porcelain arrangement in a glass container on a grave, its white doves and roses now stained a pinkish hue. These objects spoke of a feminine tenderness in rough men who grieved for a mate lost in their quest for gold. The women's graves had a particular poignancy: graves of women who had died in childbirth or from domestic violence, like the grave of the Japanese prostitute who had been murdered by her jealous husband.

My souvenirs and photographs remained signifiers of a more intimate feminine presence, while a search for my own identity continued as a sensory knowing beyond the typecast sexualized body. Later, the collected objects inspired the motifs for embroidery. Much further north, in the Pilbara, an embroiderer Jane Bailey[11] described a parallel experience: "Karratha is dry and has a desert-like landscape. It has a definite strength and unique beauty, yet it seems to ooze with feelings of eeriness and a message which tells me that I don't belong here." She continued, "Using hand embroidery brings me closer to the emotion intended. I feel that by embroidering by hand I am putting more of myself into the piece; the feelings are coming

Figure 30 *Abandoned Graveyard*, **1995.** Kalgoorlie, Australia. Photographer: Tim Brook.

straight from my heart into my hands and onto the fabric." She concluded, "I have always loved fabrics, but the main reason for my choice is that being a woman, I feel a kinship, an affinity with these particular tools. Embroidery and fabrics seem, for me, to go hand in hand with women and femininity" (Rogers 1992: 11).

Earlier feminist writing acknowledges the legitimacy of conventional feminine pursuits such as embroidery, while endeavoring to free women from its association with passivity and repression. Rozsika Parker, whose discourse equally applies to Australia, writes that in the nineteenth century, "Embroidery was on the one hand expected to be the place where women manifested supposedly natural feminine characteristics: piety, feeling, taste and domestic devotion; on the other it was the instrument which enabled a woman to obliterate aspects of herself which did not conform to femininity" (1984: 164). This ideal was reinforced in the literature read by young women of the era, with embroidery used as a signifier of the feminine behavior demanded by masculine desires. I can only imagine the shocked surprise on the faces of men who received a gift of a handkerchief that bore a beautifully embroidered text, only to discover that the text was a demand for Australian women's rights, Lucile Carson's recollection of her aunt's political activities in early 20th century Sydney.[12] While obeying the rules of their gendered social duties, women used their expert embroidery skills to communicate their demands. By transgressing the political law that relegated them to the position of second-class citizens, suffragette Australian women spoke out for legal recognition in the political process. In the midst of their jubilation, as the legislation recognized Australian women's political rights, I wonder if they too experienced an embroiderer's *jouissance*?

In twenty-first-century Australia, embroidery is still frequently regarded as a passive feminine pastime from a bygone era. Film media persist in romanticizing

embroidery by aligning it with either the early Australian colonial virtues or later postwar nation building. In both these eras sewing was an effective tool to reinforce a domestic role for women helping establish and maintain a civilized society.

Contemporary Australian media continues to present these roles for women by publishing and broadcasting stories equating sewing with nurturing feminine figures who selflessly stitch special garments for family members and sensible items for the less fortunate.[13] This perception of embroidery and utilitarian sewing has always reinforced traditional conservative gender roles. Florence Nightingale, the notable reformer, described embroidery as "symptomatic of the restraints imposed on women by the feminine ideal" (Parker 1984: 165). I take an alternative view, arguing that embroidery has liberating capacities that offer a space for individual search, desire, and expressive potential for both women and men.

It is from this problematic background of contradictions that embroidery has gathered its supporters and opponents. Parker concludes, "detractors and defenders of embroidery were equally correct. It was both a cause of confinement and a comfort" (1984: 151). This is the tension for contemporary embroiderers who participate in what could be viewed as a conservative custom but also find genuine enjoyment, intellectual challenge, and solace in the meditative rhythm of stitching. They oscillate between two positions: quietly submitting to conventions or instead making every stitch a dissent and sedition. In claiming back an identity through stitching the experience of an embroiderer's *jouissance* arises as a kind of secret shame mixed with a perverse pleasure in engaging in stitching. There is also a willful delight in stepping outside life's demands to transgress the laws of the contemporary workplace and to play in embroidery *jouissance*: it becomes a hermeneutic spiral.

As an act of resistance and silent protest, embroidery continues to extend this interpretation of *jouissance* as an act of disobedience, which might appear to contradict the rules of formal needlework. Maureen Daly Goggin (2014) writes about the *Bordados por La Paz (Embroidering for Peace)*, a community project that protests against the ongoing brutal violence in the Mexican–US war on drugs. Victims' families, friends, and supporters were invited to embroider handkerchiefs, each one commemorating a victim of the war. In 2011 the embroiderers met in Mexico

City's main square to stitch on large white handkerchiefs. A red thread signified a dead victim, while a green thread expressed a hope that the missing person was still alive. Each victim's name, together with any details known about their death or disappearance, was hand-stitched onto the handkerchief. The protest quickly spread across Mexico as a collaborative project, then to other cities around the world, acknowledging all the people who have been killed in the war on drugs. Goggin observes, "Through both sewn words and images, these embroidering activists seek to denormalize violence and argue for peace by giving a "face" to each victim who would otherwise remain anonymous. They seek deliberation about the horrific outcomes of the war. They also seek dignity and respect to those having suffered a dehumanizing fate." The delicate, gentle practice of embroidery empowers and heals those doing the stitching. By stitching collectively, the embroiderers exercise a creative strength to protest the murders and attempt to heal the wounds of their communities. Goggin summarizes the impact of their embroidery: "each handkerchief is saturated with a number of conflicting traumatic emotions: anger, frustration, protest, discomfort, uncertainty, love, desire, and relief experienced through the act of stitching." The activist embroidery in *Bordados por La Paz* offers these embroiderers a powerful opportunity to experience Lacan's *jouissance*. They harness their embroidery skills to demand an end to violence and suffering; the pleasure of stitching embraces their suffering, releasing a creative energy that mixes these powerful emotive forces.

I continue to be drawn back to the raw natural beauty of the goldfields, while being acutely aware that the land continues to be exploited. In 2015, Kalgoorlie appeared to be very subdued. World economics has changed the Australian workplace, mimicking workplaces in other Western countries. Even the presence of bikies had become less obtrusive. The idea of women as essentially homemakers has radically changed. Women now make up to 50 percent of the workforce at the Super Pit: they are not only truck drivers. However, "skimpies" are still a regular feature in Kalgoorlie's hotel entertainment and prostitutes still stand provocatively outside the local brothels. It all serves to maintain the myth of a wild, lawless town. There is now a more varied configuration of identity, not defined through restrictive gendered roles. At the time I was there the gender separation was simplistic, biased, and binary,

based on domination. As such, my refusal to participate in certain women's rituals was a particularly bold statement for that time; ideas of fluid identities had not yet circulated widely in the popular or academic domains, let alone into this industrial mining area of Western Australia.

I continue to embroider, sometimes with a voice of protest, so my Kalgoorlie experience of *jouissance* returns. I now explore the impact of change on another Australian environment: I stitch my protests about the changing sub-alpine landscape of Canberra. Rapidly expanding urban developments have deconstructed early farmland, swallowed up remnants of original bush habitat, and erased native grasslands. I have embroidered my protest about the scourge of European rabbits on the Australian land and the effects of deforestation on water quality.

As I write this, trucks and bulldozers are arriving across the street to excavate the former school site. Originally it was native grassland where kangaroos grazed, then it was a government experimental farm, then a primary school and now it is to become urban infill for 300 ugly apartments. My fingers tingle as I look for a piece of cloth and select some threads, I can feel another *jouissance* opportunity arising.

Notes

1 Headframe—the structure over the top of an underground mine shaft used for supporting the winding equipment. *Macquarie Dictionary* (1998).

2 Fimiston Open Pit was then the largest open-cut gold mine in the southern hemisphere. The Super Pit, owned by Kalgoorlie Consolidated Gold Mines, will eventually be 3.5 km long, 1.5 km wide, and 700 m deep.

3 A bikie is a member of an outlaw motorcycle club, which is often a cover for an organized crime syndicate.

4 Drinkers attempt to toss a coin into the barmaid's cleavage. When the coin drops in, the barmaid briefly reveals her breasts to the punters, in what they call a "tit flash."

5 The hyper-saline water here is six times the salinity of sea water. It seeps through the rock, dripping onto the miners in the underground tunnels.

6 A "skimpy" is a barmaid who wears only her skimpiest underwear while serving in the bar.

7 There was a long-standing superstition that bad luck would result if a woman merely entered a mine.

8 According to the *Concise English Dictionary* (1976): "Working: mine, quarry, etc., or part of it which is being or has been used." In Western Australia it refers to small-scale operations.

9 For Lacan, *jouissance* is gained through an experience of both obedience and transgression of the law. It is a pleasure, but also a shame, an obscenity; it may be an experience of pleasure to the extent of suffering. There is clearly the pleasure received in doing one's moral duty, to responding to a good and honorable ideal, yet there is enjoyment and pleasure gained in the breaking of the law. This law-breaking pleasure is characteristic of Australia's legendary larrikin behavior. ("Larrikin" is an Australian English term for a person, usually male, who acts with complete disregard for social or political conventions in a boisterous and mischievous manner.)

10 Kalgoorlie College and Western Australian School of Mines later amalgamated under Curtin University as an external campus.

11 Jane Bailey interview by J. Rogers (1992) for *A Sense of Place: Contemporary Needlework*, Sydney: Angus & Robertson.

12 Ms Lucile Carson, oral history, interview by author (2016) Canberra, Australia.

13 Simple sewing project provides confidence to schoolgirls in Papua New Guinea [TV programme] ABC 13 April 2016. http://www.abc.net.au/news/2016-04-13/sewing-for-charity-brings-confidence-to school-girls-in-png/7322666 (accessed 25 January 2017).

References

Carson, L. A. (2016), oral history, interviewed by author, January 26, Canberra, Australia.

The Concise Oxford Dictionary (1976), 6th ed., Oxford: Oxford University Press.

Goggin, M. D. (2014), "Threads of Feeling: Embroidering Craftivism to Protest the Disappearances and Deaths in the "War on Drugs" in Mexico." Available online: http://digitalcommons.unl.edu/tsaconf/937/ (accessed January 29, 2017).

Lacan, Jacques ([1949] 1977), "The Mirror Stage as Formative of the Function of the I as Revealed in Psychoanalytic Experience," in *Ecrits: A Selection*, ed. A. Sheridan, 1–7, London: Routledge.

Laplanche, J. and Pontalis, J.-B. (1973), *The Language of Psychoanalysis*, New York: W. W. Norton and Co.

Leader, D and Groves, J. (1995), *Lacan for Beginners*, Cambridge: Icon Books.

Macquarie Dictionary: Australia's National Dictionary (1998), 3rd ed., Sydney: Macquarie University.

Maddison, M. and Kesteven, S. (2016), "Simple Sewing Project Provides Confidence to School Girls in Papua New Guinea," Australian Broadcasting Corporation. Available online: http://www.abc.net.au/news/2016-04-13/sewing-for-charity-brings-confidence-to-school-girls-in-png/7322666 (accessed January 25, 2017).

Parker, R. (1984), *The Subversive Stitch: Embroidery and the Making of the Feminine*, New York: Routledge.

Rogers, J. (1992), *A Sense of Place: Contemporary Needlework*, Sydney: Angus & Robertson.

Thoughts on the erotic:

If I was wearing Westwood in a crowded room, people inevitably looked at me . . . Despite being physically bound with the buckles and straps of bondage-inspired clothes, I felt liberated in the sovereignty of my own self-confidence. I felt transformed into a supreme being.

MALCOLM GARRETT

6

Flying in the Face of Fashion: How through Punk, Fetish and Sexually Orientated Clothing Made It into the Mainstream

MALCOLM GARRETT IN CONVERSATION WITH ALICE KETTLE

Malcolm Garrett is a London-based designer whose career has included a diverse portfolio of work, including record sleeves, interactive multimedia, and digital magazines and cinema.[1] Garrett actively participated in the fleeting subcultural synthesis of music, fashion, politics, sex, and art, referred to as "punk" of the 1970/1980s. The iconic record cover for the Buzzcocks' single "Orgasm Addict" (1977), designed by Garrett, set a benchmark for graphic design at this time. This interview discusses and reflects back on his personal experiences, his notable contributions to graphic design, and the wider influence of punk in design. He owns an extensive collection of Vivienne Westwood clothes for both men and women: "I've been adding to this collection for more than thirty years—I bought my first piece, a black glazed cotton bondage jacket, in 1978" (Garrett in conversation with Kettle: 2015).[2] This desire to collect his own cultural history is shared as emblematic of the collectability of a living designer whose audaciousness has become a commodity. Garrett is among those who through collecting acknowledge their role in "what is claimed as the most important cultural phenomenon of the last quarter of the twentieth century" (O'Neill 2006: 382). Garrett illuminates how living through the politics of the time was sewn into the seams of his own painted black jeans, the loose printed bondage gear, and the tight black latex dresses. The overtly erotic aesthetic of punk is within his lived experience of wearing the clothes and the broader social movements of that period, with an impact that is still present.

AK: Why do you think punk emerged as a subversive subculture in the seventies? What else was going on at the time and why was adopting sexualized clothing an important expression of youth, resistance, and non-conformity?

MG: I was not necessarily driven by the sexuality of clothing per se but I was conscious that the themes of the day embraced a new attitude to sexuality and identity. When Sex Pistols declared there was "no future"[3] for England's youth, a loud cry of revolt was heard across the whole of the United Kingdom, whether as a response or as a synergistic feeling that was "in the air." At the time, there was a general feeling of impotence and immobility among young people. The hippy ideals of the sixties were slowly fading and glam rock—a saccharine-sweet, kids' version of swinging sixties pop—was top of the charts.

There was a palpable sense of dissatisfaction with everyday life, where respectability was the norm in a stifling political climate. Punk emerged as conformity and sobriety were confronted and forcefully rejected en masse by a broad swathe of people across the country, who for the most part had little in common with one another beyond their distaste for the superficiality of the media at the time.

With disparate origins and attitudes "punks" were brought together with a unanimous feeling of being different from other people. As an alternative to the mainstream, punk was liberating thanks to its chaotic and "do-it-yourself" approach. All at once everyone seemed to be either in a band or trying to get a band together; it was an incredibly exciting time. Punk encouraged you to embrace your differences and create something. Whether it was dyeing your hair a different color every week or cutting up and writing on your clothes, people were experimenting on themselves in whatever way they could. A fresh and distinctive graphic language emerged, through appropriation of typography and imagery, remaking it in an expression of your own individualism.

The attitudes at the time were very playful and experimental, taking existing cultural symbols and images to take them out of their original context and alter their meaning. Siouxsie and the Banshees, for example, drew upon Nazi symbolism for its shock value.[4] Sexual imagery also played a critical role in the development of this graphic language of resistance and shock. The sexual nature of the fashion associated with punk was very important.

AK: The feeling of repression and frustration is symptomatic of the punk movement. Can you describe how eroticism in clothing was an aggressive reaction to and a playful subversion of a society that this youth culture wanted to disown?

MG: The diverse worlds of art—embracing music, performance, visual arts, and fashion—all merged to create mixed collectives of people who were bravely exploring identity and with it the potency of sexuality. It was a rich mix of hedonism and aggression, and sexual motifs were used to symbolize a subculture. Sex was forcefully presented and used as a weapon of confrontation. It became a totem of social challenge.

Malcolm McLaren's and Vivienne Westwood's shop SEX (1974–6) at 430 King's Road, London set the scene. They sold fetish and bondage clothing as fashion garments,

Figure 31 *Jordan in front of SEX, 430 Kings Road*, **1976.** Photographer: Sheila Rock.

famously worn by the earliest members of Sex Pistols. The shop name/sign was wrapped in tight flesh pink latex, and this erotic aesthetic gave these young activist musicians an injection of glamour and stimulation. They became the vanguards of a mini-revolution.

The band are often erroneously referred to as *The* Sex Pistols, but the group deliberately dropped "The" as a conscious rejection of band-name convention and distinct provocation. The use of the definite article could only serve to confine by evoking historic precedent, but Sex Pistols as a standalone is deliberately out of time. A "sex pistol" was also a blatant euphemism for penis, as was the name of another group who began operating in a parallel space: Cosey Fanni Tutti[5] and Genesis P-Orridge had formed COUM Transmissions, a performance art collective, and then in 1976 launched their band, Throbbing Gristle. The group was driven by the desire to present challenging anti-social issues in a manner that had hitherto been uncharted. They blurred the division between art, performance, film, music, and entertainment by performing at venues that were not normally associated with music, such as schools, art galleries, and community centers.

In 1976 they held an exhibition at the Institute of Contemporary Art, London. The exhibition, called *Prostitution*, featured props from *COUM*'s performances such as used tampons, nudity, and striptease, and a discussion with sex-industry workers. Cosey had a unique presence that pushed the boundaries of performance art[6] and deliberately used the sensual encounters with various media to explore the subversion of social respectability.[7] The press described them as the "wreckers of civilisation,"[8] a direct antecedent to the "filth and the fury" headline that followed Sex Pistols' appearance on the Bill Grundy show shortly afterwards.

Self-consciously provocative, the group went on to create performance pieces where sexuality and deviance are prime subject matter. Often referencing acts of violence, such as in "Slug Bait" (1977), which describes first-hand the acts committed by a mass-murderer.

A resonant feature of a Throbbing Gristle performance was the physical assault of the noise they generated. Sound had a sensual role to play in directly affecting how you felt. In a recent interview, Cosey describes how "Chris Carter built his own speakers so that we could really tweak the frequencies for the people that were there . . . the way they responded created the music, so you've got this loop going—you start something off, you get a reaction, then it comes back and it keeps going to make the performance."[9]

AK: What was your response to these events at the time? How did your life and work become a part of this scene?

MG: I felt that the drab brownness of seventies Britain had suddenly become engulfed by a welcoming fluorescent pink glow. Life in 1977 was a non-stop whirlwind of social activity where the distinction between work and life was completely blurred. It seemed like we spent almost every night of the week at either a gig or at a party. We seldom went to pubs because that was where the locals were likely to beat you up for looking different. When I look back everything seemed to happen simultaneously, but really I am describing a series of interconnected events that played out over a few months from late 1976 to early 1977 and informed the course of my life from thereon. It was a period when my life was reshaped and my energies redirected. This reflected the tectonic shift that punk affected culturally and socially. We became very selective about what influences from the past were important and relevant, since there seemed to be a reassessment of everything, a kind of "year zero" where nothing that had gone before could be accepted at face value.

A key event was when I went to London to do a three-week work placement (over the Christmas break 1976–77) and rapidly became acquainted with the new music of the city: Eddie and the Hot Rods, The Damned, The Clash, Generation X and of course Sex Pistols. I came back to Manchester at the beginning of January with a different frame of reference and my transition gathered momentum.

Linder (Sterling, née Mulvey), a close friend, was studying illustration in the year above mine at Manchester Polytechnic. Linder created photomontages by mating images of G-plan kitchens and domestic scenes with pornography; as on the cover of "Orgasm Addict." The graphic works mirror the transformation Linder (and many others) underwent after seeing Sex Pistols at the legendary Lesser Free Trade Hall gig in the summer of 1976. Linder cast aside her twin-set and reappeared in a black PVC catsuit. It didn't take long for me to catch up and my flares and other post-hippy clothing were replaced with purchases from second-hand stores, or with modified high street garments.

The distressing and breaking-in of the clothes was an actual component in their construction as exotic rather than just necessarily new things.

O'NEILL 2006: 385

It was through Linder that I met Buzzcocks, who had formed to support Sex Pistols.[10] They recorded and self-funded the *Spiral Scratch* EP, and sold them from the house they shared in Lower Broughton Road, Salford. At that time I was sharing a flat with fine art student and guitarist John McGeoch. We hosted a party in early 1977 and invited Linder, Howard, and Pete from Buzzcocks, and Richard Boon who had begun to manage them. Pete Shelley played songs on John's guitar late into the night. Howard had already decided to leave Buzzcocks, but the very next week he and John started playing together in a new band that they called Magazine.

Unlike the claims of thousands of others, I was not there at the Lesser Free Trade Hall gig.[11] In fact, I never did manage to catch Sex Pistols performing, but I did go to see as many of the new punk bands as possible. The period 1977 to 1978 in Manchester was an unprecedented and intense period of accelerated development: personally, socially, and as a designer. I was very aware of the significance of the cultural phenomenon I was wrapped up in but only later came to realize my own importance within it.

A new approach to design was emerging, which deeply resonated with me. Good design communicates in a seamless way as it becomes indistinguishable from the content it is communicating. Along with punk fanzines, record sleeves were pivotal in the presentation and circulation of new ideas and images. The first Throbbing Gristle record sleeve was particularly inspirational: plain, unadorned white cardboard, straight from the pressing plant, with just an innocuous black-text sticker in the top corner which read: *The Second Annual Report of Throbbing Gristle* (1977). It was in 1978 that I saw a few performances by Throbbing Gristle, and I bought the first album, admiring its wonderfully sublime title. The record presented "noise" as music, but in a quite different way from, say, Brian Eno's ambient music. It used the noise of machines and distorted electronics to capture themes of violence, propaganda, and latent sexuality. Anti-consumerist, anti-capitalist, and idiosyncratic, the album abandoned any resemblance to rock and, crucially for me, the sleeve gave nothing away. There was a whole interconnected network of related imagery that created an entirely new visual language,

where fashion had a particularly potent currency often with an erotic quality to the clothes we were wearing that was meant to question ideas of decency.

Erotic imagery and obscenity were important in establishing a new graphic language. The cover of "Orgasm Addict," with the use of Linder's feminist photomontage, is a good example of how punk offered a fresh canvas for radical visual thought. Complex yet simple, budgetry constraints meant it was printed in two colors. The consensus was to use one of Linder's montages and together we chose the image you see on the sleeve. I had access to a photocopier (rare at the time) at the factory in Bolton where I was interning, so I copied the image both to reduce it to the size I wanted on the sleeve and to emphasize the contrast in the photo so it would print better in monochrome. I chose a dark navy blue to retain its legibility. Blue combined with yellow was a reference to Bauhaus-era modernism. The typography was a combination of the architectural stencil font, traditional handset cold-metal type (produced in the college typography department), and modified Letraset (the type lettering system) for the Buzzcocks logo. The band photograph was remotely art directed because I required four rectangular images to fit the rigorous layout. I suggested we capture the band posing behind the four panes of glass of a Manchester bus stop.

AK: You have an extensive collection of Vivienne Westwood clothing. Early on you recognized the significance of these clothes for their emancipatory and erotic qualities. Westwood plays with contradictions, with power and powerlessness, role reversal and inversions of gender and androgyny; skirts for men and codpieces for women (González and Bovone 2012). Was experimentation with sexuality part of wearing Westwood clothes? Westwood was a maker, she made and customized clothes to be individual and become a supreme being. Can you explain how Westwood's clothing creates "spectacular creatures"? (Evans in Clark and Holt 2016: 201).

MG: The clothes were very distinctive and made whomever was wearing them visibly prominent in any environment. If I was wearing Westwood in a crowded room, people inevitably looked at me. They had a presence that was disarming and wearing them was an experience that transcended clothing and fashion. Despite being physically bound with the buckles and straps of bondage-inspired clothes, I felt liberated in the sovereignty of my own self-confidence. I

felt transformed into a supreme being when I wore them. When walking down the street, people would inevitably want to ask "Why have you got your legs tied together?," which always seemed a dumb question to me. It was the sense of that entrapment that symbolized freedom through self-expression. The clothing embraced a visual language of resistance and closet sexuality.

Bondage clothes were worn as fashion garments but wearing them did not necessarily mean you were into bondage as a sexual preference. Sex was important through its lack of importance. It didn't matter who or what you were into, punks didn't care. Bondage clothing was emblematic of an attitude which was unapologetic and unselfconscious. The tight and revealing clothes facilitated a transformative loss of inhibitions. The transparency of the muslin shirt, for instance, with its unconventional structure necessitated nakedness because nothing could really be worn underneath. Shrouded by the cloth, yet exposed through it, the garment powerfully emphasized sexuality and dissolved differences between genders, since both wore the same.

Sexuality was thus both ambiguous and neutral; punk was not asexual but unisexual. The inter-changeability of the sexes was part of the liberalization of sexuality as experimental and challenging of norms. Vivienne's clothes were unisex and the same garment could look quite different on a man or woman. In some ways they were intended to be personalized, with more appliqué panels, paint splashes, stencil lettering, or simply by ripping them. The clothes simultaneously ignored and exploited eroticism. They played with the trappings of deviant sex, but the boys and girls who wore them seemed oblivious to it.

This was a time when women recognized themselves as empowered. Prior to the punk generation there weren't really any women playing a leading role in rock music. We'd already had Suzie Quattro, a girl playing bass guitar like a boy biker in leather catsuit, but punk saw the emergence of "new women" like Jordan, Sue Catwoman, Debbie Juvenile, Siouxsie Sioux, and The Slits, all of whom exploited their own particular eroticism, subverting their femininity as dominant sexual beings.[12] Punk allowed girls to wear boots and bondage, T-shirts with slogans, boys' clothing, fetish clothes. Siouxsie even had no qualms about exposing her breasts, or wearing hotpants and thigh-high boots.

The idea that *all* punks wore bondage trousers was not true, of course. It was mainly a London thing. In fact, it was Linder whom I first saw wearing pair of *genuine* bondage trousers from Seditionaries. They were made from militaristic, glazed black cotton with a toweling bum flap. The zips looked good open or zipped up, and the strap which bound the knees together was a wonderful piece of theatrical showmanship, because despite appearances it did not hinder freedom of movement at all.

There was no such thing outside of London as a shop that sold "punk" clothes. In Manchester we became used to buying secondhand oddities (from what are now known as "vintage" stores),[13] and making or modifying our own from whatever was to hand in what is seen as punk's and Westwood's DIY approach. That's why ordinary shirts painted with slogans, school blazers embellished with pins and badges, and half-tied ties (that ordinarily no young person would want to be seen wearing) became synonymous with punk. The challenge was simply to take "uncool" and make it your own. And again, the look was unisex.

My clothes included old jeans painted with black household paint, my sister's school blazer, colored T-shirts splashed with fluorescent paint and stencil lettering, white cricket shoes, painted Dr. Martens boots, trousers made from furnishing fabric,[2] anything military surplus, anything orange (or pink), anything from the sixties: for example, a fake leatherette shift dress cropped to make a sleeveless shirt, a blue fun fur jacket, a fake leopard skin jacket.

AK: McLaren and Westwood's King's Road shop was variously named Too Fast to Live Too Young to Die, Sex, Let It Rock, Seditionaries, and World's End. These are described as names for imaginary places (Clarke and Holt 2016: 201), perhaps one of the preconditions for the erotic? Westwood says, "Sometimes you need to transport your ideas to a world that doesn't exist and then populate it with fantastic looking people" (2013). Can you comment on these clothes as a means of owning an alter ego and entering the erotic fantasy?

MG: To the right of the Seditionaries' door there was a small brass plaque, not dissimilar to those legally required to be displayed by limited companies, which had the simple etched script:

Malcolm McLaren. Vivienne Westwood.
Seditionaries.
 "Clothes for Heroes."

And that was the point. As a punk you felt distinctive because you didn't belong anywhere. What you wore filled

you with a sense of straying into a world of impending danger, yet you felt heroic, having made a commitment to wearing such outrageously challenging clothes. And Vivienne's clothes, more than anyone's, enhanced that feeling. A feeling of being in possession of some arcane knowledge that only you are privy to. Her garments were imbued with a sensuality that was equally as potent in menswear as in womenswear.

The overt sexuality of punk concerned itself not so much with the sexual act nor with sexual fantasy, but was principally important for empowering the sexes, with men and women given equal voice and the ability to feel super-human, transported into their own fantastic new world.

You wore the clothes as though you felt yourself to be, and in turn were perceived to be, from another planet. And of course her enduring magic was to maintain that feeling when wearing her clothes, long after punk itself had faded into cliché.

AK: Can you talk about some items in your collection and what makes them significant?

MG: I have a few pieces I'm particularly fond of. I regard the classic Seditionaries bondage jacket (with straps that connect across both wrists and elbows, and encircle the torso at shoulder level) as the most important item of fashion created in the postwar years, because it was so radically different to anything any designer had made before or since. Consequently, it was the first item I bought from the King's Road shop. It, along with the "parachute" top and the muslin shirt with its over-length sleeves that clipped back to the elbows, were designed making direct reference to straitjackets, eroticizing the functional but constrictive clothing, turning it into a glorious display of bondage and into highly individual fashion.

At their most quintessential her garments are also like gallery pieces. I could quite easily go to sleep gazing admiringly at my prized bondage jacket hung up across the room. Although relatively expensive purchases at the time, I knew I was buying a piece of history.

I thought I looked like a princess from another planet . . . I thought I couldn't look any better. I particularly loved my SEX look: my rubber stockings and the T-shirt with pornographic images and my stilettos and spiky hair . . . I stopped the traffic in my rubber negligée.

WILSON 2014

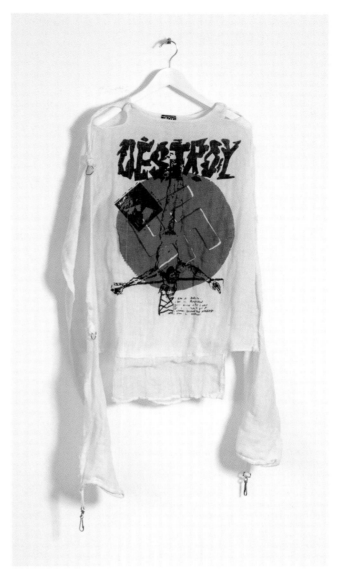

Figure 32 Vivienne Westwood, *Destroy Shirt*, BOY reprint 1991–1992 (Original Seditionaries design 1977). Collection: Malcolm Garrett Collection, Manchester Metropolitan University Special Collections. Photographer: David Penny.

Paul Simonon, the bass player in The Clash said something like, "Pink is the colour of rock 'n' roll."[14] For me, pink is undoubtedly the color of punk. Admittedly moving on a few years from punk, Sarah Stockbridge (Vivienne's model muse) was famously photographed wearing a pink knitted Westwood bodice with a cleavage slit. I bought this iconic garment from Steve at Rellik, whose shop is in the shadow of Trellick Tower at the northern end of Golborne Road, London. Previously based at the Portobello Market, he became known as *the* source for secondhand Westwood

Figure 33 Vivienne Westwood, *Corset Jumper*, roll neck with long sleeves and open décolletage, from the "Dressing Up" collection, 1991–1992. Collection: Malcolm Garrett Collection, Manchester Metropolitan University Special Collections. Photographer: David Penny.

MG: I can't speak directly for the gay community because, not being gay, I have never been an "insider," as it were, and among my friends, straight and gay, it never needed to be a topic of conversation. Punk expressed individuality and difference from the norm, so homosexuality was always regarded as normal because we were all different; that was the common ground. Hence it never crossed my mind to inquire about something that was not of direct concern to me personally. The punk community felt as outside of society as did the gay community so there was a level of camaraderie. There was no issue to being a punk in a gay club. As a teenage punk you didn't go into pubs, but clubs like Pips in Manchester, with its now legendary Roxy Room, had always attracted a diverse and non-heterosexual crowd. Suffice to say, the feeling was always that within the gay community it was a safer environment, and you really could wear what you liked without causing a commotion. The Ranch Bar, adjacent to a well-known transvestite club owned by Foo Foo Lamar, became a regular punk haunt in 1977–8.

My friend Judy Blame[15] was a punk, who as a young gay man "ran away from home" in 1977, first to London and then up to Manchester where I was studying graphic design. I recognized a kindred spirit through his creativity and individuality which manifested itself in a distinct look. He was an inspiration and he always looked so fabulous.

You have a more interesting life, if you wear impressive clothes.

FRANKEL 2012

clothes. The collection I have acquired has been expanded through some choice purchases from Rellik alongside those from Westwood's own stores.

When Vivienne split with Malcolm McLaren and launched World's End, the King's Road clothing store BOY acquired a license to reproduce various Seditionaries classics, including studded boots, bondage trousers, muslin shirts, and the parachute top, which they produced in various new color ways. Through connections that came about through working with Boy George and Culture Club, I art directed and designed a couple of catalogues for these ranges. As a result I was able to add to my collection with these BOY editions of clothing first produced by Seditionaries.

AK: How was homosexuality and other "trans" sexuality explored through this clothing?

AK: Westwood has commented on the impotence of rage. The erotic seems less angry in her clothes of the late eighties and beyond. The erotic fantasy is like role play and she uses the symbolism of tradition and traditional materials. Is this still about subversion of power and class?

MG: Vivienne went through a period where she explored classical imagery and re-envisaged traditional clothing, such as using Harris tweed[16] or her red riding jacket. The clothes are exaggeratedly excessive and sublimely subversive. Mini-crinolines and corsets echo the bondage of the punk style, but the fantasy was about the corrupting of establishment itself through satirizing it.[17] Westwood made clothes for women to show their sexuality through emphasizing and exaggerating their sexual selves with plunging necklines, tight bodices, and shoes with excessively

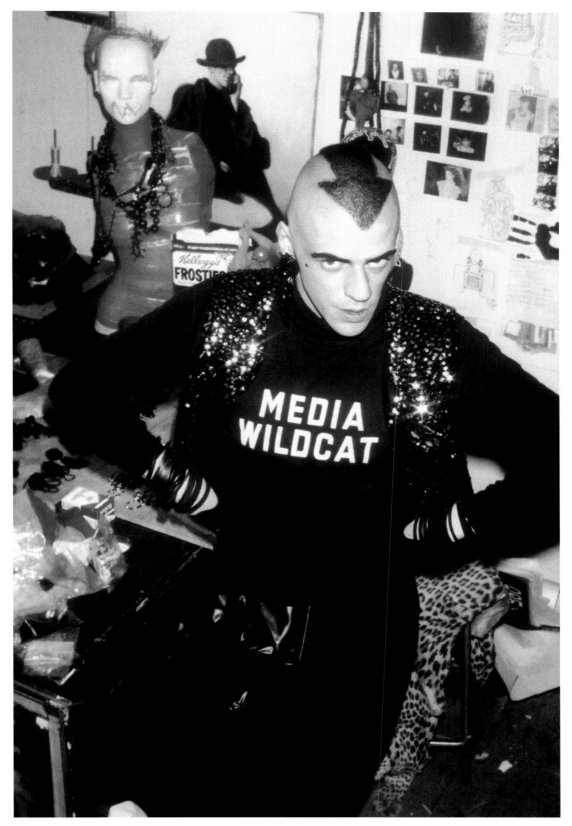

Figure 34 Jewellery Designer, Judy Blame in *The Bank*, a Studio building in Curtain Road that he shared with Malcolm Garrett, and was the first of its kind in Shoreditch, London, 1984. Getty images 558229551. Universal Images Group. Photographer PYMCA/UIG via Getty images.

elevated heels. These clothes celebrate the curvaceous female form, they are theatrical and still adhere to the epithet "Clothes for Heroes."

> [Westwood's clothes] suggest a giddy flaunting in the robes of the past to evoke something quasi-historical and perverse in the present. This is not only felt by the people who wear her clothes, but it is also appreciated by the people who trade in the buying and selling of vintage clothing and by those who buy fashionable twentieth-century dress for costume collections.
>
> **O'NEILL 2006: 382**

AK: You were part of the London scene when *i-D* magazine was launched by the designer and former *Vogue* art director and friend Terry Jones. Tell us about that time.

MG: In 1978 I moved to London, into the fifteenth floor of a council-owned tower block on the Isle of Dogs, where there was no tube line so it did not exist on the map! Myself, Judy Blame, and Jakki, my girlfriend, all moved from Manchester together. I painted the flat to echo the industrial docklands landscape outside with grey walls, red electric sockets, and black and yellow hazard stripes on doors, window frames, and skirting boards (a style much like the one adopted by the Hacienda club in Manchester years later). Working in the music industry, I soon became acquainted with Alex McDowell and his design company Rocking Russian. He was working with ex-Sex Pistol Glenn Matlock and had helped Vivienne Westwood print the celebrated "Destroy" shirts.

i-D magazine defined street style with its innovative vision and a docu/fashion photography. The founders were Terry Jones,[18] Alex McDowell, and Perry Haines, a young fashion journalist from St Martins, who had recently moved into the Isle of Dogs flat. I remember driving home with Perry and getting stopped by the police (another story) with the car trunk filled with issue one of *i-D* magazine. Perry had a fearless and infectious attitude towards street fashion and introduced what he called the "straight-up" shot. He would stop people in the street whom he thought looked interesting, posed them against the wall, and had them talk about what they were wearing. In Perry's mind genuine fashion was coming from the individual and not the fashion house. Perry had a witheringly critical attitude towards couture fashion, which he described as "wearing pound notes." You can't buy style, you can't buy individuality, it is about self-expression. A sense of visual superiority that came from emphasizing being different—not necessarily exploring sexuality but certainly referencing it through the creation of your own visual environment. For me, *i-D* was the style bible, not *The Face*.

Following the explosion of new style magazines at the beginning of the 1980s one in particular stood out. *Skin Two* was a magazine founded in 1983 to show latex fetish clothing, literally a "second skin," in a mainstream fashion context. Musicians such as Adam Ant, who oozed sexuality with his "Antmusic for Sexpeople," helped with making fetish wear "acceptable" without compromise. Before he adopted the Red Indian/Native American look, he was dressed in black and bondage, simultaneously provocative and alluring. From here on I became more conscious of the direct sexuality in clothing. The punk erotic origins of Kim West's pink rubber-wear were clear to see as she pioneered taking sexually orientated fetish clothing out of the closet and into the street.[19]

AK: How do you see the influence and legacy of punk's iconoclastic and satirical style? Has subversive fashion become commodified? Has individualism and the erotic become marketable?

MG: The sadness of it is that it is turning back on itself. What the punks started and what *i-D* celebrated in anti-fashion *has* turned into pound notes. Alexander McQueen and Westwood herself have become establishment, albeit for justifiable reasons, I guess, and maintaining a semblance of radical credibility. What was subversive has become iconic. Anti-culture has become mainstream. Still there is a legacy of customization, do-it-yourself, and originality. Even though adopted by couture designers, punk demands that we revise and question complacency. With the whole of the Western world being increasingly threatened by right-wing politics, the anarchic rebellion of punk is needed on the streets again, arguably now more than ever before.

The world needs punk again.

> *Try to get involved in seeing art then you'll be a freedom fighter, you'll be working for a better world . . . What do I know about anything? I'm only a fashion designer.*
>
> **JEFFRIES 2011**

Notes

1. He is now creative director of communications agency IMAGES&Co.

2. This collection numbering well over 100 pieces is in Manchester Metropolitan University Special Collections. The curator, Stephanie Boydell, describes it as follows: "Malcolm Garrett is a hugely important figure in British design, and this collection illustrates his eclectic tastes, from everyday, mass produced, pop-culture objects to haute couture. It tells a remarkable story about how culture, past and present, shapes and informs great design." http://www.art.mmu.ac.uk/news/item-617/ (accessed December 20, 2016).

3. From the Sex Pistols' song "God Save the Queen' (1977).

4. Siouxsie commented, "everyone was convinced I was making some nasty political statement. I was completely ignorant of all that" (Paytress 2003: 52).

5. She performed with the name Cosmosis and changed it to Cosi Fanni Tutti in 1973.

6. Tutti, Cosey Fanni, 3 Day Performance, Hayward Gallery, London, 1979. http://www.coseyfannitutti.com/content/art-photo/1979haywardgallery.html (accessed August 20, 2016).

7. "My work in the photographic, film and striptease business began as a project in its own right, an exploration of a fascinating part of our culture. One which many women never explore or admit to having an interest in. It is an area of great exploitation both of women and men. There is sadness, laughter and pain and most of all a wealth of knowledge about our own sexuality." Cosey Fanni Tutti, 1988, http://www.coseyfannitutti.com/content/texts/ttt.html (accessed December 7, 2016).

8. Conservative MP Nicholas Fairbairn quoted in the *Wreckers of Civilsation*, 1999. London: Black Dog Publishing (2014: 159).

9. Cosey Fanni Tutti [Video]. (2010). Red Bull Music Academy. from http://www.redbullmusicacademy.com/lectures/cosey-fanni-tutti-visceral-sounds (accessed September 19, 2016), 56 min.

10. Buzzcocks brought Sex Pistols to Manchester for two celebrated performances at the Lesser Free Trade Hall and thereby introduced punk to Manchester and the North West. The subsequent release of their *Spiral Scratch* EP on their own New Hormones label effectively initiated the DIY indie music scene. Their cultural provocations continued later when they invited radical support acts on tour with them. These included Gang of Four, Penetration, Joy Division, and Siouxsie and the Banshees.

11. For the full document of those who claimed they were there see Nolan, D. (2006) 'I Swear I Was There: The Gig that Changed the World', London, Independent Music Press.

12. Jordan was the SEX shop girl and pink legend herself. The famous 1976 photo shows Westwood, Jordan, and Chrissie Hynde at SEX wearing rubber clothing.

13. There was a shop downstairs in a vintage store near Kendals department store in Manchester that many Manchester punks frequented and found many sartorial gems.

14. See Liv Siddall (2005).

15. Blame was art director for *The Face*, *Blitz*, and *i-D* in the 1980s and 1990s. Accessories designer, art director, and fashion stylist, he worked with, among others, Neneh Cherry, Boy George, Massive Attack, and Björk. In 1985 he set up the House of Beauty and Culture.

16. 1987 collection "Debutantes going to balls but with a Barbour flung over their ballgown" quote from Kelly and Westwood (2014: 292).

17. Westwood credits the Canadian Gary Ness, art historian and portrait painter, for the historical referencing of her work from the 1980s. Ness urged her on as a revolutionary but a counter-revolutionary. "The basic idea," he once said, "is that Rousseau—proto-socialist and godfather of the idea of the 'noble savage'—is responsible for the damage that has been done to traditional ideas." http://www.lrb.co.uk/v36/n22/bee-wilson/punk-counterpunk (accessed December 23, 2016).

18. Jones, T. (1990) Instant Design/a manual of graphic techniques, London, ADP Designfile.

19. She was the first designer to print onto latex from 1984 to 1992 and relaunched online in 2009. She made the documentary *The Sex Hunters* for Channel 4 in 1992.

References

Clarke, J. S. and Holt, R. (2016), "Vivienne Westwood and the Ethics of Consuming Fashion" *Journal of Management Inquiry*, 25 (2): 199–213. doi:10.1177/1056492615592969. Available at: jmi.sagepub.com (accessed August 20, 2016).

Ford, S. (1999), *Wreckers of Civilisation: the Story of Coum Transmissions & Throbbing Gristle*. London: Black Dog.

Frankel, S. (2012), "Vivienne Westwood: 'You have a more interesting life if you wear impressive clothes'." Available at: http://www.independent.co.uk/news/people/profiles/vivienne-westwood-you-have-a-more-interesting-life-if-you-wear-impressive-clothes-8157187.html (accessed December 23, 2016).

González, A. M. and Bovone, L. (2012), *Identities through fashion: A Multidisciplinary Approach*, Oxford: Black.

Jeffries, S. (2011), "The Saturday Interview: Vivienne Westwood." Available at: https://www.theguardian.com/lifeandstyle/2011/dec/03/vivienne-westwood-cool-earth-environment-fashion (accessed December 23, 2016).

Kelly, I. and Westwood, V. (2014), *Vivienne Westwood*. London: Picador.

Lowey, I and Prince, S. (2014), *The Graphic Art of the Underground: A Countercultural History*, London: Bloomsbury.

O'Neill, A. (2006), "Exhibition Review: Vivienne Westwood: 34 Years in Fashion," *Fashion Theory: The Journal of Dress, Body and Culture*, 10 (3): 381–6.

Paytress, M. (2003), *Siouxsie & the Banshees: The Authorised Biography*, London, Sanctuary Publishing. 18 May 2017.

Siddall, Liv. (2005), "The Clash's Paul Simonon on Painting Outdoors and Sketching in Museums. It's Nice That." n.p. Available at http://www.itsnicethat.com/articles/paul-simonon (accessed September 19, 2016).

Throbbing Gristle (1977), "The Second Annual Report of Throbbing Gristle," London: Industrial Records.

Westwood, V. (2013), "Worlds End Blog," Available at: http://worldsendshop.co.uk (accessed December 15, 2016).

Wilson, B. (2014), "Punk Counterpunk," *London Review of Books*, November 20, 36 (22): 31–2.

Further Reading

Brauer, J. (2012), "'With Power and Aggression and a Great Sadness': Emotional Cashes with Punk Culture and GDR Youth Policy in the 1980s," *Twentieth Century Communism*, 4: 76–101.

de Jongh, Nicholas (2014), "From the Archive, 18 October 1976: Controversial Art Plunges in to the Rusty Hilt at the ICA."

Guardian, n.p. Available at: https://www.theguardian.com/music/2014/oct/18/genesis-p-orridge-ica-exhibition-1976 (accessed August 21, 2016).

Jones, P. (2002) "Anxious Images: Linder's Fem-Punk Photomontages," *Women: A Cultural Review*, 13 (2): 161–78. doi:10.1080/09574040210148979.

Morley, Paul (2011), "The Sex Pistols Play the Lesser Free Hall: All of Indie Manchester Sees the Future of Music," *Guardian*, n.p. Available at: https://www.theguardian.com/music/2011/jun/14/sex-pistols-lesser-free-hall (accessed August 20, 2016).

Parsons, Tony (1976), "'Prostitution Show' ICA, London, England, 18 October 1976." *NME*, October 30. Available at: Brainwashed.com, n.p. www.brainwashed.com/tg/live/ica.htm (accessed August 20, 2016).

Sex Pistols (1977), "God Save the Queen" [single, side A, vinyl record], UK: Virgin, A&M.

Triggs, T. (2006), "Scissors and Glue: Punk Fanzines and the Creation of a DIY Aesthetic," *Journal of Design History*, 19 (1): 69–83.

PART III

The Alternative Cloth

The three chapters in this section explore the cloth/body narrative through the haptic, the tangible, and the transgressive on the skin, in the skin, and under the skin. The clothes we select to wear can evoke, disguise, and rearrange our sexuality. Through our clothing, cloth and skin become one, and clothing becomes not only the substitute for the body, but the body itself—the body of the self and the body of the Other. Our discarded clothes co-mingle with those of our lover, skin on skin, cloth on cloth. We hold the clothing and we hold the absent body, its stains and traces. We smell it, we taste it, we feel it.

Clothing as skin, skin as clothing: a deceptive envelop to the eyes, and a revealing braille under the fingertips. The two sides of the erotic as expressed through living and dying are inseparable from the body, and are caught in and on the cloth/skin that wraps the body. The three chapters examine the physicality of eroticism as understood through folds of cloth, folds of flesh, the layers of the skin. These chapters are placed within the context of film, political activism, and textile making, in order to interrogate the inner experience of eroticism, affirmation, and denial.

Thoughts on the erotic:

Erotic desire is excess, impulse, compulsion; erotic energy arouses, insists, triumphs; erotic sex heightens, transgresses, is dissolute; erotic power is painful, intrusive, taboo.

CATHERINE HARPER

7

Present or Absent Shirts: Creation of a Lexicon of Erotic Intimacy and Masculine Mourning

CATHERINE HARPER

There is a moment in Ang Lee's film *Brokeback Mountain* (2005), based on the short story by Annie Proulx (1997), when the cowboy Ennis seeks out the smell, the scent, the "presence in absence" of his lover Jack, ostensibly beaten to death earlier in the film. The cowboy lovers of Brokeback Mountain have experienced the sexual pleasure and somatic agony of their illicit love affair, paralleling their normative marriages, their "wholesome" fathering of children, and their external manifestation as essentially hetero-masculine men (cowboys, fathers, husbands). The violence of Jack's roadside murder speaks of the dark dangers of societal exposure, revelation, and censure, and points to what Mendelsohn refers to as "the specifically gay phenomenon of the 'closet'" and the "disastrous emotional and moral consequences of erotic self-repression and of the social intolerance that first causes and then exacerbates it" (Mendelsohn 2006: 10–12).

Following Jack's death, Ennis visits Jack's parents, a tense enactment of the awkward coincidence of familial and erotic worlds. Jack's mother allows Ennis to see his lover's boyhood bedroom, and there Ennis discovers two of their old work shirts hidden in the back of Jack's wardrobe, stained with Jack's blood on the cuff: "his own plaid shirt, lost, he'd thought, long ago in some damn laundry, his dirty shirt, the pocket ripped, buttons missing, stolen by Jack and hidden here inside Jack's own shirt, the pair like two skins, one inside the other, two in one" (Proulx 1999: 281). The shirts "spoon," Jack's shirt seeming to hold Ennis' on the same hanger, both suspended in the physical and representative closet (Kitses 2007: 26). They are the garments that the two men wore on their last day on Brokeback Mountain, the physical location of their sexual union and their spiritual, amorous, and erotic connection. The shirts reflect the men's intertwined intimacy, and, hanging in the darkness of the closet, they serve to highlight that Jack and Ennis' "life together has been one of life apart, a life of constant separations, a life separate from all others too, family included. All separate lives" (Kitses 2007: 27).

The leakage of blood onto, into, and between the cuffs of both garments from their playfight on that last day free on the mountain, the interleaving of them—shirt on shirt, man-on-man, absent body on absent body, blood on blood—in the cell-like, coffin-like space of the wardrobe, re-actions their coupling and their bodies' fluidic

exchanges. The claustrophobic space mirrors Ennis' closed-off memory space, and stands in sharp contrast to the awesome scale of the landscape of their relationship's erotic enactments.

The palpable bodily phenomenon of blood on fabric affects as evidence of sensual experience made visible on the textile. Stained fabric is soaked with libidinal meaning: imagine sweat stains vivid on a vest, lipstick kisses on collars, virgin blood on sheets, an unstoppable discharge affronting Lewinsky's frock. Intuitive and erotic understanding of bodies, matter and materiality, is stitched into the very structure of cloth, not least in its peripheral margins, skin dusting in its seams, private feminine bleeding, and the mourning associated with trauma and loss in the physical tearing and rending of fabric skin. Faiers asserts that "the more feminine the garment the more impact the defilement of a bloodstain will have" (2013: 264), but here men bleed into each other in a sanguinary sex act as futile as it is erotic.

Ennis seeks the scent and sense of his own and his lover's presence—in sorrow—in those worn shirts, their illicit love caught in the denim and plaid, communicating both sexual pleasure and suffering of the scale of the immeasurable mountainous region they inhabited. While the essential nature of cloth being that "it receives us: receives our smells, our sweat, our shape even" (Stallybrass 1999: 28), Prouxl provides no such closure for Ennis:

> He pressed his face into the fabric and breathed in slowly through his mouth and nose, hoping for the faintest smoke and mountain sage and salty sweet stink of Jack but there was no real scent, only the memory of it, the imagined power of Brokeback Mountain of which nothing was left but what he held in his hands.

PROUXL 1999: 281

The shirts alone, then, become affective devices for articulation of death and desire, mingled on cloth, and creating a lexicon of erotic intimacy and masculine mourning. With Jack dead, Ennis is now longing after a man he can't have. He changes the shirts, placing his own on the outside, embracing, cherishing and protecting the shirt-body of his absent lover.

Jack's parents, waiting downstairs, silently acknowledge their son's love and the grief of his lover. The mother's demeanor suggests some sympathy, the father's hints at

Figure 35 *Breathing the Shirt (Heath Ledger) Brokeback Mountain, 2005.* Screengrab. Director: Ang Lee. Producers: Larry McMurtry, Diana Ossana, James Schamus.

darker, haunted, hostile feelings. Their son would *not* be buried on Brokeback Mountain, but firmly back in the family plot, reclaimed by tradition and genealogy, with illicit history erased. But birth cloth to love shirt to death shroud, the warp and weft of the textile holds the sensational and internalized intimacies of moments when skin tissues and mucous membranes fold upon themselves, inscribing their memorialized histories onto the skin's surface, creating unmovable tactility—traces of cloths that have caressed that skin, torso, and beating hearts (Serres 2009: 30). These shirts have made those intimate, membranous, delicate and eroto-poignant touchings.

Extending the sensual and somatic is the connection of the *sexual* acts or enactments of sex and sexuality with cloth that creates an unstable and incendiary polemic of personal identity eroto-politics. Ennis' caress of Jack's shirt is as tender as the embodied embrace of corporeal lovers, and as affective: but have no doubt that these men not only caressed but fucked on the mountain, and the blood is material evidence of the forceful and mortal aspects of the *petit mort*. Those "stains that will not go" linger on as faded indexes of existence (Wronsov 2005: 5). Their atomized power is that of the "poetic punctum," the

"poignant prick" on clothes and sheets (Barthes 1981), and in Ennis' closed down, hidden erotic imagination, their persistence is that of the body itself, stubbornly resisting ultimate erasure.

Jack's mother makes a final gesture as Ennis leaves wordlessly, handing him both shirts in a paper bag, a *momento mori* that she and he both know has massive significance but cannot ever be spoken of. Significantly, it is she who has elected not to launder her son's clothes, but to leave them hanging as they were at the time of his death. It is she who has governed the closet in which two shirts were interleaved. It is she who has avoided the rituals of laundering that concern the transformation of soiled cloth. It is she who has refused to expunge that which has "sullied" *and* eroticized—the cloth and the corpus. And it is Ennis who will take the textile stand-in for Jack, a stand-in that—like his lover—will fade and rot, be susceptible to the ravages of time, remain tucked away, folded and concealed, privately preserved, but with the talismanic potency of erotic charge.

Shirts, in my part of Ireland's north-west, mean women's work. The city of Derry's long tradition of shirt-making stretches back over nearly two centuries, its strong

Figure 36 *Women in Shirt Factory*, Derry City and Strabane District Council Archive, c. mid-twentieth century.

association with an overwhelmingly female workforce cementing the notion of a "Maiden City," so-called because its 400-year-old defending walls have never been violated. When the linen cloth trade in the city declined in the 1830s, master weaver William Scott's wife and daughters produced finest quality hand-sewn shirts for sale to Scottish merchants. And the 1853 invention of the sewing machine plus concurrent Scots Presbyterian business investment meant that the Tillie and Henderson factory, mentioned in Marx's 1867 *Das Kapital*, was operating on a fully mechanized, industrial scale by the mid-1850s.

The collective memory in heads, hearts, and hands of low-income, high-talent women working en masse in the city to create "shirts for the backs of men" is palpable and powerful. Women's lives shrank a little as the shirt industry transferred in bulk to Far East production in the later twentieth century, but there are still women alive today to recollect the "craic" they enjoyed while they cut, sewed, and pieced the high quality, highly desirable shirts. The subculture of sex was never far away—ribaldry shared when a young male fitter tended a sewing machine belt between a woman's knees, occasional love notes popped speculatively into the breast pocket of a uniform shirt destined for an unknown overseas soldier, the gendered

burden of being a breadwinner, wife, and mother in a city of historical and intense male unemployment.

Each shirt piece—cuff, placket, sleeve, collar, and so on—was made by an individual skilled in the creation of that particular piece, with assembly of a single shirt in two minutes and with contribution from eight workers. The collective and individual labor, linking Derry women to other "rag trade" workers, bodies unionized, colonized and not, across the globe. For those women, their ghosts and their successors, a shirt was more than a shirt. They too recognized textile carriage of memorialized histories that hover on or near the inscribed skin of the man, caressing him with a good fit, betraying him with a rouged mark, irritating him with a frayed collar, smelling of his body, stained by his sweat, and soliciting her touch over his beating heart, along his torso, and around his back.

Women and stitch are inextricably linked in cultural history and textile tradition—heads bowed, patient, sitting still over many hours, repetitive and obsessive work. The maidens of the Maiden City played their part in the paradoxes of a textile culture marked by the cross-tensions of warp and weft, the selvedges of a cloth, and the fabric hiding, revealing, protecting, shrouding, enveloping, draping, covering, touching, possessing, protecting, wrapping . . .

Another shirt hangs in a glass cabinet in the National Museum of Ireland, Dublin. Impotent as a flaccid flag, this blood-marked relic acts as an empty garment memorial for James Connolly, Irish Easter Rising patriot, leader of the Irish Citizen Army situated in Dublin's General Post Office in its main O'Connell Street during the insurrection in 1916.

This shirt is representative of a feminized, colonized, and yielding Ireland, oppressed by the dominant British-masculine power. Again, a shirt stands for an absent man, and carries tangible evidence in the threads of its materiality of his somatic presence—blood and sweat impregnate this textile, his body eroticized through the memory, mythology, and mourning that celebrates and even ritualizes the moment of death in subsequent narratives of the Rising.

The Rising itself saw only around 1,250 individuals active in Dublin and up to 3,000 elsewhere in Ireland, with most Dubliners either bewildered by or hostile to the unfolding events. Its purpose was to overthrow British rule in Ireland and establish an independent Irish Republic, and it was engineered to catch Britain off-guard while its focus was on the fronts of World War I. The fighting lasted for six days, ending in unconditional surrender and execution of fifteen of the leaders, including Connolly, who had sustained a serious bullet wound to his ankle. Its brutal suppression, including the execution of Connolly by a British firing squad while seated in a chair due to his wound, however, swelled popular support for Irish Republicanism and the rebels' cause. Shot seated, seemingly emasculated, feminized even, Connolly was buried coffin-less in a mass grave, and Mother Ireland's martyrdom was guaranteed. Seventy-three Sinn Féin seats were won in the British parliament in the 1918 General Election, and the subsequent Irish War of Independence from 1919 to 1921 between the Irish Republican Army (IRA) and British security forces led to the eventual and effective partition of Ireland.

In the National Museum, Connolly's shirt is displayed as one of 100 objects that tell "the long history of our island, one object at a time." While its curator's label reads "presumably the garment was removed when he was hit in the leg three days into the rising," this is not certain. The faintly striped garment of cream, pink, and grey flannelette is grimy and sweat-stained, with a visible blood mark under the right arm. The executioner's bullet hole cannot be discerned, but the imagination of an audience sympathetic to the seduction of blood sacrifice constructed a narrative of pitiful suffering, innocence and piety, and cruel and unnecessary subordination of the heroic body. The original fabric of a banal work shirt was made sacred (Taussig 1999). The body's vulnerability and humanity is never more apparent than when it is punctured, wounded, pierced. The creation of a marginal orifice in skin or cloth, through which the marginal stuff of life emerges—blood, but also milk, urine, feces, or tears—traverses the boundaries of the body and is discomfiting as "matter out of place" (Douglas 1966: 150). And while stains are stains, they also evidence the enervated and encountering body, marking outwards from that body to create those stains, insisting on the body's vitality as long as it can.

Consider here Jackie Kennedy's baby pink Chanel-style suit bearing the stains of John F. Kennedy's blood and brain matter on the day of his assassination in 1963. She continued to wear that suit for seventeen hours after his killing as a visible testimony of her and her nation's trauma. One of the most powerful and recurring images of the twentieth century, the suit is stored with blood and matter still in place in a carefully air-conditioned vault in the US National Archives and Record Administration, Maryland. Asked why she would not remove the suit immediately following the emergency, Jackie Kennedy apparently replied, "No, I want them to see what they have done." The urge to hold onto bloody traces of trauma is strong, and that garment remains un-cleaned in cold storage to this day.

Consider too Michael Collins' famous wool greatcoat, in which he—as then President of the Irish Republican Brotherhood and Commander-in-Chief of the Irish National Army—was shot dead in a 1922 ambush outside Cork. That garment exhibits Collin's dried blood on the right hand side of the collar in the National Museum of Ireland as a history note on Ireland's violent War of Independence.

Consider finally the baby's sleep suit used to staunch the wounds of the seventeen-year-old Michael Kelly, fatally wounded by the British Army on Bloody Sunday in Derry—Londonderry in 1972, and preserved in the Museum of Free Derry. The surface of these garments has allowed histories of their traumas to remain etched in blood, imprinting the absent bodies beneath in a non-text, non-verbal social history of considerable potency.

The concept of the "noble martyr" inverts the stain's meaning as tarnish, and transforms it to a badge of honor,

Figure 37 *James Connolly's Shirt*, 1916. Cotton. Collection: National Museum of Ireland.

a relic of repression, and lauded evidence of the suffering that produced the stain. If bullets can be like arrows, if memories are sometimes wounds, the actual or conjured bullet hole in the Connolly shirt is as much a pin-piercing, pin-punishing, pin-penetration as the curse of a petulant lover, the bitter puncture of the casual sadist, the prick of the spiteful seamstress, the arrow's vicious dart into the flesh of Saint Sebastian, or the sword and nails of abjection for the crucified Christ.

Ireland's long-established tradition of Republican martyrdom depends on a particular brand of feminized subordination and erotic suffering to create its male heroes. Connolly's shirt activates the eroto-pierce, agonized masochism, ecstatic torso of the arched, bound, and lashed Sebastian, unmistakably male, but "one whose martyrdom is the embodiment of female passivity," reflective of the Virgin Mary's special status of "pierced but pure" (Derwent 2008). Moreover, Connolly's shirt points backward in Irish history to a configuring of the land as a pious Catholic virgin spread-eagled for Britain's repeated rape and pillage. Utilizing tropes of sacrifice, violation, the male body in abjection, the penetrated skin-cloth tantamount to Christ Crucified, the homoeroticism of the stretched, racked, repressed body depicted in every Irish parish, and not lost on the festering and fervent appetites of lay or religious sexualities.

The Irish Easter Rising created born-again martyrs whose after-life exceeded in importance their lives. Christ's resurrection was followed shortly after by his disappearance from the earth: as Kuryluk puts it "skin dies, cloth may come alive and replace the body . . . the body falls, garments fly up" (Kuryluk 1991: 197). The visible evidence of Christ's being was maintained by the shredded skins of miraculous cloths, the fetishized sweat rags like those offered him on the road to Calvary by Veronica, or like his burial shroud, on which his image was impressed by the printing inks of his oozing-edged body. So too the Connolly shirt is the visible evidence of his so-called supreme sacrifice.

Cloth's significance in a sexualized political culture is also apparent in the homoeroticism of the "non-shirts"— the shit-impregnated blankets—of the Northern Irish hunger strikers of the 1980s. The symbolic (pseudo)- potency of the un-shirted Irish male body, emaciated and violated arguably by choice as well as by domination, allows further reflection on the shirt's role in imaging the male body in starched erection, wrinkled de-tumescence, or neutered erasure, within a lexicon of erotic intimacy and masculine mourning.

Bobby Sands was the first of ten men who starved themselves to death in Belfast's Maze Prison between March and October of 1981, seven abject months in Northern Ireland's abject history. As the life of the 27-year-old waned, Northern Ireland experienced fierce rioting, furious despair, and the deaths of sixty-one people in bitter sectarian violence. Never was policing and punishment, prison and penetration, potency and impotency, the phallus and the flag more closely aligned.

The Irish Republican hunger strikers had five demands, one being to wear their own clothes rather than British prison uniforms, so as to have special category political rather than criminal status (the others being the right not to do prison work; to freely associate with other prisoners; to organize educational and recreational pursuits; to receive one visit, one letter, and one parcel per week; to see restoration of remission lost through the protest). While these were not permitted, the men led the protest via unwashed, unshaven nakedness, their *non-shirts* being prison-issue blankets that were adopted only for visiting times and exercise periods. Using their naked bodies to protest what they saw as intolerable de-sexing as incarcerated and neutered Republican freedom fighters, the

so-called "blanket men" grew their hair and beards, refused prison shirts, smeared their cell walls with their own excrement, and used their urine as a weapon. The emotional impact of this protest was extraordinary, with the extreme vulnerability of these otherwise hardened men drawing much public empathy and concern.

Smuggled messages between prison and the public realm were frequent, in the transfer of tiny mouth-concealed "comms." Avoidance of censorship by the prison authorities was a "soft act" of defiance, with messages composed of tiny script written on cigarette or toilet paper, wrapped in cling film, and concealed in the mouth to be smuggled out of jail through a kiss between prisoner and visiting family members. Communications between cells were exchanged though small packed word-parcels transported in the "blanket men's" rectal passages and dug out by their cellmates with clawing, groping fingers. Words became scatological and ejaculatory in their transmission, emanating from the body's orifices in physical form, base and abject in their mobility, as "free speech" was deliberately and very cunningly manipulated to gain as much public sympathy as was possible. Externally, "comms" became fetishized objects, with political and erotic charge far beyond their materiality or textuality, and the seductive and radicalizing authority of voices both near and beyond death.

Derry artist Locky Morris' "Comm" exhibition at Manchester's Cornerhouse in 1992 showed giant pink toilet paper and clingfilm tongues French kissing across the gallery wall, while "Comm II" at Derry's Orchard Gallery in 1994 dissolved the plastic of the tongues to create one vast, smeared and burnt, abject and erotic "mega-comm" that echoed the "simultaneous attraction and repulsion" of the feces-smeared walls of the political wings of the Northern Irish prisons of Maze (Long Kesh) and Armagh (Darke 1994). The delicacy and secretion in and on the body of "comms" situates them within the classification of textile in its widest, most somatic, most "written-on-the-body" sense, and the expedient use of the body's orifices as simply carriers rather than as sexually receptive cavities defined the erotic extremis of war.

In photographs of Sands and the others, we see the absence of the shirt, a "lack" that combined with the visual compulsion of the humiliated, dominated, and emaciated male body to create a potent symbol of Ireland as de-masculinized, unclothed, marginalized, naked, martyred and defiled, stripped—literally—of human decency by a

bullying imperialist British force. Trailing back in history to the Great Famine of the 1840s, the hunger strike in the early twentieth century that saw twelve men dead, the hunger strike by forty IRA prisoners in 1972, the blanket and dirty protest by IRA and Irish National Liberation Army prisoners in 1976, the 1980 Maze and Armagh Women's Prison hunger strike which saw its main protagonist lapse in and out of coma before the fifty-three-day hunger was ceased by apparent concession, the 1981 hunger strike has a serious pedigree and attracted serious international witnesses. Between May 5 and August 20, 1981, Bobby Sands, Francis Hughes, Raymond McCreesh, Patsy O'Hara, Joe McDonnell, Martin Hurson, Kevin Lynch, Kieran Doherty, Thomas McElwee, and Michael Devine starved to death at intervals lasting forty-six to seventy-three days.

The Secretary of State for Northern Ireland, Humphrey Atkins, stated that Sands had committed suicide, reiterated by Prime Minister Margaret Thatcher, who said that Sands "chose to take his own life." The strike was eventually terminated on October 3, 1981, with thirteen other men taken off strike and partial concessions granted. The language of "sacrifice" was now common parlance in Republican circles, and while the original pathologist's report recorded cause of deaths as "self-imposed starvation" this was later amended to simply "starvation," with the coroner's verdict remaining "starvation, self-imposed." The bodies of Sands and the other hunger strikers, covered only in rough blanket substitutes for the human form of the shirt, became sites likened to those of the flayed and naked Christ, and were conjured in the same sacrificial terms in press and propaganda. The prison deathbed scene from Steve McQueen's 2005 film *Hunger*, for example, makes close reference to Niclaus of Haguenau and Matthias Grünewald's *Isenheim Altarpiece* (1512–16) as a means by which this point might be emphasized. The same tableau cinematography is at play in the *Brokeback Mountain* scene where Ennis scents and senses Jack's closeted shirt, and recalls pictorial representations in history of the biblical *Haemorrhoissa* (menstruating woman) who touched the hem of the cloak of Jesus in pursuit of healing. If "textile has the explicit capacity to transfer essences of the owner's body . . . The clothing of a body constitutes that body . . . The lower hem of the garment is a border between one's own body and the body of the other" (Baert 2011: 312), then consider Jack's shirt's cuff as a hem, "as a liminal zone

where transfer and transpositions become potent between the 'I' and the 'other,' between me and you" (Baert 2011: 343). Consider Ennis, then, as the bleeding (mourning) feminine, defiled and devastated, seeking healing (solace) from the edges of Jack's sacred skin (garment).

As with Connolly's 1916 execution in his chair, the tropes of martyrdom played into the hands of the Provisional IRA, with Britain's recalcitrance—ostensibly over wearing a shirt (though not blankets to starve in, or pajamas to die in, or coffin cloths to repose in)—creating a phenomenal recruitment tool for the "ballot and bullet" strategy of Republican terrorists. Cloth's capture of the abject-erotic nexus of death and valor points to the seduction of suffering in a cruel world, hinting though at the power of suffering to attract, to mesmerize, to win hearts and devotion, and to secure both votes and recruits. Bobby Sands' slow self-starvation enabled a perverse attraction as pin-ups in adolescent girls' bedrooms were replaced by masturbatory fantasies associated with Republican martyrdom and the death fetish.

Michael Taussig argues that "defacement exerts its curious property of magnifying, not destroying, value, drawing out the sacred from the habitual-mundane . . . rather than offending what is already sacred . . . acts of desecration seem to create sacredness, albeit of a special variety (1999: 51–4). For him, that defacement—as with the hunger strikers' fecal defacement of their cells, blankets, and bodies—creates a certain kind of retrospective or even nostalgic value that perversely creates an assumption of pristine sacredness rather than disgusting abjection. Taussig further posits that we then consider the wearer—of the blankets in this case—as sacred. So when Sands died on May 5, 1981—having become an absentee British Member of Parliament while starving naked to death, and after sixty-six days of hunger in the Maze Prison—the structure of the HMP Maze H Blocks where prisoners were housed was likened to the iconography of Christ's crucifixion cross.

Sands' pallid and feminized corpse *was* Christ-like: his West Belfast funeral attracted over 100,000 people, disciples for the Republican cause. Wives and mothers sutured symbolic wounds, pressed poultices on the unclothed, unwashed, un-shirted bodies of more martyr-victims as the hunger strike progressed relentlessly through its ten victims, in what Arthur Aughey indicated was a heady "ideologically *erotic* mix of self-sacrifice

and self-righteousness" (2005: 36). Mothers tucked their skin-and-bone sons into the linen swaddles of their coffin shrouds (as Jack's mother tucked the shirts into a paper bag), mobilizing as a form of protest a "sewing stance" inculcated with submissive obedience, heads bowed, patiently positioned, sitting very still over many hours (remember the shirt factory women).

Maria Power's deliberation on the question of Catholic suicide provides multi-dimension to the transition from the status of living to corpse via either the self-infliction of fatal wounds as suicide or the self-infliction of fatal wounds as martyrdom (Power 2016). Hunger strikers' burials became pinch points for discussion of the difference between the two inflections, for the full extravagance of the Catholic funeral, consisting of a Requiem Mass, public funeral, and ecclesial burial was not formally available by Roman Catholic Code of Canon Law as it stood in 1981 to suicides. Cardinal Basil Hume, then leader of English and Welsh Catholics, made this abundantly clear to Bishop Edward Daly of Derry in April 1981. Yet, at the death of Bobby Sands a month later, Daly stated in *The Tablet*:

> I would not describe Bobby Sands' death as a suicide. I could not accept that. I don't think he intended to bring about his own death. I think that he thought there was a possibility, that he hoped that something would be achieved.
>
> **POWER 2016**

For Julia Kristeva, the "abject is edged with the sublime . . . the same subject and speech bring them into being" (1982: 11), and whether suicide, self-sacrifice, martyrdom, or misguided and exploited, the 1981 hunger strikers made the most powerful point in Irish history. Blankets covering their emaciation, characterized as dead men walking, they mobilized a divine eroticism that could not fail to compel. Their ragged and filthy blankets were not comforters or swaddles or quilts. Rather they were what Salman Rushdie calls repression's "seamless garment" (1983: 173), the shrouds of emaciated, self-starved martyr-masochists, marked by the excreta of their bodies, imprinted by the certain agony of their psyches. Imprinted on their surfaces, embedded in their weave, along with tears, blood, pus, sweat, shit, semen, and saliva, were the unbearably intimate body-memories of a time of sorrow, abjection,

valorization, and a curious sexualized reading of martyrdom. The leakage of persistent sores, scars, and raw wounds as the starving bodies disintegrated to mess and ooze created a special stigmata, a fetish object-sign on textile, an objection and a protest, hovering on the border between the living and the corpse, encroaching the borders between what we accept and what terrifies us because it represents our own obliteration (Kristeva, 1982).

The blankets themselves have taken on the dimensions and potency of an "Irish Turin shroud," reflecting the reverence many Christians have for the cloth cherished as purportedly bearing the imprint of the body of Christ after his crucifixion. Unlike Turin, no shit-marked Maze blanket exists as a physical relic, although the bed Sands died in is purported to be still at the now redundant prison. In his essay "The Index of the Absent Wound (Monograph on a Stain)" (1987), Georges Didi-Huberman relates how questions on the Turin cloth's provenance in relation to any scientifically proven genetic material it might have held had strayed into circumspection about not only traces of Christ's blood, but of his sperm, potentially emitted during the involuntary bodily spasms of death on the cross. That is as may be, but in relation to the vexed bodies of Bobby Sands and his comrades, Michel Serres' description of the shroud of the wounded seems most apt:

> cloth the purpose of which is to wipe away sweat, the sweat of the dying man . . . painful tortures, covered with sweat, blood, spittle, dust, scarified by flagellation, pierced by nails, run through by spears . . . a thin layer between an atrocious world and the printed skin . . . buried beneath this veil . . . the veil becomes a canvas and displays the traces of the body and face. This is the man.
>
> **2009: 36**

Linkages are clear. Cloth is man. Cloth is Bobby, Jack, Ennis, James, and the rest. Its markings are the external demonstrators of his soma's excreta and his psyche's turmoil. HMP Maze Prison is long since razed, the blankets incinerated, inmates' hair and beards cut away, or buried. The shirts are merely museological or "disappeared" relics. But in the ghosts of the blankets, we imagine the unbearably intimate body-memories imprinted on and embedded in their weave. Scar-stigmata on functional fabric substrates: the leakage of persistent sores and raw wounds borne by the unhealed messy flesh of the body.

The absent Belfast blankets of Bobby, Francis, Raymond, Patsy, Joe, Martin, Kevin, Kieran, Thomas, Michael, the "disappeared" Brokeback Mountain shirts of Ennis and Jack, the Dublin museum-displayed shirt of James, each evidence the collective abjection of tears, blood, pus, sweat, feces, semen, and saliva that make up the stains of men:

> We leave a stain, we leave a trail, we leave our imprint.
>
> Impurity, cruelty, abuse, error, excrement, semen—there's no other way to be here.
>
> **ROTH 2000: 242**

Here, men's images, thoughts and drives are impressed in blood or sweat, creating somatic flaccid flags, erotic markers for their bodies, utility fabrics credited with a specialized and miraculous incorruptibility. Flag-like, both the shirts and the non-shirt blankets promise a resurrection—an engorgement, a tumescence, an erection—of the skin: Jack's in the tangible and romantic memory of what was his beloved Ennis, Connolly's in the continued, romantic efforts toward Irish national wholeness, Sands in the same. Each discharge in disappointment.

In our mortuary imaginations, the dead are not absent or decomposed, but rather they are in rags. Libidinal rags comprising the blood-stained shirt-within-a-shirt, a garment coupling now shuffled away into a paper bag; a dead and rotted soldier buried on some battle arena with a note from an unknown Derry woman imagining a more exotic life; the blood-stained museum piece—pressed and presented far from its origin on a breathing, breeding, vital form; the blankets of disgust and fascination.

In the context of an "erotic cloth," I argue against a notion of cloth itself being erotic. Rather, it is the body that is alert or awoken to touch by the cloth or its absence. It is the bodies named above that are tactile, tangible, touched, torn, touching of themselves, and soliciting touch. If we look beyond hard walls and the softer interfaces of shirts and their substitute blankets, we find that it is the fetid, scatological, fluidic, and fetish-erotic emergence of the inner body onto these textiles' surfaces that mesmerizes and repels. The auto-eroticism of blood ejaculate, the orchestrated masochism, the self-inflicted orgasmic hunger, the penetrated martyrdom—these enliven the textiles, but do not eroticize them, for it is the bodies' performance below and beside these cloths that drives their erotic power.

References

Aughey, A. (2005), *The Politics of Northern Ireland: Beyond the Belfast Agreement*, Abingdon: Routledge.

Baert, B. (2011), "Touching the Hem: The Thread between Garment and Blood in the Story of the Woman with the Haemorrhage (Mark 5:24b–34parr)," *Textile*, 9 (3): 308–51.

Barthes, R. (1981), *Camera Lucida: Reflections on Photography*, fifth ed., New York: Hill & Wang.

Brokeback Mountain (2006), [Film] Dir. Ang Lee, USA: Focus Features, USA: River Road Entertainment, Canada: Alberta Film Entertainment, USA: Good Machine.

Darke, C. (1994), "Locky Morris (Review)," *Frieze*, September 6. Available at: https://frieze.com/article/locky-morris–0 (accessed July 12, 2016).

Derwent, C. (2008), "Arrows of Desire: How Did St Sebastian Become an Enduring, Homo-Erotic Icon?" *Independent*, February 10. Available at: http://www.independent.co.uk/arts-entertainment/art/features/arrows-of-desire-how-did-st-sebastian-become-an-enduring-homo-erotic-icon–779388.html (accessed June 17, 2016).

Didi-Huberman, G. (1987), "The Index of the Absent Wound (Monograph on a Stain)," trans. T. Repensek, in A. Michelson et al., *October: The First Decade 1976–1986*, 63–81, Cambridge, MA: MIT Press.

Douglas, M. (1966), *Purity and Danger: An Analysis of Concepts of Pollution and Taboo*, New York: Frederick A. Praeger.

Faiers, J. (2013), *Dressing Dangerously: Dysfunctional Fashion in Film*, New Haven, CT: Yale University Press.

Hunger (2005), [Film] Dir. Steve McQueen, UK, Ireland: Film4, Channel Four Film.

Kitses, J. (2007), "All that Brokeback Allows," *Film Quarterly*, Spring 60 (3): 22–7.

Kristeva, J. (1982), *Powers of Horror: An Essay on Abjection*, trans. L. S. Roudiez, New York: Columbia University Press.

Kuryluk, E. (1991), *Veronica and Her Cloth: History, Symbolism and Structure of a "True" Image*, Oxford: Blackwell.

Marx, K. ([1867] 1967), *Capital: A Critique of Political Economy*, ed. Frederick Engels, Vol. I, New York: International Publishers.

Mendelsohn, D. (2006), "No Ordinary Love Story," *The Gay and Lesbian Review Worldwide*, May/June, 13 (3): 10–12.

Morris, Locky (1992), *Comm* [Exhibition], Manchester: Cornerhouse.

Morris, Locky (1994), *Comm II* [Exhibition], Derry: Orchard Gallery.

Niclaus of Haguenau and Matthias Grünewald (1512–1516), *Isenheim Altarpiece*, Alsace, France: Unterlinden Museum.

Power, M. (2016), "Suicide or Self-Sacrifice: Catholics Debate Hunger Strikes," *The Irish Times*, July 6. Available at: http://www.irishtimes.com/culture/books/suicide-or-self-sacrifice-catholics-debate-hunger-strikes–1.2706886 (accessed July 22, 2016).

Proulx, A. (1997), "Brokeback Mountain," *The New Yorker*, October 13: 74–9.

Proulx, A. (1999), *Close Range: Wyoming Stories*, New York: Scribner.

Roth, P. (2000), *The Human Stain*, Boston: Houghton Mifflin.

Rushdie, S. (1983), *Shame*, London: Jonathan Cape.

Serres, M. (2009), *The Five Senses: A Philosophy of Mingled Bodies*, trans. M. Sankey and P. Cowley, London: Continuum.

Stallybrass, P. (1999), "Worn Worlds: Clothing, Mourning, and the Life of Things," in D. Ben-Amos et al. (eds), *Cultural Memory and the Construction of Identity*, 35–50, Detroit, MI: Wayne State University.

Taussig, M. (1999), *Defacement: Public Secrecy and the Labor of the Negative*, Stanford, CA: Stanford University Press.

Wronsov a.k.a von Busch, O. (2005), *Notebook on TEXTILE PUNCTUM Embroidery of Memory*. Available at: www.selfpassage.org (accessed May 13, 2016).

Thoughts on the erotic:

When we think of erotic cloth, we remember a tantalizing history of daring in dress. We think of the Edwardian bustle skirt which eroticized the buttocks; DuPont's fishnet stockings, contouring the legs, inviting both desire and censure. We recall the tiny pieces of taffeta applied to the face which beckon the lover in Boucher's Lady Fastening Her Garter. *And in the art of the tease, the Burlesque dancers who bind their nipples with pasties and spinning tassels contrast with Madonna, the rock diva whose exaggerated conical breasts on the "Blond Ambition" tour parody womanhood.*

CAROLINE WINTERSGILL and SAVITHRI BARTLETT

8

Empowering the Replicant: Visual and Haptic Narratives in *Blade Runner*

CAROLINE WINTERSGILL AND SAVITHRI BARTLETT[1]

ozens of tiny explosions ripple across the night sky as a vast, illuminated cityscape comes into view, its horizon obscured by smoke. Hovercars in the foreground haloed by rings of light direct our gaze toward vast twin pyramids in the far distance. The camera drifts slowly in to allow us to explore the texture of one of these glittering monoliths, all ironwork and blinking light, external elevators crawling up its surface. In flashes, we see the megalopolis reflected on the surface of a gigantic eye.

We know from the opening minutes of *Blade Runner*[2] that surfaces will be important. Throughout the film, surfaces entice and mislead: animals turn out to be synthetic; crowds in the Chinese sector carry parasols against a non-existent sun; photographs reflect implanted memories; super-sized neon billboards promote opportunities to migrate off-world, when everybody capable of leaving has already left. Elevators appear to be carved out of stone, classical columns denote an imperial past, but there is no imperial past: this is LA in the near future. Or we are told it is LA, but this information too seems unreliable since the cityscape resembles a degraded version of Fritz Lang's *Metropolis*, and indeed it was shot on the "Old New York" street set on the Warner Brothers backlot. The *mise-en-scène* is so detailed and creatively wrought that it becomes part of the problem of surfaces: audiences may be mesmerized by the retrofitted sets cluttered with the detritus of urban life, and sent up blind alleys. In an early review, the critic Pauline Kael complained that "*Blade Runner* doesn't engage you directly; it forces passivity on you. It sets you down in this lopsided maze of a city, with its post-human feeling, and keeps you persuaded that something bad is about to happen" (1982).

The acres of print expended on the film since its first release suggest that critics have not all watched passively. Nonetheless, the visual artistry of the film has received particular attention—the architecture of the cityscape and the Tyrell Corporation pyramid; the long-lens technique which compacts the elements in the frame to give the street scenes their distinctively dense look; the film noir interiors, with their ceiling fans and striped light through blinds; the technical wizardry of the hovercars. But references to the texture of the film have focused almost exclusively on hard surfaces. Commentary on the "soft" surfaces of the film is usually confined to a few lines (at most!)[3] on costume design, generally starting and ending with the observation

that in common with the interiors and the lighting, Rachael and Deckard's wardrobes are inspired by 1940s film noir and that this period aesthetic has prevented the film from looking as dated as one might expect from a 1980s representation of the future. More sophisticated accounts have referred to the fragmented cultural and cinematic citations of the film's wardrobe as examples of the way the film expertly deploys postmodern pastiche (e.g., Bruno 1987). Perhaps costume rarely merits detailed analysis because it works as an intrinsic part of Ridley Scott's multilayered aesthetic vision, of "build[ing] a world that hasn't yet been invented" (Abbott, *On The Edge of Blade Runner* 2000[4]), by evoking, layering, and rearranging images of the past, to overwhelming textural effect. Or perhaps, as Deborah Jermyn suggests (2005: 162), there is a link between the critical focus on male "heroes" (with Deckard and Roy privileged over Rachael), the "masculine" action plot (interrogation, fighting) and the "male" spaces opened up by the film, for example its representation of the city and technology.

We offer an alternative reading. We find that on repeated viewings of this visually stunning film, and across all its versions, it is the soft surfaces—the cloth, or sometimes, the absence of cloth—that compel, both in themselves and in contrast to the hard surfaces of the film. Much critical commentary ignores the film's constant textural juxtaposition: hard surface set against soft surface; structure versus fluidity; the move from the crowd to the still moment; close-ups of faces bewildered, crying and in pain contrasting with the detail-rich city sets. Think of Rachael's kimono-style shirt, let loose from under the tailored suit, extending into the space around her body. Think of the scenes in which first Zhora and then Rachael let down cascades of Pre-Raphaelite hair. Think of the Amazonian Zhora, her skin covered in golden scales, emerging from the crowd of ephemeral "glow worms" in their veiled headpieces, in the smoky candlelight of the Snake Pit. Think of the elevator rising up the monolithic external wall of the pyramid and the contrast with Tyrell's bedroom, the megalomaniac in embroidered white pajamas and a handsome, eighteenth-century-style dressing gown with raised stripes, reclining in his draped and candlelit cocoon. Think of the textural shift in the closing scene, Deckard's hard-boiled raincoat replaced by a voluminous knitted cardigan, Rachael's high-collared fur coat open at the neck and her hair loose over the collar. Our

contention is that these are surfaces that engage not just *visually* but *haptically*. In this chapter we want to examine the *fabric* of the film—to understand how its visual and haptic narratives work in conjunction with or in opposition to each other and to other narrative elements. We want to probe the relationship between machine and flesh and between cloth and skin: how it is problematized, how it reveals the physical life and the psychology of the characters—both human and Replicant—and how it alludes to other narratives that reach beyond the scripted action of the film.

Laura U. Marks (2002) defines *haptic perception* as a combination of the tactile, the kinesthetic, and proprioceptive functions; in other words, the way we experience touch both on the surface of, and inside our bodies: through our skin, our muscles, and our nerves. She also draws a helpful distinction between *optical visuality* and *haptic visuality*, in which the eyes themselves function as organs of touch, engaging the viewer's body in the process of seeing. In this chapter, we have tended to simplify this distinction verbally, referring to *optical visuality* as visual and *haptic visuality* as haptic. Our contention is that the close focus on texture from the very start of *Blade Runner* triggers a different form of perception, one that is automatic and independent of the viewer's conscious recognition. Viewers may be engaged affectively by Rachael's vulnerability as her ego is eviscerated or by Roy's desperation to feel alive in the moments before his death, but long before this they have been engaged haptically, by the choreographed movement of the colorfully dressed crowds through the dark, rainswept streets, by the smoky, chiaroscuro interiors, the close-ups of light moving across fabric and across skin, viewed against the moody soundscape of Vangelis' score. Marks reminds us that modernist theorists of early cinema, including Walter Benjamin, wrote of the sympathetic relationship between the viewer's body and the cinematic image in this period, and that it was only later that theories of linguistic signification began to dominate, though both Burch and Deleuze wrote of the haptic qualities of cinema from the 1960s onwards (Marks 2002: 7). More illuminating to us in understanding the embodied experience of *Blade Runner* is the work of the dance critic, John Martin, who wrote:

> When we see a human body moving, we see movement which is potentially produced by any human body, and therefore by our own. Through kinesthetic sympathy we actually reproduce it vicariously in our present muscular experience and awaken such associational connotations as might have been ours if the original movement had been of our own making.

MARTIN 1936/1968: 117

Recent literature on dance audiences has replaced Martin's *sympathy* with kinesthetic *empathy*, referring to a mostly automatic sense of fellow feeling, embodied and predicated on both muscular and psychic experience (Foster 2010; Mills 2016). The experience of *Blade Runner* is not quite that of the dance audience. It is stranger and more disorienting in (at least) three ways: first, because our experience is more than kinesthetic, it is tactile and proprioceptive too; second, because we feel not just haptic empathy but also, and conditional on this, haptic *alienation*—on discovery of the profound kinesthetic difference of the Replicant Pris in gymnastic motion or the tactile shock as hands are plunged into boiling or freezing liquids; and third, because in particular scenes our tactile, kinesthetic and proprioceptive responses may be in conflict. We see Roy writhing in agony with a nail through his hand to stave off rigor mortis, and moments later basking in the last-chance sensuality of rain on skin. It is the engagement of our haptic empathy that produces both the shudder of alienation and the profound visceral shock of moments of extreme violence in the film—Pris' frenzied assault on Deckard or Roy's blinding of Tyrell. The film's emotional effect is triggered, at least in part, by the jolting shifts of haptic perception it provokes.

The film is rich in both optical and haptic metaphors: eyes, hands, or fingers, and skin reappear constantly as contrapuntal motifs. The gigantic eye in the opening sequence reveals the cityscape with its blazing smokestacks, but does it see as well as reflect? Sight seems to be privileged as a conduit to truth: the police conduct their hunt for Replicants on the basis of visual evidence, but they rely on machines to do their seeing for them. The Voight—Kampff test ignores the subjects' answers and relies only on the dilation of their pupils; yet, as Kaia Silverman (1991: 111) has pointed out the veracity of the machine must be in doubt when the eye it shows is always green, yet Leon's eyes are blue and Rachael's are brown. Deckard's Esper machine enlarges sections of photographs that are completely hidden to the naked eye, while the snake scale found in Leon's office is microscopically

examined, revealing a barcode that leads directly to Zhora. The visual perception of the glowing-eyed Replicants is far superior to those of the humans and the technology they deploy. As Leon and Roy symbolically dress Hannibal Chew, the eye designer, with his own replicated eyes, Roy says, "If only you could see what I've seen with your eyes." Dr Tyrell, the "omniscient" creator, requires thick glasses but he still cannot see what he has created and as Roy realizes this, he enacts his revenge by blinding his maker. In the climactic scene on the roof, Roy's transfiguration occurs when he recounts the marvels he has seen: "I have seen things you people wouldn't believe." And yet, the visual remains slippery. Gaff is human (as far as we know), but his tiny origami models, barely spotted on the ground, hint at new levels of truth. Photographs are treasured as evidence of history but evoke memories that turn out to be implanted. Yet when the visual evidence of Rachael's subjectivity is undermined, we are directed to respond to her reaction in a close-up of her face, with a tear rolling from her eye. If *Blade Runner* is concerned with seeing, it is also concerned with touching. The alien nature of the Replicants is signaled by first Leon and then Pris plunging their hands into tanks of freezing or boiling liquid. The first we see of Roy is him painfully clenching and unclenching his fist to reveal his creeping mortality, then immediately prior to his final showdown we witness him drive a nail into his hand to release the tendons. He breaks Deckard's fingers, depriving him of the use of his own machine-appendage—his gun—and we see Deckard's fingers losing grip at the roof edge and being pulled to safety by Roy's superhuman hands. *Blade Runner* challenges us to question whether we should rely on what we see with our eyes, or on what we feel with our fingers or on our skin. It asks how what we see affects how we feel, or whether it is impossible to rely on the senses at all in a world in which skin and eyes, of the Replicants and of the animals whose skins they wear, are designed and made like costumes, by artisanal creators.

How do the textiles of *Blade Runner*, the distinctive costumes in particular, contribute to the dialogue between visual and haptic? Costume designers Michael Kaplan and Charles Knode drew on an astonishing and evocative range of influences for their work on the film: from Renaissance and eighteenth-century portraiture to the Hollywood Golden Age style of Adrian; from 1920s Jean Patou to 1960s Pierre Cardin; from the figure of geisha to the

Bande Dessinée of Mœbius. The clothes of the leading protagonists draw on, and simultaneously subvert archetypes of the femme fatale, the hard-boiled private eye, the Ayran *übermensch* or the *living doll*.

The three female protagonists, Rachael, Zhora, and Pris, may seem at first sight to belong to completely distinct film worlds. Rachael evokes old-time movie glamour, inhabiting the legendary silhouette invented by Adrian for Joan Crawford in *Humoresque* (1946) (Fogg 2013), updated by Knode and Kaplan with rounded shoulders and fabrics shot through with metallic thread. Kaplan has described Rachael's wardrobe as "a bit of a whacked out take on the 1940s that pushed the clothes into the future." (2011), though there are also references that reach further into the past: her chevron-striped fur coat may be an homage to a 1920s Jean Patou coat in the collection of the Los Angeles County Museum of Art (Maeder 1987). Given the status accorded to animal skins in the film, the suggestion is that this may be a "real" inherited fur, signaling both high status and a family history for Rachael. Though Kael claims that "her shoulder comes into a room a long time before she does" (1982) the first impression we have of Rachael is her high heels clicking across the marble floor. She is soft-spoken, but aloof, almost Garboesque. Some critics have expressed disappointment that, given her wardrobe, Rachael is not played as a wise-cracking broad. Kael complains that she "seems more of a zombie than anyone else in the movie, because the director tries to pose her the way von Sternberg posed Dietrich . . . if Deckard had felt compelled to test her responses it could have been the occasion for some nifty repartee; she might have been spirited and touching" (1982). In Christine Cornea's more critical understanding, Rachael is "a fully encultured being, who like the surrounding cityscape, has been retrofitted with an identity that harks back to film history," her femme fatale silhouette signaling the gendered identity that has been "man-ufactured" for her. Cornea points to the contrast between our expectations of the "dangerous and duplicitous" femme fatale of classic film noir and what she sees as the "vacuous and passive" character of Rachael, which, she argues "foregrounds her function as fetishistic object" (2007: 154–5). Her role as a fetishistic object is underlined by the clear visual parallel between her swept-up hair, white face, heavily kohl-rimmed eyes, and glossy red lips, and the figure of the geisha on the neon billboard that towers above the city, often glimpsed partially obscured through the ironwork of buildings.

The costumes of Pris and Zhora belong to a wholly different genre—underlining their identity as "street people," rather than "air people" (Raban 1991) and allowing them to blend into the chaotic world of the dystopian city streets. Theirs are distinctive and provocative looks, but looks that would be unlikely to merit exceptional comment in the postmodern city, where they might be read as expressions of individualism or of a particular subcultural identity (see Hebdige 1979). Giuliana Bruno notes a continuity between the deterioration and detritus of the post-industrial city and the costumes of Pris and Zhora, which reveal how "consumerism, waste, and recycling meet in fashion, the 'wearable art' of late capitalism" (1987: 64).

We encounter Zhora after her shift as an exotic dancer. Like Pris and Rachael, Zhora's costumes situate her as a fetishized object of male fantasy, both in the strip club and the street. But seen emerging naked from the decadent cocktail set of the Snake Pit club she takes on a mythical role too. The club is part opera set, part George Grosz canvas: its denizens pose in veiled hats, feathers, and oddly sculptural garments of wildly varying period references[5]—from Elizabethan ruffles to the cocktail hats of the 1950s Parisian *femme fleur*. Zhora is almost naked, covered in gold reptilian scales with a snake draped around her neck. She is announced by the club compère as "Miss Salomé," though he introduces her with a line relating to Shakespeare's Cleopatra: "watch her take the pleasures from the serpent that once corrupted men." We might also read allusions to Eve, Lilith, or Medusa. In her dressing room, Zhora changes into streetwear, releasing her hair, as Rachael later does, into wild Pre-Raphaelite curls and putting on the leather bikini and thigh-high buckled boots of the dominatrix, covered by a 1960s Pierre Cardin-inspired transparent plastic raincoat.

We first meet Pris as a homeless punk teenager, hiding in a pile of garbage. She is part waif, part sex-worker, with peroxide hair, torn stockings, garters, a studded collar, and an animal print coat. It is significant that all three Replicant women are seen wearing animal skins. Animals hold a mythological status in the world of *Blade Runner*: we know from the questions put to Rachael in her Voight—Kampff test that many species are close to extinct on earth. They denote a world that has passed. Even replicated animals, such as the owl in Dr. Tyrell's office, are expensive and carry high status. There seems to be a desire on the part of the Replicants to associate themselves with organic life, even if the animal skins, like the skin of the "skinjobs"

themselves, are fabricated. Roy pleads: "we're not computers Sebastian, we're physical," and his climactic scene with Deckard has him howling like a wolf on a roof surrounded by birds—one of which he clasps to his breast and releases into the sky as he dies. In the cases of Pris and Zhora though, the association with animals also reveals the wildness at their core: when hunted, they turn savage.

As we accompany Pris into J. F. Sebastian's apartment, we find that it is populated by dozens of automata. Sebastian explains that he has "made" his own friends, but for a high-tech genetic designer he has created them to a curiously retrograde model: this is a nineteenth-century toymaker's workshop, straight out of Offenbach's *Tales of Hoffman* (1880), with mechanical toys including tin soldiers, bewigged princesses, and a bear in a Napoleon costume. Seen within this context, with her doll-like make-up and stiff movements, we read Pris as an updated version of Olympia—the living doll from the opera,[6] created by the evil Coppélius, who may be read as Tyrell. We know from Bryant's briefing of Deckard that Pris is a "basic pleasure model." She has been created as an object of fetish: a sexy but unthreatening ingénue, with extraordinary kinesthetic abilities, literally capable of doing *anything* for male pleasure. But when Sebastian asks her (as a male client might) to "show me something," what she chooses to reveal first is her nascent subjectivity, quoting Descartes: "I think, therefore I am." With Sebastian, we are pushed toward recognition of a being who resembles us intellectually as well as visually. Yet, she follows this by plunging her hand into Sebastian's egg-boiler, triggering a sudden sense of haptic alienation, a shiver of the uncanny.

Nicholas Royle's depiction of the uncanny as "a crisis of the proper and natural, it disturbs any straightforward sense of what is inside and what is outside" (2003: 2), could refer directly to the Replicants of *Blade Runner*. Interestingly, in their foundational work on the uncanny, both Jentsch and Freud extensively refer to Olimpia (in her original appearance in Hoffman's short story "The Sandman" (1816)).[7] Like *Blade Runner*, Hoffman's short story is shot through with images of both eyes and hands, of seeing and of touch: Coppelius tortures the young Nathaniel by throwing fire embers into his eyes and twisting his hands; Coppola trades in lenses, spectacles, and telescopes, announcing his wares with the cry "Pretty eyes! Pretty eyes!"; Nathaniel is fooled into thinking that Olimpia is real by watching her through a telescope, yet her

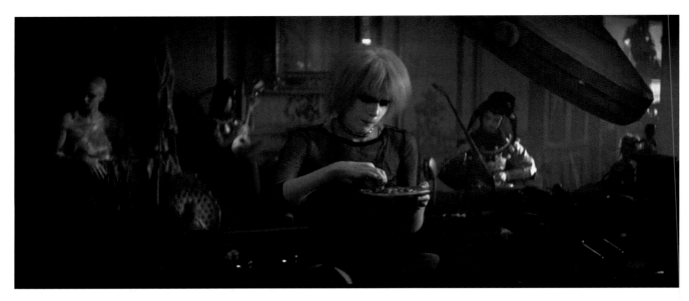

Figure 38 *Pris as Olympia.* Screengrab taken from *Blade Runner: The Final Cut* ([1982] 2007). Director: Ridley Scott; Producers: Michael Deeley (1982), Charles de Lauzirika (2007).

stiffness of movement and coldness of touch belie her humanity. Like Olimpia, Pris shows that she is kinesthetically and tactually alien and, although she doesn't lose her eyes as Olimpia does at the end of "The Sandman," she symbolically blacks them out with make-up.

Masahiro Mori's concept of the "uncanny valley" (1970)[8] may be instructive in understanding the emotional trajectory of our response to *Blade Runner*'s Replicants. Mori argues that the humanoid robot provokes a positive emotional response until a certain point of simulation when replicas appear human but are, somehow, not quite right, when our emotional response dips dramatically and sudden revulsion is triggered. However, as the robot continues to become less distinguishable from a living human, our emotional response becomes positive once again, until it approaches the normal empathetic response to a human subject. *Blade Runner* plays with this uncanny trajectory. In the final scene between Roy and Deckard, we ride the upward slope of Mori's uncanny valley, as the Replicant transforms himself from the uncanny predator able to smash his head through walls, to a moribund Everyman, seduced by the feeling of rain on his skin and transfigured by the beauty of what he has witnessed. During the scenes with Rachael in Deckard's apartment we feel a normal, or near normal empathetic response, which dips sharply into the uncanny valley as Pris turns from doll to murderous, cartwheeling assassin. Indeed, in this scene,

Pris' capacity to terrify goes beyond her uncanny association with Olimpia and she is reminiscent more of the *living doll* figure, a regular trope of the horror genre from the 1960s, but perhaps especially vivid in 1980s films such as *Poltergeist* (1982) and *Child's Play* (1988). Abigail Whittall (2017) has suggested our response to the living doll of the horror movie goes beyond the unsettling realms of the uncanny and into the territory of Julia Kristeva's mapping of the *abject*: "essentially different from 'uncanniness', more violent too, abjection is elaborated through a failure to recognize its kin; nothing is familiar, not even the shadow of a memory" (1982: 5). We suggest that both Pris and Zhora, in their final scenes, personify the abject rather than the merely uncanny. For Kristeva, abjection "disturbs identity, system, order" (1982: 4), "separating out the human from the non-human and the fully constituted subject from the partially formed subject" (Creed 1993: 8). Central to Kristeva's account is the figure of the mother: the "object that guarantees my being as subject" (1982: 33) and the image of abjection as a violent rupturing of surfaces: "evocation of the maternal body and childbirth induces the image of birth as a violent act of expulsion through which the nascent body tears itself away from the matter of maternal insides . . . the skin apparently never ceases to bear the traces of such matter. These are persecuting and threatening traces" (1982: 101).

The skin of the Replicants, however, bears no such traces

of rupture; there is no maternal object guaranteeing their being as subjects. Replicants are derogatively known as "skinjobs" to the blade runners—a term that carries echoes of both prostitution and slavery, but also refers more literally to the crafting of their skin by designers. The synthetic snake scale found in Leon's apartment is microscopically analyzed and found to carry a barcode, which leads Deckard to its Egyptian creator and thus to Zhora in the Snake Pit. Zhora herself carries a "maker's mark," the tattoo of a snake on her cheek, on which the camera lingers after her death. As Roy Batty strips down to his skin on the roof, we see curious markings on the skin of one arm—reminiscent of the branding of slaves. For the Replicants there is no real difference between clothing and skin. Their skin is cloth, crafted for them and part of their fetishized identity: it allows them to pass as human subjects while denying them subjectivity.

Robert Steltenpool (2015: 9) reads Zhora's death scene as a Kristevan rupturing, noting that she is the focal point of three intersecting surfaces: her transparent plastic coat, the glass windows that she runs into, and the laser beam that perforates her skin. He sees her slow motion crash through glass as attempt to escape the boundaries of the city—which fails because there is nothing external—each surface gives way to a new series of boundaries stretching into the distance. The scene has also been read as a post-human reworking of Salomé's "Dance of the Seven Veils." It is critical that what is being ruptured here is a hard surface—pane after pane of glass. This is not the organic "soft surface" of the body, tearing itself out of the maternal flesh and bearing the lifelong imprint on the skin. Zhora's abjection becomes clear when we see her plasticized face, no different from the shop-window mannequins that surround her, with a snake tattoo on her skin—no trace of the mother here, only the trace of a maker.

In her chapter for this book, Catherine Harper writes (with reference to *Brokeback Mountain* (2005)) of the way in which "the palpable bodily phenomena of blood on fabric affects as evidence of sensual experience made visible on the textile. Stained fabric is soaked with libidinal meaning." A curious feature of *Blade Runner* is that cloth remains strangely unsullied by its contact with flesh. Knode and Kaplan have claimed that they deliberately aged the costumes, fading and dirtying them to give the sense of the hard life of the dystopian city for those humans left on earth and to avoid the synthetic quality of other futurist films. That may be true of the crowd scenes—and Deckard appears to have been around the block a few times in his coat, but the clothes of the Replicants do not seem to bear the imprint of a body. Though they carry a strong visual narrative, there is no haptic trace. Zhora's PVC coat has a surface that carries no imprint of the body that wears it and repels bodily fluid—both Deckard's blood and her own. Even in the most violent confrontations cloth resists staining. We recoil with visceral shock as Roy drives his thumbs

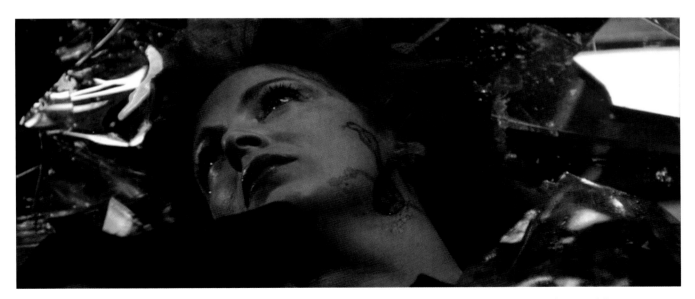

Figure 39 *Zhora abjected, with her maker's mark.* Screengrab taken from *Blade Runner: The Final Cut* ([1982] 2007). Director: Ridley Scott; Producers: Michael Deeley (1982), Charles de Lauzirika (2007).

into Tyrell's eyes; we see the blood gush. Yet Tyrell's white nightwear and bed linen remain pristine; only his glasses are seen covered in blood. We have discussed Rachael's clothes as fetishistic: but they do not reveal the body, rather they sculpt an exaggerated, almost architectural silhouette. This is clothing as *costume*, clothing as *disguise* rather than clothing as *worn*. It is clothing that acts as a protective shell, against pursuers, against the city, against the body. Sebastian first appears in a helmet, protecting him against the city, and a curious multicolored jacket with a soft ruff, which references both 1940s motorcycle jackets and the doublets of Henry VIII—perhaps an appropriate combination for a young man suffering from Methuselah Syndrome. There are elements of the fairytale in his dress, reflecting the storybook setting of his apartment. But it is also worth noting that the ruff is traditionally a protective garment, inhibiting direct contact between the outer clothing and the skin, thus protecting Sebastian from the effects of his accelerated decrepitude. On her first visit to Deckard's apartment, Rachael appears in a dramatic dark coat, her collar turned up high—evocative of a figure from Jacobean revenge drama as much as film noir, but she also looks forward (as befits a film set in the future) to Jennie Peneus' "head-cocoons," designed to enable urban dwellers to hide from surveillance cameras, or Veasyble's "wearable accessories," convertible at a touch into a means of isolation (Bolton 2002). She is protecting herself against the city and also against closer interrogation as a human. Her clothing and hair, coiffed into a style reminiscent of Marlene Dietrich's cloche hat in *Shanghai Express* (1932), ensure that she remains inscrutable.

Rachael's protective mask slips as Deckard deconstructs her childhood memories and the photographic evidence of her mother is revealed to be fabricated. In her discovery of her Replicant status comes our discovery that her cool exterior is replicated too. Like Zhora and Pris she is a fetishized object, as much a product of Laura Mulvey's "male gaze" as her classic cinematic counterparts and the model of what a powerful man might want in a personal assistant—beautiful, inscrutable, coolly witty, and dressed in a constricting wardrobe that binds her according to male expectations. We remember Deckard's words to Tyrell: "how can *it* not know what *it* is?" (emphasis ours). Rachael has been "man-ufactured" (to use Cornea's expression) as an object not a subject. Kristeva's abjection is a powerful theme in this scene: Rachael's childhood recollections

are of baby spiders breaking out of their egg and eating their mother and of running away to avoid showing her female body to her brother. But instead of haptic alienation we are encouraged to feel haptic empathy. We see Rachael's reaction in close-up, her vulnerability clear in her face. When cornered, she does not, like Leon, Zhora, or Pris turn violent, inhuman. The "emotional cushioning" with which she has been designed to allow her creators to better control her also grants her self-control. In *Undressing Cinema*, Stella Bruzzi writes of how the femme fatale is constructed yet misunderstood under the male gaze: "Is not the gaze of the hapless men in film noir at least in part mocked because they never understand the complexity of what they are looking at?" (1997: 127).

Rachael's response, like Roy Batty's later Oedipal encounter with Tyrell, is to abject herself by the violent destruction of her kin—and she shoots her fellow Replicant, Leon. She returns to Deckard's apartment in shock, where he recognizes the "shakes" she experiences as the emotional reaction of a fellow human. As Deckard sleeps, Rachael removes her structured jacket, revealing a liquid satin blouse. The blouse is sensuous and tactile but there may also be a reference to the kimono-inspired garments of Kenzo Takada[9] and thus a further link to the figure of the geisha, imprisoned on her neon billboard. In Japanese culture, the geisha and the mother figure are seen as opposing binaries. We see Rachael test out a deeper layer of her memory by playing the piano (it is significant that her fingers are brushing the ivories—another reference to a vanished world of organic matter), and then studying the family photographs on Deckard's piano, which show generations of mothers. Seemingly in imitation she lets her hair down curl by curl. And in this undoing of her sartorial carapace—the fetishized exterior—the woman emerges as an erotic figure. We might recall here that the femme fatale was not invented by film noir. She extends back into mythology, to Pandora, Eve, or Lilith, women who tempted and ultimately ruined men. As she lets her hair down at the piano, Rachael resembles a Pre-Raphaelite femme fatale. Jan Marsh describes the Pre-Raphaelite brotherhood as "fascinated but repelled, at women of a curious frigidity, cold but sensual, erotic but invulnerable," controlling their fear of female malevolence by the creation of the symbolic figure of the femme fatale—in which "women are rendered decorative, depersonalized; they become passive figures rather than characters in a story or drama" (1985: 144).

Figure 40 *Rachael lets down her hair.* Screengrab taken from *Blade Runner: The Final Cut* ([1982] 2007). Director: Ridley Scott; Producers: Michael Deeley (1982), Charles de Lauzirika (2007).

"Cold but sensual, erotic but invulnerable": this epitomizes the male fear of the Replicant woman. When confronted by the erotic but invulnerable Zhora—the image of John Collier's *Lilith*—naked and draped in a snake, Deckard's fear of her malevolence is palpable. If she is Salomé, he cannot reveal himself as John the Baptist, so he casts himself in the role of the nerdish petty bureaucrat checking for peepholes—emasculated and hardly worthy of ruination.

Just as the "male gaze" misunderstood the complexity of the 1940s femme fatale, so the Pre-Raphaelites misunderstood the complexity of their muses. The Pre-Raphaelite paintings reveal a newly sexualized female body emerging from the rigidity of Victorian dress; they also reveal women who are reflective, increasingly empowered, and sometimes defiant. In thinking about Rachael it may be instructive to look beyond Rossetti's *Lady Lilith* to one of his many paintings of Jane Morris, gazing not at the painter but inwardly, at herself. The "difficult" seduction scene between Deckard and Rachael, should, in our view, be read in this light, with Rachael struggling to emerge into erotic subjectivity from a containment she has only just recognized. We find Kaja Silverman's reading of the scene convincing (1991: 129): it hinges on Rachael's muttered line "I can't rely on . . . " and its relation to the immediately preceding conversation in which Rachael explains that she didn't know whether she would be able to play the piano, since her memory of

lessons may have belonged to someone else. Silverman reads this as Rachel telling Deckard that she cannot rely on the desire she is feeling as it may come from someone else. While Deckard's coercion remains problematical, what he is trying to do is to induce her to articulate a desire she has already revealed in kissing him. If we cannot trust what we see, or what we remember, then we must trust what we feel with our bodies: the haptic truth. Rachael's emergence as an erotic subject is confirmed by her unprompted utterance: "put your hands on me," and by her passionate kiss.

In the concluding moments of the film, Deckard returns home to find Rachael asleep under a sheet. There is a moment's suspense in which we fear a repeat of Pris or Zhora's final scenes, the haptic alienation of the abject, Replicant body. But Rachael is alive and draped in fabric, like Leighton's *Flaming June*, with echoes too of the comfort and protection of the maternal bed. It is a rare image of everyday sensuality, in this dystopia of hard surfaces, revealing a Replicant who has, miraculously, been reborn, humanized.

Rachael may indeed have been empowered by her sexual agency; but Deckard's role in her seduction remains problematical. As she rises to leave he slams the door, hurling her aggressively against a window frame, he kisses her forcibly, and he tries to put words into her mouth. This is a man who has recently shot a woman in the back and is about to shoot a second. Bruzzi notes that female characters in film are always more likely to be "read" through the

way they look than male characters (1997: 126), but Deckard's wardrobe is worthy of attention. He is the model of the 1940s hard-boiled private eye, a Sam Spade for the post-apocalyptic world and presumably precisely what the regime might have wanted for its blade runners: cynical, amoral, detached. He wears an updated variation on a Burberry gabardine Macintosh, a coat made famous by men of action including Roald Amundsen and Ernest Shackleton. Like Rachael his costumes have a contemporary twist, with shirts and ties redolent of the Armani ensemble worn by Richard Gere in *American Gigolo* (1980). Since, like Rachel, Deckard is a film noir archetype, and we know that Rachael is a Replicant, this must raise questions about Deckard. But Silverman points out that Deckard is not the only "human" character to be a citation from film history: Tyrell himself "reprises a whole history of imaginary scientists who give rise to unconventional lifeforms, from Frankenstein to *Metropolis'* Dr Rotwang" (1991: 124). Gaff is the image of a 1940s mafioso in his colorful bow tie and waistcoat and his fedora hat. Perhaps it doesn't matter whether Deckard is a Replicant or not: the point is that like everyone else trapped in this endless megalopolis of smoke and mirrors, Deckard has very little agency. He is under the control of Bryant and his vocation as a blade runner. He is in love with a woman who won't live. Freedom, like the unicorn Deckard dreams of, is a mythical concept.

And what of Roy Batty? Roy first appears in a 1940s military parka (Gunn et al 2014); with his white blond hair and his sardonic smile he is the image of Aryan manhood. But the menacing Nazi exterior is ironic: Replicants are the Jews in this Fascist regime, systematically "dehumanized" by their creators in order to justify their annihilation (not "execution" but "retirement'). After his Oedipal confrontation with his "father"—a passionate kiss followed by violent murder—Roy appears on the roof, an abject figure, bloodied and near-naked, as if reborn (though we know he is dying), taunting Deckard into a contest to decide which anti-hero can perform their humanness with the most conviction. His nakedness reveals his refusal to be fetishized—except by himself. Like Rachael wrapped in her sheet, he seems in love with the world of the senses, but he luxuriates in his ability to feel pain as much as the feline agility of his body or the sensuous touch of rain on his skin. Scott Bukatman notes Roy's "joy in *performance*. He purses his lips, taunts, teases, confesses remorse, paints his face and in general eroticizes the world," quoting one of the drafts of Hampton Fancher's original screenplay in which Roy is described as "somewhere between a Comanche warrior and a transvestite" (Bukatman 2012: 96). Of all the allusions this final scene could have made—Prometheus, Frankenstein—with his athletic body in underpants and shoes and his white blond hair, the cinematic citation that most comes to mind is Rocky, from

Figure 41 *Roy's final moments in the rain.* Screengrab taken from *Blade Runner: The Final Cut* ([1982] 2007). Director: Ridley Scott; Producers: Michael Deeley (1982), Charles de Lauzirika (2007).

The Rocky Horror Picture Show (1975). Roy may speak the most transcendent lines of the film: "I've seen things you people wouldn't believe," but, as Bukatman argues, he is above all a transgressive figure. In terms of the haptic narrative of the film, it is significant that his last act is about touch—taking Deckard's bloodied fingers and pulling him back from the edge; and that his soliloquy has haptic as well as visual resonance ("all these moments will be lost in time, like tears in rain").

Blade Runner is a palimpsest, upon which layer after layer of historical and cultural allusion has been written, erased, and rewritten. In this chapter we have tried to extract some of the film's myriad references—to fashion, architecture, cinema, literature, mythology, painting, opera, dance, and the natural world. Some become important subtexts; others flicker into life suggestively for a millisecond before disappearing. Together, they construct a world in the late stages of human history, which bears the traces of everything that has been before. We read the text of *Blade Runner* as an archetypal story, against the backdrop of myriad subtexts. The cinematic citations observed in the leading protagonists continue into the scenes of city life, which, like the scene at the Snake Pit club, are reminiscent of a masked ball. We view a tapestry of scurrying figures under umbrellas, Hare Krishnas in saffron robes, urban gangsters, girls in taxis in 1940s-style berets; against backdrops of Greco-Roman remains, Egyptian souks and Vietnamese street markets. If Replicants are citations of the past, then so are we all; we make and remake ourselves from fragments of memory. As we suggested earlier in this chapter the effect on the viewer of all these intertextual riches is at a subconscious level; we join the dance and we lose ourselves in its rhythm.

We opened this chapter with a discussion of the surfaces of the film: why do hard surfaces predominate, both in the film itself and in critical readings of it? Why are the soft surfaces, when they do appear, so compelling? This is the city as machine, its inhabitants cyborgs (even those who think they are human rely upon machines to see, to deduce, to entertain, to befriend). There are no animals, no trees, no sun, no sense of the city ever ending: the only glimpse of nature or daylight we get is in Deckard's reverie of a unicorn—an impossible myth. In the absence of nature it is the soft surfaces of *Blade Runner* that carry the embers of the organic world. They remind us of reproduction, birth, maternal comfort, joie de vivre, sensual delight:

things we have seen and felt and are now merely tears in rain. In a sense, it is the megalopolis itself in *Blade Runner* that is abject, but forever carrying traces of the organic life from which it has been torn.

Notes

1 We would like to thank Alison Carter who, despite a personal dislike of science fiction, watched *Blade Runner* with us with a costume historian's eye, suggesting myriad references or allusions that we would otherwise have missed. We would also like to thank Dana Mills and Abigail Whittall for presenting fascinating papers on seemingly unrelated topics (respectively dance and political theory and the *living doll* in horror cinema) which led us to new connections with and understandings of *Blade Runner*.

2 There have been several different versions of *Blade Runner* since its first release in 1982. In this chapter we refer to *Blade Runner: The Final Cut* (Scott 2007), widely regarded as the definitive version since it is the only one over which Ridley Scott had complete artistic control. It contains a full-length version of Deckard's "unicorn reverie" but omits the voiceover and "happy ending" of the original release.

3 There is either no mention of costume at all, or a scant few lines of description in the vast majority of cinéaste literature on *Blade Runner*, including the otherwise comprehensive *Future Noir: The Making of Blade Runner* (Sammon 1996), or in either of the documentaries on the making of the film (*On the Edge of Blade Runner* (2000) and *Dangerous Days: Making Blade Runner* (2007). *Blade Runner* costumes have been exhibited in several exhibitions of film costume including *Hollywood Costume* at the Victoria and Albert Museum in London in 2013, and they feature in a number of costume books (e.g., Maeder 1987; Landis 2013). Original costume sketches by Charles Knode and Michael Kaplan may also be seen online: https://issuu.com/futurenoir/docs/bladerunner_sketchbook (accessed January 10, 2017). There was a useful article "The Look of Blade Runner" on Christian Esquivin's Silver Screen Modes blog in June 2012: http://silverscreenmodes.com/tag/blade-runner/ (accessed January 10, 2017). In the academic literature we have found only a single article devoted to costume: "Skirting the Edge: Costume, Masquerade, and the Plastic Body in *Blade Runner*" (Myman 1996) which focuses on the costume of the female Replicants.

4 Interview with Michael Deeley, *Blade Runner* producer.

5 For a vivid description of the costume references in the Snake Pit, see Myman (1996).

6 A connection between Pris and Olympia in *Tales of Hoffman* has been previously noted by Kael (1982) and Bruno (1987).

7 Hoffman used the German spellings for his characters Olimpia and Coppelius, while Offenbach's librettist, Jules Barbier used the French spellings, making them Olympia and Coppélius.

8 The concept is Mori's but the term "uncanny valley" first appears in English in Reichardt (1978).

9 In 1977 Kenzo staged an influential show for the opening of Studio 54 in New York, with Grace Jones, of which Knode and Kaplan would have been aware.

References

American Gigolo (1980) [Film] Dir. Paul Schrader, USA: Paramount Pictures.

Blade Runner: The Final Cut ([1982] 2007) [Film] Dir. Ridley Scott, USA: Warner Brothers.

Bolton, A. (2002), *The Supermodern Wardrobe*, London: V & A Publishing.

Bruno, G. (1987), "Ramble City: Postmodernism and 'Blade Runner,'" *October*, 41: 61–74. doi:10.2307/778330.

Bruzzi, S. (1997), *Undressing Cinema: Clothing and Identity in the Movies*, London: Routledge.

Bukatman, S. (2012), *Blade Runner*, 2nd ed. London: Palgrave Macmillan on behalf of the British Film Institute.

Child's Play (1988) [Film] Dir. Tom Holland USA: MGM.

Cornea, D. C. (2007), *Science Fiction Cinema*, Edinburgh: Edinburgh University Press.

Creed, B. (1993), *The Monstrous-Feminine: Film, Feminism, Psychoanalysis*, London: Routledge.

Dangerous Days: Making "Blade Runner" (2007) [Video] Dir. Charles de Lauzirika, USA: Warner Home Video.

Esquivin, C. (2012) "The Look of Blade Runner," Silver Screen Modes. Available online: http://silverscreenmodes.com/the-look-of-blade-runner/ (accessed November 5, 2016).

Fogg, M. (2013), *Fashion: The Whole Story*, London: Thames & Hudson.

Foster, S. L. (2010), *Choreographing Empathy: Kinesthesia in Performance*, London: Routledge.

Freud, S. ([1919] 2003), *The Uncanny*, London: Penguin.

Gunn, D., Luckett, R., and Sims, J. (2012), *Vintage Menswear: A Collection from the Vintage Showroom*, London: Laurence King.

Hebdige, D. (1979), *Subculture: The Meaning of Style (New Accents)*, London: Routledge.

Hoffmann, E. T. A. ([1816] 2016), *The Sandman*, London: Penguin.

Humoresque (1946) [Film] Dir: Jean Negulesco, USA: Warner Brothers.

Jentsch, E. ([1906] 1996), "On the Psychology of the Uncanny," trans. R. Sellars, *Angelaki*, 2 (1): 7–16.

Jermyn, D. (2005) "The Rachel Papers: In Search of *Blade Runner's* Femme Fatale" in W. Brooker (ed.), *The Blade Runner Experience: The Legacy of a Science Fiction Classic*, 159–72, London: Wallflower Press.

Kael, P. (1982), "Baby, the Rain Must Fall," *The New Yorker*, July 12: 82–5. Available online: http://scrapsfromtheloft.com/2016/12/28/blade-runner-review-pauline-kael/ (accessed January 29, 2017).

Kaplan, M. (2011), "How I Dressed the Movie Stars for Success," *Independent*, January 21. Available online: http://www.independent.co.uk/arts-entertainment/films/features/michael-kaplan-how-i-dressed-the-movie-stars-for-success–2318165.html (accessed November 5, 2016).

Kristeva, J. (1982), *Powers of Horror*, New York: Columbia University Press.

Landis, D. N. (2013), *Hollywood Costume*, London: V & A Publishing.

Maeder, E. (1987), *Hollywood and History: Costume Design in Film*, London: Thames & Hudson.

Marks, L. U. (2002), *Touch: Sensuous Theory and Multisensory Media*, Minneapolis, MN: University of Minnesota Press.

Marsh, J. (1985), *Pre-Raphaelite Sisterhood*, London: Quartet.

Martin, J. J. (1936/1968), *America Dancing: The Background and Personalities of the Modern Dance*, New York: Dance Horizons.

Metropolis (1927) [Film] Dir. Fritz Lang, Germany: Universum Film.

Mills, D. (2016), *Dance and Politics: Moving Beyond Boundaries*, Manchester: Manchester University Press.

Mori, M. ([1970] 2012), *The Uncanny Valley: The Original Essay*, IEEE Spectrum: Technology, Engineering, and Science News. Available online (http://spectrum.ieee.org/automaton/robotics/humanoids/the-uncanny-valley (accessed February 1, 2017)

Mulvey, L. (1989), *Visual and Other Pleasures*, London: Macmillan.

Myman, F. (1996), "Skirting the Edge: Costume, Masquerade and the Plastic Body in *Blade Runner*." Available online: http://francesca.net/PlasticBody.html (accessed January 16, 2017).

On the Edge of Blade Runner (2000) [TV program] Dir. Andrew Abbott, London: Channel 4, July 15, 2000.

Poltergeist (1982) [Film] Dir: Tobe Hooper, USA: MGM.

Raban, J. (1991), *Hunting Mr Heartbreak*, London: Picador.

Reason, M. and Reynolds, D. (2010), "Kinesthesia, Empathy, and Related Pleasures: An Inquiry into Audience Experiences of Watching Dance," *Dance Research Journal*, 42: 49–75.

Reichardt, J. (1978), *Robots: Fact, Fiction and Prediction*, London: Penguin.

The Rocky Horror Picture Show (1975) [Film] Dir. Jim Sharman, UK, USA: Twentieth Century Fox.

Royle, N. (2003), *The Uncanny*, Manchester: Manchester University Press.

Shanghai Express (1932) [Film] Josef von Sternberg, USA: Paramount Pictures.

Silverman, K. (1991), "Back to the Future," *Camera Obscura*, 9 (3 27): 108–32. doi:10.1215/02705346

Steltenpool, R. (2015), "Abject interiors, Uncanny Surfaces, and Laser Beams in Blade Runner." Available at: https://www.academia.edu/9120446/Abject_interiors_Uncanny_Surfaces_and_Laser_Beams_in_Blade_Runner (accessed January 27, 2017).

Whittall, A. (2017), "When Dolls Attack: Horror Films, Living Dolls and the Monstrous-Feminine," Faculty of Arts Research Seminar Paper, January 25. Winchester: University of Winchester.

Further Reading

Bolton, A. (2004), *Wild: Fashion Untamed*, New York: Metropolitan Museum of Art.

Fisher, W. (1988), "Of Living Machines and Living-Machines: *Blade Runner* and the Terminal Genre," *New Literary History*, 20: 187–98. doi:10.2307/469327.

Marks, L. U. (2000), *The Skin of the Film: Intercultural Cinema, Embodiment, and the Senses*, Durham, NC: Duke University Press.

Piazza, A. (2016), *Fashion 150: 150 years/150 Designers*, London: Laurence King.

Sobchack, V. (1991), *The Address of the Eye: A Phenomenology of Film Experience*, Princeton, NJ: Princeton University Press.

Sobchack, V. (2004), *Carnal Thoughts: Embodiment and Moving Image Culture*, Oakland, CA: University of California Press.

Wilcox, C. (2015), *Alexander McQueen*, London: Victoria and Albert Museum.

Thoughts on the erotic:

Erotic cloth is the sweep of silk across dry, warm skin, the almost touch of the caress. It is the awakening to myself and to the cloth through that touch at the surface of my skin.

CATHERINE DORMOR

9

Caressing Cloth: The Warp and Weft as Site of Exchange

CATHERINE DORMOR

Skin moves against and towards, across and over skin. It is warm here. Within the intimacy of the moment, an infinitesimal space between opens out and becomes its own universe. Two bodies enfolded within the voluptuousness of that which emanates from within and between.

Entwined, entwining, interlaced, the bodies move and shift, against and alongside and yet do not merge into one. Held together with flexible threads, enabling each other to spill out and over, enabling exorbitance and excess. Movement together continually repeated as it reinforces each's individuality.

You-ness and I-ness spill out and over in their own extravagance

You surface at my skin and I at yours

I Love to You

I come close to you

Thinking of and from an attentive body, this chapter takes as its starting point the notion of the caress as a means of thinking that starts from bodily exchange with cloth. In this it positions warp and weft as a site of agency, production, and erotic exchange.

The interplay of warp and weft offers a means by which to think through the caress as a form of porous communication. Taken initially as an intimate relationship between two, the discussion here will be framed around the notion of the caress as a (re)awakening. This term draws upon Luce Irigaray's search for a language of the caress (2000) and aims to establish a generative space of, and for, bodies, cloths, and structures of cloths that moves from binary towards multiplicity. The caress enables this shift in its focus upon existing and producing within the space, rather than prioritizing notions of arrival, possession, and product.

For Irigaray, the caress is "a gesture between us," that is, "neither active nor passive . . . an awakening of gestures, of perceptions that are at the same time acts, intentions and emotions" (2000: 25). In this sense, then, the caress can be characterized as gesture-word (*geste-parole*) (ibid.: 26), and thus establishes it as an intentional act that moves between the intimate and the intersubjective. Thus the caress operates both as an invitation to the other and to a return to the self. Such movement between self and other describes a site for the caress that binds together body and world: gesture-in-making and gesture-of-production (ibid.: 25–9). This is a subtle distinction, but one that is worth making here in that subtlety. Where gesture-in-making is the bodily action that expands touching and touched into the space of the caress, i.e., making the caress, gesture-of-production is that which the space of the caress produces, i.e., the awakening of both to that space and its dialogue. It is thus through the space of the caress, the gesture-space, that enables the intimate act to become a site of multiplicity.

In order to construct and explore this framework, three points of departure will be taken: *interlacing*, which explores the idea of the caressing cloth as stimulus between "skins" or bodies; *insertions*, which develops the idea of the caressing cloth as a gesture-space which enables the body to expand and enfold into/onto itself; and finally, an *itinerant* caressing cloth, which sets out in search of a space that can hold both anticipation and memory in repeated, restless relationship.

In thinking about the caress as an awakening to the self, to the other, and to the space generated between and around that gesture, there is the potential for thinking about intimacy and touch beyond the private, but without losing the intensity of that encounter. To this end three artists and artworks will be the focus for this thinking, all of which are monumental in scale, but all offer the caress of cloth as in intense and intimate relationship of openness and porosity: Ann Hamilton's *The Event of a Thread* (2012–13), Chiharu Shiota's *The Key in the Hand* (2015), and Susie MacMurray's *Promenade* (2010). All three artists work with textile, thread, and cloth specifically for its syntax, histories, and haptic potential, making them useful leaping-off points for thinking of cloth as gesture-space.

(Re)awakening

The caress is an awakening to you, to me, to us.

IRIGARAY 2000: 25

Cloth surrounds us from the moment of birth, making it probably unsurprising that it constantly exceeds the cognitive, verbalized meanings, metaphors, and concepts that are applied to it. It is this excessive, exorbitance and over-spilling of language that gives cloth its potency, but also makes talking about it complex and sometimes fraught. Textile practitioner and theorist Solveigh Goett describes the particular affinity that arises between skin and cloth as one that is self-evident (Goett in Jefferies et al. 2016: 122). For Goett, this intimate, self-evident relationship becomes the basis for a bodily understanding of cloth. Cultural theorist Sarat Maharaj refers to such overspilling of cognition and knowing as "boundaried boundarilessness" (1991: 94), as a means for thinking about the excessiveness of cloth that doesn't attempt to pin it down, to restrict its fluidity an;d multiplicity. Janis Jefferies (2016) refers to textiles' "ambivalence," which conjures up similar notions and flags up textiles' resistance to such bounding. Such ambivalence brings us back to Goett's "first and second skins," and the intimate, porous, and excessive relationship between cloth and body: "Textile knowledge emerges from experience involving all the senses—it touches the skin, enters through the nose, makes sounds and has taste . . . experience lived and felt by being, quite literally, in touch with textiles" (Goett in Jefferies et al. 2016: 130).

Body and cloth's caress is further interwoven by the caressing of warp and weft within the cloth itself. Cloth is produced through this intimacy, giving both warp and weft agency in the erotic charge, mirroring and expanding the exchange between body and cloth. Thus cloth and body produce together an intimate, caressing space of woven cloth, warp, weft, skin, and body, forming a supplementary perspective for knowing, making and activating: for thinking through cloth, which like the caress becomes a site of erotic exchange: of excessiveness and exorbitance.

Interlacing

As skin caresses skin, cloth caresses skin, skin caresses cloth, they exist in proximal relationship. To think of this as an interlacing between skin, cloth, and skin is to think of an intricate crisscrossing of threads that can be loosened or tightened accordingly.

the event of a thread is made of many crossings of the near at hand and the far away: it is a body crossing space, is a writer's hand crossing a sheet of paper, is a voice crossing a room in a paper bag, is a reader crossing with a page and with another reader, is listening crossing with speaking, is an inscription crossing a transmission, is a stylus crossing a groove, is a song crossing species, is the weightlessness of suspension crossing the calling of bell or bellows, is touch being touched in return. It is a flock of bird and a field of swings in motion. It is a particular point in space at an instant of time.[1]

Installed in the Park Avenue Armory, New York, the work is complex and intricate, constructed from ropes, pulleys, swings, readers, writers, birds, and waves of white silk, 70 foot high and more than twice the hall's width.

The installation focuses around an immense, white silk cloth suspended across the center of the armory's 55,000 square foot Drill Hall. On either side, at intervals, are

Figure 42. Ann Hamilton, *The Event of a Thread,* **2012.** Wade Thompson Drill Hall, Park Avenue Armory, New York, USA. Photographer: Al Foote III.

forty-two wood-plank swings, big enough for two adults, each suspended with heavy chains to both the ceiling beams and to the rope-and-pulley system supporting the cloth. The swings are for the viewers, and it is their swinging that animates the cloth, causing it to billow and swirl above the floor, as more viewers lie beneath.

Surrounding and embellishing the cloth and swings are further elements that intertwine with one another: a flock of homing pigeons that coo and peck in their cages; forty-two radios in paper bags that viewers can carry with them and listen to their broadcasts; broadcasts made by readers at one end of the hall reading from scroll-like texts (Charles Darwin, William James, Ann Lauterbach, Thomas Emerson); a scribe at the other end writing unscripted texts in response to the space and its inhabitants (letters, poems, short stories, disconnected scraps of thought). At the end of each day, the pigeons are released from their day cages, free to fly around the hall and trained during the timespan of the installation to return to their large homing cage, serenaded by a vocalist. Each day the song is cut into a record, ready to be played back during the following day.

The white cloth undulates and billows in response to the swings, while viewers lie and sit beneath, raising their hands upwards to feel its caress. The cloth moves backwards and forwards, sweeping up and down, capturing its audience within its folds—each apparently caught up in the intimacy of its caress within the public space and publicly in intimate caress.

Hamilton speaks of the many crossings as a particular point in space at an instant of time, a way of talking that captures the sense of the caress as an interlacing. Through these crossings or interlacings of the caress the partners exist together to surface at each other's skin.

To think of this work in terms of the caressing cloth calls to mind Hannah Arendt's summons to enlarged thinking: "To think with an enlarged mentality means that one trains one's imagination to go visiting" (1978: 257).

For Arendt it is imagination that allows us to see the world from another's point of view. In this sense, then, Arendt's "visiting imagination" is the mechanism of interlacing by which we are able to gain another's vantage point or viewpoint. Visiting is "being and thinking in my own identity where actually I am not" (Arendt 1966: 241). Thus the visiting imagination entails the preservation of one's own identity, while metaphorically or physically placing ourselves alongside that other and allowing thinking to run "from place to place" (ibid.: 242).

To go visiting is to spend time in those places, with their residents, to be introduced through their eyes and bodies, rather than in place of them. Interlacing offers a mechanism or process for approaching, for coming into intimate proximity with others, with identities distinct from our own but to which we can relate through our own experiencing of them and through our enlarged imagination.

The event of a thread takes its viewer visiting, crisscrossing the voluminous space of Park Avenue Armory, to Anni Albers' reflection that all weaving traces back to "the event of a thread" (1965: 13), to the swingers moving to and fro, activating the excessive white cloth that bags and billows above the expectant bodies strewn below. The parts affect each other and yet retain their own individuality within the whole. *The event of a thread* lingers between solitary acts and communal field: there is an attendance, an enlargement towards the others along the crossings, threads and interlacings that make up this work.

T'ai Smith, in her essay "The Event of a Thread" (2015: 76–88) goes visiting Anni Albers and the Bauhaus to understand what the event Albers refers to is. Smith argues that Albers brings together the specificity of weaving cloth with other modes of thought (such as philosophy, economics, and poetry) in order to transform the ubiquitous and thus unspoken known into thought patterns that matter. In visiting, Smith approaches the event of a thread in dialogue with Albers and finds a mode for thinking that is not *about* weaving, but one that emerges *from* within its structures and processes, from the caresses.

Returning to Hamilton's *the event of a thread*, the caresses between warp and weft, cloth and skin affect and are affecting, touch and touched in reciprocal exchange. This interlaced space of the caress acts as a stimulus between that exceeds and spills over in exorbitant production: makes space for the erotic charge of the caress.

In this spilling over, the cloth and its interlacing together is exceeded. Like the caress, it awakens to the other and thus becomes Maharaj's "boundaried boundarilessness." In the intimacy of the caressing space, of body and cloth the exorbitance generated requires a supplementary approach, a means to enable and support the expansion and excess. This space needs to be expandable to work more closely to the body, but also to enable greater movement through the insertion of extra fabric sections. Such

insertions simultaneously stabilize the cloth structures and create greater fluidity and flexibility in relation to the body. In this sense they extend the work of interlacing, responding to the awakening stimulated, allowing the silk to move freely to and fro across the shoulder, giving space for the wool to drape down the leg.

Insertion

Where Hamilton presents the viewer with a voluptuous, excessive, caressing cloth, Chiharu Shiota's *The Key in the Hand* (2015) features dense webs of threads. Shiota's web or hyphology[2] entails themes of remembrance, home, and the loss of childhood and result in the production of quietly mysterious, disturbing, and poetic artworks. As the spider, she spins her webs, her tissue incorporating and enveloping her prey: keys, boats, photographs, videos, memories, children, and viewers. These thread secretions invade and insert themselves into the space, establishing a tensional field that holds the viewer between the familiar and unfamiliar, safety, and danger. The works threaten to entrap, while at the same time they promise of travel and movement. The web of threads and its entrapments appear to reach out towards that viewer, creating a gesture-space

that invites the viewer into the space: a point of erotic charge. The boundaries between threads, boats, keys, artist, and viewer become porous and each becomes enhanced and diffused in the touch of one upon the other. The caress as insertion suggests a gesture-space that hovers between invasion and refuge, parasitic and symbiotic, not quite either, always provisional.

Touch, and thus the caress, has a physical manifestation and process that is useful here in locating cloth as a site of erotic and creative exchange. The two upper layers of the skin, the epidermis and the dermis, are the organs of touch only when acting reciprocally and in tandem with one another. The epidermis is the upper surface of the skin, the outermost, protective layer; this is the layer we see. Beneath this lies the dermis, the thickest layer and home to the sense receptors for most forms of touch, pressure, and pain.

In the act of touching and caressing, the epidermis is what is felt and it is the dermis that feels. As the one lover caresses the other, so both partners are active, meaning-making participants, both feeling and felt, dermis and epidermis, simultaneously reversing and connecting. Thus to feel is to be felt as the activity of dermis and epidermis of both partners come together at the site of the skin.

The shape of such an exchange can be thought of in terms of cloth insertions. By this I mean the sort of

Figure 43 Chiharu Shiota, *The Key in the Hand*, 2015. Installation for the Japan Pavilion, 56th Venice Biennale.

insertion found in tailoring, whereby extra fabric is inserted to expand, shape, and extend the flow and fit of the garment: godets, gussets, and gores.[3] The insertion is thus a supplement to the main body of the garment.

For Jacques Derrida, the supplement as an addition functions as an extra or surplus that enriches and completes, so that the original elements that have been supplemented can be recognized fully (1976: 144–6). In this way the garment without a gusset, godet, or gore sits against the body, but once the extra fabric piece has been added, it moves and flows *with* that body—the supplement recognizes the body and completes the both garment and body. In this sense, then, the insertion resists a supporting role, establishing itself as necessary and vital to both garment and body.

To think of the caress in terms of an insertion or supplement to the relationship between body and cloth is to think of it in terms of a gesture-space within which both partners act as insertions to one another, neither penetrating nor submitting to one another. Here skin and cloth are mutable and undulating. Here Goett's "first and second skins" slip and slide against each other, touching and being touched in reciprocal and simultaneous exchange.

Returning to Shiota's work, *The Key in the Hand* comprises multiple insertions. The elements of the work constantly move and shift against, toward and with one another, supplementing one another. Within the delicate and yet enveloping mesh of threads, Shiota scripts their multiple stories: stories of journeys planned and taken, planned and abandoned, unplanned, imagined, forced. Wool, keys, boats, screens, and images become epidermis and dermis by turns. Their surfaces approach the skin and in so doing bring the whole body into play as a site of, and for, the caress—body, thread, image, and skin—the caress completed through one another.

Philosopher Edith Wyschogrod describes the caress as a "feeling-act through which a self grasps the affective act of another through an affective act of its own" (1981: 28) Such a feeling-act is a necessarily repetitive and time-laden activity, the to and fro, dermis and epidermis, crucial to its transformative and generative potential. The caress as insertion emphasizes its potential as a site of erotic awakening and creative expansion.

In spinning passageways and webs, Shiota describes the intimacy of being in relationship. Shiota's work derives from a form of intercultural experience and as such is redolent of fluid meaning and fertile paradoxes. With multiple and layered readings she extends and supplements the interwoven, ethical, political, and aesthetic issues evident within her practice. This work, while undeniably powerful, also maintains a subtle dialect, a caressing.

The Key in the Hand draws attention to notions of safety and intimacy that the action of holding and feeling a key in the hand offer. Keys have the potential to protect and give entry to their bearer: our houses, our belongings, our personal safety. We hold them safely in our hands, they warm to our touch, we feel their weight and form, and we turn the lock to open. Keys are given as coming-of-age symbols; they stand as a symbol of privilege and safety for many. This multilayered narrative inserts closeness into distance, openness into protection: supplementing and completing.

As multiple and moving elements drift to and fro across Shiota's images/screen, so they become spaces of supplementarity, separation, reconnection, and completion. The dermal layers are caught up in the action of touching: the outer, sensed epidermis and the inner, sensing dermis, surface and resurface throughout *The Key in the Hand*. Skin and thread are brought into contact with the viewer as the dermis and epidermis of Shiota, the children, their memories, the boats, the red glow from the threads cutting across the gallery spaces, the physicality of the passageways formed, the hands holding keys, and the revealing and concealing of thoughts and spaces. The insertions complete the form: identity and alterity emerge on the surface, the skin, of the work.

To think of the caressing cloth in terms of insertions—as godets, gussets, and gores that supplement and complete both body and cloth—acts as a reminder that the caress is not a static, once and forever moment of touch. Instead, it moves, shifts, turns, and repeats. It is itinerant, nomadic, and homeless. Like the insertion, it sits within the seam, as an extra-dermal layer, within the site of the skin. This leads to the third point of departure: an *itinerant* caressing cloth, a cloth that passes to and fro repeatedly awakening and reawakening the skin it touches.

An Itinerant, Caressing Cloth

The caress as gesture-space that expands the distance of the intimate requires an attentiveness to the other with whom the space is being formed. In this sense it expands presuppositions of intimate here and distance there in favor of attentiveness toward that other.

With such attentiveness at the heart of the site of the caress, there is already an anticipation of movement and openness. To think of the caress as an itinerant relationship is to think of it as one in which mind and body together experience and negotiate the landscape. To be itinerant means to move from place to place, habitually, and often following a particular circuit or route, typically to work. Irigaray suggests that to move in this way is to move, "through the world, across the universe of dancing [to] construct more of a dwelling for myself" (1984: 175) For Deleuze and Guattari, the nomad is an agent taken up with unfinished business, who draws upon settled and sedentary ideas, to unsettle them within the gaps between (1980: 380)

Taking these as starting points for thinking of an itinerant, caressing cloth, sets it as a traveling cloth, one that knows and is known through repeated movement and through doing rather than by looking. The lovers' caresses, then, can be thought of as an itinerant form of touch that is performative, repetitive, and active.

Progress within the caress is intense and all-consuming, holding within itself a sense of infinity, a repeating without return, each moment of and for itself. At the same time as the caress awakens, so too it authors its own demise. Itinerant, the caress moves away, leaving the memory of the touch, perhaps a temporary hotness in the skin. But unless revitalized with further caresses, the heat soon cools and dissipates. So, the caress relies on the repeated visit: skin returning to skin, silk falling against thigh, wool settling against arm. Movement repeated is necessary to (re)awaken the caress.

When I first encountered one of Susie MacMurray's installations at Pallant House, Chichester, my immediate response to the shell and velvet "wallpaper" of *Shell* (2006) was a bodily attentiveness to the materials, an awareness of their pulsating rhythms up and down the stairwell into which this site-specific work had been installed. Here 20,000 or more shiny black mussel shells, each stuffed with blood red velvet lined the walls in serried ranks, ordered and yet disorderly with the velvet pieces escaping the mussel lips: each shell like its neighbors, but withholding its individuality in its markings, the length of its opening and its openness. At once both foodstuff and yet there is no hiding from the notes of erotica, bodiliness, menstruation, and female sexuality, MacMurray's shells roam between intensity and sterility, order and chaos, the monumental and the intimate.

In the massed forms of MacMurray's broader work, the imprints of small elements build to monumental scale and meaning. There is a logic of production which mimics and mirrors the bodily, referencing it both directly and obliquely. In this sense, the notion of an itinerant practice cuts between that of site-specific art installation, performance, obsession, and time-laden repetitive production.

MacMurray plays with these themes, producing work that is both temporary and permanent, but with her main preoccupation on histories, biographies, site-sensitivity, and the evocative language of her materials. It is in, and through, the repetitive, repeated, and persistent form of her materials that she seduces and entices the bodily viewer into her works. Like the caress, these works are not about possession, for that is to reach out too quickly and to prioritize arrival over the journey. As Catherine Harper writes of MacMurray's practice: "Each material is carefully considered to find its emotional pitch and to activate its internal content" (2006).

It is this notion of an emotional pitch emanating from the repeated and repeating form in the materials that resonates with the caress: the potency, the vibrancy and the erotic charge: awakening and reawakening—itinerant and traveling. Harper continues, this time referring to MacMurray's use of hair in *Maidenhair* (2001): "I was electrified by the perfect pitch of the moment when my body entered is affective arena, and the human thread knotted itself around the intangible, ephemeral, essential parts of my soul" (2006). In her powerful and yet often physically delicate works, the imprint of MacMurray's presence and labor is evident: it is as if they are continually in the process of growing, expanding, and producing.

Taken as itinerant, the caressing cloth can be characterized as an ecology, an ecology of materials, making, and affect. To approach MacMurray's work in this way brings into focus the artist's labor and agency of production. Like the caress itself, there is a precarity to the ecology. As the lover caresses and is caressed, self must give way to the other, but remain caressing that other. As she plays with the language of the heroic sculptor and the monumental, so she subverts it through her modes of production, materials, sites, and histories. In this way her practice caresses and seduces the viewer onto the surfaces, into the installations, and into the labor, agency, and materiality of her work.

In a another installation *Promenade* (2010), MacMurray warped 105 miles of gold embroidery thread between the

neoclassical columns in the Marble Hall at Kedleston Hall, Derbyshire. As MacMurray's golden thread wound its way to and fro between the columns, their delicacy and luminescence were bathed in a wash of light from above, creating a sense of volume and capaciousness from within their fineness. The threads shimmered against the alabaster, each held in careful tension: taut enough to remain in place, but not so tight as to weaken and thus break. The whole glistened between the huge columns, each thread contributing to the one before in creating a translucent screen. As itinerant, repeated action, the caress creates meaning in the present and awakens memory of the past. At its core is the (re)awakened relationship between: as one opens out to, and onto, the other, so a reciprocal rather than reversible relational interplay occurs.

In MacMurray's work the caress as itinerant gesture offers a reading that brings artist, artwork, installers, and viewers into proximal and intimate relationship. In the timespan and tensioning of their caressing, both lovers exist on both sides of the skin's boundaries—boundaries collapse at the level of bodily encounter. As the hand comes into contact with the thread and winds it around the column, surface and volume emerge, bringing *Promenade* into being. MacMurray places the labor of her work within the register of the visceral body, stretching and expanding across that body, her materials and the sites towards and beyond each other. Such knowing through the body transcends language without eradicating language and the search for an appropriate language. To know in this way is not through the fusion of object and subject, but rather through the itinerant caressing between subjects.

Reawakening

The caress, defined as the gentle touch or gesture of fondness, comprises the mutual touch between two subjects. To consider the interplay between body and cloth as the caress is to establish a form of thinking-with-cloth from an attentive body. In (re)awakening that body–cloth relationship the reciprocal nature of the caress becomes foregrounded as one of openness, mutuality, and production. In the intimacies of the caress each participant enables the dynamic exchange of action and reception, in a mirroring or replication of the warp–weft exchange within woven cloth. Here the agency of each creates openness toward the other and reception of

their touch, carrying in that moment the erotic charge that moves touching into caressing. Thought of in this way establishes the body–cloth caress as doubly awakening in the sense that as warp is caught up in caress with weft, so warp and weft together become caught up in caress with the body.

In this way the caress moves beyond touching and being touched, its erotic charge secreted through its generative and productive aspirations. This erotic charge between cloth and body circulates and repeats, growing and expanding. In this sense, then, the themes of interlacing, insertion and itinerancy become here staging points from which to approach this interplay between body and cloth.

Where interlacing foregrounds crossings, re-crossings and expansion, Hamilton's white, caressing cloth envelopes and undulates around, above and beyond the viewers' bodies, returning again and again. Here the body and cloth go visiting, enlarging each other's sense of self in boundaried boundarilessness. This interlaced space becomes here a series of events of threads, operating together and in sequence with each other: as warp and weft pass between and around each other in the process of forming the cloth, each event or passing affects those that precede and those that succeed while being themselves affected in turn. In this way, the interlaced space is not so much concerned with beginnings and endings of those threads and actions, but rather about the pliability and expandability that such a way of being in relation enables.

Inserting a godet, gusset, or gore into a garment supplements the cloth and completes the body. At this site of exchange, both body and cloth are in reciprocal relationship: touched and touching. It is through the reciprocation that the erotic charge is sparked. Shiota's thread secretions invade and insert and complete both viewer and artwork. In the intimacy and exorbitance created by the caressing threads, this work recognizes the multiple bodies and completes them, making them possible as the caress makes each partner possible.

The caress relies upon repeated, itinerant visiting to awaken and reawaken the erotic charge between. Here MacMurray's *Promenade* sets its wandering between the alabaster pillars, creating capaciousness within their delicacy. As the itinerant traveler moves within the space of the threads, so both are brought together again, reawakened by one another, and so increasingly eroticized in the space of the everyday. Boundaries collapse between body and thread. The itinerant nature of the caress becomes a circle

of touched, touching and sharing between body and cloth. Each caresses the other; they are temporarily, mutually, eroticized in the one space and yet remain resolutely two. To engage itinerant caress is to "go visiting," to see alongside another's skin, which is to unsettle and thus expand. The itinerant traveler knows and understands the landscapes, experience its shifts and changes. To travel in this way is to exist in an unfinished state of exchange which, like the caressing cloth, needs to be unfinished in order to retain its agency of movement, its very itinerant nature.

At the outset of this chapter I referenced the caress through thinking and caressing Irigaray's text *To Be Two* (2000). Within that same book she continues, here allowing breath to caress rather than cloth, but which resonates loudly with the caressing cloth:

> Who will allow me to remain two: the one, the other and the air between us? . . . Each one, therefore, trains the breath in order to be, to be and to become: divided between us, perhaps, but together at the same time. Distanced by our difference, but present to each other.
>
> **IBID.: 11**

In a relationship of mutual exchange and erotic charge, what is the thing that distinguishes one from, at the same time as uniting one with, another? What enables me to touch and be touched in equal measure? The caressing cloth, as Goett's "second skin" offers a site at which warp and weft, together with cloth and skin, awaken to each other and to themselves.

Within the body–cloth space, arises the spring of mutual caress, of both otherness and unity. Through interlacing with one another, acting as insertions for one another and so supplementing, the parties are enabled to go visiting. At this site, otherness and unity together spark erotic charge where cloth finds skin, skin finds cloth, skin finds skin, and cloth finds cloth. Warp and weft are brought together as a site of agency, exorbitance, and erotic charge.

Notes

1 Artist's statement: http://www.annhamiltonstudio.com/projects/armory.html (accessed July 12, 2016).

2 For Roland Barthes, all text is a perpetual weaving and unweaving and is thus a fundamental undoing. In this he considers the theory of the text as a *hyphology*, where *hyphus* is the tissue and the spider's web (1975: 64).

3 A gusset is an extra piece of fabric inserted into a seam to shape or expand the garment; gussets are most commonly found in the underarms and the crotch of clothing and form the side or bottom panels in bags. A godet is also an inserted piece of fabric, but this time it is a circular sector and most usually set into the lower part of a dress or skirt to add width and volume. A gore is in many ways similar to the godet, but usually runs from the waistband down to the hem. The overall effect is a more gentle fullness than with a godet.

References

Albers, A. (1965), *On Weaving*, London: Studio Vista.

Arendt, H. (1966), *Truth and Politics*, Washington, DC: American Political Science Association.

Arendt, H. (1978), *The Life of the Mind: Thinking*, Vols. 1 & 2. trans. M. McCarthy, San Diego, CA: Harcourt Publishers Ltd.

Barthes, R. (1975), *Pleasure of the Text*, New York: Hill & Wang.

Deleuze, G. and Guattari, F. (1980), *A Thousand Plateaus: Capitalism and Schizophrenia*, 2004 ed., London: Continuum.

Derrida, J. (1976), *Of Grammatology*, 1st American ed., trans. G. C. Spivak. Baltimore, MD: Johns Hopkins University Press.

Harper, C. (2006) "Shell Essay," *SusieMacMurray*. Available at: http://www.susie-macmurray.co.uk/?page_id=196 (accessed July 12, 2016).

Irigaray, L. (2000), *To Be Two*, London: Athlone Press.

Jefferies, J. (2016), "Talking of Textiles: Professor Janis Jefferies and Dr Jennifer Harries," lecture at Manchester School of Art, April 27.

Jefferies, J., Wood Conroy, D., and Clark, H. (2016), *The Handbook of Textile Culture*, London: Bloomsbury Academic.

Maharaj, S. (1991) "Arachne's Genre: Towards Inter-Cultural Studies in Textiles," *Journal of Design History*, 4 (2): 75–96.

Smith, T. (2015) "The Event of a Thread," in R. Frank and G. Watson (eds.), *Textiles—Open Letter*, 76–88, Berlin: Sternberg Press.

Wyschogrod, E. (1981), "Empathy and Sympathy as Tactile Encounter," *Journal of Medicine and Philosophy*, 6 (1): 25–44. doi:10.1093/jmp/6.1.25.

Further Reading

Diprose, R. (2002), *Corporeal Generosity: On Giving with Nietzsche, Merleau-Ponty, and Levinas*, Albany, NY: State University of New York Press.

Irigaray, L. (1984), *An Ethics of Sexual Difference*, 2004 ed., London: Athlone Press.

Merleau-Ponty, M. (1945), *Phenomenology of Perception*, 1976 ed., London: Routledge & Kegan Paul.

Sartre, J.-P. (1943), *Being and Nothingness: An Essay on Phenomenological Ontology*, 2003 ed., London: Routledge.

PART IV
The Performing Cloth

This section is concerned with cloth in performance—describing, hiding, revealing, and alluding to the body. The cloth acts as the narrative conduit for the body and as an extension of the body in movement, becoming "an expression of visual representation and an interactive form of image making" (Bruno 2014: 37). The activated cloth traces and echoes the body, falling, rippling around and draping the actual, and the longed-for, form, enfolding the space between being and becoming. This is the most seductive of all the materializations of the erotic cloth and the most fugitive.

Flowing along the serpentine line, the interrelationship between the cloth, the body, and the dance sometimes binds and connects; at other times it is the expression of freedom and liberation from the limitations of the body. The undulating cloth in motion may be the agent for the sublimation of the erotic, a veil of acceptability; on other occasions the cloth takes us to the heart of intimacy through an unexpected gesture or an unintentional revelation of a private space. These three chapters use the languages of film, drawing, and dance to develop a fluid narrative between place, time, cloth, and the body. They explore stillness and motion, the rhythms and pauses that are essential in the unfolding of the relationship between cloth and the body.

Thoughts on the erotic:

It is a tantalizing concept that William Hogarth's line of Beauty can extract the intangible, such as eroticism and seductiveness embedded within a fabric medium, and translate it into something physical the observer can perceive.

GEORGINA WILLIAMS

10

Curvatures of Cloth: William Hogarth's *Line of Beauty* and "The Heart of True Eroticism" in Serpentine Dance

GEORGINA WILLIAMS

In the middle of the eighteenth century, artist and theorist William Hogarth, in trying to ascertain a visual grammar within the artworks he was being forced by convention to physically copy, sought to establish an aesthetic language he could interpret. The serpentine curve—the *line of beauty*—became a signifier of this grammar, as Hogarth was later to communicate in his 1753 published manuscript *The Analysis of Beauty*. Art historian Joseph Burke remarks that "Memorizing" for Hogarth was assisted "by a natural impulse to abstract the salient," an observation Hogarth endorses when he proclaims how "'the most striking things that presented themselves made the strongest impressions, in my mind'" (Burke 1955: xxxix). Interpretation of the written, or aural, word or phrase in order to productively describe physical expression is fundamental to the examination being undertaken in this chapter because of the multitude of ways in which the *line of beauty* as a visual construct can be employed. In addition, there is munificence of meaning in how any variations within a presentation will ultimately be interpreted by the observer.

When Hogarth describes the *line of beauty* within his *Analysis* he composes some very arresting literary translations of this visual language, noteworthy not only for their own illustrative value, but also for how they productively articulate the beauty of movement through a narrative (Williams 2016: 18). The expressions "*leads the eye a wanton kind of chace*" (Hogarth 1997: 33, italics in the original), and "the pleasure of the pursuit" (ibid.: 34), are both evocative phrases ascribed to the *line of beauty* that suggest collusion between the viewer and the visual construct is required in order for the *line of beauty*'s attractional value to be productively understood. Movement communicated via a serpentine curve, when manifested as a contributing construct in the collation that is necessary for the creation of both two- and three-dimensional works,

Figure 44 William Hogarth, *Analysis of Beauty Plate I*, 1753. Heritage Images/Contributor. Collection: Hulton Archive Museum of London. Getty Editorial: 464472083.

can be said to initiate Hogarth's "pleasure of the pursuit"; this is not only when a viewer visually encounters the *line* that consequently "leads the eye a wanton kind of chace," but also as it pertains to the necessary role the viewer's imagination plays in prolonging that chase (Williams 2016: 69–70). Within these concepts lies the potential for not only an affect upon the viewer's perception of the *line* itself, but also upon his or her perception of the medium through which the visual construct is conveyed. In this way, and keeping in mind the importance of Hogarth's adamant assertion that pursuance of the *line* is unproductive "without the assistance of the imagination" (Hogarth 1997: 42), the medium as well as the construct have the potential to act as a mechanism by which both implicit and explicit suggestions and perceptions of the value of the *line of beauty* can be explored. It is through this process that Frédéric Ogée's suggested premise can be evoked—that is to say, that Hogarth's "pleasure of the pursuit" can be discerned as being centered "at the heart of true eroticism" (2001: 64). It is this supposition as it is connected to both construct and medium that forms the basis of this investigation.

"Painting, Dance, Drawing, and Coquetry"

The premise regarding physical interpretation of the written or aural can be expanded upon when such lyrical phraseology as described above is viewed through the prism of Imagism—the early twentieth-century poetic movement which "sought clarity of expression through the use of precise images" (*OED* 2009: 711). In this particular regard, Patrick McGuinness analyses the work of English poet and critic T. E. Hulme, and this writer's proficiency within a particular poem in putting across "the idea of one movement . . . by means of another kind of movement" (2003: xxix). McGuinness most effectively illustrates this skill by saying how the work "pivots on a simile" this "masterpiece of economy" (ibid.) reflecting Hogarth's apparent intentions in constructing the phraseology in the way he does when striving to put his literary interpretations of the physicality of movement across to his readers in an efficacious fashion. In broadening this point, it is of note to recall James Grantham Turner's reference to art

historian Angela Rosenthal's analyses, in that Hogarth cites the *line of beauty* in describing the execution of a fan being presented, and that this is one of many "seductive gestures" relevant to the "language" of the fan (Turner 2001: 46). Turner remarks that "Wanton movements" of our eye signify "an aesthetic motion virtually indistinguishable from desire" (ibid.: 40)—that there can be a connection between one's eye and the art it encounters that goes beyond merely aesthetic appreciation. Rosenthal describes the fan as "the fanciest of all artifice in the culture of corporeal display" (2001: 122), and in these concepts can be seen the possibilities for removing the *line of beauty* from the two- and three-dimensional painting, print, and sculpture. In so doing, these static representations of movement, albeit movement, Hogarth declares, which is at its most beautiful (1997: 33), can be vivified in order to explore the construct's potential in ways that lie outside conventional examinations, as is the objective of this chapter.

In offering one interpretation of how the *line of beauty* can be elevated from its established context and in the process attempting to not only retain but also enhance the spirit of Hogarth's theories, it is worthwhile to note Ogée's reference to Hogarth's thoughts regarding expression through the literal creation of his engravings. In considering the surface of the skin of Hogarth's characters within these artworks, built up through a careful contrivance of lines, Ogée speaks of the "delicate veil that covers the human form," that "which the waving and winding of the serpentine line is said to enclose" (2001: 63). When this idea is expanded it opens the way for an investigation into the concept of a veil upon the veil—cloth upon the skin. This veil can be one that is in motion, conceivably a veil of beauty, one that is often seductive, potentially erotic, yet still articulated through Hogarth's cherished serpentine curve despite ultimately being a constructed augmentation. In this respect, Ogée writes how "Hogarth defines a dynamic aesthetics of 'pleasing discovery' illustrated by the line's most erotic way of gradually teasing knowledge out of form until the 'sublime' climax" (2001: 63). This is an observation with the potential to be as pertinent to the veil upon the veil—to the cloth upon the skin—as it is to the skin itself.

The attraction of the *line of beauty*, Hogarth theorizes, is encapsulated in its ability to express motion: movement that leads the viewer's eye along a winding country path in

a painting, for example, or serpentining the graceful pose held ad infinitum as stone or marble sculptural incarnations of a ballerina. In this latter respect, Hogarth is adamant that the medium of dance epitomizes movement conveyed as serpentine curvature (Hogarth 1997: 110)—an observation that effectively endorses the premise that the ballerina is a "machine for manufacturing beauty," which is how the dance writer and critic André Levinson chooses to describe the technique (Garelick 2007: 139). Hogarth remarks that "the pleasure" the *line* "gives the eye is still more lively when *in motion*," and confirms this with his reminiscence of how "my eye eagerly pursued a favourite dancer, through all the windings of the figure, who then was bewitching to the sight, as the imaginary ray . . . was dancing with her all the time" (1997: 34, italics in the original). This "imaginary ray" Hogarth speaks of is, in effect, the line of sight between the viewer and the object; consequently, when the object is moving—or dancing—this metaphoric line is moving, or dancing, synchronously.

The ideas considered here demonstrate a possibility for the concepts under examination to be intensified when such expression of the *line of beauty* is not restricted to a static representation of dance as drawing, painting, or sculpture, nor even confined to the capabilities of a dancer's actual body. Of utmost significance in this context, therefore, is the aesthetic output of modernist dancer Loïe Fuller who, perhaps ironically when considered in respect of the points made above, deliberately conceals her own figure in the manufacture of her serpentine dances, shrouding herself in many meters of cloth. Although early incarnations of this expansive mantle bore illustrative depictions of motifs related to the dances she performed, Fuller undertook "a kind of modernist streamlining" by ultimately sculpting these motifs in a literal fashion out of the "vast robes of white silk" she was subsumed within (Garelick 2007, 35). Writer and art critic Guillaume Apollinaire reflected in 1912 that "it may well be that it was that great artist of line and colour Loïe Fuller who became the precursor of the women's art of today when she invented that brilliant mixture of painting, dance, drawing, and coquetry that has very properly been called 'the serpentine dance'" (2001: 230). Similarly, and in extending Apollinaire's view of Fuller as an artist over and above the performer she was predominantly renowned as, the "task" of Fuller as that artist can be "implicitly outlined:

the aesthetic pleasure" that is generated through the artwork is demonstrated by the efficacy of the artist's "ability to grasp and render the transience of this delicacy, as much as the delicacy of this transience, both tangibly and suggestively" (Ogée 2001: 63). Ogée's contention that the artist's role is to imbue his or her creative output with "aesthetic pleasure" for the viewer to perceive focuses attention on what is an important aspect within the context under scrutiny here—that is to say, that it is not the literal, physical form of Fuller's body that creates the serpentine lines evident to the onlooker. Instead, the *lines of beauty* are created by the carefully contrived result of the way Fuller uses long rods and hooks to manipulate the vast swathes of cloth that surround her dancer's body (Garelick 2007: 40). It is this coordinated orchestration that holds the key to this phenomenon, the amalgamation of this fabric cloaking with the corporeal beneath in order to fundamentally enhance the dancer's physical potential.

"20,000 Revolutions a Minute"

In his 1916 Futurist manifesto titled *The New Religion—Morality of Speed*, Futurism's founder F. T. Marinetti declares how, "In an s-shaped curve with double bends, velocity achieves its absolute beauty" (2009a: 228); this is an observation that echoes Hogarth's description of the serpentine curve while simultaneously demonstrating the Futurists' enthrallment with movement, speed, and technology. Concepts, including those that determine "analogies between the 'giro rapidissimo' (rapid turn) of a dancer and the 'ttattattatta' of machine gun fire" (Poggi 2009: 320), as has been attributed to the work of Futurist painter Gino Severini, connects the machinic—including the mechanisms of war—with art forms that embrace the choreography and performance that manifest within Fuller's oeuvre. This latter example demonstrates an arguably less predictable influence upon the Futurists' literary and aesthetic output, lying as it does in contemporaneous trends including those relating to dance in general and modernist dance in particular.

It is intriguing to consider the reasons as to why such a sinuous art as dance cannot only inspire, but also be so central to such mechanistic bodies of work, including the conjecture that the Futurists' fascination with dance as an

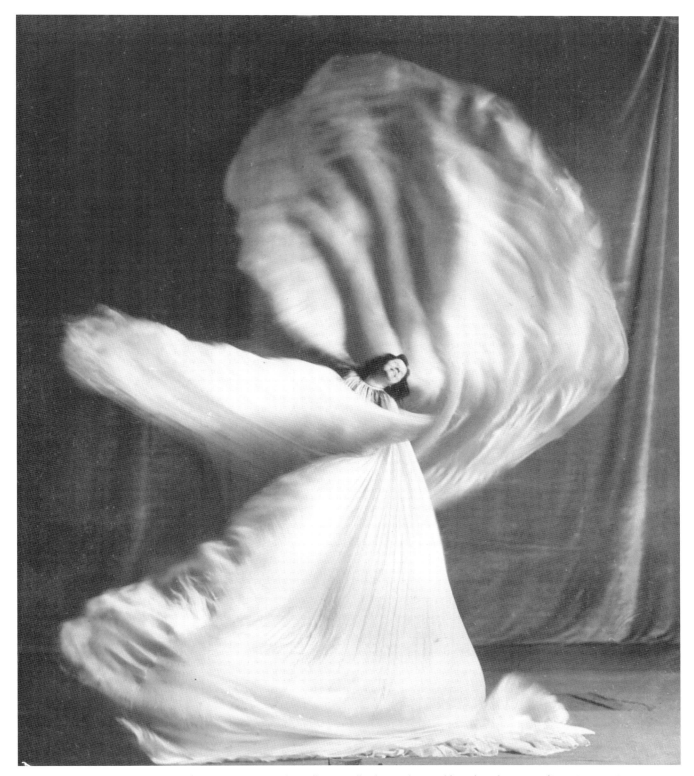

Figure 45 Loïe Fuller, *Dance of the Lily*, c. 1896. Imagno/Contributor. Collection: Hulton Archive. Photo by Imagno/Getty Images. Getty Editorial: 545942997. Photographer: Theodore Rivière.

art form stems simply from free-flowing, often expeditious movement required in its execution (Williams 2016: 77): Marinetti, in exalting variety theater in a 1913 manifesto of the same name, comments on the inclusion of "spiral cyclones of dancers" (2009b: 127). This undoubted physicality can in itself be construed as technological, affirming the reasons why performers such as Fuller were held in great esteem by those artists and writers within the Futurist movement. Fuller, as one of Marinetti's favored modernist dancers, is directly referenced by him in his manifesto *Futurist Dance* (2006), with the writer remarking how Futurists "prefer" dancers who utilize "mechanical devices" (ibid.: 210). Of import in respect of Fuller particularly is that there exists within her serpentine dances elements of the machinic that enhances her attraction to an avant-garde art movement mesmerized by technology as well as performance. Fuller, in blending her body with cloth and machinery to generate these serpentine dances, effects a technological construction that not only creates literal *lines of beauty* but in the process is additionally able to evoke Marinetti's call to "kneel in adoration before the whirling speed of a gyroscope compass: 20,000 revolutions a minute" (2009a: 225). Significantly, in light of the exploration of ideas and subject matter under examination in this chapter, within his manifesto on Futurist dance Marinetti speaks of "a continuous billowing" of "veils" (2006: 215). This distinctly apposite description is subsequently connected directly to Fuller in the sentence, "Such billowing veils were used with great technical proficiency by Loïe Fuller" (Berghaus in Marinetti 2006: 468), as stated in the endnotes that accompany this particular collection of Marinetti's writings.

Moreover, the Futurists' manifestos stipulate the high value these artists and writers place on lines and planes, and in so doing express the belief that lines they consider to be "trepidating" are contributory in expressing "a sensation of chaotic excitement" (Boccioni et al. 2009: 49); the Futurists utilize "*force-lines*" (ibid.: 48, italics in the original) as a phrase to describe the conveyance of both emotion and movement. Hogarth—who dedicates his published treatise to an analysis that incorporates the examination of lines in his pursuit of beauty—writes that "having form'd the idea of all movements being as lines, it will not be difficult to conceive, that grace in action depends upon the same principles as have been shewn [sic] to produce it in forms" (1997: 105). The rods and fabric used by Fuller in the execution of her serpentine dances are employed as prosthetics, with Fuller's physical actions exclusively designed to allow her body beneath the cloth to extend the whole into a mechanistic form through which the desired effect of specific lines and planes in motion can be achieved (Williams 2016: 81). This "displacement of erotic kineticism" (Garelick 2007: 170)—a very specific interpretation of ballet as "a deeply mechanized and fetishistic art form" (ibid. 2007: 139)—serves to translate the Futurists' concepts relating to an internal, frenzied force into physical aesthetic expression.

Consequently, this prospective "mechanomorphic modernism" (ibid: 32) is potentially demonstrative of the ways in which cloth can be exploited to beautifully and seductively express not only the emotion of motion, but also emotion through motion. It is this physical manifestation of an internal sensation—and the means by which it can be achieved—that is of interest to these hypotheses, thereby provoking the question as to how emotions and sensations that are essentially invisible, can be solidified into that which is then made visible and therefore subsequently of attractional value to the viewer.

Of consequence in considering this in the context of how the *line of beauty*, acting as a construct through which an internal sensation relating to the erotic can be rendered as external representation, is Ogée's utilization of the nouns "suggestiveness" and "potentiality" in qualifying his belief that Hogarth's *line* is connected to eroticism (2001: 64). The employment of these two words is of particular import because each appositely lends itself to the concept of implicit and explicit intimation of eroticism, while together they evoke the journey that takes place in the observer's imagination as the eye sweeps from one end of the serpentine curve to the other. Furthermore, as Ogée continues,

> In the end, Hogarthian beauty and grace, far from being some abstract metaphysical concept or the aesthetic consequences of the application of a set of rules, emerge as transient, "living," physical phenomena apprehended through visual caresses and imaginary frictions, where the beholder plays a crucial, fulfilling role.
>
> **2001: 66**

This succinct summary demonstrates the importance of "suggestiveness" and "potentiality" in their relation to the serpentine curve—the *line of beauty*—as a visual

Figure 46 Georgina Williams, *Serpentine Dance: Lines and Planes in Motion*, **2016.** Pen on Paper Digitally Manipulated. 30 × 42 cm.

construct, and in addition creates conditions of possibility whereby any prospective boundaries can be effectively breached by the weight of a serpentine line that is subsequently multiplied and in motion.

Moreover, Hogarth writes that

> There are other dances that entertain merely because they are composed of variety of movements and performed in proper time, but the less they consist of serpentine or waving lines the lower they are in the estimation of dancing-masters: for, as has been shewn [sic], when the form of the body is divested of its serpentine lines it becomes ridiculous as a human figure.
>
> **1997: 110**

This is an interesting perspective, expanding as it does on the notion of the serpentine line not only enhancing the

movement that is expressed through the medium of dance, but also that without the magnification of the movement that forms serpentine curvature the dance as well as the dancer is reduced to a degree Hogarth defines as risible. Furthermore, even greater enhancement is achieved in Fuller's serpentine dance because of the prosthetics— including the fabric—she utilizes in order to intensify those *lines of beauty*. It is this prevalence of the *line of beauty* that increases the value, as Hogarth seemingly perceives it to be, of both the dance and of the dancer who performs it. Of note in further contextualizing these ideas within a modernist perspective is Futurist photographer Anton Giulio Bragaglia's belief that, rather than an interest in a precise representation of movement, the Futurists' more compelling concern arises from "movement which produces sensation, the memory of which still palpitates in our awareness" (2009: 36). Through the serpentine dance,

Fuller, along with the performers she influences into staging their own versions of her creation, executes a way in which what is considered generally to be unseeable can be made to be seeable through a physical translation of internally held sensations. Consequently, these serve not only as palpable, visual examples of Bragaglia's expressed objective, it also assists in further unveiling the link to Ogée's reflections connecting the *line of beauty* with an expression of eroticism.

Desires, Fantasies, and Fetishes

In appraising all this from an alternative perspective, Rhonda K. Garelick's observation regarding the "ballerina's alter-ego" (2007: 133) is noteworthy; within her study of Fuller, Garelick maintains that the ballerina's "offstage identity as desirable, fleshy woman, was permitted to show through her onstage role. The fluttering swan or disembodied phantom coexisted easily . . . with the erotic presence of the real human being" (2007: 133). Marinetti similarly observes that through variety theater there exists a proposition to "distract and amuse," and he cites "erotic stimulation" as a means by which this can be achieved (2009b: 126). In exploring this idea in conjunction with the points previously made, it can be argued that in Fuller's case it is not the sensuality of the dancer beneath the vast shroud of cloth that seeps through to the viewer in a literal sense, regardless of how "fancy" is the "corporeal display," as commented upon earlier in relation to the presentation of a fan. The technological construction Fuller developed in order for her to stage her serpentine dances can be considered to have assumed a similar role to the fan, as Rosenthal describes it, in that it "produced a sign language predicated on the mediation between 'machine' and body" (Garelick 2007: 123). The key contention, therefore, is that the dancer's ability allows an eroticism to be expressed that is separate from the corporeal, and in so doing instigates a sensuous infusion of eroticism into the manipulated cloth which can then be seductively rendered.

In support of this particular aspect of Fuller's physical distance from the effect she created—regardless of whether this distance was intentional or otherwise—it is of interest to see how a poster of Fuller by artist Jules Chéret, advertising a performance at the Folies Bergère in Paris, bears no resemblance to her at all in either face or physique (Garelick 2007: 166). Furthermore, neither does it accurately represent the technological feat of the serpentine dance, failing as it does to depict Fuller's immersion in the voluminous cloth that is key to her performances. Cheret's particular illustrative example, created about 1893, depicts a ballerina, yet one who is arguably borne from a more traditional perspective than imagery of Fuller should potentially generate. The figure itself, albeit as already noted erroneously represented if purporting to actually be of Fuller, nonetheless expresses the serpentine curvature that is not only central to her choreography but also indicative of that which Hogarth insists projects movement at its most beautiful. The *line of beauty* is explicit in the pose Chéret chooses for his model, yet the impressionist sweeps of Chéret's brush suggest the complete antithesis of Fuller's modus operandi, the poster artist allowing the drapery around the dancer to reveal not only the figure but also the limbs, head, face, and long flowing hair. As previously stated, Fuller conceals her body within her specifically constructed creation, ensuring it is the cloth shroud and her method of manipulating it that becomes not merely the focus of the dance, but expressive of the serpentine dance in its entirety. Although clearly Fuller is the catalyst in the creation and execution of the dance, her physical presence remains virtually unseen nonetheless, an aspect that will be explored later in this chapter.

Chéret was not alone in this visual misrepresentation: Jean de Paleologue's contemporaneous depictions of *La Loïe Fuller Tous les Soirs* (Loïe Fuller every night), for example, and also designed on behalf of the Folies Bergère, similarly reveal far more of the dancer than correctly represents Fuller and the aims and ambitions of her serpentine dances. De Paleologue (or "PAL" as he sometimes signs his work) does, however, drape his illustrated dancers in a swathe of white cloth, thereby demonstrating more effectively the impression Fuller sought to convey— white silk orchestrated by her movements and "the play of lights" upon the "ephemeral shapes" created (Garelick 2007: 42), rather than the bright colors present in Chéret's manifestation. More importantly, and as already intimated, Fuller's performances elicit the perception of erotic imagery. In the same way the hypothesis connecting an erotic articulation of the *line of beauty* with the presentation of a fan argues that it is this particular movement "thus registered and betrayed in its dynamic deployment" that conveys "the thoughts and emotions of its owner"

(Rosenthal 2001: 122), it is this perception of eroticism the artists and sculptors who immortalized Fuller desired to capture. Furthermore, these artists, in presenting Fuller as they did, were also projecting their and the audience's own desires, fantasies, and, arguably, fetishes onto these two- and three-dimensional representations of this particular modernist dancer (Garelick 2007: 170).

When this is considered in the context of the separation of the corporeal from the cloth commented on earlier, it uncovers the concept of circular cause and consequence. The explicit manifestation of eroticism is revealed via the *lines of beauty* formed through the movement of the billowing veil of cloth—physical, literal, *lines of beauty* in motion. Yet this is only achieved because of the precise action of the dancer, the serpentining motion of the figure concealed within the shroud. Without the ballerina as essential engine beneath there is no serpentine dance, no "whirling speed of a gyroscope," no "pleasure of the pursuit" rooted "at the heart of true eroticism"—no potential, therefore, for seductive suggestion derived from an eroticism of cloth. As Garelick maintains, Fuller may well have "refused to adopt the ballerina's status as erotic commodity" (2007: 150), but an arguably implicit suggestion of eroticism manifests itself in explicit expressions of the *line of beauty* via the contrived motions of her and her fellow serpentine dancers' fabric shrouds, and it is the serpentine line that translates into the potential for the cloth itself to articulate the erotic.

"The Felicity of Rapid Motion"

Bearing the above in mind it can therefore be argued that capturing the essence of Fuller's very specific serpentine dance is a futile exercise when restricted to the two- or even three-dimensional adaptation, as the Folies Bergère poster artists at least attempted to achieve, because it is the constant movement that is of most consequence. This is not only from Fuller's point of view, in so far as we can perceive her intention to be, but also from the perspective of the contentions considered here—that the movement of the cloth is the conduit that transports that which is unseeable within the dancer, and liberates it into that which then becomes seeable and subsequently of tangible value to the viewer. The veil assumes a unique role as "that most delicate terrain of negotiation between the inside and the outside of the body—the skin is what touches and sends (inwardly) sensorial data . . . as well as what reveals (outwardly) the emotional reactions of that body" (Ogée 2001: 66). This underscoring of the idea of a transference of internal to external emotion via a veil, and the hypothesis that extends that to a veil upon the veil, is supported by Hulme's contention that "All emotion depends on real solid vision or sound. It is physical" (2003: 38). It is similarly reflected in Robert Polhemus' referral to what he describes as a "typically Austenian phrase, 'the felicities of rapid motion'" (1982: 56). This comment is qualified, and thereby contextualized for the purposes of this exploration, in the remark that "All dances are essentially mating dances, and the end, as well as the means, of dancing is the felicity of rapid motion" (ibid.). This is an affirmation that echoes Hogarth's documented theories, as well as underscoring the Futurists' attraction—not just to dance, nor just to movement, but to movement when it has achieved its greatest velocity. Furthermore, the physicality of such movement, along with the freedom encapsulated in the serpentine dance, supports Hogarth's lyrical narratives regarding his *line*, and in addition assists in endorsing his assertion that there can be no mathematical calculations involved in defining his ideal serpentine curve as being the *line of beauty* (Paulson 1997: xxviii).

It is, of course, more than possible for a facsimile of the visual effects of the serpentining cloth to be produced without the human figure as central cog in the mechanism, and it is particularly intriguing to consider this alternative, purely machinic (and feasibly mathematically contrived) version from a Futurists' possible point of view. However, as already commented upon, the Futurists were fascinated by Fuller and it is the metamorphosing of corporeal and prosthetic that is so central to her performances—effectively, Man and Machine—which is a significant feature of the Futurists' aesthetic and literary work. Consequently, it is recognized that only the dancer as protagonist can successfully transform internal sensations into external phenomena if every seductive, erotic, fetishistic nuance is to be captured in each palpable sweep, swirl and slide of the *line*. Certainly Hogarth indicates a requirement for a reliance on the eye over and above any "mathematical schemes," which he considers to be "foreign to this purpose" (1997: 65), a belief endorsed by John Dewey almost two centuries later when he writes that "Curved lines. . . are agreeable because they conform to the natural

tendencies of the eye's own movements" (2005: 104). This apparent requirement for the intuitive is as relevant to the onlooker in his or her understanding of the visual as it is to the dancer charged with executing the physical interpretation of the internal emotion to which that onlooker is exposed and subsequently attracted.

In conclusion, therefore, the *line of beauty*—a construct considered to convey a suggestion of movement capable of effecting a productive response from within the viewer, albeit one which requires the viewer's imagination to fully engage with its potential—precipitates a more dynamic and sensuous an experience within that viewer when the *line* itself is in motion. In extending the premise to embrace that which additionally lies beyond movement in, for example, the medium of dance, the sensations stirred within the observer can prospectively be enhanced exponentially. Loïe Fuller can be variously described as an artist, a designer, an inventor, a choreographer, and a performer, and arguably it is the apparent invisibility of the actual dancer that is the most important aspect of what makes the serpentine dance so effective, especially within the context described here. It is easy to consider how a viewer's perception of a suggestion of eroticism can be enhanced when virtually all that the onlookers are conscious of is the swirling cyclone of shimmering silk that billows across the stage before them. It could even be reasoned that the performers have an obligation to disappear, a required acceptance from every one of them that they be totally subsumed beneath the machinery and fabric that manufactures this specific ballet, in order for the serpentine dance to be seen as a presentation at its optimum level of effectiveness—at least in as much as the technological feat of the performance allows for such a withdrawal from plain sight. A distraction rooted in the substantial would then cease to be a factor in the performer/spectator process, in the sense of an intrusion into the extravaganza by a human form, one which may pervade a viewer's consciousness and consequently affect his or her imagination.

The onlookers' engagement is therefore focused, and imaginations are subsequently set free to explore and interpret that which lies beyond the corporeal, existing only within the serpentining spectacle that plays before the eyes. In serpentine dance the *line of beauty* becomes a mechanism by which the viewer is seduced into embarking upon a journey of suggestion and potential, one which leads the eye in pleasurable pursuit as it navigates the veil

upon the veil, until the veil of cloth can be seen to positively burst with literal manifestations of Hogarth's serpentine curve. Ogée's premise of "Hogarthian beauty and grace" assists in elevating the *line of beauty* so that the construct itself can be seen to initiate the emergence of Ogée's "transient, 'living' physical phenomena" (2001: 66). Consequently, the conditions are created so that an internal emotion becomes connected to the onlooker via the cloaking of cloth as it serpentines in motion, and it is in this way that the *line of beauty* can be perceived as being productively centered at "the heart of true eroticism."

References

Apollinaire, G. (2001), "Art News: Women Painters (Le Petit Bleu, April 5)" in L. C Breunig (ed.), *Apollinaire on Art: Essays and Reviews 1902–1918*, trans. S. Suleiman, 227–30, Boston: MFA Publications.

Boccioni, U. et al. (2009), *The Exhibitors to the Public 1912*, Exhibition catalogue, Paris: Galerie Bernheim-Jeune. "Exhibition of Works by the Italian Futurist Painters," Sackville Gallery, London, March 1912, in U. Apollonio (ed.), *Futurist Manifestos*, trans. R. W. Flint, 45–50, London: Thames and Hudson Ltd.

Bragaglia, A. G. (2009), "Futurist Photodynamism 1911," in U. Apollonio (ed.) *Futurist Manifestos*, trans: C. Tisdall, 38–45, London: Thames and Hudson Ltd.

Burke, J. (1955), "Introduction," in W. Hogarth, *The Analysis of Beauty*, ed. J. Burke, xiii–lxii, Oxford: Clarendon Press.

Concise Oxford English Dictionary, Luxury Edition (2009), 11th edn, eds C. Soanes and A. Stevenson, Oxford: Oxford University Press.

Dewey, J. (2005), *Art as Experience*, New York: Perigree.

Garelick, R. K. (2007), *Electric Salome: Loïe Fuller's Performance of Modernism*, Princeton: Princeton University Press.

Hogarth, W. (1997), *The Analysis of Beauty*, ed. R. Paulson. London: Yale University Press.

Hulme, T. E. (2003), *Selected Writings*, Manchester: Fyfield Books.

Marinetti, F. T. (2006), "Futurist Dance," in G. Berghaus (ed.), *F. T. Marinetti: Critical Writings*, trans. D. Thompson, 208–17, New York: Farrar, Straus and Giroux.

Marinetti, F. T. (2009a), "The New Religion-Morality of Speed," in L. Rainey et al. (eds), *Futurism: An Anthology*, trans. L. Rainey, 224–9, New Haven & London: Yale University Press.

Marinetti, F. T. (2009b), "The Variety Theatre 1913," in U. Apollonio (ed.) *Futurist Manifestos*, trans. R. W. Flint, 126–31, London: Thames and Hudson Ltd.

McGuinness, P. (2003), "Introduction," in T. E. Hulme, *Selected Writings*, vii–xlv, Manchester: Fyfield Books.

Ogée, F. (2001), I: "Crafting the Erotic Body: The Flesh of Theory: The Erotics of Hogarth's Lines" in B. Fort and A. Rosenthal (eds), *The Other Hogarth: Aesthetics of Difference*, 62–75, Princeton: Princeton University Press.

Paulson, R. (1997), "Introduction" in W. Hogarth, *The Analysis of Beauty*, ed. R. Paulson, xvii–lxii, London: Yale University Press.

Poggi, C. (2009), "Introduction" in L. Rainey et al. (eds), *Futurism: An Anthology*, 305–30, New Haven & London: Yale University Press.

Polhemus, R. M. (1982), *Comic Faith: The Great Tradition from Austen to Joyce*, Chicago: University of Chicago Press.

Rosenthal, A. (2001), "II: The Anatomy of Difference: Unfolding Gender: Women and the "Secret" Sign Language of Fans in Hogarth's Work," in B. Fort and A. Rosenthal (eds) *The Other Hogarth: Aesthetics of Difference*, 120–41, Princeton: Princeton University Press.

Turner, J. G. (2001), "I: Crafting the Erotic Body: "A Wanton Kind of Chace": Display as Procurement" in *A Harlot's Progress and its Reception* in B. Fort and A. Rosenthal (eds), *The Other Hogarth: Aesthetics of Difference*, 38–61, Princeton: Princeton University Press.

Williams, G. (2016), *Propaganda and Hogarth's* Line of Beauty *in the First World War*, Basingstoke: Palgrave Macmillan.

Thoughts on the erotic:

"La petite mort" is French for orgasm. Birth and death are intertwined in sex and cloth as we arrive and depart this world wrapped in fabric. The skin senses and responds to this other membrane and it is the perception and visualization of sensuality through inert yet mutable material that is my interest.

LIZ RIDEAL

11

The Echoes of Erotic Cloth in Film

LIZ RIDEAL

This chapter addresses heterosexual attraction and the erotic as visualized through filmed cloth. We might ignore cloth (to use the word generically) because of its general functionality, yet it surrounds us, covering us, soaking up excretions, and retaining imprint and smell, all important elements of sex, life, and death. If a filmmaker can exploit the subliminally referenced acknowledgement of coition through impregnated stained cloth, whether with blood, sweat, semen, or other secretions, and contrast this with, for example, crisp, clean, pure sheets, a range of associated erotic, and fetishistic experience can be implied. "Eroticism is, of course, a personal experience, but that does not mean it cannot exist in the generalized world of the cinema. A film is an externalized utterance of the concept of a group of people, but it is also a concept in the mind of the individual viewer" (Webb 1979: 290).

In Oscar Wilde's *Salomé*, her expression of sexual power is evinced in Herod saying he will give her anything she desires if she will dance for him. That she chooses as reward for her veil dance the head (that is the murder) of John the Baptist, whom she desires, confounds Wilde's minimal stage direction: "Salomé dances the dance of the seven veils" (see Fothergill 1996: 253, 236). Her earlier comment to John the Baptist's guardsman regarding a possible tryst between them (in a previous bargain to see the prisoner) confirms Salomé's own predatory sexual gaze: "I will look at thee through the muslin veils, I will look at thee . . . It may be I will smile at thee." (ibid.). Veils can cover and reveal, depending on who is gazing. Filmed versions offer a standardized erotic veil dance, whether by Rita Hayworth as Salomé (1953) or in Al Pacino's visceral interpretation (2013). The films discussed here all emanate sexual atmospheres and tensions associated with cloth, but none of their erotic expression replicates the standardized pattern of the Salomé films. They employ cloth in a role as signifier and protagonist, integral to the storylines of *Singin' in the Rain* (1952), *The Inn of the Sixth Happiness* (1958), *The Great Gatsby* (1974), *In the Mood for Love* (2000), and *MOI NON PLUS* (2015).

Abstract cloth imagery in film uses plot to animate and permit the function of emotive signifier. Cloth can create mood and atmosphere, and indicate scene shifts, but with *context* it acquires narrative purpose. Cloth itself can become eroticized but only in conjunction with color, form, sound, and action. Items of clothing or pieces of cloth can denote aspects of the narrative, act as protagonist, suggesting that emotion is making the role of fabric integral to a film's denouement.

Despite their different dramatic genres and production dates spanning over forty years, the films employ the same visual metaphors to imply similar ideas in a similar fashion. What they have in common is the personal rather than the general. Cloth in various guises recurs during the films, in a repetitive, additive fashion, forming an unspoken parallel with the movement of a weaving machine as it relays and portrays the relationship between matter (raw material) and product (length of cloth). The focus on cloth and edited cross-cutting lends cinematic thrust and a sense of continuity to the storylines without using speech to clarify phases of the plot. In fact, the fabric often binds the stories together as does the narrative within the pellicle of film. The array of emotions expressed by the actors find their aesthetic expression literally materialized in and through fabric, bound within the format of the film frame, the alternative rectangular weaving frame within which the action occurs. The erotic "temperature" of the cloth is therefore in symbiosis with the overall atmosphere and context of the form. As stated, what is considered erotic is an individual matter. However, the dominant male gaze as defined by Mulvey when she wrote "unchallenged, mainstream film coded the erotic into the language of the dominant patriarchal order" (1975) is on the agenda but not specifically the subject of this essay. The focus here is Freud's scopophilia: the pleasure in looking, our enjoyment of the look and activity of cloth as subject matter. It is precisely because of its ambiguity that cloth can be deployed as adjunct to all manner of sexual practices; an example might be lingerie as interpreted as part of heterosexual sex play.

The sexual nature of erotic cloth can be connoted by a variety of interlinked ideas and interpretations; these reflect personal responses within the boundaries and privacy of sexual practice. Thus definitions regarding the erotic as embodied in cloth are reflexively loose, ambiguous, and fluid. One can only suggest, make analogies, and draw parallels in order to expand on the matter, the stuff, or *stoffa* of sex. "*Stoffa*" in Italian can mean both "stuff" and "textile," paralleling all manner of other puns associated with sex and stuffing.

The personification of gathered and then explosively active cloth as orgasmic abandon is one aspect of erotic

cloth. Another can be evoked by the sexual allure and suggestive feel of translucent sheer silk. Furthermore, the notion of cloth as ligature within sexual role play alludes to danger by noting formalized sadomasochistic role play (see Ôshima's 1976 film *In the Realm of the Senses/Ai no Corrida*). This could further be related to the ancient practice of foot binding—yet another form of sexual control, whereby the female feet were bound tightly from birth, stunting foot growth in order to create the erotic "lotus" foot.

The cloth used to wrap around and pull back and forth in the tug of war of sexual encounter emerges as eroticized and fetishized by these actions, becoming an implicit, active yet dumb performer within the sexual dynamic.

There is a danger inherent in explaining the pace and symbolic resonance of film as ideas penetrate visually far faster than the written or spoken word. Thus to expand on what one sees can reduce impact. However, by eliding similar visual statements one can assess their collective power to communicate. Because of the ambiguous nature of material itself, general themes can be useful in focusing on similar effects. In these five films it is precisely this communality of inference that gains our attention; as cloth is akin to and connected with skin and touch, it unites a series of hints and implications that together give weight to these effects.

Film can work better than other media in expressing erotic subtleties because the moving image can easily show and imply touch and the physical rhythm of sex. However, the cloth examples discussed are relatively "chaste," presenting an antidote to the explicit nature of pornography,[1] be it hard or soft core. What is a "chaste" example of cloth and can this exist? Historically, non-machined cloth has hands all over it, from gathering raw material (for example, shearing sheep) through to spinning, weaving, cutting, and fashioning. The examples in these films stand out as the specificity of the individual experience portrayed is augmented and personalized via the reiterated cloth references. Reverberations pulse through wrapping, embroidery, blood, color, history, and presence. These differently effected and active fabrics influence the unfolding of the films.

Metaphor

In *Singin' in the Rain* (Donan and Kelly: 1952), Gene Kelly and Cyd Charisse dance together, on a huge open set as part of a separate "vignette-subplot" to the main story. A wind-machine animates a length of white cloth that is used as metaphor for the "pure" dance of ballet, binding them in an erotic embrace of mutual attraction and love of dance itself. They pretend their intimacy and then despair on separation.

Simultaneous mutual love and love of dance is manifest by the entwining of billowing cloth. The two are bound together during the entire sequence by the white, diaphanous active swathe of moving cloth, and they pulse apart when the choreography dictates. This cameo of enacted physical attraction is subsumed into the sexuality of the dance and further explored by the presence of the entwining, undulating cloth as the third component that represents an active sublimation of their emotional framework, all of which is underpinned by the accompanying musical score. As this sequence happens in parenthesis, it reinforces the role of Charisse as the "other woman," a dancing girl, not the apple-pie girl that the Kelly character is really "in love" with. Charisse had played a similar role in the first subplot set in New York, where she was typecast as the gangster's moll, replete with black net tights and in envious green silk. In this instance there is no hiding that she is an embodiment of sex on (very long) legs.

The cloth here is actively performative, behaving like a three-dimensional serpentine line (Hogarth 1753) and becoming a third character in relation to their intense duo; snowy white and suggestive of a proverbial biblical snake.[2] This is no lightweight and fluttering chiffon, nor a ballet tutu, but a muscular adjunct to their jazz dance; all sinew and twisted energy. The coiling fabric in their dreamlike tango arcs and billows in relation to their constant dance "negotiations." Prolonged foreplay is conjured through the dance where the sexual tone is set by these physically fit, seductive, handsome, excellent dancers. Their electric attraction is heightened by the tensions displayed in the erotic movement of the white cloth that envelopes, ruffles, tangles, distances, binds, and bonds them together. The length of cloth suggests the pure white linen of a bedroom storm while simultaneously and coyly avoiding this. It symbolizes the action of coitus yet refrains from showing sweat and remains throughout as a mutable potential between them, a castrated interloper or eunuch conductor. This is the key to the eroticism of this essential third protagonist within their duet, whose role is one of

titillation, palpitation, and mounting excitement. The fabric, by nature of its innately ambiguous form, connotes a perfect subsidiary presence; energizing the dance, punctuating the undulations of the dancers, gathering and unfurling and being set free in a quasi-orgasmic rhythmic wave. But the sequence is a vignette; it is self-contained, a seemingly auto-erotic secret that, like a virus, can infect but remain hidden. As a subplot there is no pressure to include it in the willing suspension of disbelief of the "reality" of the story and it can function independent of the rest of the film.[3] That the cloth that they perform with is sari-like permits another analogy with Indian film. During her discussion about the inception of a Western erotic gaze objectifying the female within the Hindu musical, Natalie Sarrazin pinpoints this specific change in

the film *Khalnayak* (1993), citing the song *"Choli ke Piche kya hai"* ("What is under my blouse") also in *Pardes* (1997). The heroine "is positioned for us in a soft pornographic pose as the wind blows through her hair and teases at her dress" (Sarrazin 2008: 12). These pivotal moments galvanize a connection between the genres and the underlying eroticism communicated through cloth in both Hollywood and Bollywood musicals. Further, it is the common aspect of dance that liberates the body advertising and embracing its natural sexuality yet all the while displaying it within the "chaste" context of a "parental guidance" approved viewing. Sarrazin's discussion of courtship songs makes another useful comparison as it focuses on the isolation of the pair that we may focus on their complicity.

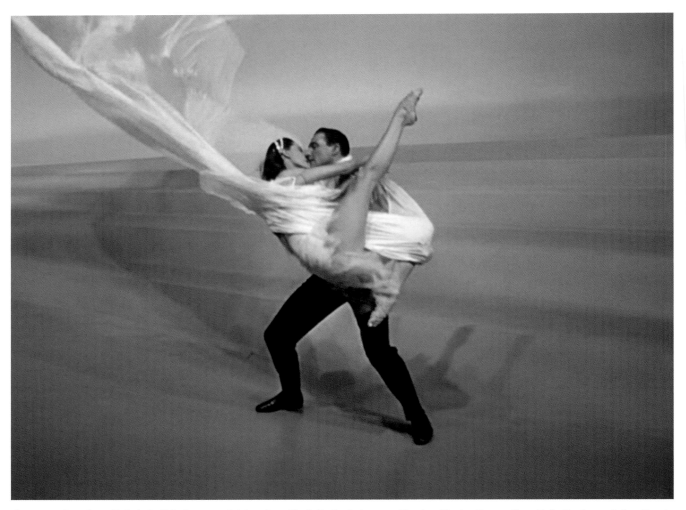

Figure 47 *Broadway Melody Ballet.* Screengrab taken from *Singin' in the Rain*, 1952. Director: Stanley Donen, Gene Kelly. Producer: Arthur Freed.

Sublimation

During *The Inn of the Sixth Happiness* (1958), different types of cloth impinge on the narrative, communicating a range of subtle hierarchies relating to sexuality, work, and gender. The practice of foot binding is used as an entrée into another culture, revealing it as an arcane yet still desirable practice despite enforced societal changes. Similarly, the focus on a luxurious silk cheungsam alludes to a life of wealthy leisure and entertainment. Both are fabric-related, intertwined in their references to sex (romantic or other) and both underpin the narrative. The story is set in Yang Cheng, China, (the birthplace of silk production), in the turbulent years preceding World War II and, despite being filmed in the Welsh Snowdonian hills, it has an authentic charm. The exoticism suggested by this Chinese backdrop might imply some predilection towards the eroticism of "the oriental" (Said 1978); indeed, a rampant colonialist missionary zeal is portrayed. However, couched within this atmosphere is an interesting exposure of the mixed-blood racism that Lin Nan (played by Curt Jürgens) suffered as a child. His Dutch father took him and his novelty "beautiful Chinese mother" back to Holland, but when she became an embarrassment he divorced her and sent her home. This obviously wounded Lin Nan psychologically as later he asks Genaii (Ingrid Bergman), "Would it offend you to be loved by a man of another race?"[4] The night she wears her red cheungsam, she is "honored" to accept him. It is Lin Nan who had originally arrived in the province to reinforce the anti foot-binding law program "aimed at the equality of women" and which led women to wear the lotus shoes.[5]

Figure 48 *Chinese Lotus Shoes for Women with Bound Feet,* **Nineteenth century.** Collection: Victoria and Albert Museum, London. Photographer: Liz Rideal.

Why is this story relevant to the theme of erotic cloth? Superficially, this benign "feel good" vintage tale contains a strong feminist message tempered by polite romanticism, featuring many orphans, the "natural" by-product of sexual encounters of whatever kind. In fact one of these, "Sixpence," is adopted from a woman who is typecast as a prostitute, sporting flash jewelry and a winning if crooked smile. Invited to remain in Yang Cheng as the "foot inspector" by the local Mandarin (Robert Donat in his last film role), Genaii's character must change public perception and so implement a law forbidding female foot binding, a practice originating with dancers at the Chinese court in the late tenth century that came to reinforce the hierarchy of the class system. Bound feet became desirable to aspirational families and popular for wealthy women who could afford not to work. It was a form of conspicuous consumption in the story of fabric and fashion, but who was "consuming" whom in the sexual gender politics of the fashion? Slippers for the tiny, crescent-moon shaped feet (typically ten centimeters long) were known as lotus shoes; bound "petal" feet became more prized than facial beauty and essential for a good marriage. The Chinese believed that women obliged to walk, with the small uncertain steps of bound feet, signaled the development of strong vaginal muscles, making for more pleasurable sex (Foreman 2015). This is reminiscent of present-day cosmetic surgery where vaginas are tightened for similar male gain and the enlarged penis hailed as the most desirable appendage. There are numerous different cultural examples of interference with body form, growth, or decoration, from tattoo to breast enlargement. "Bondage" is a loaded term sexually, with roles for both the sadist and masochist, and foot bondage too infers power play and dominance. The small feet were fetishized. Impeded movement and thus female independence was curtailed with women forced to stay in or near the home. We witness a seminal moment in the film, when an old woman helps to convince the women to unbind their feet, although this was dangerous to do after a lifetime of deformity. On the surface far from erotic, the very act of unbinding describes a release in three dimensions and with that a sense of relaxation coupled with excitement for having resisted the status quo. Fundamentally, the parallel can be drawn between this event and that of a woman letting down her hair. Abandonment is signaled: it is a step toward equality, if not quite in the bedroom, at least on the ground.

By contrast in the film, Genaii is independent, emancipated, and wears ordinary working clothes, which is why, when presented with the red silk cheungsam in a lacquered presentation box, the luxury item makes such an impact as a different kind of material object. It heralds her future sexuality by drawing attention to her dormant self-view as asexual ("I'm not attractive in that way," she tells Lin Nan). Red, in this context, is lucky and is traditionally used in Chinese wedding clothes so that it also hints at her impending romantic, marital attachment. The gift is symbolic, purposely given to her as someone who purports no vanity and always wears a plain Chinese-type workers' outfit of jacket and trousers. But the brightly colored cheungsam is made of fine silk and so connects to the expensive raiment worn by the dancers who entertain the group of VIP invitees at the special dinner organized by the Mandarin. Their act is enclosed behind stage curtains and they perform at his behest. The lacquered box is red and intricately carved, heart-shaped, and opens like a clam to reveal the luscious cheungsam. She takes it out and presses it to her body, enjoying the silken feel and the projection of how this will transform her. There are shades of auto-eroticism implicit in the gesture; her hands outline her form, potentially echoing those of Captain Lin Nan.[6] Later, when he finds this garment among the shattered ruins of the inn after the air raid he also caresses it as if it was Genaii herself, making a fetish of it, not knowing then if she is alive or dead. Without her inside the dress making it come alive with movement, it becomes dead and lifeless as she might be. The garment embodies the potential of their affair so pregnant with possibility, the sex teetering on the edge of these fabrics, ever present and suggested but never explicit, always postponed.

Tête-bêche[7]

Wong Kar-wai's film *In the Mood for Love* (2000)[8] offers a similarly allusive sexual commentary that is triggered by and revolves around the selection of erotically charged cheongsams worn by Su Li-zhen (Maggie Cheung). As with Genaii and Lin, the eroticism is all in the allusion, the imagined, and, like the dancers at the VIP dinner, behind curtains. In fact, a red-curtained corridor is pictured twice in *In the Mood for Love* and this recurrence works in tandem with the Su Lin-zhen's repetitive change of outfits that together with the tango-like mesmeric musical score[9] build a tense and restricted personal space. The red of the

wafting curtains continues the ambiguity of feeling that communicates to us via the main characters. That they in their turn replicate what is happening between their respective spouses is another reflexive echo of the piece. The director says, "These are the good guys, because their spouses are the first ones to be unfaithful and they refuse to be. Nobody sees any darkness in these characters—and yet they are meeting in secret to act out fictitious scenarios of confronting their spouses and of having an affair."[10] As the audience is taken along a semi-somnolent journey, small variations within the sequences impart snippets of information and we rely on supposition to guide us through what we sense is suppressed passion on both sides. It is the story of unrequited love, love told in stylized code through the different patterned fabrics and the lonely mundane ritual of collecting takeaway noodles.

The art direction for the film is strictly choreographed, relying on the successive waves of claustrophobic interiors to be punctuated by the intense, printed colors worn by Su Li-zhen as she glides in and out, her sleek body encased within her tight sheaths, bound within the stricture of cloth that molds her form, clinging, outlining, constantly delineating. She is picture perfect like the famous Vladimir Tretchikoff painting *The Chinese Girl* from 1951. Indeed, the film is set in 1960s Hong Kong, at a time when social codes remained strict and the two main characters appear to respect and obey the mores of the time.

Her "dresses" and the fabrics that form them punctuate the narrative and change the pace of the film by their color and pattern; rich flower bursts, jazzy geometric designs, or combinations of these. Some costumes recur but others are reserved for important events within the film coinciding specifically with the music. All have high collars, this strict yet exotic clothing carries the film, simultaneously imparting a physical and formal layer of structure while literally encapsulating the erotic focus around which the film revolves. The interior and exterior scenes also pivot on the color and pattern juxtaposed and reflected by mirrors. The atmosphere is poignant, the protagonists are open to chance yet utterly restricted, caught. "We are wrapped in a mental atmosphere, folded in its mood . . . [In this film] where nothing happens, only the clothes change" (Bruno 2003: 113–22).

Cloth, despite its palpability, can be like music and smell, lingering in our lives and permeating in subtle ways beyond immediate classification. It is this hazy, elusive quality that invades the screen. As the director says, "In a movie, things that you don't see are things you cannot confirm. You can only guess."[11]

Stendhal Syndrome

F. Scott Fitzgerald's fiction of dysfunctional love unfolds during *The Great Gatsby* (1974) in which cloth is used symbolically—with implied erotic twists—in two pivotal scenes: first, in the flying excesses of Jay Gatsby's expensive rainbow-colored shirts. and then as a demarcation line, when the undulating semi-transparent pool curtains split open to reveal Jay in swimming trunks, floating languidly on an air mattress seconds before his murder.

The lavish, stylish clothes combined with sumptuous interiors add to the dominant atmosphere of magnificence. The film opens with sailing boats—their great white sails billowing—oozing wealth as they glide with sleek hulls across the bay in view of millionaires' waterfront properties. Jay in white is the provider of luxuriously laden tables with pristine cloths for parties "where men and girls came and went like moths." In the novel, references to color pepper the text and this is reflected in both the 1974 and the 2013 films directed by Jack Clayton (screenplay by Francis Ford Coppola) and Baz Luhrmann respectively.[12]

The love triangle of Daisy, her husband Tom, and Gatsby, as narrated by Nick, operates on a number of levels. Their clothes behave like pastel dabs of paint flitting across the landscape backcloth seeping into the atmosphere of the film throughout. A scene taken entirely from the novel occurs in Gatsby's dressing room. "I've got a man in London who buys all my clothes. He sends over a selection of things at the beginning of each season," says Jay as he throws the shirts disdainfully into the air. These symbolize privilege and ownership, like clothes in Renaissance portraits. Testifying to his worldly success, they fall around Daisy in a rainbow-colored ring. As she buries her head in them, she weeps, "I've never seen such beautiful shirts before," while quivering in the throes of a "Stendhal" moment. The mixed emotions of the memory of her youthful love for him are overcome with the knowledge that now he is rich, available, and using expensive shirts as emblems of consumer power to seduce her once more. Her riposte is pathetic and he is too blinded by love to realize the exposed poverty of her personality. This is cloth

Figure 49 Liz Rideal *India Song*, 2015. Photographer: Liz Rideal.

as a sexual bargaining tool within the dynamic of competitive male posturing. Can the exquisite shirts worn by Daisy's husband compete with Jay's? Should she swap men? Although at one remove from Jay's body—as these multicolored shirts rain down around her and she gathers them to her face inhaling deeply—they engulf rather than smother her with the essence of Jay—they *are* Jay. After weeping into a peach pink shirt and then laughing she moves to the window: "I'd like to get one of those pink clouds and put you in it and push you around." Enthralled and visibly moved in a way that does not occur in any other part of the film, she admits that she wants to control him—now that he is wealthy.

"Rich girls don't marry poor boys" was Jay's refrain from their youthful encounter. Now his fortune is made, she wants to get back in the game provoked by the sexual sublimation of shirts. Set free from their ordered, neat, constricted piles, they symbolize the possibility of her liberation. The

"stiff shirts" burst out uncontrollably—someone else will pick them up and restore mundane order. They "explode" after years of repression and denial, opening the way for Daisy and Jay to take up where they left off. The weeping is like the post-orgasmic release of tension, palpable in Daisy's dry, suppressed, stuttering utterances that create a jumpy, staccato background soundtrack. Her voice is constantly referred to in the text, and the pink clouds of nirvana are where its notes are heading.

Abstract Expressionism

The films discussed so far are traditional in their narrative strands and use the cloth to symbolize their remit. In contrast, *MOI NON PLUS* (2015) concentrates on images of cloth and how the material responds to air currents and consequent editing. The eroticism emerges from the

combination of colored cloth in action and the poetry heard in syncopation with the rhythm of the swathes of performing material. Cloth itself becomes eroticized via the mind. "A successful erotic film will stimulate the imagination as well as the emotions; it will inspire a sort of empathy; it will engage the viewer intellectually through a subtle form of artistic presentation. The "skin-flick" maker aims at a short-lasting physical thrill little to do with real eroticism" (Webb 1979: 290).

Painting influenced photography and, in turn, the visual tropes of filmmakers. Film's real power over painting is movement as illustrated through linear narrative and the juxtaposition and interruption of a series of still pictures. In my film I engage with Hogarth's painting, on which the camera lingers during the film, by drawing attention to the cracked flat surface, and the layered fronds of cloth visualized by brush and pigment, while exposing the duality of media through an insistence on recognizing the illusion and allusions of the lens's membrane in repeated flux; an iteration of the sex act itself. *MOI NON PLUS* spins a seriality of stills rather than using specific images to connect a storyline. I wished to combine word and image in a symbiotic way, "The Jade Stick is planted firmly between—it has found its way into the Hidden Opening . . . Their sweat has dampened the red quilt and now her arms are indolently folded behind her head. But who can stay indolent while tasting such joy?" (Gulik 2004: 215). The Ming Dynasty Chinese erotic poems become a verbal backbone, enriching the visual pace of abstract cloth and relating aspects of this consequently eroticized cloth to the "Lotus" (bound) feet of the female lover.[13] The title refers to the Jane Birkin/Serge Gainsbourg duet from 1969, "*Je t'aime . . . moi non plus*," that caused a furore and was fabled to have been recorded live during sex with much heavy breathing in a studio in Marble Arch. The opening sequence of my film is punctuated with a black, blank screen redolent of "*la petite mort*" spliced with sherbet-sharp colored stills and a dribbling Roman fountain with attendant gobbets of tumbling water droplets. Another trio of elements are conjured with Hogarth's pornographic diptych *Before and After*,[14] poems translated by Robert van Gulik (these accompanied erotic color prints of the late Ming period), and palimpsest footage of cloth in movement projected onto cloth in motion. The initial poem describes the formation of the "Elixir of Longevity," implying that vaginal ejaculation contains a woman's Yin essence, to be collected by men aspiring to

immortality, the mixture "completing" their Yang essence. Sumptuous and ordinary bedding appear as traditional locations briefly setting the erotic scene. The text posits the question of the ambiguity of sexual power, cloth used as a vehicle in male and female arousal and the tensions surrounding the sexual act. My film avoids overt pornography and uses jump cuts to imply the "positions of the flowery battle," focusing on the complexity of arousal and the repetitive nature of sexual congress. I aim to coalesce a plethora of ideas on a simultaneous platform in a syncopated collaboration of eye and brain.

Cloth is mute but is the canvas for projected eroticism whether painted, photographed, or filmed, offering the perfect medium for all fantasies, be they suppressed, sublimated, or liberated within the behavioral realm of sexual excitement and desire. Further aspects emerge: the quality of cloth, who does what to whom, or who experiences the doing or the receiving? The eyes gauge the textural quality of fabric and equate degrees of passion; touch itself is necessary in order to complete the circuit of tactile experience. In *MOI NON PLUS*, the tempo of the spoken word echoes the visual score of cloth "in performance." Translucent silks, together with transparent cottons, wave in graceful action to the tune of saucy text. This poetry, though descriptive of the sexual act, is still at one remove; analogies abound and these are eloquent even if interpreted as an extreme form of poetic license. It is as if a screen exists between the reality of the action of intercourse and, as the description evolves, the membrane that is evoked by Wilde exists here too, as a permeable barrier—not physical, but intellectual and visual. The drapery is simultaneously the mutable impediment and the equivalent of the pumping action. Much like the bound feet referred to in the text that are exotic and erotic yet remain out of sight,[15] so here the drapery is eroticized, it performs the action, while hiding any action from view.

As editor, I control the intriguing, circuitous complex web of eroticized cloth and engage covert analogies, such as the threading process (akin to the vagina pierced by the penis), the weaving of a story (similarly the production of a length of cloth) further to embroidering embellishments. This skein of film that recounts a sexually titillating tale is one of procrastination, delayed gratification and desire held in a constant tremulous stasis like perennial tumescence as opposed to premature ejaculation or a mutually

attained orgasm: therein lies the essence of erotic arousal and the elasticity of performative cloth.

To conclude this tale of spin and pirouette and frame the picture of abstract cloth, we can note that not all cloth has sexual energy, even with its innate ability to flow, move, and wrap. *French Cancan* (1954) directed by Jean Renoir showed us that despite successive waves of Degas-like dancers in frothy white knickers doing scissor splits, filmed cloth can look sexless. Phillip French disagreed, describing "its kinetic beauty accelerating in a steady crescendo to a powerfully erotic, not to say orgasmic, climax," illustrating how subjective and potentially gender-biased the frilly matter is (French 2011). That film portrayed Le Moulin Rouge, but real life Loie Fuller (1862–1928) performed at the Folies Bergère, displaying her own butterfly-like creations of fabric in a "serpentine dance." Interviewed in *Éclair* magazine in 1914, she commented, "I wanted to create a new form of art, an art completely irrelevant to the visual theories." She wasn't attempting an intellectual "Salomé." Fuller's live art[16] was given texture by animated roiling fabrics, yet ironically, without the document of film, we could not now testify to its magical delight. Her performance remains un-erotic because it is so literal; my film proposes rather than depicts sex, inviting the viewer to intuit eroticism through combined voiceover and fabric manipulation. Sex remains oblique and in the realm of suggestion; tapping into our brains and proffering fantasy, always the bedfellow of soft-focused erotica as opposed to that of explicit hard porn.

Notes

1 Pornography also uses cloth and the behavior of material to inject suggestive frisson to sexual proceedings with the portrayal of different kinds of lingerie coming a close second.

2 Symbolizing the devil and temptations of the flesh.

3 In the film *Silk Stockings*, there is an independent sequence where Ninotchka "dances" with her newly acquired silk stockings, an erotic vignette. Charisse is also the star in the film *Silk Stockings* (1957) [Film] Dir. Rouben Mamoulian, USA: Metro-Goldwyn-Mayer Studios, a remake of *Ninotchka* (1939) [Film] Dir. Ernst Lubitsch, USA: Metro-Goldwyn-Mayer Studios starring Greta Garbo.

4 This question is doubly ironic as both actors are foreigners from the viewpoint of a British audience.

5 The Victoria and Albert Museum's collection includes Chinese lotus shoes. See http://collections.vam.ac.uk/item/O89365/pair-of-shoes-unknown/ (accessed October 21, 2016).

6 Colonel Lin Nan is a military hero, like Wallace in *Braveheart*, who also associates fashioned cloth with his loved one. Perhaps these instances also reflect and characterize the "softer" (more feminine?) side of the male protagonists.

7 "Tête-bêche" is a term describing stamps that are printed top to bottom and placed to face each other. In the context of the film, it is a descriptive term denoting the structure of the film—that is, head to tail—which is predicated in this interlinked fashion.

8 See A. Yue (in Berry 2003: 128–36).

9 "This poisonously addictive stretch of music, which crops up at full length eight times in the course of the movie, was first composed by Shigeru Umebayashi for Seijun Suzuki's batso ghost-opera *Yumeji*," http://www.clivejames.com/video-finds/music/in-the-mood-for-love (accessed May 17, 2017).

10 Wong Kar-wai interview, http://www.laweekly.com/film/unforgettable–2132987 (accessed May 17, 2017).

11 In http://www.laweekly.com/film/unforgettable–2132987 (accessed May 17, 2017), the director confirms the importance of the invisible, sensed, intangible, and in this context, the film becomes analogous to the qualities of cloth.

12 Billy Wilder famously dismissed Luhrmann's version as being like "Michael Winner directing Proust."

13 In Rideal's *MOI NON PLUS*, the lotus feet are referred to in the poems that form the soundtrack to the footage of cloth in motion, http://www.lizrideal.com/works/films/moi-non-plus 2016.

14 The diptych is part of the collection at the Fitzwilliam Museum, Cambridge (Cambridge: 1731). See http://webapps.fitzmuseum.cam.ac.uk/explorer/index.php?oid=3383 (accessed May 17, 2017).

15 The prints show the women having sex with their lotus slippers on. The actual bound feet were not considered attractive; it was their scale and the effect on internal organs that was prized.

16 Each frame was individually hand-tinted using stencils and colored dyes. It is important to note that some dispute the dancer's identity suggesting that it is Papinta, The Flame Dancer. See https://www.youtube.com/watch?v=O8soP3ry9y0 (accessed October 21, 2016).

References

Braveheart (1995) [Film] Dir. Mel Gibson, USA: 20th Century Fox

Bruno, Giulliana (2003), *Pleats of Matter, Folds of the Soul, Log. No.1*, New York: Anyone Corporation.

Danse Serpentine (1896) [Film] Dir. Lumière Brothers, France: Lumière.

de Clérambault, Gaëtan Gatian (1908), *Passion érotique des étoffes chez la femme. Archives d'anthropologie criminelle de Médecine légale et de psychologie normale et pathologique*, t. XXIII, Paris: Éditions Masson et Cie.

Foreman, A. (2015), "Why Footbinding Persisted in China for a Millennium," *The Smithsonian Magazine*, February. Available at: http://www.smithsonianmag.com/history/why-footbinding-persisted-china-millennium–180953971/ (accessed May 17, 2017).

Fothergill, Anthony (ed.) (1996), *Oscar Wilde's Plays, Prose Writings and Poems*, London: Everyman/J. M. Dent.

French, P. (2011), "French Cancan Review," *Observer*, 7 August. Available online: https://www.theguardian.com/film/2011/aug/07/french-cancan-jean-renoir-review (accessed May 17, 2017).

The Great Gatsby (1974). [Film]. Dir. Jack Clayton. USA. Paramount Pictures

Gulik, Robert Hans van (2004), *Erotic Colour Prints of the Ming Period: With an Essay on Chinese Sex Life from the Han to the Ch'ing Dynasty. BC 206–AD1644*, Leiden: Koninklijke Brill.

Hogarth, William (1753), *The Analysis of Beauty*, London: John Reeves.

The Inn of the Sixth Happiness (1958). [Film] Dir. Mark Robson. UK: 20th Century Fox.

In the Mood for Love (2000). [Film] Dir. Wong Kar-Wai, Prod. Wong Kar-wai.

In the Realm of the Senses/Ai no Corrida (1976) [Film] Dir. Nagisa Ôshima, France: Argos Films, Japan: Oshima Productions, Japan: Shibata Organisation.

James, Clive. *Yumeji's Theme from "In the Mood for Love."* Available online: http://www.clivejames.com/video-finds/music/in-the-mood-for-love (accessed 17 May 2017).

Kar-wai, Wong (2001) interview. Available online: http://www.laweekly.com/film/unforgettable–2132987 (accessed 29 April 2017).

MOI NON PLUS (2015). [Film] Dir. Liz Rideal.

Mulvey, Laura (1975), *Visual Pleasure and Narrative Cinema*, Screen 16 (3): 6–18

Mulvey, Laura (2005), *Death 24 X A Second*, London: Reaktion Books.

Papinta, The Flame Dancer. Available online: https://www.youtube.com/watch?v=O8soP3ry9y0 (accessed 21 October 2016).

Said, E. W. (1978), *Orientalism*, New York: Pantheon Books.

Sarrazin, Natalie (2008), "Celluloid Love Songs: Musical 'Modus Operandi' and the Dramatic Aesthetics of Romantic Hindi Film," *Popular Music*, 27 (3): 374–411.

Shera, P. A. (2009), "Selfish Passions and Artificial Desire: Rereading Clérambault's Study of 'Silk Erotomania,'" *Journal of the History of Sexuality*, 18: 159–79.

Singin' in the Rain (1952). [Film] Dir. Stanley Donen and Gene Kelly, USA: Metro-Goldwyn-Mayer, USA: Loew's Incorporated.

Webb, Peter (1979), *The Erotic Arts*, London: Secker & Warburg.

Yue, A. (2003), "In the Mood for Love: Intersections of Hong Kong Modernity," in C. Berry (ed.), *Chinese Film in Focus: 25 New Takes*, London: British Film Institute: 128–36.

Thoughts on the erotic:

Erotic, as ambiguous sense, involves memory and uncontrolled senses awakening the erotic state of being.

MASAKO MATSUSHITA

12

UN/DRESS

MASAKO MATSUSHITA IN CONVERSATION WITH LESLEY MILLAR

The Performer's View

The preparation is the start of the performance and I'm in the preparation phase. I am in the lobby area of the toilets, which has become my dressing room. Given the nature of the place, a place very different from my usual one, it is already a shared intimacy. The toilets are available to the event participants, and they come in and go out as I walk toward the bags containing the clothing. These are the clothes that become my accomplices in the event that is taking place, for *UN/DRESS* has already begun for a single spectator: me, performing for myself in this strongly intimate atmosphere. I start by undressing in order to start dressing myself for *UN/DRESS*, separating myself from myself, in order to merge with my other self.

I pick up the bags, open them, and place the contents on a shelf. The clothes are now sitting there with me, sharing the same space as they wait to be put on. They're clothes, lots of them, already presences watching the performance. Each garment has its own history and belongs to someone. When my body approaches the garment-body, a reversal of roles occurs. My body becomes absent and each garment acquires a presence, absorbing small parts of my soul. I put on the Other, I wear it, I become many stories in one, and at the same time none, representing many in a single present.

I prepare the means of transport, and I load it with presences, energy, and concentration. It's a rite of preparation in the repetition of the act.

I'm caught.

I'm ready.

I go downstairs to approach the space where the transformation will take place. I walk toward it in a way that is different from before I took off my everyday clothing. I feel restricted, contained, limited, composed. I'm wearing more than twenty pairs of knickers. My chest is covered with a similarly large number of bras of various sizes, a sort of bodice/carapace that makes it hard to breathe.

The performance already began in the dressing room upstairs, but the best part is starting now. The clothes that I'm wearing become the main theme, but no one yet knows this. In the silence, I present myself. With my feet firmly planted, I begin looking around the room. Rays of sunlight filter through the windows of the Great Hall of the Art Workers' Guild. The electric lights are on, too, enabling me to see the spectators: not only those who are standing or sitting, but also the many imposing portraits hanging on the four walls of the room. All the portraits are of men, except for one woman, as I recall.

My field of action is limited, but the presence of spectators, including the paintings all around, make it much, much bigger. I meet their gaze, my eyes floating on the invisible waves of the wind, passing from one face to another until I have covered all of them, including the portraits. We are meeting each other for the first time. I feel I am being welcomed, and I greet them too: what is about to happen, is already happening, is an exchange. What I'm wearing demands attention. There's feeling in this room, there are energies that are reinforcing the concentration. I feel in control of the direction to be taken and my body doesn't feel lost. My body knows where it's going.

I bend my head and chest, vertebra after vertebra, as far as necessary in order to reach the first pair of black knickers. I grasp the top and pull them down toward my ankles, stopping at that level. I do the same for all the other pairs of knickers, each time covering a bit more of my legs until the flesh is completely covered. I slip my arms through the straps of the bras and only then do I look up. I present myself again, transformed, changed: now I am not here; now I am performing. With extended, dense, slow movements, I stretch out my arms, trying to fill the remaining space as much as possible, as far as I can reach within the limits of the fabric. I'm wearing a new skin that can stretch and at the same time contain me. Inside, I have an engine that feeds movement and manages the use of exertion, measuring out just the right amount so that I can move these external bodies with the appropriate conviction and delicacy in their presentation and transformation. In a nymph-like phase, first one arm and then the other escape from the covering and once outside, they stretch out, vibrating in space, freeing themselves from the constriction, breathing freely. Everything remains silent: you hear my breathing and my body is in control.

The upper limbs are free and they move down to the hips to take hold of the skirt made of knickers and change its use. They are slipped off with a faster action than before, a movement that then returns to the slow steady pace once they have been taken off and lifted up above my head with arms stretched upwards. My body becomes elongated, reaching to a point, while it already begins to take on a different shape, moving downwards, towards gravity,

feeling the weight of the clothes and of the limitations they bring with them.

I end up sitting down on a small wooden ledge.

Alone here again, I feel as if I'm a painting, another portrait that has appeared among the ones on the walls. I turn my head, with my back to the audience, looking toward the other audience hanging on the walls. Again I meet their gaze as in the beginning, and then I turn back to look at the audience in the room and to meet their eyes again. There's an enchantment there, and I, too, feel enchanted by the place and by the presence of such an intense audience.

I let the hat made of knickers slide to the ground and I rest my head on the clothes. In this position, lying down, intimate, I have arrived.

Figure 50 Masako Matsushita, _UN/DRESS_, 2015. Photographer: Gerry Diebel.

UN/DRESS—the Audience View

The large room is packed and silent, not a spare seat, and the air vibrates with anticipation. Almost no one in the room knows what is about to happen. Then, noiselessly, you are there, standing at the top of the steps leading down to the room, looking straight ahead. You stand absolutely still as people begin to be aware of you and take in your extraordinary appearance. You are small and wearing a leotard, your bottom seems disproportionately large for your size and you have several brassieres around your waist. You turn your head and look at us, catching our eye, making contact, seeing who we are.

Then you look away as you place your legs slightly apart and, without warning, gently ease the knickers down to just above your ankles. This is no strip/tease, it is as if you are alone, self-absorbed, removing the underwear for washing yourself, or going to the lavatory—a totally private action. Suddenly, we are the Elders watching Susannah at her toilette, and we don't turn away. As you remove this first pair of knickers you reveal you are wearing another pair. Now we know why your bottom seemed so bulky. You repeat the action again and again, creating a multicolored "skirt," covering from your ankles to your waist, made up of more than twenty pairs of knickers, each pulled down to overlap the previous pair. Nobody moves. The action of pulling down the knickers is one of such intimacy that we barely breathe. You carefully adjust the skirt and then slip your arms into the many brassiere straps hanging down at either side.

Your body is now very restricted; your legs must keep apart for the knicker-skirt to stay in place, your arms are caught to your sides. Again you stand perfectly still, looking ahead. Then you move your arms slightly away from your sides, like a butterfly or moth inside its self-spun chrysalis, and you begin, very slowly, to come down the steps toward us. Your movements are incredibly graceful, especially considering how constrained are your limbs. You bend slightly and sway; the fabric of the knicker-skirt stretches and gives, like skin. A skin made from the most personal of clothing—we are seeing the inside, the most intimate surface, turned to face us. You look at us, leaning backwards as you move with extraordinary control, your feet curling to balance your body. You hold the room in your gaze. There is such confidence in your eyes, you are very vulnerable in your encasement but you are beautiful and strong.

Swaying, bending, in control of every muscle, every foot placement carefully explored, you move to some internal rhythm across the floor in front of us, stopping unexpectedly to release one arm from its fettering. The arm rises like a wing, then the other arm, and you stretch, luxuriating in the freedom of movement. You stretch and arc your back in a gesture of abandonment, then abruptly bend down and quickly shed the knicker-skirt, which automatically rolls and curls in on itself, like a peeled skin. You hold it aloft and study it, then place it onto your head, where it sits: a bundle of cloth. It no longer binds you, but sits as a weight to be carried.

Slowly, you lower yourself to a half-kneeling, half-sitting position, always holding your head high, and turning as you go from facing us to having your back to us. You move your head to one side and then the other, then extend one hand along the floor, slide down and turn onto your stomach to face us again, still balancing your bundle of cloth. You level your eyes at us, each of us feeling an individual connection. We recognize you now as the eternal Odalisk, turban on your head, hand under your chin, inviting the viewer's gaze and looking directly back at us, observing the observer. It is a long, long moment of exchange and recognition. You have achieved your goal, drawing us in without ever inviting us. The narrative of the cloth—the knickers and brassieres, their intimate contact with the body, caught us and held us, as you were caught and held. Then you close your eyes, allow the turban to slip to the ground and you roll over on your back; we are dismissed.

London, UK, January 11, 2016

LM: In his Introduction to *Dressing Dangerously: Dysfunctional Fashion in Film*, Jonathan Faiers suggests that the stripping away of a garment's normal function allows it to be transformed and to "become an alternative set of vestimentary signals with a communicative power beyond the narrative confines of the film" (Faiers 2013: 9). Do you think there is a resonance here with your approach to your performance in *UN/DRESS*?

MM: *UN/DRESS* is a metaphorical performance that comes from the fusion of subject and object; it is a momentary state of becoming in which the spectator is free to interpret. I place myself in a state of transformation. It is also a matter of perception. It is interesting for me to see

Figure 51 Masako Matsushita, *UN/DRESS*, 2015. Photographer: Paolo Piaggi.

the audience responses to this work in different countries. In some countries they laughed but British audiences are totally engaged and serious.

LM: Did they laugh for embarrassment?

MM: Yes, it is the transformation which is a taboo (isn't it ambiguous too?)—lingerie is something we women have to wear, whether it is comfortable or not. And I am making a movement with the panties which is very common— pulling them down as if I am going for a pee, that is the moment when people recognize the movement and are embarrassed. It is a movement that is not usually public; actually, what makes the transformation is that it is not sexy. I would remove the lingerie in a totally different way if I wanted to be sexy, prior to lovemaking, for example.

LM: Of course, it is not just the lingerie that is intimate, it is also that movement which is so associated with a totally private action. Nevertheless, because of the intimacy, because of the privacy it also is very erotic, but not the eroticism people think they are going to get. But it is erotic.

MM: Do you remember one of the first times we spoke about the work and you asked me: "Did you think your work was erotic?" Of course there is something very erotic about the performance but there is also something very specific and personal in this way of undress. I did not make *UN/DRESS* with the aim of creating an erotic piece. When I received the invitation from you and Alice to be a part of the book *The Erotic Cloth*, I started consciously thinking about the subject, rather than knowing that the erotic was innate within my performance. I have to exercise a rigorous self-control over my body in order to achieve the movements and, most importantly, to hold the attention of the audience, which comes from concentration and self-control of me as being in performance mood. To perform in this way, to display movement, you have to be totally aware of yourself—your body and mind. I wonder, perhaps the erotic comes from the intensity of the presence from my side. Maybe it is the link between eroticism and control and that is why and how I bring eroticism to the performance. If there is something more it comes from the audience, not from me.

LM: For me, I think that the erotic exists in the moments before one or other takes control—it is a feeling you are not controlling

MM: What if I say that what you see as erotic in *UN/DRESS*, that is the moment when I am in control the most?

LM: I would say that once I understand that, it moves from erotic to desire, that desire is about control. The minute we name it we transfer that ambiguous sense of arousal into a desire to have.

MM: That's true. Erotic, as ambiguous sense, involves memory and uncontrolled senses awakening the erotic state of being. The erotic floods the subject because of not being in control of it. Sensation that is of pleasure and delight. But this happens from the audience in the context of what is seen. I am that flood.

LM: We are also witnessing a transformation, of the clothing, and of you—the lingerie becomes a skirt, then a peeled-off skin and then a hat. It is almost you are saying to the audience "What did you think these things were?" They are totally transformed—as a skin is shed, as you take off your cloth/skin it becomes something else which has no personal association at all, it is "other." The items have undertaken a passage from being as close to the center of you as possible to being unrecognizable. I wonder, at what point did you decide you would put the items on your head?

MM: It was during the processes of working out ways of transforming and discovering possibilities between my-self and the other self (object-body). It was about changing perspective, reversing. I do this because I like to change the way things look, to transform them, to find other meanings that can be created behind the given function—I am in a state of constant research—what I do as an artist, what I always try to bring to my work, is to see things in a different way, to create another narrative.

In terms of the performance, when removing the "skin" of the lingerie, I decided to create a movement that goes from the waist down the legs, off the body, and away from the body. That is when I hold the shed skin up in the air, but I feel it has to come back onto the body, it belongs to the body, but transformed, so it goes on top of the head. Skin off, skin on. Then I feel a weight on my head and I/my body must move down under the weight.

LM: As you describe the bundle on your head, you describe it as a weight, and of course it is also the weight of the past . . . the weight on your head of all those people who wore the lingerie, those presences, those absent

bodies. The cloth becomes your absent body and/or the absent body of the Other—a co-mingling of both.

MM: From the body, out of the body, on the body. I consider it a dotted cycle of the invisible/visible in which weight is being carried and carries me. Becoming absent from the presences, belonging to the present by being present through the absent bodies. I think this could go on in an endless repetition, in life too.

LM: In your dance *TaikokiaT* you wear many kimono, which must have real physical weight. You talk about "kimono layering"—could you explain what you mean?

MM: I use many layers of kimono to add weight to the body. All these amazing fabrics one on top of another, so that I am initially hidden and can hardly move. All the different layers that restrict and limit. And within this limitation I want to show, reveal an aesthetic emerging from a delicacy of undress.

LM: The delicacy of undress? So the delicacy is beneath the kimono? And you undress to reveal the delicacy?

MM: Yes, within this constriction it is possible to be aware of one's body, to feel it. Then after this constriction to strip the layers off, to take them away, there is a reincarnation of seeing yourself again, the internal layer after shedding/losing all the layers which were on top. It is a similar action to taking off the lingerie in *UN/DRESS*. An emerging from a skin.

LM: Your movements are extremely eloquent and, certainly in *UN/DRESS*, very slow, emphasizing the constraint and then the freedom from that constraint.

MM: The movement comes from the core. I feel the layers on me, the limitations. In order to move I have to move from the center. It is very intense.

 In my movement I am influenced by butoh—finding the use of the space and the imagery. The slow walk in butoh, as I experienced together with Marie-Gabrielle Rotie, I leave behind the past and move to the future. Moving in this way, it is as if you leave behind the soul, but you feel it behind you. Every movement is like a frame, a movie frame, you leave the position but you remember the position you have just left, and at the same time you move into the unknown, into the next frame, entering the future; future which becomes present in the very moment you enter, a present which has already passed.

LM: As the cloth flows behind you . . . the erotic cloth serves to represent that which we cannot see—the absent-present body.

MM: Echoing that delicacy of the body movement.

Pesaro, Italy, May 30, 2016

LM: I feel that in your work, cloth acts as the mediating surface for the visceral body, yet in the latest version of *UN/DRESS* you take everything off, you are totally naked.

MM: After the constriction of wearing a skin made out of lingerie I followed the need of getting free from limitations and constraint. I felt the necessity of stripping the layers off, taking them away, reinforcing the presence of the self again. The reincarnation of the internal layer after having had all the layers on me. The one being left is my flesh, a cloth made out of skin, freedom in wearing the pure body. Wanting to show what I need before starting another transformation.

LM: The moment you remove all the underwear it is like removing a shell, like a butterfly coming out of a cocoon. It is also quite violent as you push and pull yourself out of the underwear.

MM: Yes, like an eagle trying to change its beak. That takes more than a month and is very painful—it is driven to do it otherwise the eagle would die, and it pecks at the rock until the old covering breaks off. The new beak takes two weeks to grow. This doesn't happen when they are very young; they are already a certain age when they have to do this. When I perform the new *UN/DRESS* I struggle with the women's items as if I was peeling off a skin like a snake, changing the beak like an eagle, and then I move into the stripes of cloth lying on stage. I weave my body in and out, finding my way through using the structure, a regular structure in order to merge into one shape; my shape in relation to a structure that in life we have to follow.

LM: But you change it, you make it your own, the seemingly rigid structure of lines is transformed into another kind of clothing, free-flowing, non-structured.

MM: Like a kimono without stitches—and then it becomes an extension—somehow intangible and tangible.

LM: The body is glimpsed through the spaces between the lines, so you are covered but not entirely covered and then it begins to become erotic again. You fold yourself into the cloth, threading your body between the spaces. I think this is where your relationship to the erotic cloth lies, in that space, where you put your body, where the body isn't.

MM: I wonder if the erotic lives longer than desire—you can never escape it. The erotic never goes away.

LM: I am interested in this idea that one is never able to escape the erotic; that it is always there although one is not always in it. It doesn't have precision, it is ambiguous, fluid, and nuanced. The interesting thing is that ambiguity isn't arbitrary, it isn't one thing or another and I maintain that to remain in the erotic, it must remain ambiguous because the erotic, like ambiguity, has no boundaries, shifting, without edges.

MM: When you say edges, what comes to my mind I think it is not edges of obstacles or limitation, walls or . . .

LM: When you stand still there is an edge, as soon as you move the edge changes.

MM: Yes it does, constantly, and possibly it doesn't come back

LM: The body turning one way or the other, there is no edge to the body, it is a continuous contour; we know that even if it is only partially visible at any one time.

MM: Past movements and future movements . . . in some pieces I do move from one to the other . . . last time we spoke about butoh—leaving traces of the body and going into the future through the body. Going very, very, very, slowly you can feel layers of skin left behind—it is not one thing or another. The figure left behind, you can't catch it anymore but it still resonates in the space. I am moving and as I visualize it, the figure is already blurring away.

LM: That is such a textile image, it's not cloth but it is something like cloth, the movement described by the cloth—as you spoke I could see it, as I said before, like a floating cloth describing where you were before, because you are not where the cloth is, the cloth is where the body just was—always as you move the cloth is where you just were . . . The absent body is in fact oneself, the body we can never see. We recognize others through our eyes, but

we can never see our eyes looking at our self. Although I can see my eyes in the mirror I cannot see myself seeing, but the cloth can describe the seeing, can describe the body which is no longer there.

Drew Leder (1990) writes that the very nature of the body is to project outward from its place of standing. From the "here" arises a perceptual world of near and far distances. From the "now" we inhabit a meaningful past, and a futural realm of projects and goals.

MM: Yes, when I stand naked there is no past and no future. When I take the clothes off and put the other cloth on, these are the moments of landing and departing, of perceiving past and future.

LM: Leder also says that we can understand neither the origin, orientation, not texture of the perceptual field without reference to the absent presence of the perceiving body.

The cloth always maintains the imprint of the body, so therefore the body is always there—the body in the cloth, from the past, in the present and for the future. . .

MM: There is always the importance of people when I make performance, for example the underwear of people in *UN/DRESS*. Also the recent piece, *Diary of a Move*, is about catching other people's movements. I record one or more gestures a day that people around me make, for a specific number of days. I follow a specific process to put them together and I execute them. When I dance the *Diary of a Move* each move brings me back to those specific passed moments. I am living for a little while the story of those people through their gestures. It is a translation of a translation.

For *UN/DRESS* I was thinking about suits of armor and the inside space of the armor which has gone through a moment in time which is past and so it is a memory and within the armor is a body made from space and time—the container is a membrane which allows things to pass through.

LM: How do you relate that to your own performance?

MM: When I work collaboratively I don't necessarily access it, depending on the nature of the work. But when I perform solos I find I have a straight connection to that by delivering it through myself finding a way to become absent by shifting between my armature and my inside volume.

LM: However, the cloth always knows the story of the skin.

MM: So the story doesn't end.

Continuing *UN/DRESS*—
the Performer's View

Theatre, black box. On stage is the body of a woman and eight long strips of fabric perpendicular to the audience.

All around is dark, with a faint light where I am.

The first part of *UN/DRESS* ends with my body lying curled up, downstage right. Spatially, I am in the opposite position from the beginning. It is here that the development of the work begins.

I'm lying with my head resting on the cushion of "changing underwear." Lying on my back, I undo the hooks of the bodice, loosening its grip around the bust. Gradually, my lungs acquire space inside my rib cage. I roll over onto my stomach and continue the action. It's a habitual action, that of undoing a bra, with a panting, convulsive movement. I free myself from the constriction of the garment. I shell myself from the pod. I shed my snake skin. I abandon the wrapping, the packaging, the covering, to present the nudity. Nudity as the pure identity of a body ready for union.

I find myself on my feet and the confrontation becomes stronger, displaying myself just as I am. Naked, wearing the costume of myself.

The whole of the stage lights up as I walk to the center of the room between the fourth and fifth strips of fabric. Slowly, I lower myself so that I am lying in a state of contemplation. I give myself up ecstatically to the immersion and fusion of the my-body with the object-body (the lines). The presence of the strips of Prussian blue fabric represents a symbol of precision, structure, regularity, direction, dimension. The strips are lines that expand the horizons, marking a crossing. A geometric body that determines the way to achieve an aim.

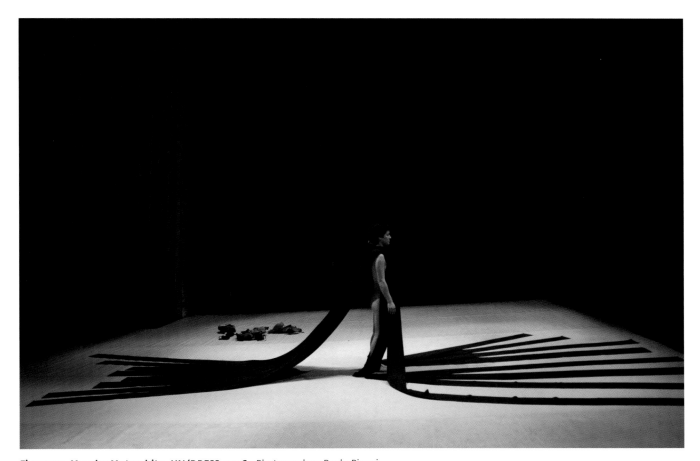

Figure 52 Masako Matsushita, *UN/DRESS*, 2016. Photographer: Paolo Piaggi.

The strips are lying on the ground next to me. I extend my arms and slide the palms of my hands underneath the two strips adjacent to me, so as to lift them up to the sky and bring them to me. I continue, picking up the remaining strips, one after the other, bringing them to lie twisted together on my body. I sew my skin to another skin, fusing myself in a single body.

The boundary line gives rise to the rebirth of the body.

I re-emerge from a two-dimensional surface with a new garment, generating three-dimensionality.

The body is strongly present and at the same time, absent.

The body is the central point of the fusion, the isthmus that joins, the hourglass.

References

Faiers, J. (2013), *Dressing Dangerously: Dysfunctional Fashion in Film*, New Haven, CT: Yale University Press.

Leder, Drew (1990), *The Absent Body*, Chicago: University of Chicago Press.

Afterword: Erotic Cloth—the Case of Kimono

YUKO IKEDA

Cloth is erotic. The drapery, for example, that was carved in the marble sculptures created by Bernini or Canova is very erotic. The sculpture of the ripe body covered with draped cloth stimulates our tactile perception as if it were a living substance.

By way of contrast, the Japanese kimono, and the cloth from which it is made, is much more subtle in its eroticism. The kimono is created with straight pieces of cloth, which do not follow the form of the body, but cover it cylindrically, almost chastely, without drapery. Beneath the outer kimono Japanese women wear another kimono called a juban. As the wearer moves, the cloth of the juban can be seen unexpectedly through the sleeves or hemline of the kimono. The wearer sometimes dares to select a sober color for the main garment, but a brilliant color for the juban. This is the Japanese aesthetic sense of iki, identified by the Japanese philosopher Shūzō Kuki, which he described in his book *The Structure of Iki* (1930) as containing the most admired traits of the Edo period: sensuousness, courage, and acceptance.

Additionally, a tiny cloth called haneri is sewn on the neck of the juban. Although the haneri inherently functions as protection against dirt, it is often made with a totally different type of cloth like velvet or an ornamentally embroidered cloth. The haneri can be glimpsed between the garment and the neck or the bust. These cloths draw our eyes to the border between the garment and the bare skin and lead us to imagine the covered body inside the kimono.

Japanese men usually wear quieter colored kimono, or ones without decorative pattern, but which have a tiny motif print or embroidery on the hem. When standing or sitting, this tiny motif is hidden under the layers of cloth; however, when the man is walking or climbing the stairs, it suddenly appears and catches our gaze. Men also wear a short kimono-style jacket called haori over the main garment. The lining of haori often contains printed or embroidered pictorial patterns, for example a dragon, phoenix, Mt. Fuji, waves, and so on. These patterns cannot be seen when the jacket performs its function; they only appear when the haori is taken off. These clothes with motif or pattern suggest the spirit hidden inside the body.

The cloth of kimono is very erotic. It is an eroticism that can be imagined through the eyes.

Reference

Shūzō Kuki (1930), *The Structure of Iki*. English translation available in Nara Hiroshi (2004), *The Structure of Detachment: The Aesthetic Vision of Kuki Shuzo*, Honolulu: University of Hawai'i Press.

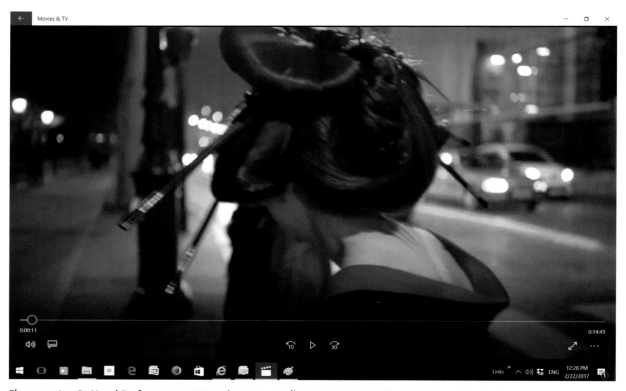

Figure 53 Les R. Mond Performance at Pont des Arts. April 21, 2011. Screengrab. Artist: Yuca. Director: Enzo.

INDEX

In this index illustrations are indicated in *italics*